PAUL CÉZANNE

Also by Gerstle Mack

TOULOUSE-LAUTREC

"Gerstle Mack's book, so complete, so searching, so just, adds to his own already high prestige as a biographer and once more . . . puts the art world in his debt. The Toulouse-Lautrec biography is informed throughout with a spirit of warm human understanding and of fine critical integrity." —*The New York Times*

GERSTLE MACK

PAUL CÉZANNE

PARAGON HOUSE
NEW YORK

First Paragon House edition, 1989

Published in the United States by

Paragon House Publishers
90 Fifth Avenue
New York, NY 10011

Copyright © 1935 by Gerstle Mack

Published by arrangement with Alfred A. Knopf, Inc.

Library of Congress Cataloging-in-Publication Data

Mack, Gerstle, 1894–
Paul Cézanne / Gerstle Mack.
p. cm.
Reprint. Originally published: 1st ed. New York : Knopf, 1935.
Bibliography: p.
Includes index.
ISBN 1-55778-214-8
1. Cézanne, Paul, 1839–1906. 2. Artists—France—Biography.
I. Title.
ND553.C33M3 1989
759.4—dc20
[B] 89-9262
CIP

Printed and bound in Canada

PREFACE

WHEN Paul Cézanne died in 1906 his name was known only to a
small group of painters and a few far-sighted collectors. Today he
is hailed the world over as one of the masters of the nineteenth
century; many critics, indeed, consider him not only the foremost
painter of his era but one of the greatest of all time. There are still
a few dissenting voices, and no doubt it is far too early to attempt
anything like a final estimate of his place in history. Yet his impor-
tance, both as an artist in his own right and as a dominant influ-
ence on the present generation of painters, can no longer be
questioned.

During the years that have elapsed since his death a great many
books and articles, biographical as well as critical, have been writ-
ten about Cézanne. But his story — especially that portion of it
which deals with his personal life rather than with his art — has
remained, until now, curiously incomplete. Numerous inaccu-
racies and misconceptions have crept into the record, where they
have become crystallized into a Cézanne legend. There are also
important gaps in the narrative; many circumstances which, if
known, might have illuminated the obscurities of his character
have been neglected altogether.

A great deal of this neglect has been unavoidable. Until re-

cently all attempts to write an exhaustive biography of Cézanne have been frustrated by an actual lack of precise information concerning whole decades of his life. As a result some of his more obvious idiosyncrasies have been distressingly overemphasized, while the true (and far more interesting) inner nature of the man has been lost sight of, and Cézanne appears but dimly through the fog as a shadowy, half-mad genius, a violent, hysterical bundle of eccentricities.

In reality he was nothing of the kind. Within the last few years much new and important material has come to light, and with increased knowledge our ideas about Cézanne must be correspondingly revised. The present study is based as far as possible upon documentary records, principally letters; supplemented, of course, by personal interviews with all of Cézanne's surviving relatives and acquaintances whom I have been able to locate. Through the courtesy of their respective owners and custodians I have been permitted to consult and copy more than one hundred unpublished letters from Cézanne to various correspondents, covering almost the whole of the painter's adult life. Chief among these invaluable, and hitherto untouched, sources of information are a series of letters to Émile Zola, discovered after the death of the novelist's widow in 1930, and now preserved in the Bibliothèque Nationale in Paris. Less numerous, but in their way equally enlightening, are Cézanne's surviving letters to his son, to his friends Camille Pissarro and Philippe Solari, and to other less intimate acquaintances, most of which are reproduced here for the first time. In addition I have quoted extracts from a number of other letters which have appeared from time to time in French books and periodicals, but which have never before been translated into English. Contemporary newspapers and catalogues, municipal and parish registers, and the official archives of the Louvre have also yielded many relevant facts and dates.

Outwardly Cézanne's life was neither adventurous nor romantic, but it was by no means altogether devoid of incident. His frequent clashes with his stubborn, domineering father; his

relations with the woman whom he married after many years of intimacy, and with the son born of that union; his numerous (if sometimes evanescent) friendships; above all, his lifelong struggle to express on canvas his " sensations in the presence of nature " are all set forth without reservations of any kind. Nevertheless, although the great amount of new material so kindly placed at my disposal has made it possible to correct certain popular errors and to fill in a number of the blank pages in Cézanne's history, his nature remains highly complex and at times difficult enough to understand. There are still some empty spaces in the record: episodes the authenticity of which is doubtful, vexing problems which are not yet solved. Wherever such uncertainty exists I have left the question open, merely presenting the available evidence on all sides in the hope that some day further research and the discovery of additional facts may throw more light on these unsettled points.

I am deeply indebted to a number of people whose kindness and courtesy have helped immeasurably in the preparation of this book. In particular my thanks are due to Monsieur Paul Cézanne *fils*, son of the painter, for many intimate personal reminiscences, for family photographs, and for permission to reproduce extracts *ad lib.* from fifteen unpublished letters written to him by his father during the last three months of the latter's life, as well as from seventy-five unpublished letters from Cézanne to Zola. To Madame Denise Le Blond-Zola and Monsieur Maurice Le Blond, respectively the daughter and son-in-law of Émile Zola, for permission to quote from these same letters to Zola; also for a photograph of Zola. To Monsieur Émile Solari for five letters from Cézanne to himself and four from Cézanne to his father, Philippe Solari; for valuable notes and reminiscences; and for photographs, hitherto unpublished, of two busts of Cézanne executed by Philippe Solari. To Monsieur Maxime Conil of Aix-en-Provence, Cézanne's aged brother-in-law, for family photographs and personal recollections. To Monsieur Paul Émile Pissarro for permission to quote extracts from six unpublished letters from

vii

PREFACE

Cézanne to his father, the painter Camille Pissarro; to Monsieur
Charles Camoin for personal reminiscences, and for permission
to quote from five letters (one of them unpublished) written to
him by Cézanne; and to Monsieur Albert Chardeau, son-in-law
of the late Monsieur Martial Caillebotte, for an unpublished let-
ter from Cézanne to Gustave Caillebotte. To Monsieur Marcel
Provence of Aix for permission to consult his collection of news-
paper clippings relating to Cézanne, and for other courtesies. To
Madame Marie Gasquet, widow of Joachim Gasquet, for per-
sonal recollections of Cézanne. To Monsieur Ambroise Vollard
for permission to reproduce two pictures in his collection:
Cézanne's portrait of Monsieur Vollard himself, and a sketch of
Zola at the age of twenty-one. To Dr F. Corsy for permission to
visit the Jas de Bouffan, the former country-house of the Cézanne
family near Aix. To the late Monsieur Paul Guillaume for sev-
eral useful letters of introduction, and for other kindnesses. To
Madame Chamson, *archiviste* of the Louvre, for assistance in my
search for documents preserved in the files of that gallery. To Mr
H. S. Ede of London for a great many helpful criticisms and sug-
gestions. To Miss Rhoda Welsford, librarian of the Courtauld
Institute of Art in London, for valuable information concerning
the Cézannes owned by the Institute. To Mr Walter Pach of New
York for sound and illuminating suggestions. To Mr Jerome
Klein of New York for much kind assistance, particularly in con-
nection with the dating of Cézanne's works. To Mr Alfred H.
Barr Jr, Director of the Museum of Modern Art in New York, for
permission to consult copies of several unpublished letters writ-
ten by Fortuné Marion to Heinrich Morstatt, the originals of
which are in the possession of Morstatt's daughter, Frau Hedwig
Haag, of Stuttgart. And lastly to the municipal authorities of Aix-
en-Provence, Saint-Zacharie, Marseilles, and Briançon, who
kindly placed their registers and records at my disposal.

G. M.

viii

PAUL CÉZANNE

CONTENTS

CONTENTS

ILLUSTRATIONS

ILLUSTRATIONS

xii

xiv

PAUL CÉZANNE

FAMILY TREE

A VAGUE but persistent legend traces the origin of the Cézanne family to the little town of Cesana in the mountains of western Piedmont. Family tradition of this kind is not always reliable, but in this particular case there is no reason to doubt its credibility, and there are at least two pieces of positive evidence that tend to confirm it. One is the name itself; in the Middle Ages, and even later, surnames were commonly derived from place-names, and it is not unreasonable to assume that when certain adventurous citizens of Cesana emigrated they took with them the name of their native town. The other item in support of the Cesana hypothesis is the appearance of Cézannes in the parish records of the town of Briançon as early as 1650. Briançon, just over the frontier on the French side, is only fifteen miles from Cesana by road and considerably less by the steeper footpaths over the mountains. Even in those days travel between the two communities must have been a simple matter.

The progressive corruption of the name from the soft Italian Cesana to the harsher Provençal Cézanne is easy to follow in the records. In the seventeenth century the spelling of proper names seems to have been dictated by no rule more consistent than the

3

whim of the transcriber, and the parish rolls of Briançon contain such intermediate variations as Césane and Cézane before the present form Cézanne appears.

There were two distinct branches of the family in Briançon, one of which used the hyphenated name of Cézanne-Bert while the other called itself simply Cézanne. Of the plain Cézannes the name which occurs most frequently in the parish register is that of a certain Blaise Cézanne — *honneste* Blaise Cézanne it is always written; but as nearly all of his fellow-citizens are qualified by the same adjective, it may safely be assumed that the addition of the word *honneste* indicates merely a conventional recognition of his respectable position in the community and is not intended as a special compliment to his personal integrity. Honest Blaise was by trade a master shoemaker. He was twice married, first to a lady named Catherine Fine, and after her death to Barbe Faure. The second marriage took place in 1691. Each of these unions produced five or six children, most of whom — rather exceptionally for those times — reached maturity.

Some time before 1700 the Cézanne family — or at least one member of it — moved to Aix-en-Provence. But there is a gap in the record here, and the identity of the link between Briançon and Aix is unknown. The earliest mention of the name in the register of the parish of Sainte-Madeleine at Aix concerns one Jacques Joseph Cézanne, born August 9, 1702, the son of Denis Cézanne and Catherine Marguerit (which would probably be written Marguery today), his wife. But who Denis Cézanne was, and where he came from, we do not know. He may have been one of the older sons of Blaise Cézanne of Briançon by his first marriage, but that is only a guess· I have been unable to identify him in the chaotic records of that town. In any case, Denis and Catherine seem to have been the founders of the Cézanne line in Aix. Their third son, André, born at Aix on April 15, 1712, was a *perruquier* by profession, which may have meant either a wig-maker or a hairdresser, or more probably both. André and his wife, *née* Marie Bourgarel, had several children, only one of

4

whom need concern us here: a son born on November 24, 1756 and christened Thomas François Xavier Cézanne.

Thomas Cézanne was a tailor, a *tailleur d'habits*. Little else is known of him except that he married a lady named Rose Rebuffat, moved to the small town of Saint-Zacharie, about fifteen miles from Aix in the neighbouring department of the Var, and died there in 1818, leaving a son, Louis-Auguste — the father of the painter Paul Cézanne.

* *

Louis-Auguste Cézanne was born at Saint-Zacharie on June 28, 1798; or according to the Revolutionary calendar then in use, on the tenth Messidor of the year VI.

He was a delicate, sickly child, but his health improved as he grew older, and with increasing physical strength his naturally vigorous, aggressive character began to assert itself. He was beyond all things a born moneymaker. On the one hand shrewd, unsentimental to the point of harshness, a close and skilful bargainer, with an almost uncanny flair for finding opportunities to add to his rapidly growing wealth, and the intelligence to make the most of such occasions when they appeared; on the other hand frugal in his expenditures, close-fisted, cheese-paring, he was determined to secure the maximum possible value for every sou that left his hands. The accumulation of property was the consuming passion of his life. And, inevitably, money flowed into his pockets as if drawn by an irresistible magnet, and stuck to them. Starting from a poverty-stricken childhood he succeeded in building up, little by little, an immense fortune for the time and place in which he lived; and when he died at the age of eighty-eight he left in cash, investments, and property about 1,200,000 francs to be divided among his three children.

Yet Louis-Auguste, though he was hard and stern and a good deal of a martinet in his relations with his business associates and his family, was a just man according to his lights. He was uncompromising enough in his dealings with a debtor whom he con-

sidered idle, incompetent, or extravagant; these were cardinal sins in his eyes; but he could be merciful to a thrifty hard-working peasant who made an honest effort to meet his obligations. Sometimes he would voluntarily grant a longer credit or more advantageous terms than a timid borrower dared to ask. But his shrewd business sense and his intimate knowledge of the financial status of every applicant told him when such concessions might safely be made and when they might not. His generosity rarely left him out of pocket.

But woe to the debtor who turned out to be shiftless or who had the bad judgment to mismanage his affairs! Louis-Auguste was at his throat instantly. There is a story of one such client in Marseilles who, having borrowed a considerable sum — on what seemed to be excellent security, of course — was discovered to be on the verge of bankruptcy because of his extravagant style of living. Louis-Auguste wasted no time in idle protests. He promptly moved to Marseilles, installed himself bag and baggage in the potential defaulter's house, and proceeded to regulate the household expenditures according to his own ideas of proper economy. He dictated every detail of the daily life of the unlucky spendthrift and his still more unfortunate family; ordered the meals, prescribed the amounts of meat and butter and potatoes to be consumed. And he kept up this minute supervision — how galling it must have been! — for two years, though it is unlikely that the self-invited and unwelcome visitor actually lived in his debtor's house all that time. In the end the drastic remedy achieved its purpose. The borrower was restored to solvency and domestic independence, and the triumphant Louis-Auguste collected the full amount of his loan — with interest.

A strange father, this Provençal captain of industry, for the unworldly genius who was Paul Cézanne! Paul Cézanne, to whom the simplest and most commonplace business transactions of daily life were always unfathomable mysteries, so that he used to speak of himself, half despairingly, half humorously, as " *faible dans la vie* "! The long career of Louis-Auguste Cézanne was a

steady progress towards the acquisition of wealth, and with it the power and the position that money can procure. While still in his early teens he recognized that Saint-Zacharie was too small and too isolated a community to hold him and his aspirations; he needed a larger field for the successful development of his projects. The nearest important towns were Marseilles and Aix-en-Provence. Marseilles was a good deal the larger, but Aix was the city in which his family had lived for more than a century, and undoubtedly there were connections there who might be useful to an ambitious youngster. To Aix, accordingly, Louis-Auguste went.

His first employment there seems to have been with the firm of Dethès, wool-merchants. But his restless energy soon discovered a business that promised quicker and richer returns: hats. During the first half of the nineteenth century Aix-en-Provence was one of the principal centres of the trade in felt hats. The rabbits from whose fur the felt was made flourished in the surrounding country, where they were raised in great quantities by the Provençal farmers, and hats manufactured in the workshops of Aix were exported all over the world.

For some unknown reason, however, Louis-Auguste did not learn the trade of a hatter in Aix, but in Paris, where he was apprenticed to a maker of felt hats about the year 1821. He remained in Paris three or four years, at first as *ouvrier-chapelier,* or common workman, and later as *commis-chapelier,* or salesman. He was an intelligent young man and a hard worker and was highly thought of by his employer. It is rumoured that he found even greater favour in the sparkling eyes of his employer's wife, for he was a handsome lad and had a way with women. But no details concerning this youthful romance, if it ever occurred, have come down to us.

About 1825 Louis-Auguste, having completed his apprenticeship in Paris, returned to Aix, where he opened a shop in partnership with a hatter named Martin. Soon afterwards they were joined by one Coupin, a man whose temper was even more pep-

pery than that of Louis-Auguste himself. The firm was engaged only in the sale and exportation of hats, not in their manufacture. The shop, located on the Cours Mirabeau at the corner of the rue des Grands-Carmes (now rue Fabrot), bore the firm name of Martin, Coupin, and Cézanne; which gave rise among the good people of Aix to a pun, meaningless in English and not very brilliant even in the original: "*Martin, Coupin, et Cézanne [seize ânes] font dix-huit bêtes.*"

In spite of the local *bon mot* the three partners, each one as canny as the next, were far from being asses, and the business flourished until the associates separated about 1845 — for what reason we do not know, though it is not improbable that the members of so astute a trio proved in the end to be too shrewd even for one another. Louis-Auguste, now unencumbered by his colleagues, continued to sell hats by himself for some years longer, until he abandoned shopkeeping for good in favour of a still more profitable enterprise, banking.

The rabbit-farmers who supplied the raw material for the hat industry of Aix were often in need of ready cash to tide them over until they received payment for the sale of the skins. For several years, as a side-line to the business of selling hats, Louis-Auguste had made a practice of lending small sums of money to the farmers to enable them to continue the production of rabbit fur. These loans, repaid with interest — the rate was high in those days — soon proved to be a more profitable source of revenue than the hat trade itself. Gradually Louis-Auguste enlarged the scope of his operations in this lucrative field, advancing money not only to rabbit-growers but to other farmers and business men of the community. More and more of his time and energy were devoted to finance, and less and less to hats. It was only to be expected that he should decide at last to give up the hat-shop entirely and concentrate on his banking activities.

The opportunity came in 1848. The only bank in Aix at the time, the Banque Bargès, had recently failed, and the field was clear for a new enterprise. Louis-Auguste selected as his partner

the former cashier of the defunct bank, one Joseph Richard Maximin Cabassol, as clever and ruthless a man of affairs as the ex-hatter himself. The bank of Cézanne and Cabassol was inaugurated on June 1, 1848. According to the terms of the partnership — the agreement is still preserved in the archives of the Bureau d'Enregistrement at Aix — the two associates were to share equally in the profits, although the entire capital of a hundred thousand francs was furnished by Cézanne, Cabassol contributing to the enterprise only his *" industrie ":* in other words, the financial experience and technical knowledge that Louis-Auguste lacked. The latter received interest on his capital at the rate of five per cent, and each partner was entitled to draw two thousand francs a year for personal expenses.

To begin with, the partnership was established for a term of five years and three months. But the new bank prospered, as was natural with two such shrewd directors, and in 1853 the association was renewed. It continued to flourish until 1870, when the advanced age of the partners brought about its final dissolution. The first offices were opened at 24 rue des Cordeliers; later they were moved to a house belonging to the Cabassol family at 13 rue Boulegon, only a few doors from the house in which, more than half a century later, Paul Cézanne died.

Most of the loans were made on short-term notes. Although the partners drove a hard bargain they were not usurers; they never exceeded the legal rate of interest and seem to have treated their clients with scrupulous fairness according to the not very lofty standards of their day. In large measure their success was due to their intimate knowledge of the financial standing of every potential borrower in the neighbourhood, which enabled them to distinguish instantly between a good risk and a bad one and to determine almost to the sou exactly how far it was safe to go in any particular case. They rarely made a mistake. If Louis-Auguste considered an applicant's security insufficient to warrant a loan, he employed a simple code to convey his opinion to his partner. " What do *you* say, Cabassol? " he would shout in

9

the Provençal dialect he generally used. And the wily Cabassol, who knew his cue, would shake his head sadly and answer: " No! "

The establishment of the bank brought about a rapid and substantial increase in the fortunes of Louis-Auguste. It was also of great advantage to him in a less tangible way. The social position of the only banker in town was considerably higher than that of a mere hatter, and Louis-Auguste now found himself not only one of the richest but one of the most respected pillars of society in Aix. He was by no means insensible to his improved station and took great pride in it. Not that he had social ambitions or wished to lead the life of a *grand seigneur* such as his wealth might have enabled him to do in spite of his humble origin. In the stress and strain of his struggle for material success he had had no time to acquire a taste for vain display. Bourgeois he was and bourgeois he remained to the end, and his children after him.

* *

While Louis-Auguste was still engaged in the hat trade he became acquainted with another young man in the same line of business, one Louis Aubert, who may even have been employed at one time in the shop of Cézanne, Martin, and Coupin; but of that we cannot be certain. This Aubert had a sister, Anne-Élisabeth-Honorine. Louis-Auguste found her attractive, and apparently she did not repel his advances with too much determination. Their relationship, however, did not lead immediately to the altar. It was by no means unusual at that time, in the social class to which Louis-Auguste and Élisabeth belonged, for a young couple to put off the marriage ceremony until after the birth of one or two children. No particular slur was cast on either of the parents by such a postponement, nor were the children stigmatized as illegitimate if they were publicly acknowledged by the father through registration at the *mairie* at the time of their birth. So that when Louis-Auguste Cézanne and Anne-Élisabeth-Honorine Aubert were married on January 29, 1844

they were already the parents of two children: a son, Paul, and a daughter, Marie.

Élisabeth Aubert was born at Aix on September 24, 1814. She was the daughter of Joseph Claude Aubert, a chairmaker — *tourneur de chaises* — born at Aix on June 25, 1776 and married on November 11, 1813 to Anne Rose Girard of Marseilles. The genealogy of the Aubert family is of little interest. For several generations their names appear on the parish registers of Aix, where they are inscribed as followers of various respectable but humble trades.

On the Girard side family tradition claims descent from a certain brigadier-general in the armies of Napoleon, who is supposed to have held a high command in the expeditionary force sent in 1802 to subdue the West Indian island of Santo Domingo under the leadership of General Leclerc, husband of the Emperor's sister Pauline Bonaparte. This General Girard is said to have brought back from the Caribbean not only glory but a native wife, thus introducing a strain of Negro blood into the family veins.

In this case, however, family tradition appears to be mistaken, and Cézanne's descent from the distinguished Napoleonic warrior and his dusky bride may be dismissed as a romantic myth. The official records of the parish of Notre-Dame-du-Mont in Marseilles indicate clearly that Paul Cézanne's maternal grandmother, Anne Rose Girard, was born on August 27, 1789 — thirteen years before the invasion of Santo Domingo took place — and that she was the daughter of Antoine Girard, a humble labourer in a saltpetre works, and a woman named Anne Bresq. Antoine Girard in turn was the son of Jean Antoine Girard, who died in Marseilles in 1792 at the age of seventy-nine and who must therefore have been born about 1713. Hence there is no gap in the records which might conceivably be filled by the supposititious General and his West Indian spouse.

All this investigation of Cézanne's ancestry, with its tedious array of names and dates, is of little interest except in a negative

11

way. It is remarkable that his genius should have sprung from roots in which there is not the slightest evidence of any artistic predisposition whatever. Thus we cannot say that he inherited this or that quality from any particular progenitor, or even from one branch of the family rather than from another. All we know is that in general disposition and temperament he resembled his mother far more closely than his father; and that his mother, while she exhibited no tendency towards artistic creativeness herself, understood her son's passion for art to some extent and sustained and encouraged him in his early struggles with the philistine Louis-Auguste.

BOYHOOD: 1839–1858

PAUL CÉZANNE was born at one o'clock in the morning on January 19, 1839, at 28 rue de l'Opéra, Aix-en-Provence. This house, which is now occupied by a girls' school, was not the residence of Louis-Auguste. At the time of Paul's birth his father was living in the old building in which his hat-shop was located, number 55 Cours Mirabeau; the east side of the house faces the narrow, dingy Passage Agard, from which a small door under the arch gives access to the living-quarters upstairs. It has been generally assumed that Paul was born in his father's house, but this is obviously an error: the entry in the municipal register of births states clearly that he was born in the rue de l'Opéra:

" L'an mil huit cent trente neuf et le dix neuf janvier à quatre heures du soir, par devant nous adjoint remplissant par délégation de Monsieur le Maire les fonctions d'officier public de l'État Civil de cette ville d'Aix, est comparu Sieur Louis Auguste Cézanne, chapelier, âgé de quarante ans, natif de St. Zacharie, Var, domicilié en cette ville d'Aix et y demeurant sur le Cours N° 55, lequel nous a déclaré qu'il se reconnait père d'un enfant du sexe masculin, né aujourd'hui à une heure du matin rue de l'Opéra N° 28, et auquel il déclare vouloir donner le prénom de Paul. . . ."

But although Paul was not actually born in Louis-Auguste's residence on the Cours Mirabeau, he and his mother were installed there very soon after his birth, and it was in this house that he spent the early years of his childhood. It was in this house too that his sister Marie was born two years later, on July 4, 1841. Both children were acknowledged at birth by registration at the *mairie,* and legitimized, as was customary under the circumstances, by the marriage of their parents in 1844.

The Cours Mirabeau — or *Courss* in the thick Provençal accent of the region — was, and still is, the principal street of Aix: a wide straight boulevard shaded by double rows of immense plane trees which have replaced the elms that grew there when Cézanne was a boy. On either side the avenue is lined with ancient mansions, many of them beginning to crumble for all the massiveness of their stone walls. The house occupied by the Cézannes was one of the smallest and least imposing of these. It is still standing, much as it was a century ago except that a jeweller's show window now occupies the ground floor fronting on the Cours in place of the shop in which Louis-Auguste's stock of tall felt hats was formerly displayed. There are even traces of an old sign painted on the wall, a mute reminder of the days of Martin, Coupin, and Cézanne, wholesale and retail hatters.

When he was about a month old, on February 22, 1839, Paul was baptized at the parish church of Sainte-Madeleine. His godmother was his maternal grandmother, Anne Rose Aubert; his uncle, Louis Aubert, acted as godfather.

Even as a child of three or four he exhibited signs of the violent and uncontrollable temper which was to be a curse to him — and to all who came in contact with him — throughout his entire existence. The fits of nervous irritability passed as quickly and as unpredictably as they appeared. During the periods of calm weather between these occasional brief storms he was a cheery, playful, gay little boy, docile and affectionate.

He was devoted to his sister Marie, and she to him. Marie was a born manager and quickly became aware of her brother's tem-

14

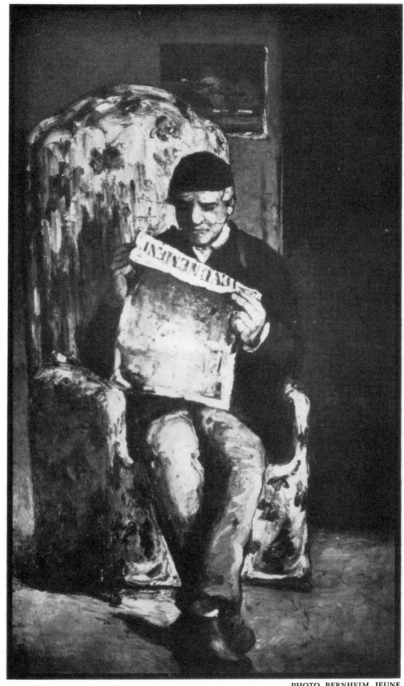

1. PORTRAIT OF LOUIS–AUGUSTE CÉZANNE
ABOUT 1868. PELLERIN COLLECTION

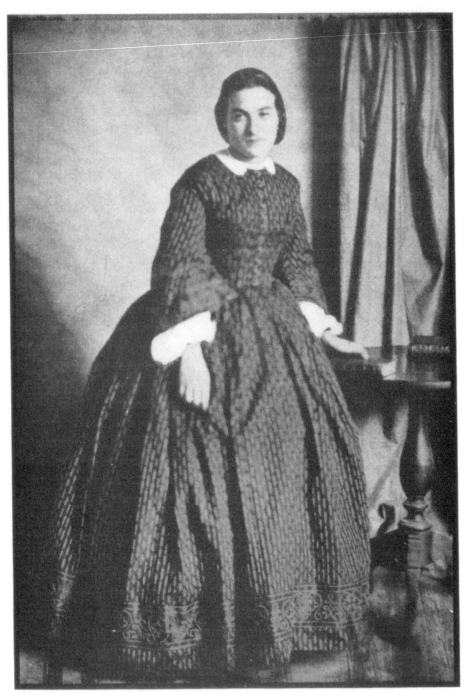

2. MARIE CÉZANNE ABOUT 1870

FROM A PHOTOGRAPH

peramental inability to cope with the ordinary problems of a child's daily life. Almost as soon as she could walk she took Paul under her efficient wing — though he was two years older than herself — and firmly protected, advised and frequently bullied him. Paul marvelled at his sister's display of practical common sense and cheerfully allowed himself to be "managed." The relationship established between the two almost in infancy continued, in one form or another, until the end of Cézanne's life.

On March 16, 1911, some five years after the painter's death, Marie wrote a letter to her nephew, Cézanne's son, in which she set forth a few reminiscences of Cézanne's childhood:

" My earliest memory is this (perhaps you have heard the story from your grandmother) : your father must have been about five years old; he had drawn on the wall, with a piece of charcoal, a drawing representing a bridge: M. Perron, Th. Valentin's grandfather, exclaimed when he saw it: ' Why, it's the Pont de Mirabeau.' The future painter was already discernible."

Paul and Marie were instructed in the rudiments of the three R's at a primary school in the rue des Épinaux. Paul attended this school for about five years, until he was ten years old. " Your father," writes Marie, " looked after me carefully; he was always very gentle and probably had a sweeter disposition than I, who it seems was not very nice to him; no doubt I provoked him, but as I was the weaker he contented himself with saying: ' Shut up, child; if I slapped you I should hurt you.'

" When he was about ten he was sent as a half-boarder to the school of Saint-Joseph, run by a priest, the Abbé Savournin, and his lay brother; it was while he was there, I think, that your father made his first communion at the church of Sainte-Madeleine. A quiet and docile student, he worked hard; he had a good mind, but did not manifest any remarkable qualities. He was criticized for his weakness of character; probably he allowed

15

himself to be influenced too easily. Saint-Joseph's school was soon closed; the directors, I believe, did not make a success of it."

It is said that while Cézanne was a pupil at Saint-Joseph's he was taught drawing by a Spanish monk. Cézanne's mother was convinced that he would be a great painter, for the excellent reason that he had the same Christian name as several of the masters. Marie's letter goes on:

" I remember hearing Mamma mention the names of Paul Rembrandt [*sic*] and Paul Rubens, calling our attention to the similarity between the Christian names of these great artists and that of your father. She must have been aware of your father's ambitions; he loved her dearly and no doubt was less afraid of her than of our father, who was not a tyrant but who was unable to understand anybody except people who worked in order to get rich."

Marie appears to have confused Rembrandt with Veronese in her list of Pauls. Though she was a reasonably well-educated woman she had little knowledge, and less understanding, of art. In another paragraph of her letter to Cézanne's son she acknowledges this deficiency: " You are much better able than I to appreciate the artistic side of his [Cézanne's] nature and his art, which I confess is a riddle to me because of my ignorance."

Cézanne's passion for drawing and painting gained strength as he grew older. Vollard tells the story of an old paint-box, picked up by Louis-Auguste in a lot of assorted merchandise bought from a travelling pedlar. Considering it of no value and not worth the trouble of selling — for Père Cézanne was not too proud to turn an honest penny by dealing in second-hand goods if the reward were tempting — he had given it to his son to play with. Rivière's less picturesque version of the incident states that the box was given to Paul by one of his father's friends and not by the banker himself. But whether the box was acquired in either of these ways or in some other manner, Louis-Auguste

16

would have been horrified indeed could he have foreseen the ultimate consequences of this casual present. The immediate results were not very alarming. Paul took the paint-box and proceeded to colour everything in sight, especially the illustrations in the *Magasin Pittoresque*, a periodical subscribed to by the family. But of course these childish efforts were not taken seriously. They were smiled on as a harmless pastime, nothing more. They may even have been encouraged by his parents because they kept the youngster out of mischief and seemed to have a soothing effect on his spells of tempestuous fury.

* *

In 1852, when Paul was thirteen, he was entered as an *interne* — a resident pupil or boarder — at the Collège Bourbon, now known as the Lycée Mignet. It was the proper place for a rich man's son to go, and though Louis-Auguste had not yet reached the full flood of his material success he could well afford to send his only son to the best available school as a preparation for his future career as a banker. The Lycée occupies a huge building whose forbidding grey façade extends interminably along the rue Cardinale. Paul remained here for six years, until 1858. But for the last two years he was an *externe*, or day scholar, and lived at home.

The cheerless atmosphere of the Collège Bourbon seems to have had no depressing effect on the youthful Cézanne's high spirits; in after years he often thought of his schooldays, and even of the dingy old building in which those days were spent, with tender regret. In fact he was inclined to resent the enlargements and modernizations the school had undergone since his boyhood. Joachim Gasquet quotes a conversation in which the painter, standing before the school building and looking back through the haze of forty years, remembers the past:

" The pigs! See what they have done to our old school! We are living under the thumb of the bureaucrats. It is the kingdom of

engineers, the republic of straight lines. Tell me, is there a single straight line in nature? They make everything conform to rule, the city as well as the country. Where is Aix, my old Aix of Zola and Baille, the fine streets in the old suburbs, the grass between the cobblestones, the oil lamps? Yes, oil lamps, instead of your crude electricity that destroys mystery, while our old lamps gilded it, warmed it, brought it to life *à la* Rembrandt. . . . The acacias drooped over the walls, the moon touched the portal of Saint-Jean with silver, and we were fifteen years old. We expected to swallow the world at that time! . . . But in this beastly school nothing is left of those days."

This quotation cannot be taken as a literal transcription of Cézanne's words. They were not taken down at the time but were written later from memory; and the poetical trimmings are obviously Gasquet's, not Cézanne's. Cézanne's conversation, like his letters, was never so literary. But there is no reason to doubt that the sentiments originated with Cézanne; certainly they fit in well enough with what we know from other sources about his opinions. His repudiation, in his old age, of the " kingdom of engineers," his preference for the mellow light of old-fashioned oil lamps, are indications of the innate conservatism of the man who was at the same time a pioneer of the radical movement in painting.

Paul was always a conscientious student, and in certain subjects a brilliant one. Marcel Provence has unearthed from the school records a list of his grades and prizes and has published them in the *Mercure de France* for February 1, 1925. In his first year at the Collège Bourbon — he was then in the sixth form — Paul was awarded a first *accessit* (mention) in Latin translation, second mention in history and geography, and first prize in arithmetic. Evidently he was going to be a credit to his father the banker, since he could add and subtract so competently! And for the next two or three years he continued to receive prizes or at least mentions in mathematics. In the fifth form he fell from grace

18

and was given only second mention in that science, which must have displeased the stern Louis-Auguste and been the cause of many frowns and headshakings at home. But in the fourth form Paul redeemed himself with a second prize in both arithmetic and geometry, and in the third he carried off the first prize in geometry. During his last two years at school his name did not appear on the prize lists for mathematics; but whether this was because he allowed himself to lapse, in defiance of his father's wishes, from the higher standard of his earlier years, or merely because the subject was dropped from the curriculum after the third term, we do not know.

Some of his school prizes — little books bound in elaborately stamped blue covers — were preserved by his sister Marie and are now in the possession of Monsieur Provence.

Paul was fond of both Greek and Latin, especially Latin, and he must have attained a considerable degree of proficiency in that language, for he continued to write scraps of Latin verse for some years after he left school, and throughout his life he was able to read Virgil in the original and to quote Latin tags and proverbs both in conversation and in his letters. To Cézanne and his compatriots the " dead " languages were not the esoteric and pointless studies they seem to many of us, to be learned per-functorily and forgotten as soon as the school doors have closed behind us. Aix-en-Provence is the centre of a classic land, filled with well-preserved ruins of Roman monuments and imbued with vivid memories of an ancient civilization. It is not surprising that Paul Cézanne, good Provençal that he was, should have picked up his love for classic literature almost from the air he breathed. That he did so to some purpose is attested by the list of school prizes. In the sixth form he won first mention in Latin translation; in the fifth he was awarded first prize in Latin trans-lation and second prize in Greek; the following year he achieved only a second mention in Greek translation and nothing at all in Latin, but in the third form he came to the fore again with a third mention in Latin composition, a second mention in Latin

19

verse, a second mention in Greek composition, and the first prize in Greek translation. The end of the second form brought him further honours: first mention in Latin translation, second mention in Latin essay, third mention in Greek composition, and again first prize in Greek translation. In his sixth and last year he received first mention in Latin discourse.

In the remaining subjects which made up the curriculum of the school: history, geography, physical geography, grammar, chemistry (which he liked, particularly the experiments that so often resulted in more or less devastating explosions), physics, religious instruction, music, drawing, and painting, he drew occasional prizes, but more erratically than in his favourite classics. It is somewhat surprising to find that Cézanne — always devout, and increasingly pious as he grew older — should have achieved in school only a moderate success in the study of religion, whereas his fellow-pupil Zola — Zola the skeptic, the future author of *Lourdes* — consistently outranked him in this subject. But perhaps it is not so surprising after all; history is full of such apparent paradoxes, and creeds, if they are sincere and deeply rooted, are often slow to develop.

It is even more remarkable, on glancing over the record of Cézanne's school prizes, to discover that drawing and painting are almost never included in the list of subjects in which he excelled. In his second year at the Collège Bourbon he received a first mention in painting; and that is all. On the other hand Zola — again a paradox! — whose talents as a draughtsman were at best mediocre, and who later became a notoriously bad judge of painting, carried off several prizes. The evolution of Cézanne's genius was unusually slow, and it may be that his drawings and paintings in these early days really did not measure up to the very moderate standard set by the students in a provincial preparatory school. But it does not seem very likely. A more plausible explanation is that his work was already beginning to show traces of the power and originality which later caused it to be either damned or ridiculed by all good followers of the academic tradi-

tion. In that case it is small wonder that his schoolboy drawings and paintings were frowned on or at best passed over by his instructors.

Unfortunately practically none of his efforts of this period has survived, and it is therefore impossible to settle the point one way or the other. There is one charcoal drawing of a nude male figure in the museum at Aix, supposed to have been drawn by Cézanne in 1862 while he was attending evening classes at the École des Beaux-Arts of Aix after his return from his first trip to Paris. The study is unsigned, and its ascription to Cézanne is somewhat doubtful. If it really is by him it is the only specimen of his work owned by the public gallery of his native town. The drawing is quite undistinguished and is certainly academic enough to have satisfied the most pedantic of teachers.

Some instruction in music — probably very mediocre — was given at the Collège Bourbon, but it is not recorded that Cézanne ever received so much as a third mention in this art. His friend Zola was more proficient and once was honoured with the first prize for wind instruments. The music lessons which Paul was forced to take at home were no more successful than the ones he endured at school, if the recollections of his sister Marie, written more than half a century later to her nephew, are trustworthy: " He took no interest whatever in the music taught by a professor at home, and often the descent of a violin bow on his fingers bore witness to M. Poncet's displeasure." Yet he must have picked up some slight knowledge of music, for he and Zola were both enrolled in the school band organized by another classmate, Marguery. The young musicians were allowed to play in the streets of Aix during fêtes and processions, and we may imagine that, boylike, they made the most of these opportunities to create a glorious din. Marguery, the leader, played first cornet, Cézanne second cornet, and Zola clarinet.

Certainly music played but a minor part in Cézanne's later life, and yet the popular assumption that he took no interest whatever in music — that he was, in fact, insensitive to harmony — is by

no means justified. He was a great admirer of Wagner, to whose early work he was introduced by Heinrich Morstatt, a German musician who came to Marseilles in 1865 as agent for a firm dealing in musical instruments. One of Morstatt's fellow-lodgers at the Pension Arnoux was Fortuné Marion, a native of Aix and an intimate friend of Cézanne's. At that time Marion was a painter; afterwards he abandoned art for the study of geology and other natural sciences, which he taught at the University in Marseilles. It was probably through Marion that Cézanne and Morstatt became acquainted. Marion and Morstatt carried on an active correspondence for some years, and on two of Marion's surviving letters to the musician there are short postscripts written by Cézanne.

The first of these letters, dated December 23, 1865, contains an invitation to Morstatt to spend Christmas at Aix: an invitation which is cordially seconded by Cézanne, who hopes that Morstatt will play Wagner for them. The second note in Cézanne's handwriting is appended to a letter from Marion dated May 24, 1868. In this postscript the painter announces that he has had the pleasure of hearing the overtures of *Tannhäuser, Lohengrin,* and *The Flying Dutchman,* though he does not say where or when this concert took place. The overture to *Tannhäuser* must have made a particularly deep impression on Cézanne, for in 1866 he painted a picture to which he gave the name *L'Ouverture du Tannhäuser,* which is described by Marion in a letter to Morstatt dated August 28, 1866. This composition contained the figures of a young girl seated at the piano, her father in an armchair, and a child with a " stupid expression " listening in the background. The following year Cézanne painted a second version of this subject, which is now in the Museum of Modern Western Art in Moscow. In this canvas the girl (probably Marie Cézanne) is playing the piano as before, but the figures of the father and the child have been replaced by that of a woman (presumably the painter's mother) sewing or knitting on a sofa. The picture was undoubtedly painted in the salon of the Jas de Bouffan; the arm-

22

chair, covered with a flowered material, is the same as that used in Cézanne's portraits of his father (Plate 1) and Achille Emperaire (Plate 5).

The only other reference to music which I have been able to find in Cézanne's correspondence occurs in a letter to his son written on August 12, 1906, only two months before he died:

" At Saint-Sauveur, the former choir-leader Poncet has been replaced by an idiot of an abbé, who runs the organ and plays off key. So that I cannot go to hear mass any more, his way of playing music makes me absolutely ill."

In spite of his early enthusiasm for Wagner and his appreciation of well-played church music, it is probable that Cézanne actually heard very little good music during the course of his life. Madame Marie Gasquet, widow of Joachim Gasquet, has told me that Cézanne sometimes asked her to play the piano for him — preferably selections from *Oberon* or *Der Freischütz* — but that he almost invariably went to sleep; she used to play the last few chords *fortissimo* in order to wake him up before the end and spare him the embarrassment of acknowledging that he had dozed off. Cézanne's wandering attention can easily be understood, however; at that time he was already old and ill and very tired.

CHAPTER III

ÉMILE ZOLA

PAUL's schoolbooks and the prizes he carried home each August did not completely fill his time during the six years of his attendance at the Collège Bourbon. The long summer holidays were far more important in their influence on his future life and art. During those hot idle months he would roam about the countryside with two or three companions, exploring every dusty road and sleepy hamlet for miles around, fishing in shady pools, swimming in the cool waters of the Arc, climbing the rocky slopes of that Montagne Sainte-Victoire which in after years he painted so many times from every angle. On these rambles he absorbed half unconsciously the colours and shapes of the olive trees, the pines, the rocks, the vineyards, and the pink and white farmhouses with their roofs of moss-covered tiles, until the familiar scenery became in time almost a part of himself. Though he spent much of his life, later on, in Paris and its environs, no northern landscape ever succeeded in weaning him away for long from the beloved surroundings of his youth. He returned to Aix again and again, drawn by the spell of the woods and fields and hillsides, the light and air of his native Provence.

Among Paul's comrades two in particular were his almost constant companions on these excursions: Émile Zola and Baptistin

Baille. The three inseparables would wander off day after day, starting early in the morning with their lunches in a knapsack, and a book or two of poems which they would read aloud by turns while resting in the cool shade after their midday meal. Then followed interminable animated discussions about poetry and literature in general — for all three of the youths had literary ambitions at the time, and wrote quantities of verse themselves, which they were inclined to take very seriously; even Baille, a philistine at heart, was carried away by the enthusiasm of the other two and contributed an occasional masterpiece. Needless to say their styles in verse-making changed frequently under the shifting influence of each newly discovered author.

Zola, writing years afterwards in *L'Œuvre,* the most autobiographical of all his novels, has left an account of these outings which he always remembered as among the happiest experiences of his life. The three friends in the story, Claude Lantier (Cézanne), Dubuche (Baille), and Sandoz (Zola himself), are exchanging reminiscences of their youthful days in the town of Plassans (Aix) :

" Then other memories came back to them, causing their hearts to swell, of the fine days of fresh air and sunshine they had lived down there, away from school. While they were still children, in the sixth form, the three inseparables had a passion for long excursions. They took advantage of every holiday, they discovered new places, becoming bolder as they grew up, until finally they roamed over the whole countryside on outings that sometimes lasted several days. They slept wherever night happened to overtake them, in a hole in the rocks, on a stone-paved threshing-floor, still scorching from the sun, where the beaten wheat straw made them a soft bed, in some deserted hut whose floor they covered with a heap of thyme and lavender. These were escapes from the world, an instinctive sanctuary in the breast of nature, the unconscious love of children for trees, streams, mountains, for the limitless joy of being alone and free.

" Dubuche, who lived at school, only joined the others during the holidays. . . . But Claude and Sandoz never tired, and one would wake the other every Sunday at four in the morning by throwing stones at his shutters. Especially in summer they yearned for the Viorne [Arc], the river whose thin trickle waters the low meadows around Plassans. They learned to swim when they were scarcely twelve; and they loved to dabble in pools where the water was deep, to pass whole days, naked, drying themselves in the hot sand only to plunge in again, to live in the water, on their backs, on their bellies, searching the grasses along the river banks, submerging themselves to the ears, and watching the hiding-places of the eels for long hours. This trickle of pure water which kept them moist under the hot sun prolonged their childhood, gave them the gay laughter of runaway kids when, as young men, they returned to town in the oppressive heat of the July evenings. Later they took up hunting, but hunting as it is practised in that gameless land, six leagues of stalking to kill half a dozen warblers, tremendous expeditions from which they often returned with empty pouches, or with an imprudent bat brought down when they unloaded their guns at the entrance to the town. Tears came to their eyes at the memory of these orgies of walking: they saw again the white roads, interminable, covered with a layer of dust like a thick fall of snow; they followed these roads, happy to hear the scuffle of their heavy boots, then they cut across the fields, over the red earth tinged with iron, where they trudged on and on; and a blazing sky, not a speck of shade, nothing but olive and almond trees with scanty foliage, and each time they came home, the delicious relaxation of weariness, the triumphant boast of having walked farther than the last time, the joy of being at last unconscious of their steps, of plodding mechanically ahead, spurred on by some bloodcurdling marching song which was, to them, as soothing as a dream.

" Already Claude carried, between his powder-horn and his box of cartridges, a sketch-book in which he drew bits of landscape; while Sandoz always had a book of poetry in his pocket.

It was a romantic frenzy, wingèd verses alternating with barrack-room obscenities, odes tossed to the luminous vibrations of the burning air; and when they happened on a spring, four willows that made a spot of grey against the intense colour of the earth, they let themselves go the limit, they acted plays that they knew by heart, their voices swollen to a bellow for the heroes, thin and quavering as the sound of a fife for the ingénues and the queens. On such days they let the sparrows alone. In this far-away country district, in the sleepy dullness of a small town, they had thus, from the age of fourteen, lived isolated, swept by a fervent passion for literature and art. At first the gigantic conceptions that appear on the immense stage of Hugo in the midst of the eternal strife of opposites enchanted them, caused them to make grand gestures, to watch the sun set behind ruins, to see life pass by under the false and superb illumination of the fifth act. Then Musset came to overwhelm them with his passion and his tears, they could hear their own hearts beating in him, a more human world was opened to them that overcame them by pity, by the eternal cry of distress that they would ever after hear mounting on all sides. They were not really hard to please, they exhibited the gluttony of youth, a prodigious appetite for reading, swallowing impartially the best and the worst, so anxious to admire that often the most execrable works threw them into the same exaltation as a true masterpiece.

" And as Sandoz now said, it was the love of long tramps, it was this hunger for literature, that saved them from the deadening influence of their surroundings. They never entered a café, they professed a loathing for the streets, claiming that they withered away in them like eagles in a cage, while their comrades were already soiling their schoolboy sleeves on little marble tables and playing cards for the drinks. This provincial life that caught hold of children while they were still young, the local club, the newspaper spelled out laboriously to the last advertisement, the everlasting game of dominoes, the same stroll at the same hour on the same street, the final degeneration under this

millstone that ground one's brains flat, infuriated them, caused them to revolt, to clamber up the nearby hillsides in order to find some hidden refuge, to shout verses under the driving rain without seeking shelter, because of their hatred of towns. They planned to camp out on the banks of the Viorne, to live like savages, to do nothing but swim, taking along five or six books, not more, which would be ample for their needs. No women would be allowed there, they suffered from timidities, awkwardnesses, which they idealized in their own minds as the chastity of superior young men. For two years Claude had been consumed with love for a milliner's apprentice, whom he followed every day at a distance; but he had never had the courage to speak to her. Sandoz had visions of ladies he would meet while travelling, of lovely damsels who would appear suddenly in some unknown forest, who would yield themselves to him for a day, and who would vanish like ghosts at twilight. Their only gallant adventure still made them laugh, it seemed so silly: serenades played to two young girls, when they were members of the school band; nights passed in playing the clarinet and the cornet under a window; horrible discords that frightened the neighbours until the memorable evening when the exasperated parents had emptied all the chamber-pots in the house on their heads.''

The picture which Zola has drawn out of his own memories of thirty years before is a sympathetic one, and on the whole exceedingly accurate. The long hot walks, the refreshing dips in the little river, the fishing and hunting expeditions (though Cézanne was in reality an even less enthusiastic and accomplished huntsman than his fictional prototype Claude Lantier), the voracious and undiscriminating literary appetites of the trio, even their youthful timidity towards the fair sex, which they were wont to offset by the most extraordinary amorous adventures (always ending happily of course) in their own lively imaginations; in all of these matters Zola's reminiscences are a colourful and reliable record.

Émile-Édouard-Charles-Antoine Zola was about a year younger than Paul Cézanne. He was born in Paris on April 2, 1840. His father, François Zola, was a Venetian whose paternal ancestors hailed from Zara, in Dalmatia, and whose mother was a Greek from the island of Corfu. François Zola was an engineer and was apparently a distinguished ornament to his profession. Madame Denise Le Blond-Zola, in the excellent biography published in 1931: *Émile Zola, Raconté par sa Fille,* gives the following account of her grandfather's early life:

" What can one say of the extraordinary activity of François Zola, of his taste for adventure and for travel, of his courage in misfortune? Author of a *Treatise on Levelling* which brought him the honour of membership in the Academy of Padua and a medal from the King of Hanover; at first an officer under Prince Eugene, then an engineer when Venice was conquered by Austria, he went successively to Austria, to Holland, to England. It was he who laid out, when he was twenty-six years of age, the line of the first European railway, from Linz to Gmunden, in his capacity of member of the Board of Survey of Upper Austria. Later he served as an officer of the Foreign Legion in Algeria, which he was forced to leave as the result of an unfortunate liaison with a woman. Embarking for France January 15, 1833 on the *Zèbre* . . . François Zola arrived at Marseilles, settled in the neighbourhood, and flung himself into several immense projects: a plan for fortifying Paris; the invention of various machines for scooping up earth, forerunners of our modern steam shovels; the construction of a new port for Marseilles; and finally the scheme, which was actually executed, of a canal to supply the city of Aix with drinking-water during periods of drought."

The canal project accounts for the settlement of the Zola family, consisting of the engineer, his wife (*née* Émilie-Aurélie Aubert) , and the three-year-old Émile, at Aix-en-Provence in 1843. The construction of the canal was authorized by royal decree in

1844, and the scheme approved in detail, after prodigious efforts on the part of its creator, in February 1847. But François Zola did not live to see his cherished plan carried out. Exhausted by the preliminary work and the long-drawn-out negotiations, he fell an easy victim to an attack of pneumonia and died in Marseilles after a few days' illness, on March 27, 1847, at the age of fifty-two. The canal for which he was responsible is still in operation together with the dam, known as the *Barrage Zola,* at its head; and the town of Aix has shown its gratitude by naming one of its principal streets the boulevard François Zola.

But François Zola seems to have been a better engineer than business man, and after his sudden death it was found that he had bequeathed to his widow and small son nothing more useful than a tangled mass of debts and lawsuits. Madame Zola was a courageous woman and struggled valiantly to satisfy, or failing that to put off, the horde of bill-collectors and *huissiers* that swarmed on her doorstep. In this endeavour she was aided by her parents, the Auberts, who came to live with her at Aix. It may be noted in passing that by a curious coincidence the maiden names of Émile Zola's mother and of Paul Cézanne's mother were the same; but there is no reason to suppose that the two families were even distantly related. Aubert is a common enough name in France, and besides they came from widely separated parts of the country, Madame Zola having been born at Dourdan (Seine-et-Oise) and Madame Cézanne at Aix.

At the time of his father's death Émile Zola was too young to worry much over the decline in the family fortunes. He went to primary school and later to the boarding school of Notre-Dame at Aix. He entered the Collège Bourbon in October 1852, at the same time as Paul Cézanne. Until then the two boys do not seem ever to have met, but they must have become acquainted very shortly after their admission to the Collège. Gasquet gives Cézanne's own account of the circumstances that led to their meeting:

30

" ' At school Zola and I were considered phenomenal. I used to wipe up a hundred Latin verses in no time at all — for two sous. I was a business man, all right, when I was young! Zola didn't give a damn about anything. He dreamed. He was stubbornly unsociable — a melancholy young beggar! You know, the kind that kids detest. For no reason at all, they ostracized him. And in fact it was on that account that our friendship started. The whole school, big boys and little, gave me a thrashing because I paid no attention to their blackballing, I defied them, I went and talked to him just the same. A fine fellow! The next day he brought me a big basket of apples. There you are, Cézanne's apples! ' he added, with a playful wink, ' they date back a long time.' "

Somehow this charming tale of Paul's chivalrous defence of a weaker comrade sounds just a little too noble to be altogether true. Still, Gasquet is usually a reliable reporter, and Cézanne's recollections were generally trustworthy, especially when he evoked the memories of his boyhood. So perhaps the acquaintance actually did originate in some such act of schoolboy knight-errantry. In any case it is beyond question that Cézanne and Zola soon became fast friends, and that together with Baille they formed a triumvirate of inseparables which continued without a break until Zola's departure for Paris. This took place very early in 1858, when Zola was not quite eighteen years old. Madame Zola's gallant efforts to keep the wolf from the door had not been highly successful. In order to pay the expenses of her son's schooling she had been obliged to change her lodgings on several occasions, each time moving to a cheaper quarter of the town. But after the death of Émile's grandmother in 1857 the situation grew desperate, and Madame Zola decided to give up the struggle for existence in Aix and try her luck in Paris, where certain influential friends of the family might be counted on to do something to relieve her distress, or at least enable her son to complete the education for which she could no longer afford to pay. She was not

31

disappointed. Monsieur Labot, a friend of her late husband and attorney to the Council of State, secured a scholarship for Émile at the Lycée Saint-Louis, in the department of sciences, which he entered on March 1, 1858.

BAPTISTIN BAILLE

THE THIRD member of the " inseparables," Baptistin Baille, was a personality less interesting to posterity than Émile Zola, and at the same time of less importance in the life of Cézanne. Although the three were devoted comrades in the days of their boyhood, the intimate triple friendship of their teens could not survive the more critical judgment of the twenties. Baille was the first to drop out, while the ties of affection that united Zola and Cézanne remained unbroken, though they too gradually weakened, for thirty years longer.

Baille, the youngest of the three, was born at Aix in 1841. He was a rather unimaginative, matter-of-fact youth, who must have had some difficulty in keeping up with the flights of fancy of his more volatile companions. He seems to have done his part, however, in the readings and recitations and play-acting that took place on their long expeditions into the country. But though he joined in these youthful literary orgies he was not by nature an artist. His true *métier* was science. After his graduation from the Collège Bourbon he attended the École Polytechnique and later became an engineer of some distinction. Most of his life was spent in Paris, where he married the daughter of a manufacturer of optical instruments and succeeded to the directorship of his father-

in-law's business, which was operated under the name of Baille-Lemaire. The firm still exists, headed by the son of Baptistin Baille since the latter's death in 1918.

We do not know the cause of the final break between Cézanne and Baille, if indeed there ever was a cause more definite than the spontaneous divergence of two natures, one highly temperamental and bristling with the eccentricities of genius, the other prosaic, conventional, and scientific. It is rather surprising to find that two such antagonistic characters should have had enough in common even in early youth to warrant their extravagant vows of eternal friendship, which, alas, were not to be fulfilled.

As early as 1860 a coolness arose between Paul and Baille, for some reason which is unknown to us. Baille was then in Marseilles, while Paul was still in Aix unwillingly pursuing his studies at the University. Apparently both parties to the dispute, whatever it was about, wrote their grievances to their friend Zola — then in Paris — and Zola did his best to patch up the quarrel at long distance by the rather dangerous method of writing long letters privately to each of his two comrades, letters in which he preached mutual forbearance and in which he urged them to make allowances for each other's peculiarities. Fortunately for Zola, Baille and Cézanne did not compare notes at the time, for the peacemaker, in his genuine distress over the threatened break-up of the triple alliance, was inclined to hold with the hare and run with the hounds. He was frank in his exposure of Baille's weaknesses to Paul and of Paul's to Baille. Parts of these letters, which are published in the first volume of Zola's *Correspondance* under the subtitle of *Lettres de Jeunesse,* throw an interesting light on the characters of both Baille and Cézanne as seen through the eyes of Zola, who seems to have understood his two friends clearly enough.

Evidently Paul had reported his version of the affair. On May 2, 1860, Zola wrote to Baille:

" Cézanne has written to me about you. He confesses his fault

and assures me he will improve his disposition. Since he has opened the subject, I intend to tell him my opinion of his behaviour; I would not have begun it, but now it seems useless to wait until August [when Zola hoped to be in Aix, on his vacation] before attempting a reconciliation."

Three days later Zola made his protest to Cézanne:

" You speak of Baille in your two letters. I have been wanting to discuss this good fellow with you for a long time. — He is not like ourselves, his mind is not cast in the same mould; he has many fine qualities that we lack, and many faults too. I shall not try to depict his character to you, to tell you wherein he sins, wherein he excels; nor will I call him wise, any more than I will call him a fool; all that is only relative and depends on the point of view from which one looks at life. Moreover, what does it matter, to us his friends; is it not enough that we have judged him a good fellow, devoted, superior to the rabble, or at least better qualified to understand our hearts and our minds? Should we not judge him with the same tolerance we expect for ourselves, and if anything in his conduct annoys us, by what right shall we find evil in what he finds good? Believe me, we do not know what life holds for us; we are at the beginning, all three of us rich in hope, all three equal because of our youth and our dreams. Let us clasp hands: not the embrace of a moment, but an embrace that will keep us from failing some day, or console us if we should fail. — What the devil is he mumbling about, you will say. My poor old fellow, I thought I noticed that the tie which bound you to Baille was weakening, that one link in our chain was about to break. And, trembling, I beg you to think of our happy gatherings, of the vow we made, glasses in hand, to walk all our lives along the same path, arm in arm; to remember that Baille is my friend, that he is yours, and that if his character is not entirely sympathetic to ours, he is none the less devoted to us, loving us, in short that he understands me, he understands you, that he is worthy of our con-

fidence, of your friendship. — If you have anything to reproach him with, tell me, I will try to excuse him, or better yet tell him yourself what irritates you in him — nothing is so much to be feared as those misunderstandings which are not discussed frankly between friends."

Zola's good-natured efforts to bring about a reconciliation must have borne some fruit, for on May 14 he was able to write to Baille:

" Therefore, as I told you, I have written to Cézanne about the coolness with which he received you. I cannot do better than to copy here, word for word, the few sentences he wrote me on the subject; here they are:

" ' According to your last letter, you were afraid that our friendship with Baille was weakening. Oh! no, for, *morbleu,* he is a good fellow; but you know quite well that, my nature being what it is, I don't always know what I am doing, and so if I have done him any wrong, well, he must forgive me; but otherwise you know that we get on together very well, but I approve of what you say, for you are quite right. So we are still very good friends.'

" So you see, my dear Baille, I was correct in thinking that it was only a slight cloud which would blow away at the first puff of wind; I told you that the poor old chap doesn't always know what he is doing, as he admits willingly enough himself; and that, when he hurts your feelings, you must not blame his heart, but the evil demon who clouds his thoughts. He has a heart of gold, I repeat, he is a friend who can understand us, he is as mad as we are, as visionary. — I do not agree with you that he ought to know anything about the letters exchanged between ourselves concerning your reconciliation; he should believe rather that I have interfered at your suggestion, in a word he should not realize that you have complained about him, that you were on bad terms for a moment. — As for your behaviour towards him until August, when our happy reunion will take place, it should be as follows

36

— that is, in my opinion, of course: —— you are to write to him regularly, without grumbling too much if his own replies are delayed; your letters should be as affectionate as in the past, and in particular should be free from any allusion, any reference that might recall your little quarrel; in a word, everything should be as if nothing had happened between you. We are treating a convalescent, and if we do not want a relapse, let us avoid any imprudence. — You understand what makes me write like this, the fear of seeing our friendly triumvirate split up. And you must forgive my pedantic tone, my exaggerated fears, my perhaps needless precautions, ascribing them all to the friendship I bear towards both of you."

There is another reference to the wrangle in a letter from Zola to Baille dated June 2, 1860:

" Old Cézanne tells me in every letter to send you his greetings. He asks for your address in order to write to you very often. I am astonished that he doesn't know it, and that proves, not only that he has not been writing to you, but that you have been keeping just as silent yourself. Well, since it is a request that shows his good intentions, I will satisfy it. So there is a little quarrel which has become merely a legend."

But Cézanne continued to sulk for some time longer. In a letter to Baille written on July 4, 1860, Zola suggests another way to patch up the squabble:

" As for Cézanne's continued silence, we will have to consider. I have told him to send you my poem; on your side you might write him that I have informed you that he has it and tell him how he can send it to you. Such a letter could do no harm; you would keep yourself in the background, speaking only of me or something else, and that would without doubt revive your friendship."

37

While this "slight cloud" finally blew over and the three-cornered friendship lasted for some years longer, Baille gradually faded out of the lives of Cézanne and Zola and went his own way, untroubled by the poetic dreams of his boyhood companions. The break with Cézanne, when it came, was complete; there is not a single reference to Baille in any of Cézanne's letters — at least in those which have survived — after the early eighteen-sixties; and there is nothing to indicate that they ever saw each other again. Maurice Le Blond, Zola's son-in-law, in a footnote to the *Lettres de Jeunesse* in the 1927–1929 edition of Zola's works, tells us that Zola and Baille did meet once more during the nineties, after long years of separation, and that the meeting was "sufficiently embarrassed and painful." It might well have been, considering the mockery that time and temperament had made of their solemn, often repeated oaths of eternal friendship.

Yet there is no reason to blame Baille on the one hand or Cézanne and Zola on the other for drifting into channels that eventually became so widely separated. As Zola had perceived when they were scarcely out of their teens, Baille was not like themselves, his mind was not cast in the same mould; and though all three struggled for a time to ignore the differences in their mental make-up and to preserve the intimacy that had meant so much to all of them in their schooldays, it was inevitable that a time should come, quite soon, when even the memories of auld lang syne could no longer hold together such clashing dispositions.

PHILIPPE SOLARI AND OTHER FRIENDS

PAUL had other boyhood companions who sometimes took part in the fishing and swimming and exploring expeditions during those hot summers in Aix, though none of them was ever really admitted to the intimacy of the inner circle to which Zola and Baille belonged.

First of these was Philippe Solari, the gentlest, the most sweet-tempered, and in many ways the most sympathetic character of the entire group. Solari was almost the only one of Cézanne's acquaintances who remained on friendly terms with him throughout his whole life, from the time they first played together in the streets of Aix as children of five or six until the death of Solari a few months before that of Cézanne himself. It must be admitted that this long, unbroken friendship was due in great measure to the unusually patient, forbearing — and what is more important, genuinely understanding — nature of the little sculptor. For Cézanne with his nerves and his violent capricious rages must have been at times a difficult companion, even though the meek, inoffensive Solari was generally spared the full force of these visitations. Joachim Gasquet says of Solari:

" To my knowledge he was the only one of his [Cézanne's] friends towards whom the surliness of his disposition and his sudden fits of misanthropy were never directed."

But if he were not himself the victim, Solari must have been frequently a witness of these attacks. He seems to have understood them for what they were, mere explosions of nervous irritability, altogether without malice or the desire to wound; and the friendship lasted until the end, long after so many others had crumbled into dust.

Philippe Solari was born at Aix in 1840. His parents were poor and were obliged to stretch their resources to the limit in order to send him to the local École des Beaux-Arts. Fortunately, when he was eighteen, he won the Prix Granet of twelve hundred francs, which made it possible for him to go to Paris. An article by Jules Bernex in *Méditerranée,* dated September 1911, says of his later career:

" He was forced by poverty to do odd jobs for marble-cutters and plasterers, to model religious statuettes. Later, at Versailles, he carved a swan with a child, near the Bassin de Neptune to the right of the Grand Canal. He repaired the stonework of the Louvre. He laboured as head workman on the new Opéra, for which one of his compatriots, the sculptor Chabaud, had the contract. . . . He went to Lyons, where he did a bust for the Hôtel de Ville. He worked on the château of Blois, the theatres at Reims and Tarascon, then returned to Aix. There he produced a number of studies, and made a statue of the Republic for the village of Châteaurenard. He carved chimney-pieces, including a Gothic one representing the ancient local ceremonies of Corpus Christi for Monsieur Ducros, the talented painter."

Solari also modelled the bust of Émile Zola which still marks the former grave of the novelist in the Montmartre cemetery in Paris, although the remains have now been removed to the Pan-

théon. This is a bronze cast of the original plaster bust now owned by Zola's son, Dr Jacques Émile Zola. Another copy, also cast in bronze, has been placed in the Place Ganay at Aix, set on a stone base designed by Maurice Baille, nephew of Baptistin.

According to an anecdote which may or may not be authentic, the original plaster cast of this bust was intended for the Salon; and either because the time was too short to secure the services of a professional caster or because Solari was too poor to pay for one, the mould was made and the plaster poured by the sculptor himself, assisted by Zola and Cézanne. Monsieur Émile Solari suggests that the bust was modelled in the spring of 1868 and shown in the Salon of that year. If that is so, Zola was very much in the limelight just then; Manet's portrait of the young novelist was hung in the same exhibition. But the official catalogue of the Salon of 1868 does not mention any bust by Solari, either of Zola or of anyone else. Evidently the cast was rejected, or else the sculptor's son is mistaken about the date. In the catalogue of the Salon of 1873, however, appears the entry: *Portrait de Monsieur Z—, plâtre*, by Philippe Solari. Undoubtedly the Monsieur Z— in question was Zola; but whether the bust was the same one that Cézanne and Zola helped to cast, or a new one, is not so clear. Solari did model a second bust of Zola about 1873 — now owned by Zola's son-in-law Maurice Le Blond — and this may have been the one exhibited that year. In that case we may assume that Émile Solari is correct in ascribing the earlier portrait to 1868, but mistaken in his assumption that it was exhibited in the Salon at that time.

Philippe Solari was one of the many acquaintances of Zola's youth selected by the novelist for a place in *L'Œuvre*, a book which has already been mentioned and which will be discussed again in a later chapter. Zola describes Solari under the name of Mahoudeau:

" He was small, thin, with a bony face, already lined with wrinkles at the age of twenty-seven; his coarse black hair was

tumbled over a very low forehead; and in his yellow face, terrifyingly ugly, appeared the eyes of a child, clear and open, which smiled with a charming boyishness."

Of course the character of Mahoudeau and the events of his life bear only the most casual resemblance to those of the real Solari. One of the most vivid incidents in the book, however, half amusing, half tragic, actually did happen to the unfortunate sculptor very much as Zola has set it down. In *L'Œuvre* Mahoudeau has modelled an enormous figure of a nude woman, in clay, but lacking the money to buy a suitable iron framework, he has been obliged to build up his statue on a light makeshift armature of broomsticks. The heat of the stove softens the clay and causes the statue to bend forward and break loose from its inadequate moorings, until the whole mass slowly and majestically collapses and lies sprawled out on the floor, a complete wreck.

Joachim Gasquet describes the real occurrence as follows:

" It was during that same winter [probably 1868] that Zola, one morning, brought Manet to the shop transformed into a studio in which Solari was making ready his statue for the Salon.

" It was a huge Negro struggling with some dogs, the same one who posed for Cézanne's famous painting of the Negro in blue trousers, owned by Monet. Manet, Cézanne, and Zola walked around the gigantic figure. ' The War of Independence,' said Solari, delighted. They were shivering. He lighted the fire. Then a dreadful thing happened. The framework of the statue, made of old bits of chairs and broomsticks, cracked in the heat. The Negro collapsed — Solari had to send him to the Salon, still being bitten by the dogs, but lying down. It was a great success. Albert Wolff praised it in the *Figaro*. A dealer in guano bought the woolly Independent and, after coating him with black varnish, made him, oh Muses! into his trademark. In Zola's version of the anecdote in *L'Œuvre*, the Negro has become a bacchante."

Evidently the good Solari was not unduly disturbed by the mishap and accepted his statue's accidentally acquired posture with a good grace. He simply changed the title when he sent the recumbent figure to the Salon of 1868, so that it appears in the catalogue as: *Nègre Endormi, plâtre.*

The two busts of Cézanne by Philippe Solari illustrated in this book were made about 1904 or 1905, when both painter and sculptor were some sixty-five years of age. The larger one, in white plaster, is, I believe, the only effigy of Cézanne modelled directly from life. According to Paul Cézanne *fils*, it is an excellent likeness of his father as he appeared shortly before his death. Solari must have had some difficulty in keeping the impatient Cézanne quiet during the sittings; for although the painter insisted that his own models should pose " as still as an apple," he was not inclined to live up to his own preaching when the rôles were reversed. One day a stranger happened to enter Solari's studio while Cézanne was posing, and stopped for a moment to watch the sculptor at work. Cézanne immediately broke up the sitting and stalked out in a fury; nor could he be induced to return for several weeks. He would never give up any of his own working time to anything so irrelevant as posing for Solari, but kept such subordinate occupations for the leisure of Sundays. The following letter, which bears no indication of the year in which it was written but undoubtedly refers to a sitting for this bust, is a good illustration of the unfailing courtesy he always showed the gentle Solari:

24 September

" My dear Solari,

" I should like to have a sitting Sunday morning. Would you care to lunch with me at Madame Berne's at eleven o'clock? From there we could go up to your studio — let me know if this arrangement suits you, if not I will try to meet you somewhere else, always yours,

P. Cézanne "

The smaller bust, in terracotta, was modelled not from life but from memory, in an attempt to catch a fleeting impression. Solari had been spending some hours with Cézanne, talking about art — or rather listening quietly while Cézanne talked, for the little sculptor generally took only a passive part in these discussions — and at the end Cézanne had become strangely uplifted, pensive, with a far-away look in his eyes. Solari was deeply affected by his old friend's exaltation and hurried to his studio to fix in clay the unusually spiritual expression on Cézanne's face; to model, as he said, " *un Cézanne rêveur* " (Plate 4) .

The two original busts, now in the possession of Monsieur Émile Solari, are the only examples of these works in existence. No copies have been made, nor, to the best of my knowledge, have any photographs of them been published hitherto.

Philippe Solari was distinctly a minor artist, sincere, talented, but academic: neither a genius nor a pioneer. The affectionate regard which Cézanne always felt for him is brought out in a letter to Zola dated June 19, 1880:

" I have seen the very excellent Solari. Tomorrow I shall go to visit him, he has come to my house three times, but I was always out. Tomorrow, Sunday, I shall go to clasp his hand. Nothing is going well for him, he cannot make good fortune turn in his direction. With less ability, how many lucky rascals are successful. . . ."

* *

Another friend of Cézanne's youth was Numa Coste, four years younger than himself. Coste came of peasant stock; his father was poor and could only send his son to the free school. But the ambitious boy was determined to become a painter, and spent his evenings regularly at the École des Beaux-Arts of Aix. Here, in the drawing class, he met Cézanne, and in spite of the great difference in circumstances between the threadbare Coste and the banker's

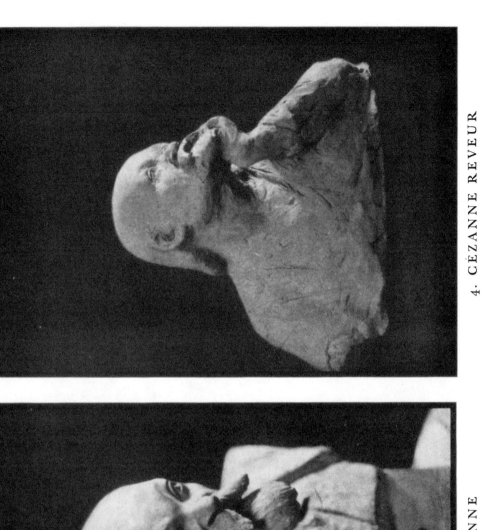

4. CÉZANNE REVEUR

ABOUT 1904. TERRACOTTA BUST BY PHILIPPE
SOLARI. OWNED BY ÉMILE SOLARI

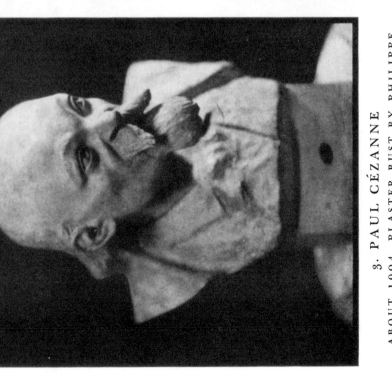

3. PAUL CÉZANNE

ABOUT 1904. PLASTER BUST BY PHILIPPE
SOLARI. OWNED BY ÉMILE SOLARI

5. PORTRAIT OF ACHILLE EMPERAIRE
ABOUT 1868. PELLERIN COLLECTION

son the two became close friends. When he had finished school Coste was employed as a clerk in a lawyer's office, but continued to attend the evening classes at the Beaux-Arts. His friendship with Paul was interrupted but not broken by the latter's journey to Paris in 1861 and the other trips that followed. The separations were bridged by a fitful correspondence, of which several letters have been preserved by Coste's sister and donated to the Société Paul Cézanne of Aix, whose director, Monsieur Marcel Provence, published them in the *Mercure de France* for April 1, 1926 together with a short biography of Numa Coste. Extracts from these letters will be given in their proper place.

In 1864 Coste, having drawn one of the unlucky numbers in the draft for military service, enlisted in the army for seven years. He passed most of this period in Paris, where he saw Cézanne frequently whenever the painter was in town. During the war of 1870 Coste held a commission in the army that defended Paris.

An unexpected legacy of a hundred thousand francs left him by a wealthy friend about 1875 changed the course of Coste's life. He promptly resigned from the army and entered the lists as an ardent champion of the new movement in art. With Zola, Paul Alexis, and others he founded the review *L'Art Libre,* for which he wrote articles defending the Impressionist painters, who in those difficult years needed all the support they could get. These journalistic activities did not prevent Coste from resuming his own painting, and he continued to send pictures to the Salon for several years without, however, achieving more than a mediocre success.

About 1881 Coste returned to Aix for good. He purchased a fine house opposite the cathedral of Saint-Sauveur, as well as a small country-house. He abandoned painting and devoted himself to archæology, particularly in connection with the antiquities of his native town and province. He wrote scholarly articles for several newspapers and reviews in addition to innumerable pamphlets and monographs. During his last years he worked on a

45

lengthy, meticulous study of the history of the cathedral of Saint-Sauveur; the manuscript was still unfinished when Coste died in 1907.

* *

Then there was Achille Emperaire, born in 1829, the strange little dwarf whose portrait Cézanne painted in 1867 or 1868. It is an extraordinary picture, this full-length study of a little man in a bathrobe sitting hunched up in a high-backed armchair, his enormous head far too heavy for his diminutive body and short shrunken legs. The dwarf's feet do not even touch the floor, but rest on a foot-warmer several inches high. The painting shows traces of almost brutal caricature, but there is no humour in the expression of the tragic wistful eyes. The colour is laid on thickly, as in most of Cézanne's early paintings, with broad vigorous brush-strokes, but the areas of skin, hair, bathrobe, and flowered chair-covering are rendered with a fine sense of their different surface textures. All in all this portrait stands out as the most successful work of Cézanne's early period (Plate 5).

Emperaire was a painter too, and he and Cézanne would discuss art by the hour, the arguments growing hotter and hotter as each developed his pet theories and defended his favourite masters. Although Emperaire, like Cézanne, was a native of Aix, it is probable that they did not meet, or at any rate did not become well acquainted, until they were fellow-students at the Académie Suisse in Paris in 1861.

Joachim Gasquet, who knew both Cézanne and Emperaire well towards the end of their lives, writes of the unfortunate little man:

" A dwarf, but with a magnificent cavalier's head, like a Van Dyck, a burning soul, nerves of steel, an iron pride in a deformed body, a flame of genius on a warped hearth, a mixture of Don Quixote and Prometheus. Like Cézanne, of whom he often talked and whose words he would repeat to me, he returned to Aix to

46

die, very old, but always believing in the beauty of the world, in his own genius, in his art; at seventy, dying of starvation, but still doing exercises on a trapeze in his miserable lodgings for an hour every day, in a feverish determination to grow taller and to keep on living. He has left some fine drawings in red chalk, and in a cheap eating-house on the Passage Agard an Amazon in the style of Monticelli and two still lifes, one particularly haunting and tragic, of game, a partridge, a duck by the side of a great bowl of blood, which Cézanne liked so much that he sometimes ate the horrible stew of the restaurant in which they were hung in order to be able to look at them in peace. He wanted to buy them, but had not had the courage, he told me, when the restaurant failed and the property was sold without the old painter's knowledge."

Emperaire was always poor, more often than not in really desperate straits. One of these crises, coming at a time when Cézanne himself was temporarily without funds because of a quarrel with his father, caused Cézanne to appeal to Zola, already in a position of some influence in Paris, to help out their unlucky friend. The letter is undated, but was probably written about 1878. The " Hortense " mentioned is Hortense Fiquet, later to become Cézanne's wife. We do not know to what the " petition " of Achille's brother refers; possibly a pension:

" My dear Émile,
" Hortense, having gone to Aix, has seen Achille Emperaire. His family is in a most distressing position, three children, winter, no money, etc; you can imagine what it is like. — Consequently I beg you, 1st Achille's brother being on bad terms with his ex-superiors of the tobacco administration, to please withdraw the papers relating to his petition, if there is nothing to be obtained for him within a short time; — 2nd See if you could find for him, or help him to get, some kind of a job, on the docks for example. 3rd Achille also asks you to find him some employment for himself, no matter how humble.

47

" So if you can do anything for him, please do it, you know how well he deserves it, being a very fine fellow, crushed under the weight of family and neglected by clever folk. There you are."

Zola's reply has not been preserved and there is no further reference to Emperaire and his troubles in any of Cézanne's surviving letters, so the result of this appeal remains unknown. We do know however that Zola was an exceedingly kind and generous man whose purse and time were always at the disposal of his less fortunate friends, so it is reasonably safe to assume that he took whatever steps he could to relieve the distress of the impoverished cripple. There is a story, unfortunately uncorroborated by letters or other documentary evidence, that Cézanne, either through Zola or someone else, did once secure a position for Emperaire as Inspector of Sewers in Paris. The job was something of a sinecure and not nearly so unsavoury as it sounds. But Emperaire considered the post beneath the dignity of an artist and refused to accept it. Evidently — if the story be true — the " iron pride " of which Gasquet speaks was well to the fore in Achille's deformed body.

Émile Bernard, in his article *Souvenirs sur Paul Cézanne* in the *Mercure de France* for October 15, 1907, writes of Emperaire: " No doubt poverty killed him, for he died of suffering and exhaustion at an early age." This however is an error; for in spite of his lifelong destitution he did not die until 1898, when he was nearly sixty-nine years old.

* *

Another painter among Paul's youthful acquaintances at Aix was Villevielle, of whom Gasquet writes:

" The transports, the passionate improvisations, the explosions of theory in which he [Cézanne] indulged with the fiery Emperaire were tempered by the industry, the more bourgeois character, the moderation of Villevielle. The latter had married a charming girl, ' rosy, plump, and merry,' and the peaceful hap-

48

piness of the virtuous household sometimes disposed Cézanne to dream of domestic joys. He was contented in this atmosphere. He remembered it with tenderness. — When, forty years later, he lost his mother, it was Villevielle whom he called in to make a drawing of her laid out on her deathbed, in one of those mysterious changes of heart by which he tried to reconcile his feelings with certain regrets, vague intuitions, and what he called the point of support of morality and ethics."

Villevielle was older than Cézanne and was already installed in a studio in Paris when Cézanne went there for the first time in 1861. Villevielle received his young and very green compatriot warmly, allowed him the freedom of his studio, gave him good advice — which was not often followed — and criticized his work. But Villevielle was too academic a painter for the already insurgent Cézanne, and they soon drifted apart. They had not seen each other for many years when in 1897 the incident reported by Gasquet occurred: Cézanne's impulsive appeal to his old friend to sketch the portrait of his dead mother.

Still another crony of those days was Marius Roux, who became a journalist and writer and who later collaborated with Zola in a dramatization of the latter's *Les Mystères de Marseille,* which was produced in Marseilles in October 1867. Zola and Cézanne attended the opening performance, but the play met with a cold reception and was withdrawn after a few days. During the war of 1870 Roux and Zola again joined forces and founded a small daily paper, *La Marseillaise.* This venture also was a failure and the journal died a natural death almost immediately. Though Roux and Cézanne were good friends during their boyhood days in Aix, they played but a small part in each other's later lives.

Antony Valabrègue, also born in Aix, was one of the two Jews with whom Cézanne was acquainted in his youth. The other was a lad named Abram, and both of these young men — or at least their rear views — appear in the background of a picture, *La Conversation* (Plate 6) , in which the foreground is occupied by

49

the figures of Cézanne's two sisters, Marie standing, Rose seated. The date of this canvas is uncertain; it is generally ascribed to 1875, but the brushwork suggests that a much earlier date — probably 1868 or 1870 — is nearer the mark. Cézanne used Valabrègue and Abram as models for another picture painted about the same time, *Les Promeneurs;* he also painted several portraits of Valabrègue alone. Valabrègue was younger than Cézanne. He was a poet, as well as a critic of literature and art for various reviews. As was the case with Marius Roux, Valabrègue's literary bent drew him more closely into the orbit of Zola's life than into that of Cézanne's; but the painter maintained his friendship with him for a number of years and frequently mentioned " *le grand Valabrègue* " with affection in his letters to other intimates.

And lastly there was Marguery, the Marguery who had organized the school band in which Cézanne blew the cornet and Zola the clarinet. His fate was the saddest of all the little group who started out so hopefully to conquer the world. Paul Alexis writes of Marguery in *Notes d'un Ami,* published in 1882:

" He was a charming youth, who had succeeded his father as a lawyer, and who died tragically, in a fit of insanity, by shooting himself with a rifle: a terrible end which neither his carefree nature nor his boisterous gaiety could have foreshadowed."

6. LA CONVERSATION
1868 1870 (?)

7. JAS DE BOUFFAN

ABOUT 1885. COLLECTION OF PAUL CÉZANNE FILS

JAS DE BOUFFAN

IN 1859 Louis-Auguste Cézanne purchased from the Jourssin family a country estate known as the Jas de Bouffan, for which he paid about eighty thousand francs. Many years earlier the Cézannes had left the combined house and hat-shop on the Cours Mirabeau. At the time of Louis-Auguste's marriage in 1844 the family was living at 17 rue de la Glacière; later they moved again to a more commodious residence at 14 rue Matheron, where Paul's younger sister, Rose, was born on June 30, 1854. After the purchase of the Jas de Bouffan this house was maintained as a town residence. The Jas was used chiefly as a summer home, and sometimes during week-ends.

The Jas de Bouffan is situated about half a mile to the west of Aix, surrounded by fields and farms and a few smaller country estates. The name signifies " Habitation of the Winds "; the Provençal word *Jas* is derived from the Latin *jacere,* to lie, to be located; *Bouffan* means a puff of wind. The place is appropriately, if somewhat euphemistically, named; in winter the mistral sweeps across the valley in furious gusts, and even in summer, when the streets of Aix are sweltering in the stagnant air, a steady breeze keeps the Jas de Bouffan pleasantly cool.

When Père Cézanne bought the Jas the property comprised

about fifteen hectares — thirty-seven acres — of land, part farm, part vineyard, with a large and charmingly laid out garden around the house. But Louis-Auguste was not inclined to spend his good money on the cultivation of the grounds; there were few flowers, and most of the planting was allowed to grow wild. There was a pool of considerable size which was useful as well as ornamental, as it provided the only bathing facilities the family possessed. But the chief glory of the Jas de Bouffan was, and still is, the avenue of magnificent old chestnut trees behind the house, which figure over and over again in Cézanne's paintings.

The house itself, built during the reign of Louis XIV as a country home for the Marquis de Villars, is large, square, and severely simple on the exterior. The stone walls were originally coated with yellow stucco which was later removed and replaced by the present facing of tawny grey cement. The low pitched roof is of red tiles, with overhanging eaves. The main entrance is in the centre of the north façade, facing the driveway; the south wall is flanked by a broad formal terrace.

On the ground floor the hall runs through the centre of the house from north to south, with the staircase near the front door. To the west is an enormous salon extending the entire length of the house, with one end rounded to form a sort of niche or alcove. It was on the walls of this salon that Paul painted the series of murals which will be described more fully in a later chapter. The dining-room and kitchen are across the hall. On the next floor are the family bedrooms, except Paul's, which is on the third storey. Some time after the Cézanne family took over the house — we do not know just when, but it was probably shortly after Paul's return from his first trip to Paris — he appropriated another room on the same floor for a studio; in order to secure the necessary amount of north light he put in a huge window which cuts squarely through the cornice on that side and has a most unfortunate effect on the otherwise symmetrical roof line. Nearly all of the rooms are large, the ceilings high, and the windows

heavily shuttered against the blazing sunlight; in its breezy situation the house must have been refreshingly cool on the hottest days, especially as Louis-Auguste's economy kept the interior sparsely furnished.

For forty years the Jas de Bouffan provided a large part of the physical background of Paul Cézanne's life. He was of too restless a disposition to live there, or anywhere else, for long at a time, and the petty irritations and interferences of life *en famille* rasped his over-sensitive nerves. But he truly loved the dignified old house and its neglected garden. When he could escape from the family and paint in peace under the trees or in his attic workroom he was perfectly happy. In general Cézanne was supremely indifferent to his surroundings except as they affected his work. A house was to him a place in which to eat and sleep, and for those purposes one habitation was as good as another. He cared nothing for luxury, for furniture, for *bibelots*. But the Jas de Bouffan had associations for him that set it apart from all his other numberless residences.

In 1899 the property was sold to Monsieur Louis Granel for approximately the same sum that Louis-Auguste had paid for it forty years before. Cézanne's mother, to whom the Jas belonged after her husband's death, had died in 1897. The decision to dispose of the Jas de Bouffan may have been due in part to a sentimental reluctance on Cézanne's part to go on living in a house which was so intimately bound up with his memories of her, but it was also due to a more prosaic desire to settle up the estate, which was divided between his two sisters and himself. Monsieur Granel made a number of changes in the grounds as well as in the house itself. The position of the driveway was altered, some old trees cut down and new ones planted — though the splendid avenue of chestnuts was left undisturbed — and balustrades and statues were scattered about the garden. Very little was done to the outside of the house except that the old front door of solid wood was replaced by a new one of wrought iron and glass, and

53

new wrought-iron balconies were set in front of the bedroom windows on the north front. But the interior was largely remodelled and redecorated and completely refurnished. After the death of Monsieur Granel a few years ago the Jas de Bouffan passed into the possession of his son-in-law Dr Corsy, the present owner.

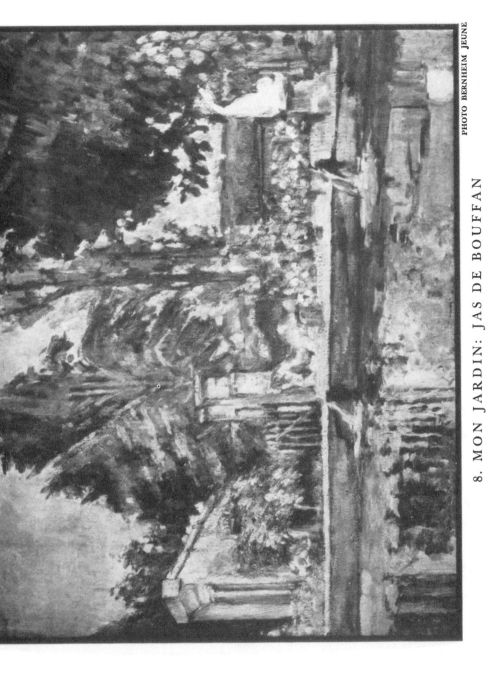

8. MON JARDIN: JAS DE BOUFFAN

ABOUT 1885. COLLECTION OF DR OTTO KREBS, WEIMAR

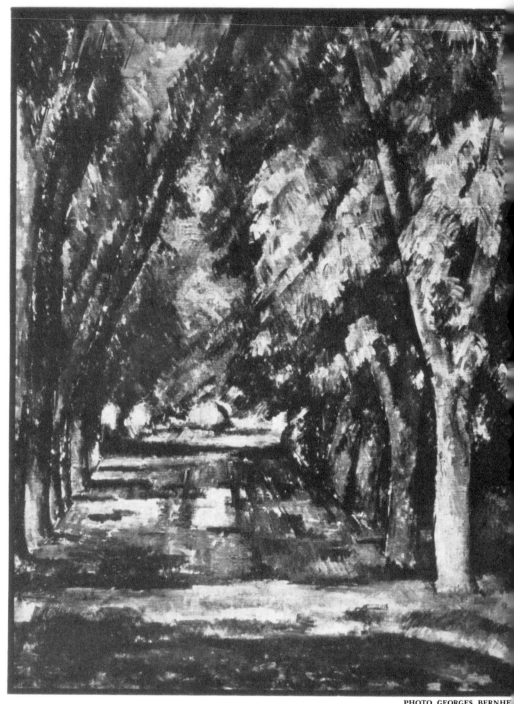

9. ALLÉE DES MARRONNIERS: JAS DE BOUFFAN
ABOUT 1890 (?)

A DIFFERENCE OF OPINION:
1858–1861

PAUL graduated from the Collège Bourbon on November 12, 1858 with the degree of Bachelor of Letters and a mention " *assez bien.*" He was nearly twenty, and it was time to think seriously of a career. Paul himself *had* thought about it very seriously indeed and wanted nothing more than permission to devote himself to the one thing he really cared for — painting — and a sufficient allowance to enable him to live modestly. While he was still attending the Collège Bourbon he had been in the habit of spending all his leisure hours at the École des Beaux-Arts connected with the Museum of Aix, where he was taught drawing from the nude by Professor Joseph Gibert. The instruction was stodgy and uninspired, and left Cézanne with a contemptuous opinion of all schools and professors which remained with him all his life. But it was the best to be had in Aix, and no doubt he profited technically if not spiritually from the commonplace teaching. At any rate he astonished, and at the same time displeased, his father by bringing home a second prize in drawing in 1858. For Louis-Auguste Cézanne had other ambitions for his son.

In the banker's opinion, messing about with charcoal and mak-

ing daubs on canvas were well enough as the harmless amuse-
ments of a child, but the idea that anyone could seriously devote
his life to such nonsense — particularly the only son of a man of
such wealth and prominence in the community as himself —
filled him with horror. The whole thing was ridiculous, and
Louis-Auguste, accustomed to having his own way, simply put
his foot down. He would have liked Paul to succeed him as direc-
tor of the bank; not yet, of course — the bank had only been run-
ning for ten years, Louis-Auguste was barely sixty and full of
health and vigour and by no means ready to let go the reins —
but some time in the future, after Paul had had the necessary
years of training and he himself should be growing old and feeble.
Failing that — for after all it was not so necessary that Paul should
be a financier if such a career were repugnant to him; Louis-
Auguste did not wish to be unreasonable, he had plenty of money
already and had every intention of making a great deal more
before he died — he would allow his son to choose among any
of the respectable professions open to a properly brought-up
young scion of a wealthy bourgeois family. For example, the law:
Paul might become a lawyer or a judge; those were promising
careers for a young man. So much would Louis-Auguste concede,
but no more. As for painting, that was out of the question.

Paul's mother tried to intercede for him, but in vain; nor were
his sister Marie's efforts on his behalf any more fruitful. Paul
could always count on his mother's support. She understood but
dimly his passionate love for painting and probably found his
own productions, later on, completely baffling; but she wanted
him to be happy. He was her favourite child, and the bond be-
tween her and Paul was a close one. She was a lively and romantic
woman, light-hearted, with quick perceptions, a fiery nature,
passionate, quickly angered, and as quickly appeased. Some of
the disputes between her and the hot-tempered, domineering
Louis-Auguste concerning their son's future must have been
violent indeed.

But Paul, even with his mother and sister behind him, could

56

not stand up against his determined father. The tradition of paternal authority was too strong for him. Besides, the banker had hold of the family purse-strings; and a tight hold it was. So Paul resigned himself to the study of law, as the lesser of two evils.

For the next two years he ground away at his law-books. Much of the time he was miserable, rebellious, fiercely resentful. Nevertheless he worked conscientiously at the University — the *Faculté de Droit* — at Aix; and in November 1859 he passed his first examinations for the degree of Bachelor of Laws. At the same time he did not give up his painting entirely. He continued to spend his evenings at the École des Beaux-Arts. Evidently Louis-Auguste had not forbidden Paul to paint a little on the side, as long as he did not neglect the study of law and kept up his daubing merely as an avocation.

Paul wanted desperately to go to Paris to study painting. He felt that there was no opportunity for him in Aix; that all the inhabitants were philistines like his father; the instruction offered by Monsieur Gibert was not only academic but inadequate; there were few good pictures to be seen in the local museum, and such masterpieces as there were he already knew by heart; he wanted to see the treasures of the Louvre. Moreover, he missed his friend Zola terribly, and Zola wrote to him constantly, urging him to defy his father and come to Paris. Paul's distaste for the law grew steadily, and with it his determination to follow his own inclinations, to paint, to paint as much as he wanted to, and to do nothing else.

Paul's proposal to study art in Paris aroused a double opposition on the part of Louis-Auguste. It was bad enough that his son should want to give up a respectable career like the law for the frivolous and precarious calling of an artist; but that he should go to Paris as well, that was the last straw! The banker remembered the Paris of his own youth and his adventures as a hatter's apprentice. Paris was a wicked city, a sink of iniquity — no place for a guileless youth from the provinces. Paul would do nothing but waste his time and his father's money there. Louis-Auguste

decided that he had never approved of Zola anyhow. He had an evil influence over Paul, and the banker was glad that he had gone away where Paul could never follow him. Louis-Auguste put his foot down harder than ever.

The deadlock lasted for three years. But Louis-Auguste, though he was a hard man in business and ruled his family with what he believed to be a rod of iron, was not really a tyrant at heart. He did not understand Paul, but he was fond of him, even fonder than he was of having his own way. The boy was obviously unhappy; he was persistent in his efforts to win his father over; and his mother and sister backed him up. One can almost sympathize with Louis-Auguste in his single-handed struggle with his unruly family; his home can hardly have been a peaceful one during those years. The united opposition gradually wore him down; at last he relented, quite suddenly, and in April 1861 Paul set out for Paris, accompanied by his father and his sister Marie.

YOUTHFUL LETTERS: 1858–1859

THE THREE years of drudgery in Aix were a trying period for Paul, but his state of mind during that time was by no means one of unrelieved melancholy. He was a healthy young man, and the light-hearted and sometimes ribald tone of the letters he wrote to Zola testify to his resilience. Of course he complained about the dullness of his law studies and compared his present monotonous life to the happier days when he and Zola and Baille roamed the countryside together. But what schoolboy does not lament his last vacation, once he is back at his desk? There is a great deal of gay nonsense in these early letters, local gossip about common acquaintances, the account of a calf-love which seems to have remained on a strictly Platonic plane; and there is an enormous quantity of verse, much of which is sheer doggerel. Judging from these examples it can hardly be said that a great poet was lost to posterity when Paul Cézanne became a painter. Yet some of the rhymes are ingenious enough, and the humour — though a bit clumsy and obvious — is not without interest as an indication of the high spirits that sparkled through the recurrent moods of depression.

For years it was believed that all of Cézanne's letters to Zola had been destroyed, and there has been much lamentation over

the loss of the verses which Cézanne was known to have written in his youth. But after the death of Zola's widow in 1930 about eighty letters from Cézanne were found among the novelist's papers. They cover two distinct periods. The first nine letters were written in 1858 and 1859, when Zola was already in Paris and Cézanne, in Aix, was longing to follow him. These are the letters containing the poems. Then there is a gap of eighteen years during which hundreds of letters must have been exchanged between the two friends, but none of them has come to light. The second group of letters runs continuously from 1877 to the final break between Zola and Cézanne in 1886. All but three or four of the documents have been deposited in the Bibliothèque Nationale in Paris.

Monsieur Ambroise Vollard, in his biography of Cézanne, gives a report of a conversation between Zola and himself which is somewhat coloured by his resentment of Zola's apparently unfair treatment of Cézanne; he is inclined to poke fun at what he considers Zola's conceit and lack of artistic appreciation. How far this opinion of Zola is justified will be discussed later on. Vollard's account of that part of the conversation which concerns his correspondence with Cézanne follows:

" Zola's face beamed with such goodwill that I ventured to speak about Cézanne.

" ' There is a question on the tip of my tongue, Master, but I have already abused your hospitality to such an extent — '

" Zola (indulgently) : ' Speak! '

" Myself: ' It is about the letters that you wrote to Monsieur Cézanne, and which are so indispensable to the world today, to teach it to feel and to think. Are they still in existence? I have not dared to speak to Monsieur Cézanne about them, because I did not want to give him reason for eternal remorse; for, if he had not preserved those precious papers, he would have been overwhelmed with the realization of how basely he had betrayed the confidence of posterity.'

" Zola: ' I too was afraid for those letters. I gave the best of my-self in them! But thanks be to Heaven, Cézanne had sense enough to treasure the merest note I wrote him with the greatest care. When I asked him to give me back my correspondence, thinking that its publication might prove to be invaluable to young artists, who could not fail to profit by the advice that a friend gave to a friend from the bottom of his heart, he returned the package — not a letter was missing. Ah! why did he not also give me the great painter upon whom I counted so much! . . .'

" Myself: ' But even if he were never able to " realize " his ideas, perhaps Monsieur Cézanne said some interesting things about painting in *his* letters? '

" Zola: ' Everything that Cézanne wrote was unexpected and original. But I have not kept his letters. I would not, for the world, have anyone else read them, on account of their somewhat loose form. — ' "

Can Zola really have been so fatuous as to talk like this? I can-not believe it; especially as it is so difficult to reconcile this story with the subsequent discovery of eighty-odd letters from Cézanne among Zola's papers, many years after the deaths of both men. Did Vollard misunderstand what Zola said? Did Zola deliberately mislead Vollard, perhaps because he sensed his animosity and was unwilling to show him Cézanne's letters on that account? Or did Zola really believe that the letters had been destroyed? The fact remains that whether or not he intended to destroy them because of " their somewhat loose form," Zola did actually keep a large number of the letters written to him by Cézanne. On the other hand, of the packet of Zola's own letters which Cézanne is supposed to have returned to him, none have been found except a group of eighteen letters written between 1858 and 1862. These have all been published in Zola's *Lettres de Jeunesse*. Hence, notwithstanding Vollard's statement, it would appear that unless Zola destroyed most of his own letters after having taken the trouble to retrieve them from Cézanne — which seems highly

unlikely — the boot is really on the other leg, and that whereas Zola kept at least eighty of Cézanne's letters to him, Cézanne preserved only a few of Zola's.

I have not attempted to translate Cézanne's verses into English. Their content is relatively unimportant, and what flavour they possess would be completely lost if the original rhymes were to be paraphrased in another language. Perhaps there would not be much point in printing more than a few lines of these verses, even in French, if their intrinsic value as poetry were the only thing to be considered. But the early poetic efforts of a man who afterwards became a great painter are something of a literary curiosity, all the more because they have not been published in any previous biography of Cézanne, though a few fragments appear in Madame Denise Le Blond-Zola's life of Émile Zola published in 1931.

The verses are too long, however, to be included in the body of this work. A number of extracts from the prose portions of Cézanne's youthful letters to Zola will be reproduced in this chapter; while for the benefit of those readers who are interested in his poetry the complete text of these letters, in French, will be found in Appendix B, together with all of the other known examples of Cézanne's verse collected from various sources.

* *

The first letter was written on April 9, 1858, shortly after Zola's departure for Paris. Paul is nearing the end of his final term at the Collège Bourbon and is looking forward to Zola's promised return to Aix to spend his summer vacation with himself and Baille. The style is free, without much regard for syntax and still less for spelling and punctuation — faults which are characteristic of Cézanne's correspondence throughout his life. The letter opens with some verses (see Appendix B) and continues in prose:

" Since you left Aix, *mon cher,* a deep sorrow has come over

me; I am not lying, I assure you. I do not recognize myself, I am heavy, stupid and slow. By the way, Baille has told me that within a fortnight he will have the pleasure of sending off to the hands of your most eminent highness a sheet of paper on which he will express his sorrow and grief at being far from you. Truly I should love to see you, and I think that we will see you, I and Baille (of course) during vacation, and then we will execute, we will carry out the projects we have planned, but meanwhile I mourn your absence."

After a second poetic outburst Paul proceeds:

" Do you remember the pine which, planted on the banks of the Arc, stretched its hairy head over the gulf that yawned at its feet? This pine, which with its foliage protected our bodies from the ardour of the sun, ah! May the gods preserve it from the sinister onslaught of the woodchopper's ax!

" We expect you to come to Aix for your vacation, and then, *nom d'un chien,* then joy. We have planned monstrous hunting expeditions, as outlandish as our fishing.

" Soon *mon cher* we are going to begin our hunt for fish once more, if the weather holds, it is magnificent today for it is on the 13th that I resume my letter."

And the epistle ends with a long and faintly obscene poem in thirteen stanzas.

At this time Zola was studying at the Lycée Saint-Louis in Paris. He missed his old friends, and though he had made a number of new acquaintances they could not take the places of the companions he had left in the Midi. The following letter, written some three months after his arrival in Paris, is certainly not the first Cézanne received from him; but it is the first that has come down to us. This letter is not included in the early editions of Zola's *Lettres de Jeunesse;* it is published only in the edition of 1927–1929. He teases Paul about some mysterious lady-love who,

judging from Paul's answer, seems to have been serenely unaware of her swain's infatuation. Paul was a timid youth and was careful to cast his sheep's eyes from a safe distance. Zola at eighteen is already beginning to acquire style in his writing; the smoothly constructed sentences of the future novelist are in marked contrast to Cézanne's vivid but often awkward and ungrammatical phrases:

<div align="right">

" Paris, 14 June 1858

</div>

" My dear Cézanne,

" I am a little behind with my correspondence; but I beg you to believe that it is because of an unusual combination of circumstances which I shall not try to explain to you because it would take too long. The heat is awful and I am dripping. So, as my poetic fire is in inverse ratio to the fire cast by the divine Apollo, I will confine myself to writing you in simple prose today. Besides, I am like M. Hugo, I like contrasts; therefore after a poetic epistle I send you a prosaic epistle. So that instead of sending you to sleep altogether, I shall only make you drowsy.

" My dear friend, I must tell you something, but something charming. I have already plunged my body in the waters of the Seine, the Seine of the wide width, of the deep depth. But here there is no venerable pine, but here there is no cool spring to cool off the divine bottle, but here there is no Cézanne with a sensitive imagination, with gay and spicy conversation! So to hell with the Seine, I said to myself, and long live the Palette and our glorious parties on its banks.

" Paris is large, full of amusements, of monuments, of charming women. Aix is small, dull, shabby, filled with women — (the good Lord keep me from slandering the women of Aix). And in spite of all that, I prefer Aix to Paris.

" Is it the pines waving in the breezes, is it the arid ravines, the rocks piled one on top of the other, like Pelion on Ossa, is it the picturesque scenery of Provence that draws me to her? I don't know; but my poet's dream tells me that a steep cliff is worth

more than a newly decorated house, the murmur of waters more than that of a great city, virgin nature more than nature tortured and dressed up. Is it rather the friends I left down there in the neighbourhood of the Arc that draw me to the land of *bouilla-baisse* and *aïoli*? Surely, it is nothing else.

" Here I see so many young people trying to be witty, believing themselves to be on a higher plane than the rest, seeing merit only in themselves and conceding to others nothing but stupidity, that I am anxious to see once more those whose real wit I know and who, before throwing stones at others, consider whether some might not be thrown at themselves. Well! I am dreadfully serious today. You must forgive me the dull ideas I have just written; but you see, when one starts to look at the world closely, one finds that it is so badly put together that one cannot help growing philosophical. To the devil with reason, and long live joy! What about your conquest? Have you spoken to her?

" Ah! you rascal, you are quite capable of it, *ma foi*. Young man, you are lost, you are going to make a fool of yourself, but I will soon put a stop to that. I don't want my Cézanne ruined.

" Are you swimming? Are you being gay? Are you painting? Are you playing the cornet? Are you writing poetry? Well, what are you doing? And your degree? Is that getting on all right? You will beat all the masters. Ah, *sacre-bleu,* we will have a grand time. I have wonderful ideas. They're immense, you'll see. . . .

" I have finished my comedy *Enfoncé le Pion.* It has over a thousand verses. You will have to swallow all that during vacation: you will swallow them, Baille will swallow them, everyone will swallow them. I shall be merciless. You may well say that you have had enough, I shall give you still more. It is a profusion of words that I shall bring you.

" But I shall not take you unawares. I am warning you in advance: so you can pay me back in the same coin, by getting together and composing a new *Pucelle* to annihilate me with. *Dieu de Dieu,* can there be anyone under the dome of heaven as stupid as I am! . . .

" I don't know how it happens, but I don't work at all, and yet I haven't a moment to myself.

" I am saying nothing in my letter because I am storing up news to bring with me to Aix. Today is the 14th; only two months more. They will not pass quickly, but still time does move. Greetings to our friends and to your family. Send me, if you have time, some nice bit of verse.

" That will distract me as well as give me pleasure. As for myself, I am dead to poetry for some time.

" What a lot of honours you are going to carry off! What bursts of applause the distribution of prizes will bring forth! For myself, I promise you that I shall not be overwhelmed. I hope to get one prize, in composition, and if I get that it will be all. What can you expect? It is not given to everyone to shine. There are so many fools that one can keep them company without dishonour.

" What's the use of continuing to pile up nonsense on top of nonsense? I think four pages are quite enough. Wait until I am with you to hear all my outlandish ideas, you will never have heard so many. I end my letter, my dear friend, I have just been working at chemistry, I am still in a flurry over it: nothing affects my nerves as much as *la chimie*. Incidentally, everything that is of the feminine gender has that effect on me. (Of course I had to end with a bit of nonsense.)

" Until soon. Your devoted friend,

É. Zola "

Cézanne's next letter is headed merely " *Aix le 29, 1858* " with no indication of the month; but as it seems to be a reply to the letter just quoted it was probably written on June 29. If so, this is almost the only case in which we have a direct answer from either correspondent to a letter from the other. In general where a group of Zola's letters have survived, letters from Cézanne covering the same period are missing, and *vice versa*. This letter is noteworthy for another reason: it contains a sketch to accompany

the verses on *Cicero Annihilating Catiline,* probably the earliest of Cézanne's drawings that is still in existence:

" *Mon cher,*

" It is not only pleasure your letter has given me, on receiving it I felt much happier. A certain inner sadness has hold of me and to tell you the truth, I dream of nothing but this woman I spoke to you about. I don't know who she is; I see her passing on the street sometimes when I go to the monotonous college. *Morbleu,* I sigh for her, but sighs which do not betray themselves externally, they are mental sighs.

" The bit of poetry you sent me pleased me very much, I was glad to see that you remembered the pine that shades the banks of the Palette. How I should like, damned fate that separates us, how I should like to see you turn up. If I did not restrain myself, I should let fly a string of *nom de Dieu,* of *Bordel de Dieu,* of *sacrée putain,* etc., against the heavens; but what is the use of getting angry, that won't help a bit, so I resign myself. Yes, as you say in another not less poetic part, still I prefer the part about swimming, you are happy, yes you are happy, but I, unhappy, I wither in silence, my love (for it is love that I feel) is unable to burst forth. A certain boredom accompanies me everywhere and only at moments do I forget my misery, that is when I have had a drink. I always liked wine, now I like it still better. I got tipsy, I shall get tipsier yet, unless by some unexpected good luck, *hé bien!* I am able to succeed, *nom d'un Dieu!* But no, I despair, I despair, and I shall get drunk.

" *Mon cher,* I expose to your eyes a picture representing: ' Cicero annihilating Catilina, after having discovered the conspiracy of that dishonourable citizen.' "

Here comes a rather ambitious poem — an amusing parody of the pompous style of the seventeenth century — illustrated by a charming water-colour drawing. Paul's threat to drown his woes in the bottle must be taken as part of his nonsense. He was

fond of the good wine of his native Provence, but he never drank to excess, even in his youth. All his life he was consistently sober and temperate. Many people who knew him well have borne witness to his abstemiousness, his almost ascetic indifference to luxurious food and wine, to the amenities of life and the comfort of his surroundings.

In the following letter Paul shows off his proficiency in Latin. He also treats Zola to some more poetry, which is frank doggerel this time. Needless to say, nothing ever came of the elaborate historical drama concerning Henry VIII which he proposes to write in collaboration with Zola. No mention of it is ever made again, and it is extremely doubtful if it was ever even started. Probably when Zola joined him that summer the less fatiguing pleasures of fishing and swimming drove it out of Paul's head:

" 9 July 1858

" *Carissime Zola, Salve.*

" *Accepi tuam litteram, inqua mihi dicebas te cupere ut tibi rimas mitterem ad bout-rimas faciendas, gaude; ecce enim pulcherrimas rimas. Lege igitur, lege, et miraberis!*

révolte	*Bachique*	*borne*
récolte	*chique*	*corne*
vert	*uni*	*brun*
découvert	*bruni*	*rhum*
chimie	*métaphore*	*aveugle*
infamie	*phosphore*	*beugle*
Zola	*bœuf*	
voilà	*veuf*	

" Which above-mentioned rhymes you will have the privilege, *primo* to put them in the plural, if your most venerable majesty prefers; *secundo;* you may place them in any order you please; but *tertio,* I require Alexandrines, and finally *quarto,* I insist; no I don't insist; but I beg you to put them all into verse, even *Zola.*

68

" Here are some little verses of mine that I find admirable, because they are mine — and the good reason is that I am the author of them."

After the " little verses " Paul returns to the rhyming problems he has set Zola:

" *Mon cher* when you have sent me your *bout-rimé* . . . I will look up some more rhymes, both richer and more outlandish, I will prepare them, I will elaborate them, I will distill them in my alembic-brain. They will be new rhymes, *hum!* such rhymes as one never sees, *morbleu,* in short, perfect rhymes.

" *Mon cher* after having begun this letter on July 9ᵗʰ I should at least be able to finish it today the 14ᵗʰ, but alas, in my arid soul, I can't find the least little idea, and yet with you what a lot of subjects there are to discuss, hunting, fishing, and swimming, aren't those varied subjects, and love (*Impudens* let us not tackle that corrupting subject) ."

Then more verses, for which Paul finds that he is " not really in the mood, alas," and the letter terminates with a postscript:

" I have conceived the idea of a drama in 5 acts, which we will entitle (you and I) : *Henri VIII d'Angleterre.* We will do it together, during the holidays."

The next letter to Zola is partly in Cézanne's handwriting, partly in Baille's; the signature is a composite of the two names: " BaCézanlle." It is hard to decide which of the two writes the greater nonsense. But they are still schoolboys, and rather young for their ages at that. At the moment Paul's chief worries are the forthcoming examinations for the degree of Bachelor of Letters. Baille has already passed them and received his diploma. Paul amuses himself, and presumably Zola as well, by putting his anxiety as to the results of the examinations into grandilo-

quent verse — which, by the way, is considerably better than most of his rhyming:

<div align="right">

" 26 July 1858
</div>

" *Mein liebe [sic] Freund*

" It is Cézanne who writes, and Baille who dictates. Muses! descend from Helicon into our spirits to celebrate my baccalaureate triumph (it is Baille who speaks and mine is not due until next week) ."

The letter continues in Baille's hand:

" This bizarre originality suits our characters well enough. We were going to give you a quantity of riddles to unravel: but the fates have decided otherwise. I went to visit our poetic, fantastic, bacchic, erotic, antique, physic, geometric friend. He had already written 26 July 1858, and was waiting for inspiration. I gave him one: I put the heading in German. He is going to write according to my dictation, and sow in profusion the flowers of my geometry together with the figures of his rhetoric (permit me this transposition, you might have thought we were going to send you triangles and things like that) . But, *mon cher,* the love that ruined Troy is still the cause of much evil. I have grave reasons to suspect that he is in love (he will not acknowledge it) ."

Cézanne takes up the pen once more:

" *Mon cher,* it's Baille who with a rash hand (oh worthless spirit) has just written these perfidious lines, his mind is not capable of anything better. You know him well enough, you know what follies he committed before he underwent the terrible examination, what has he become now? What burlesque, formless ideas spring from his maliciously mocking intellect. (You know Baille is a Bachelor of Letters — I go up the 4th August, may the all-powerful gods protect me from breaking my nose in my,

alas, approaching fall. I am cramming hard, great gods, I am breaking my head over this abominable work."

Here Paul launches a rhymed appeal for divine aid in the impending ordeal, and continues in prose:

" There's a ridiculous digression for you! What do you think of it? Isn't it extraordinary? Ah! if I had the time you would swallow a lot more of them — by the way, a little later I shall send you your *bout-rimés*.

" Address a prayer to the All-Highest (*Altissimo*) that the faculty may honour me with the wished-for degree."

Baille again:

" It is my turn to continue: I am not going to make you swallow any verses: I have almost nothing more to tell you, except that we are both waiting for you: Cézanne and I, I and Cézanne. Meanwhile we are cramming. So come along: only I shall not go hunting with you: I mean by that: I shall not hunt but I will accompany you. What of it! We can still have good times: I shall carry the bottle; even if it's a heavy one! This letter has bored you already: it is made for that: I don't mean to say that we wrote it with that intention.

" Present our respects to your mother (I say ' our ' for a good reason: the Trinity is only one person).

" We clasp your hand: this letter is from two eccentrics.

<div align="right">BaCézanlle "</div>

Cézanne adds a postscript:

" You see in this letter the work of two eccentrics.

" *Mon cher,* when you come, I shall let my beard and moustache grow: I am waiting for you *ad hoc*. Tell me, have you a beard and moustache.

<div align="right">71</div>

" Farewell, *mon cher,* I don't understand how I can be such a fool."

Zola came to Aix to spend the weeks of his vacation with Cézanne and Baille, so there are no more letters until the autumn. Apparently Paul wrote to Zola on November 14 to notify him that he, Paul, had received his degree, but the letter probably went astray as he suspects; at any rate it has not been found. So he writes again three days later:

" *Wednesday 17 November 1858*

" Work, my dear boy, *nam labor improbus omnia vincit.*

" Forgive, my friend, forgive me! Yes, I am to blame, nevertheless for every sin there is mercy. Our letters must have crossed, you will tell me, when you write to me again, only there is no need for you to trouble yourself about it, if you have not received a letter written from my chamber

rhyming with the fourteenth of November.

" I am waiting until the end of the month, when you send me another letter, for you to give me the title of a very long poem I want to write, of which I speak in my letter of November 14ᵗʰ, as you can see if you have received it, if not I cannot explain its non-arrival, but as nothing is impossible, I hasten to write to you again. I have received my bachelor's degree, but you should know that already by this same letter of the 14ᵗʰ if it ever reached you."

This is followed by more verses, ending with a long and rather dull poem entitled *Hannibal's Dream.*

Paul's next letter was written a few weeks later. There is more talk of the " very long poem " he intends to write. It is to be a poem of adventure based on the exploits of one " Pitot," apparently a modern version of Hercules. It is worthy of note that at this period poetry occupies a much more important place in Cézanne's thoughts, or at any rate in his letters, than painting. But he complains that he will have very little time to devote to

the Muse from now on. He is studying law at the University, and loathing it; but he cannot help himself:

"*Aix 7 December 1858*

"*Mon cher,* you didn't tell me that your illness was serious, very serious. You should have let me know, Monsieur Leclerc informed me instead; but since you are all right again, *salut.*

"After having hesitated for some time — for I confess this Pitot did not please me at first — I have decided at last to handle him as pitilessly as possible. So I have to set to work; but, by my faith, I do not know my mythology; nevertheless I will acquaint myself with the exploits of Master Hercules, and convert them into the lofty deeds of Pitot, as far as possible. I warn you that my work — if it should merit the name of work rather than that of mess — will be elaborated, digested, perfected by me for a long time, for I have little time to devote to the adventurous tale of Herculean Pitot."

Here Paul, in a poem, voices his regret that the study of law will prevent him from writing any more verse for the present. The letter closes with a curious postscript:

"I have just received your letter, it has given me great pleasure; nevertheless I beg you in future to use a little thinner paper, for you have caused my purse an outlay which has done it much harm, great gods, those monsters of post-office officials have made me pay 8 sous, I could have afforded to send you two more letters — so use a little thinner paper. Farewell, *mon cher.*"

Louis-Auguste must have given Paul a very meagre allowance at this time; it is amusing to find the banker's son indignant because he had to pay a tax of eight sous on a letter from his dearest friend. Twenty years later, when he was temporarily at outs with his father and consequently hard pressed for money, we see him once more protesting, in a letter written on March 28, 1878, that he has had to pay overweight on a letter from Zola:

73

" Forgive me for making the following remark: but your en-
velopes and writing-paper must be heavy: at the post-office they
made me pay 25 centimes because of insufficient postage. — and
your letter contained only one double sheet, would you mind,
when you write again, using only a single sheet folded in two."

It must be admitted that such solicitude for his pennies is not
altogether out of character with what we know of Cézanne. He
had inherited from the close-fisted Louis-Auguste a wholesome
respect for money, though he had not acquired his father's shrewd
business sense at the same time. On the other hand, as a young
man he seems to have been careless enough about money when he
had any in his pockets. In a letter to Baille dated October 2, 1860,
Zola, after reading Baille a lecture on the fallacy of excessive
economy, writes:

" In this connection I remember a profound saying of Cé-
zanne's. When he had any money, he would generally hasten to
spend it all before going to bed. When I questioned him about
such extravagance: ' *Pardieu!* ' he said, ' if I should die tonight,
would you want my parents to inherit? ' "

In spite of this testimony to his youthful prodigality Cézanne
was never inclined to be a spendthrift. His tastes were simple, and
even after he inherited his share of his father's large fortune he
continued to live unpretentiously, without the slightest ostenta-
tion. Yet he could be generous to his needier friends when the
occasion arose.

Several of Cézanne's early letters are undated. In one of these
he mentions in the body of the letter that he is writing on De-
cember 29th; the year is not given, but it is probably either 1858
or 1859. Practically the entire letter consists of a long and not very
interesting poem entitled *Une Terrible Histoire;* it is full of
thunder and lightning, phantoms, devils, and monsters.

In another undated letter which also belongs probably to 1858

74

or 1859, Paul comes loyally to the defence of Zola, whose school-fellows have had the effrontery to criticize some of his work:

" Baille has told me that the students, your colleagues in toil, have had the air, ridiculous enough by my faith, of trying to criticize your *pièce à l'impératrice,* this has stirred up my bile and though it's a little late, nevertheless I hurl at them this apostrophe whose terms are only too feeble to describe these literary penguins, abortive misfires, asthmatic sneerers at your sincere verses; if you like you may pass my compliment on to them and you may add that if they have anything to say, I am here to meet them when they are ready and will fight the first one who comes near my fist."

This is preceded by a belligerent " apostrophe " in verse. Needless to say, Paul's loyalty was never put to the test of actual combat; he was safely in Aix and Zola's offending schoolmates were in Paris.

The last of this group of early letters is dated November 30, 1859, and consists almost wholly of a long and tedious dialogue in verse, partly at the expense of their young friend Marguery, who has just become a member of the staff of *La Provence,* a local paper.

ZOLA IN PARIS: 1858–1861

WHILE Cézanne was fretting over his law-books at Aix, Zola was having troubles of his own in Paris. He spent part of the summer of 1859 with Cézanne and Baille in Provence, as he had done the previous year; but that was the last happiness he was to know for some time. He failed to pass his examinations for his bachelor's degree and did not return to the Lycée Saint-Louis. For a few months he read and wrote verses in his miserable room in a *hôtel garni,* his mother's apartment being too small to accommodate him. He was desperately poor and began to fear that he would never be able to realize any of his ambitious dreams. Early in 1860 the same Monsieur Labot who had obtained for him the scholarship at the Lycée came to his rescue again and secured him a menial position as a sort of clerk at the docks, for which he was paid the princely sum of sixty francs a month. He gives a sketch of his life at this time in a letter to Cézanne dated April 16, 1860:

" My new life is monotonous enough. At nine o'clock I go to the office, until four o'clock I make a record of customs declarations, I copy correspondence, etc., etc.; or rather, I read the paper, I yawn, I walk up and down, etc., etc. Very sad indeed. But as soon as I go out, I shake myself like a wet bird, I light my pipe, I

breathe, I live. I turn over in my head long poems, long dramas, long novels; I am waiting for summer to find an outlet for my creative spirit. *Vertu Dieu!* I want to publish a book of poems and dedicate it to you."

Zola wrote frequently to Cézanne and to Baille, occasionally to both in the same letter. His long letters are generally filled with detailed analyses of the books he has read, interspersed with somewhat ponderous reflections on the problems of life that a literary-minded youth of twenty is apt to take so solemnly: love and art and his own future. Sometimes he writes of the ties that bind him to his two distant friends, as in this letter of February 9, 1860:

" Since I came to Paris, I have not had a minute of happiness; I see nobody here and I' sit in my own chimney-corner with my sad thoughts and sometimes with my fine dreams. Still I am sometimes cheerful, that is when I think of you and Baille. I consider myself lucky to have discovered among the mob two hearts which understand my own. I tell myself that, whatever our situations may be, we will preserve the same sentiments; and that comforts me. I find myself surrounded by such insignificant, prosaic people that I rejoice in knowing you, you who are not of this century, you who would invent love if it were not a very old invention already, not yet revised and perfected. I have a certain pride in having understood you, in having appreciated your true value. Let us have done with the wicked and the jealous; since the majority of human beings are stupid, the scoffers will not be on our side; but what matter! if it gives you as much joy to clasp my hand as it does me to clasp yours."

Zola very often refers to Paul's projected visit to Paris to study painting — the visit that Zola urged so vigorously and that Paul's father opposed with equal vehemence. Zola realized that Louis-Auguste thought of him as an evil influence over Paul, a tempter who was doing his utmost to lead his son astray; the banker

blamed Zola rather than Paul's own ambitions for the domestic rebellion that was going on under his roof. It is impossible to determine to what extent Zola's importunity was responsible for Paul's defiance. If it had not been for Zola, would Cézanne ever have succeeded in breaking down his father's resistance? The question must remain unanswered. Certainly Zola's letters were a powerful support to Cézanne in moments of discouragement, and it is at least possible that without his ally in Paris he would never have won his father's consent to go there, as he did at last.

In a letter dated December 30, 1859, Zola writes of the two chief problems that are plaguing Paul at this time: his timidity in love and Louis-Auguste's refusal to allow him to paint:

" What shall I say to you to end this letter cheerfully? Shall I give you courage to advance to the assault of the rampart? Or shall I talk to you of painting and drawing? Cursed rampart, cursed painting! One is yet to be tested by the cannon, the other is crushed by the paternal veto. When you hurl yourself at the wall, timidity cries: ' Go no farther! ' When you take up your brushes: ' Child, child,' says your father, ' think of the future. With genius one dies, and with money one eats! ' Alas! alas! my poor Cézanne, life is a ball which does not always roll where the hand would like to send it."

In the spring of 1860 Paul had high hopes of convincing his father; in fact he considered the matter settled. But Zola had heard him cry " Wolf! " so often that he was inclined to be sceptical; justifiably so, as it turned out, for it took another whole year to bring Louis-Auguste round. Zola's next letter with its proposed budget and its suggestions for the distribution of Paul's working hours — which Paul adopted almost *in toto* later on — is so important that it must be quoted in full:

"Paris, 3 March 1860

" My dear Paul,

" I don't know, I have uneasy forebodings about your trip, I

mean as to the more or less imminent dates of your arrival. To have you near me, to chat together, as in the old days, pipe in mouth and glass in hand, seems to me something so marvellous, so impossible, that there are moments when I ask myself if I am not deceiving myself and if this beautiful dream is really coming true. One is so often disappointed in one's hopes that the realization of one of them takes one by surprise and one does not admit it to be possible until the facts are certain. — I do not know from which direction the hurricane will blow, but I feel a sort of tempest around my head. You have struggled for two years to arrive at the point you have now reached; it seems to me that after so many attempts your victory cannot be final without some further battles. Here is Master Gilbert [Gibert, later Director of the Aix Museum] who is trying to sound out your intentions, who advises you to remain in Aix; a teacher who sees no doubt with regret a pupil escape from him. On the other hand, your father talks of making inquiries, of consulting the above Gilbert, a council which must inevitably result in the postponement of your trip until the month of August. All this gives me the shivers, I tremble to receive a letter from you in which, with many lamentations, you announce a change of date. I am so accustomed to thinking of the last week in March as the end of my boredom that it would be very hard for me, having stored up only enough patience to last me until then, to find myself alone at that time. Well, we must follow the great maxim: let the water flow; and we shall see what of good or evil the course of events will bring us. If it is dangerous to hope for too much, nothing is so stupid as to despair of everything; in the first case, one risks only one's future happiness, while in the second, one is sad even without a reason.

" You ask me a singular question. Certainly one can work here, as one can anywhere else, if one wishes to. Paris offers you, moreover, one advantage that you cannot find anywhere else, the museums in which you can study the old masters, from eleven o'clock to four. This is how you might divide your time. From six to eleven you go to a studio to paint from the living model; you have lunch, then from twelve to four you copy, either in the

Louvre or in the Luxembourg, whatever masterpiece you like. That will make nine hours of work; I think that should be enough and that you cannot help doing well with such a routine. You see that we will have the whole evening free and that we can make use of it as we see fit, without interfering in the least with our studies. Then on Sundays we will run away and travel a few leagues outside of Paris; the places are charming and, if your heart desires, you can sketch on a bit of canvas the trees under which we eat our lunch. Every day I have charming dreams that I want to realize when you are here: poetic work, such as we love. I am lazy when it comes to rough work, work that keeps only the body occupied and stifles the intelligence. But art, which occupies the mind, enchants me, and it is often when I am carelessly lying down that I work the hardest. There are many people who do not understand that, and it is not I who will take the trouble to make them understand. — Besides, we are no longer kids, we must think of the future. Work, work: it's the only way to get on.

" As to the question of money, it is true that 125 francs a month will not allow you much luxury. I shall figure out for you what you should spend. A room at 20 francs a month; a lunch at 18 sous and a dinner at 22 sous, which makes 2 francs a day, or 60 francs a month; adding the 20 francs for your room, it comes to 80 francs a month. Then you have the studio to pay for; the Atelier Suisse, one of the least expensive, costs, I think, 10 francs; to which I add 10 francs for canvas, brushes, colours; that makes 100 francs. So you will have 25 francs left for your laundry, light, the thousand little needs that crop up, your tobacco, your amusements: you see you will have just enough to live on, and I assure you that I am exaggerating nothing, that I am rather underestimating. Incidentally, it would be a valuable experience for you; you would learn the value of money and how a clever man can always get out of a predicament. I repeat, so as not to discourage you, you can manage. — I advise you to show your father the above sums; perhaps the hard reality of the figures will make him loosen his pursestrings a little. — On the other hand, you could earn some

money here yourself. Studies made in the studios, especially copies painted in the Louvre, sell very well; and if you only did one a month, that would add very nicely to the budget for your amusements. It all depends on finding a dealer, which is only a question of looking about. — Come without fear; once your bread and wine are assured, you can, without danger, devote yourself to the arts.

" Here you have plenty of prose, plenty of material details; since they are for your sake and are useful in addition, I hope that you will forgive them. This devil of a body is a nuisance sometimes, one has to drag it everywhere, and everywhere it makes terrible demands. It is hungry, it is cold, and so on, and there is always the soul which wants to make itself heard and which in turn is obliged to keep silent and act as if it did not exist, in order that the tyrant may be satisfied. Fortunately one finds a certain pleasure in the satisfaction of one's appetites.

" Answer this at least before the 15th, to reassure me and tell me of any new developments that may turn up. In any case, I expect you to write me, just before you leave, the day and hour of your arrival. I shall go to the station to meet you and shall take you at once to lunch in my erudite company. — I will write to you again before that. — Baille has written to me. If you see him before you leave, make him promise to come to join us in September.

" Greetings to you, my respects to your family.

<div style="text-align:right">Your friend,
Émile Zola "</div>

ZOLA GIVES ADVICE

ZOLA's letters to Cézanne were seldom filled with such prosaic matters as the cost of food and laundry. He frequently wrote with enthusiasm about art, as in the following letter. In the light of what we know of the later development of the two men, the letter strikes an unexpected note. Zola, the future realist of realists, takes Cézanne, one of the most subjective of painters, to task for being too realistic, not sufficiently " poetic "! Of course they were both very young; neither Zola nor Cézanne had as yet produced enough work to betray any very definite tendencies. Had this been merely a youthful error it would not have mattered very much; but unfortunately Zola's initial misconception concerning the painter's artistic credo did not change materially as Cézanne developed. Zola probably did understand Cézanne's *character* as well as anyone; his loyalty to his friend and his genuine affection for the man in spite of his awareness of all the thorny difficulties of that strange personality are beyond question. Zola proved his devotion time and again, in ways both tangible and intangible, as will appear later. But it is equally incontestable that he never showed the slightest comprehension of Cézanne's painting or of his theories of art. To Zola, poetry in painting was synonymous with sentimentality. Witness his praise of the sim-

pering, namby-pamby Ary Scheffer as an ideal for Cézanne to follow!

The truth is that Zola, the novelist, had an almost purely literary conception of the art of painting. The subject was to him the most important element; if that were " poetic," if the picture told a moving story, it was real art; composition and colour were minor considerations. Whereas to Cézanne the subject in a literary sense was of no consequence whatever, at least after he had reached his full maturity. Small wonder that Zola was never able to appreciate Cézanne's studies of still life! For what nobility could there be in a picture of a kitchen table, a dirty bottle, a crumpled napkin, and a few ordinary red apples?

So we find Zola writing to Cézanne:

" 25 March 1860

" My dear friend,

" We often speak of poetry in our letters, but the words ' sculpture ' and ' painting ' appear in them only rarely, if ever. It is a serious omission, almost a crime; and I shall try to remedy it today. . . .

" I don't know if you are acquainted with Ary Scheffer, that painter of genius who died last year; in Paris it would be a crime to answer no, but in the provinces it is only a gross ignorance. Scheffer was a passionate lover of the ideal, all of his types are pure, ethereal, almost diaphanous. He was a poet in every sense of the word, almost never painting actual things, treating the most sublime, the most thrilling subjects. Can you ask for anything more poetic, of a more strange and heart-rending poetry, than his *Françoise de Rimini?* You know the episode in the *Divine Comedy:* Françoise and her lover Paolo are punished in hell for their lust by a terrible wind that for ever carries them along, locked together, that for ever obliges them to whirl in gloomy space. What a magnificent subject! But also what a difficult one! How to render this supreme embrace? These two souls that remain united even when they are enduring eternal punishment!

83

What expression to give to these countenances in which suffering has not effaced love? Try to obtain the engraving and you will see that the painter has emerged victoriously from the struggle; I shall not attempt to describe it to you, I should only waste paper without giving you even an idea of it.

" Scheffer, the spiritual, makes me think of the realists. I have never understood these gentlemen very well. I take the most realistic subject in the world, a farmyard. A manure pile, ducks wading in a puddle, a fig tree to the right, etc., etc. There you have a picture that seems stripped of all poetry. But let a beam of sunshine enter to make the golden yellow straw sparkle, the pools of water glitter, to glide among the leaves of the tree, break up, and emerge in shining rays; in addition let a graceful young girl enter the background, one of those peasant girls of Greuze, throwing grain to her little world of poultry: from that moment, will not this picture too have its poetry; will not one pause enchanted, thinking of the farm where one drank such good milk, one day when the heat was overpowering? Then what do you mean by this word ' realist '? You pride yourself on painting only subjects denuded of poetry! But everything has it, manure as well as flowers. Is it because you claim to imitate nature servilely? But then, since you rail so against poetry, you must say that nature is prosaic. And that is a lie. — It is for you that I say this, monsieur my friend, monsieur the great painter of the future. It is to tell you that art is single, that spirituality, realism are only words, that poetry is a great thing and that except in poetry there is no salvation."

No mention here of composition, of drawing, of colour, of the actual painting as an independent work of art. The literary-minded Zola saw in Scheffer's canvas only an illustration of an episode in the *Divine Comedy,* and the imaginary picture of a farmyard made him think of a cup of milk! The letter goes on:

" I had a dream the other day. — I had written a beautiful book, a sublime book which you had illustrated with beautiful,

with sublime drawings. Our two names shone in golden letters, united on the first page, and in this fraternity of genius went down inseparably to posterity. Unfortunately it is still only a dream.

" Moral and conclusion of these four pages. — You should satisfy your father by studying law as assiduously as possible. But you should also work at strong and firm drawing — *unguibus et rostro* — in order to become a Jean Goujon, an Ary Scheffer, to avoid becoming a realist, and finally to be able to illustrate a certain volume that is running in my mind. . . ."

Zola the art critic gives way to Zola the devoted friend:

" You write me that you are very sad; I will reply that I am very sad, very sad. It is the breath of the century which has passed over our heads, we should not blame anyone, not even ourselves; it is the fault of the times in which we live. Then you add this: ' If I have understood you, you do not understand yourself.' I do not know what you mean by the word ' understood.' For my part, this is how it stands: I have recognized in you a great kindness of heart, a great imagination, the two principal qualities before which I bow. And that has been enough for me; from that moment I have understood you, I have judged you. Whatever your weaknesses, whatever path you follow, you will always be the same to me. It is only stone that does not change, that does not deviate from its stony nature. But man is a whole world; he who would try to analyse the feelings of only one during a single day would perish in the attempt. Man is incomprehensible, if one should wish to know him down to his slightest thoughts. But what do your apparent contradictions matter to me? I have judged you to be good and a poet, and I shall always repeat to you: ' I have understood you.' "

In his next letter, dated April 16, 1860, Zola reads Cézanne another lecture, this time on the evils of commercialized art. As

events proved, this well-meant warning was as unnecessary as the previous one against the dangers of realism. Had Cézanne been dependent for a living on the sale of his pictures he would have starved in short order:

" Another phrase in your letter has given me a painful impression. It is this: ' The painting that I love, even though I should not succeed in it, etc., etc.' You not succeed! I think you are deceiving yourself. But I have already told you: in the artist there are two men, the poet and the craftsman. And you who have the spark, who possess what cannot be acquired, you pity yourself; whereas in order to be successful you have only to train your fingers, to become a craftsman. — I shall not leave this subject without adding two words. Recently I warned you against realism; today I want to point out to you another danger, commercialism. The realists do create art, after all — in their own way — they work conscientiously. But the commercial artists, those who paint in the morning for their evening's bread, they grovel in the dust. I do not tell you this without some reason: you are going to work with ——, you copy his pictures, perhaps you admire him. I am afraid for your sake of this path you are following, all the more because he whom you are perhaps trying to imitate has some fine qualities, which he uses shamefully, but which none the less make his pictures seem to be better than they are. His work is pretty, it is fresh, the brushwork is good; but all that is only a trick of the trade, and you would be wrong to stop at that point. Art is more sublime than that; art is not limited to the folds of a drapery, to the rosy tints of a virgin. Look at Rembrandt; with one ray of light, all of his figures, even the ugliest, become poetic. So I repeat, —— is a good instructor to teach you the trade; but I doubt if you could learn anything more from his pictures. — Being rich, you expect no doubt to follow art and not business. . . . Therefore beware of an exaggerated admiration for your compatriot; put your dreams, those lovely golden dreams, onto your canvases, and try to bring out the ideal love that you

have in you. — Above all, and here is the abyss, do not admire a picture because it was painted quickly; in a word, and in conclusion, do not admire and do not imitate a commercial painter."

Zola's recommendation not to "admire a picture because it was painted quickly" was hardly needed. Cézanne had no use for mere facility, and was himself one of the slowest painters who ever lived.

Ten days later Zola wrote again. He seems to have realized that his last letter smacked too strongly of the lecture platform, especially to one of Cézanne's touchy disposition; for he assures him, with complete sincerity, that only the depth of his affection is responsible for his sermons:

" 26 April 1860, 7 o'clock in the morning
" Mon bon vieux,
" I shall go on repeating to you: do not think that I have become a pedant. Each time that I am about to give you advice, I hesitate, I ask myself if it is really my business, if you will not get tired of hearing me tell you: do this, do that. I am afraid that you may hold it against me, that my thoughts may be in opposition to your own, therefore that our friendship may suffer. What can I say to you? No doubt I am very foolish to borrow trouble like this; but I am so afraid of the slightest cloud between us. Tell me, tell me constantly that you accept my counsels as from a friend; that you are not angry with me when they are in disagreement with your own way of looking at things; that I am none the less the gay friend, the dreamer, who stretches himself out so gladly on the grass beside you, pipe in mouth and glass in hand. — Friendship alone dictates my words; I feel closer to you when I mix myself up in your affairs a little; I chat, I fill my letters, I build castles in Spain. But, for God's sake, don't think that I am trying to lay down a line of conduct for you; take only what suits you from my words, what you find good in them, and toss away the rest, without even taking the trouble to argue the matter."

87

Having taken the precaution to turn away Cézanne's wrath with these soft words, Zola proceeds to enlarge upon his own conception of the painter's art. The important element is the subject, the literary association evoked by a picture, the " artistic sentiment " behind it. He is willing to concede a certain importance to " form," but to him the form — that is, the painting itself — is a secondary consideration; it is merely the craftsman's tool which enables the painter to tell a story intelligibly on canvas. Obviously Zola has failed to distinguish between " form " and " technique," about which he admits frankly that he knows nothing. But he does not feel that his ignorance of the technical problems of painting disqualifies him as a critic:

" When I look at a picture, I who can do no more than distinguish white from black, it is evident that I cannot permit myself to judge the brush-strokes. I content myself with saying whether the subject pleases me, whether the whole makes me think of something fine and great, whether the love of beauty is expressed in the composition. In a word, without troubling myself about the craftsmanship, I speak of the art, of the thought that has dominated the work. And I believe I do wisely; nothing seems to me so pitiful as the exclamations of some dabblers who, having learned a few technical terms in the studios, repeat them confidently like parrots. On the other hand, I can understand that when you look at a picture, you who have learned how difficult it is to put colours on canvas according to your wish, you are much interested in the technique, you go into ecstasies over this or that brush-stroke, over a particular colour, etc., etc. That is natural; the idea, the spark is in you, you are searching for the form you have not acquired, and you admire it in good faith wherever you find it. But take care; this form is not everything, and whatever may be your excuse, you should put the idea ahead of it. I will explain: a picture should not be to you only ground colours placed on a canvas; you must not constantly be seeking for the mechanical procedure by which the effect has been obtained,

what colour has been used; but look at the whole, ask yourself if the work is really what it should be, if the artist is really an artist. There is so little difference, to the vulgar eye, between a daub and a masterpiece. In both there is white, red, etc., brush-strokes, canvas, a frame. The difference is only in that something which has no name, which is revealed only by intelligence and taste. It is this something, this artistic feeling for possibilities, that you must discover and admire above all. After that, you may try to understand how it is done, you may think of the technique. But, I repeat, before descending to rummage about with these tools, these stinking colours, this coarse canvas, you should first let yourself be transported to the skies by the sublime harmony, by the splendid idea that emanates from the masterpiece and surrounds it as by a divine aureole. — Far be it from me to despise form. That would be stupid; for without form one can be a great painter for oneself, but not for others. It is form that establishes the idea, and the better the idea, the better the form should be also. It is through form that the painter is understood, appreciated; and this appreciation is favourable only in so far as the form is good. I shall make use of a comparison; if I should wish to talk with a German, I should send for an interpreter; but if I have no German to talk to, I have no need of an interpreter. The interpreter is the form, the German language the idea; without form I should never understand the idea, but I have no use for form if the idea is not there. That is to say, the technique is everything and nothing; one absolutely must know it, but one must not forget that the artistic feeling is equally essential. In a word, they are two elements that cancel each other separately, and which when united make a magnificent whole.''

ZOLA VERSUS LOUIS-AUGUSTE

ALTHOUGH Zola was incapable of understanding painting except as a medium for the expression of literary ideas — preferably " sublime " ones — he was none the less sympathetic, as a friend, to Paul's struggles to win his father's approval of his dream of studying art in Paris. Unfortunately all of Cézanne's letters of this period have been destroyed or lost, but we have echoes of them in Zola's replies. In a postscript to the letter just quoted, Zola writes:

" I have just this moment received your letter. — It gives me a very sweet hope. Your father is relenting; be firm, without being disrespectful. Remember that it is your future that is at stake and that your whole happiness depends on it."

Louis-Auguste must have been in an unusually agreeable mood just at this time, and Paul's hopes apparently ran high. On May 5, 1860, Zola writes again:

" In your two letters you give me a faint hope of a reunion. ' When I shall have finished my law studies perhaps,' you say, ' I shall be free to do what I please; perhaps I shall be able to rejoin

you.' May God grant that it be not only a momentary hope; that your father does open his eyes to your true welfare. Perhaps in his eyes I am a rattle-brained fellow, a madman, even a bad friend to encourage you in your dream, in your love of the ideal. Perhaps if he read my letters he would judge me severely; but even if I were to lose his esteem, I should boldly say to his face what I say to you: ' I have pondered for a long time about the future, the happiness of your son, and for a thousand reasons which it would take too long to enumerate, I believe that you should allow him to go in the direction in which his inclination leads him.' *Mon vieux,* it is a question of a little effort, a little hard work. Come, what the devil! Are we entirely destitute of courage? After the night comes the dawn; so try to make it pass as well as possible, this night, and when the day comes you will be able to say: ' I have slept long enough, Father, I feel strong and courageous. Have pity! Do not cage me in an office; let me take wing, I am stifling, be kind, Father.' "

If Paul made any such appeal to Louis-Auguste's mercy it could not have worked very well, for on June 25 Zola wrote again:

" You seem discouraged in your last letter; you talk of nothing less than of throwing your brushes to the devil. You complain of the solitude that surrounds you; you are bored. . . .

" God help me if I am your evil genius, if I am creating unhappiness for you by glorifying art and dreams. But I cannot believe it; the devil cannot be hiding beneath our friendship and be leading us both to our destruction. Therefore take courage again; pick up your brushes once more, let your imagination wander where it will. I have faith in you; and if I am urging you in the direction of ruin, may the ruin fall back on my own head. Above all have courage, and think seriously, before you bind yourself to this career, of the thorns you may encounter. Be a man, leave dreams aside for the moment, and act. . . .

" Like a shipwrecked man who clings to a floating plank, I

have been clinging to you, dear old Paul. You have understood me, your character has been sympathetic to me; I have found a friend, and I have thanked Heaven for it. At various times I have been afraid of losing you; now that seems to me impossible. We know each other too well ever to drift apart."

In spite of these and similar protestations, often repeated and perfectly sincere on both sides, the two companions did begin to drift apart very soon; yet the friendship was to remain a close one for twenty-five years longer.

In his next letter Zola begins to show impatience at what he considers Cézanne's shilly-shallying, his weakness, his unwillingness or inability to take a firm stand against his father. He accuses Paul of behaving as if his desire to paint were no more than a whim. If he is really in earnest, why doesn't he do something about it? There was some justification for Zola's annoyance. Cézanne was timid by nature and probably suffered from a constant sense of inferiority in the presence of his awe-inspiring father. On the other hand Zola was writing from a safe distance and had nothing to fear from Louis-Auguste's wrath, while Paul was in daily contact with it. Under the circumstances the latter's sudden alternations of hope and despair are not hard to understand; as the wind blew, so pointed the weather-vane. Cézanne's letters are lost; but Zola's comments on them reflect his friend's changing moods as in a mirror:

" July 1860

" My dear Paul,

" Allow me to explain myself once more frankly and clearly; all of your affairs seem to be going so badly that I am much upset about them. — Is painting only a caprice for you, that came into your head one fine day when you were bored? Is it only a pastime, a mere subject of conversation, an excuse for not working at the law? Then, if that is the case, I can understand your conduct: you do well not to carry things to an extreme and not to bring

about more family ructions. But if painting is your vocation —
and that is how I have always considered it — if you believe
yourself capable of making good at it after you have worked hard,
then you become an enigma to me, a sphinx, and Heaven knows
what of the impossible and the mysterious. One thing or the
other: either you don't want to, and in that case you are attaining
your object admirably; or you do want to, and then I don't un-
derstand what it is all about. Sometimes your letters give me
great hopes, sometimes they make me lose still more; of such
is your last, in which you appear almost to say farewell to your
dreams, which you could so easily turn into reality. In that letter
occurs this phrase which I have tried in vain to comprehend: ' I
am talking in order to say nothing, for my behaviour contradicts
my words.' I have built hypotheses about the meaning of these
words, none of them satisfies me. What is your behaviour, then?
Undoubtedly that of a lazy man; but what is surprising in that?
You are being forced to do work that is repugnant to you. You
want to ask your father to let you come to Paris to become an
artist; I see no contradiction between that and your actions;
you neglect the law, you go to the Museum, painting is the only
work you care about; there you have an admirable accord be-
tween your desires and your actions. — Shall I tell you some-
thing? — above all don't get angry — you lack character; you
have a horror of exertion of any kind, in thought as well as in
deed; your great principle is to let things slide, and to pick them
up again at random. I don't say that you are entirely wrong;
everyone sees things in his own way and has his own beliefs.
Only, you have already tried out this system of conduct in love;
you were waiting, you said, for the right time and circumstances;
you know better than I do that neither the one nor the other ever
came. The water is continually flowing by, and one day the
swimmer is astonished to find nothing left but burning sand. —
I have thought it my duty to repeat to you once more what I have
often said: my position as a friend excuses my frankness. In many
ways our characters are alike; but, *par la croix-Dieu!* if I were

93

in your place, I would have it out, risk everything for the sake of everything, not float vaguely between two such different futures, the studio and the bar. I pity you, for you must be suffering from this indecision, and for me that would be another reason to tear the veil; one thing or the other, either be a real lawyer, or else be a real artist, but do not remain a being without a name, wearing a toga soiled with paint. — You are a little careless — be it said without annoying you — and no doubt my letters lie about and your parents read them. I don't think I am giving you bad advice; I believe I am speaking as a friend and according to reason. But perhaps everyone does not think as I do, and if what I surmise above is correct, I cannot be in high favour with your family. No doubt they consider me a dangerous influence, the stone cast in your path to make you stumble. All of this distresses me greatly; but, as I have already told you, I have so often found myself misjudged that one false judgment added to the others does not surprise me. Remain my friend, that is all I ask.

" Another passage in your letter saddens me. Sometimes, you say, you throw your brushes aside, when the form does not follow your idea. Why this discouragement, this impatience? I might be able to understand them after years of study, after thousands of unsuccessful attempts. Then, realizing your incapacity, your inability to do good work, you would be wise to trample palette, canvas, and brushes under your feet. But you who have had as yet no more than the desire to work, you who have not yet taken up your task seriously and regularly, you have no right to judge yourself incapable. So have courage; all that you have done so far is nothing. Courage, and remember that, to attain your goal, you will need years of study and perseverance. — Am I not in the same position as you; is not form equally rebellious in my hands? We have the idea; let us then march frankly and gallantly on our way, and may God guide us! — At the same time, I like this want of confidence in yourself. Look at Chaillan, he finds everything he does excellent; that is because he has nothing finer in his mind, no ideal that he is trying to reach. And he will never

94

be great, because he thinks he is great already, because he is satisfied with himself."

Even before this letter was finished, the unstable wind in Aix had changed its direction once more. No wonder Zola was puzzled:

" I have just received a letter from Baille. I don't understand it at all; here is a phrase that I read in this epistle: ' It is almost certain that Cézanne will go to Paris; what joy! ' Is it of you he speaks, have you really given him this hope lately, when he was in Aix? Or has he just been dreaming, has he taken your desire for reality? I repeat, I don't understand. I urge you to tell me frankly in your next letter how things stand; for three months I have been saying to myself according to the letters I receive: He comes, he comes not. — Try, for God's sake! try not to imitate the weathercock. — The question is too important to go from white to black; frankly, what is the position? "

The " position " was still very much in the air. One day Louis-Auguste seemed to be on the point of softening, and Paul's spirits rose with a bound; on the next the paternal foot came down again, and with it all Paul's hopes. On August 1 Zola is still urging Cézanne to assert himself:

" As to the great matter you know of, I can only repeat myself, only give you the same advice I have already given. As long as both advocates have not made their pleas, the cause does not advance; discussion illuminates everything. So if you remain silent, how do you expect to get ahead and finish it? It is a sheer impossibility. And remember that it is not the one who shouts the louder that is in the right; speak quite softly and wisely; but by the devil's horns, feet, tail, and navel, speak, but speak!!! "

Zola had hoped and expected to be able to spend a few weeks of the summer of 1860 in Aix with his friends as he had done

during the two previous seasons; but his extreme poverty forced him, most regretfully, to remain in Paris. His only consolations were the letters that Cézanne, and less frequently Baille, continued to write to him. Evidently Cézanne had thought better of his threat to " *jeter ses pinceaux au plafond* " and was going on with his painting at the expense of his legal studies; for on October 24 Zola wrote gaily:

" The description of your model amused me greatly. Chaillan claims that here the models are approachable, though not of the freshest quality. One draws them in the daytime, and caresses them at night (the word ' caress ' is a little mild). So much money for the pose by day, so much for the pose by night; I am assured that they are most accommodating, particularly at night. As for the fig-leaf, it is unknown in the studios; the models undress there as they do at home, and the love of art veils what might otherwise be too exciting in their nakedness. Come, and you will see."

Possibly Zola felt that since Paul could not be persuaded to come to Paris for the good of his soul he might be tempted more successfully by the joys of the flesh. This, however, was hardly an argument that Paul could use to advantage in his efforts to convince his father. The contest went on all winter, with the seesaw now up on one side, now on the other. But Paul's ambition was slowly crystallizing and he was painting more and studying less than ever. Zola wrote on February 5, 1861:

" And so you say that you go out to paint in midwinter, sitting on the frozen ground, without caring about the cold. This news charms me; I say charms, not because I take pleasure in seeing you run the risk of a bad cold and a few chilblains, but because I infer from such persistence your love of art and the enthusiasm you put into your work."

Zola had guessed in one of his letters to Cézanne that the latter's family — by which he meant Louis-Auguste, for he must have

known that Paul's mother was on his side — considered him, Zola, a dangerous influence. That he was correct in this surmise is attested by another letter, this time addressed to Baille:

" Paris, 22 April 1861

" My dear friend,

" I thank you for your letter; it is heart-breaking, but useful and necessary. The sad impression it made on me was somewhat diminished by the vague knowledge I already had of the suspicions that floated about me. I felt myself an adversary, almost an enemy to Paul's family; our different ways of seeing, of understanding life, warned me in secret of the lack of sympathy which M. Cézanne must have felt for me. What shall I say? All that you tell me I knew already, but I did not dare admit it to myself. Above all I did not believe that they could accuse me of such infamy and see in my brotherly friendship nothing but cold-blooded calculation. I am frank, I must admit that an accusation coming from such a source surprises rather than saddens me. I am beginning to get so used to this mean and jealous world that an insult seems to me an ordinary thing, not worth getting irritated about, only more or less able to astonish me, according to who throws it in my face. Generally I am my own judge, and, secure in my own conscience, I smile at the judgment of others; I have built up an entire philosophy in order not to suffer a thousand vexations in my dealings with other people; I go ahead, free and proud, bothering little about the tumult, sometimes making use of it with an artist's eye for the study of the human heart; that, I think, is the highest wisdom, to be virtuous, gentle, loving the good, the beautiful, and the just, without trying to prove to everybody one's virtue, one's gentleness, without protesting when one is accused of evil and wickedness. But in the present case it is difficult for me to follow the path I have marked out; as Paul's friend, I should like to be, if not loved by his family, at least respected; if someone quite indifferent to me, whom I met casually and whom I should not see again, were to hear cal-

umnies about me and believe them, I should let him do so without even trying to change his opinion. But this is not the same thing; wishing at any cost to remain Paul's brother, I often find myself obliged to be in touch with his father, I am forced to appear sometimes before the eyes of a man who scorns me and towards whom I cannot repay scorn with scorn; on the other hand, I do not wish to cause trouble in that family under any circumstances; as long as M. Cézanne thinks me a vile intriguer and as long as he sees his son associate with me, he will grow angry at his son. I do not want that to happen; I cannot keep silent. If Paul is not willing to open his father's eyes himself, I must try to do it. My superb disdain would be out of place here; I must not allow any doubts to remain in the mind of my old friend's father. It would mean, I repeat, either the end of our friendship or the end of all affection between father and son.

" There is another detail that I think I can guess at and that you are no doubt hiding from me through affection. You include us both in the Cézanne family's disapproval; and I do not know what it is that tells me that I am the more accused of the two, perhaps even the only one. If that is so — and I do not think I am mistaken — I thank you for having taken upon yourself half of the heavy burden and for having tried in that way to diminish the painful impression of your letter. There are a thousand details, a thousand arguments which have led me to this belief; in the first place my poverty, then my almost declared profession of writing, my sojourn in Paris, etc. Finally, as a last reason, the decisive one: whenever there is a blow coming, it is always on my head that it falls; whenever there is an obstruction higher than the others, that is the one I meet. I shall end by believing in fate.

" The question seems to me this: M. Cézanne has seen the plans he has made thwarted by his son. The future banker has discovered that he is a painter and, feeling the eagle's wings on his shoulders, wishes to leave the nest. Astonished by this transformation and by this desire for liberty, M. Cézanne, unable to believe that anyone could prefer painting to banking and the air

of heaven to his dusty office, M. Cézanne has gone in search of an answer to the riddle. He is not willing to admit that it has happened because God willed it so, because God, having created him a banker, has created his son a painter. But having searched thoroughly, he decided at last that I was responsible; that it was I who changed Paul into what he is at present, that it was I who robbed the bank of its dearest hope. No doubt evil associations were mentioned, and that is how Émile Zola, man of letters, became an intriguer, a false friend, and I don't know what else besides. — It is just as sad as it is ridiculous. If it be done in good faith, it is stupid; if it be deliberate, it is the worst kind of wickedness. — Fortunately Paul has no doubt kept my letters; by reading them one could see what my advice has been, and whether I have ever urged him to do wrong. On the contrary, I often pointed out to him all the disadvantages of a trip to Paris and urged him above all to conciliate his father. — But there is no reason for me to justify myself to you. If a shadow of the suspicions that hang about my head existed in your mind, you could not have the least affection for me. I can be accused of nothing worse than thoughtlessness, and I have not been even thoughtless. In the advice I sometimes gave Paul I always restrained myself. Knowing that his character would not readily accept any definite opinion, I spoke to him of art, of poetry, not so much deliberately as on account of my own nature. I wanted to have him near me, but in suggesting this idea I never urged him to revolt. In a word, my letters have had nothing but friendship for a motive, and for contents only such words as were dictated by my nature. The effect of these words on Paul's career cannot be held against me as a crime; without trying to, I stimulated his love for the arts, no doubt I merely developed the germs that were there already, an effect that any other external cause might have produced. I examine myself and I find that I am guilty of nothing. My conduct has always been frank and blameless. I loved Paul like a brother, thinking always of his welfare, without egotism, without any selfish motive; reviving his courage when I saw it weaken,

always speaking to him of the beautiful, the true, and the good, trying always to raise his spirits and to make him above all a man. Such have been my relations with him; I would show my letters with pride and would still write them if they were not already written. That is what I want the world to know, and you in particular, if you did not know it already. — It is true that I never spoke of money in my letters; that I did not suggest such and such a deal whereby one could make enormous sums. It is true that my letters only spoke of my friendship, of my dreams and I don't know how many fine thoughts, coins which have no value in any business in the world. No doubt that is why I am an intriguer in the eyes of M. Cézanne.

" I am joking, and I don't feel like it. Whatever comes of it, this is my plan. After having consulted Paul, I propose to see M. Cézanne in private and come to a frank understanding. Have no fear as to my moderation and the propriety of the words I shall use. Here I can breathe out in irony my wounded self-respect; but in the presence of our friend's father I shall be only as I should be, strictly logical and with a frankness based on facts. In fact, you yourself seem to advise this interview; I may be wrong, but certain vague phrases in your letter appear to urge me to put a stop to these calumnies by an explanation.

" I say all this, and I don't know yet just what I shall do. I am waiting for Cézanne, and I want to see him before I decide on anything. His father will have to grant me his esteem sooner or later; if he does not know the facts of the past, the facts of the future will convince him.

" Perhaps I have dwelt on this subject a little too long and I admit I leave it with regret, I am so anxious to demonstrate my lack of guilt and the ridiculous side of these accusations."

The letter from Baille which gave rise to this torrent of indignant self-defence is lost, so we are in the dark as to the exact basis for Louis-Auguste's condemnation of Zola as a false friend to his son. If it were merely resentment at what he chose to consider

Zola's interference, his persistent and energetic attempts to stiffen Paul's weaker backbone, he had ample cause to dislike Zola and to wish him in Jericho instead of Paris. But if the banker really suspected, as the letter suggests, that Zola's advice sprang from selfish motives, that Zola was trying to take advantage of Paul's prospective affluence to feather his own nest, he did him a grave injustice. There is absolutely no reason to believe that Zola, in spite of his extreme poverty, ever derived the slightest pecuniary benefit from his friendship with Cézanne, or that he ever made the least attempt to do so. On the contrary: many years later, when Cézanne was hard up for a time, Zola, who was then well off though not really wealthy, lent him money repeatedly; small sums, it is true, but all that Cézanne asked for. Some of Cézanne's partisans have thought it necessary to belittle certain aspects of Zola's character in order to glorify their hero, and to place the blame for the ultimate break-up of their long friendship entirely on the novelist's shoulders. But in justice to Zola it should be noted that not even the writers who have attacked him most violently on other counts have ever insinuated that he was capable of mercenary designs on his friend's purse. Zola's motives in urging Cézanne to come to Paris were, as he himself protests, completely disinterested. He was animated solely by a genuine conviction that the move would be the best possible thing for his friend. One can readily sympathize with his indignation at being accused of intrigue; indeed, the only surprising thing about his letter to Baille is its moderation. Young men of twenty are not usually so patient and so fair when their good faith is impugned unjustly.

But the climax of this letter — a most unexpected climax — comes at the very end. After several pages of literary discussion which have nothing to do with Paul Cézanne and his family difficulties, Zola adds an excited paragraph:

" I interrupt this too rapid and unworthy analysis to shout: ' I've seen Paul!!! ' I've seen Paul, do you understand that; do

you understand all the melody in those three words? — He came this morning, Sunday, and shouted at me several times up the stairs. I was half asleep; I opened my door trembling with joy and we embraced furiously. Then he reassured me as to his father's antipathy towards me; he claimed that you had exaggerated a little, no doubt because of your warm feelings. Finally he announced that his father had asked for me, I am to go to see him today or tomorrow. Then we went out to lunch together, and to smoke a quantity of pipes in a quantity of public gardens, and I left him. As long as his father is here, we shall be able to see each other only rarely, but in a month we expect to take lodgings together."

CÉZANNE IN PARIS: 1861

LOUIS-AUGUSTE had capitulated; Paul was in Paris; his future was in his own hands. His resistance had triumphed over the banker's determination to make of his son a respected pillar of society like himself. It must have been a hard blow to Louis-Auguste's stiff-necked pride; but he was wise enough to know when he was beaten, and fair enough to acknowledge it. And when he finally did surrender he did it handsomely enough. Not only was Paul permitted to go to Paris, but he was escorted by his father and his sister Marie.

Paul had never travelled more than a few miles from Aix before, and we can imagine his excitement as the train carried him northward to Paris, to Zola, to the Louvre. The journey itself must have thrilled him as he stared out of the window at the lovely valley of the Rhône, at the changing panorama of fields and vineyards, at dimly lighted unfamiliar stations. It was an uncomfortable trip in those days, though not an unduly long one: express trains covered the distance from Marseilles to Paris in about twenty hours, approximately twice as long as the fastest trains of today.

After so much correspondence on the subject of Paul's projected visit it seems rather odd that he did not notify Zola when the matter was finally settled, so that his friend could have met

103

him at the station as he had promised to do. Was it because he preferred to surprise Zola by appearing suddenly at his lodgings, without warning? Or did the departure from Aix follow so closely upon Louis-Auguste's change of heart that there was no time to prepare Zola?

When Louis-Auguste returned to Aix with his daughter after a few weeks in the capital he left Paul an allowance of a hundred and fifty francs a month — slightly more than Zola had computed as the necessary minimum. This was soon increased to three hundred francs, which was quite a generous sum for a young man in those days. The allowance was remitted through the firm of Le Hideux, Paris correspondents of the bank of Cézanne and Cabassol. It is most unfortunate that none of Cézanne's letters describing his first impressions of Paris has survived. Presumably he wrote to Baille soon after his arrival, to give an account of his reunion with their dear friend Zola; but all of his letters to Baille seem to have been destroyed. For a picture of Cézanne's life during these first months in Paris we are obliged to fall back once more on Zola's letters to Baille.

According to Vollard, Paul's first lodging in Paris was a small hotel in the rue Coquillière near the Halles Centrales, where he remained with his father and sister during their sojourn in the city. After their departure he moved to a furnished room in the rue des Feuillantines, on the left bank, in order to be nearer to Zola, who was living in the neighbourhood of the Panthéon.

In the beginning everything went smoothly. Cézanne sketched and painted every morning at the Atelier Suisse, on the Île de la Cité, and in the afternoons generally painted in the studio of his compatriot Villevielle or copied in the Louvre. The following description of the Atelier Suisse in the sixties is taken from an article by Monsieur Dubuisson in the *Paris-Midi* for January 2, 1925:

" There were, properly speaking, neither professors nor pupils. Anyone who wanted to could enroll by paying a fixed sum per

month for the models and expenses of upkeep. Everyone worked as he pleased, in pastel, water-colour, oils, copying the model or some invention of his own, still life or composition; there was complete freedom of experimentation and method. Those who gathered there, young and old, grouped themselves according to their tastes, and a tacit understanding among them prevented the discussions from growing too stormy.

" Old man Suisse, the founder of this republic, was a former model. . . . Delacroix used to work there, also Bonington, Isabey, Gigoux, Français, Courbet, Préault. . . . The house in which this Atelier Suisse was located was at the corner of the boulevard du Palais and the Quai des Orfèvres. It was demolished some years ago to make room for the new buildings of the Prefecture of Police. . . . The atelier, which was on the second floor, was reached by means of a very old wooden staircase, very dirty and of a rather dismal appearance, always spotted with bloodstains. That was because the first floor was occupied by the office of a dentist, whose sign was visible from a considerable distance along the quai: ' SABRA, *dentiste du peuple.*' "

Gustave Coquiot, in his biography of Cézanne, contributes an amusing anecdote concerning the dentist's office:

" Since the Académie Suisse and Sabra's ' dental parlours ' were on the same stairway, amusing mistakes sometimes occurred. It was only the patients who were upset by them; and a number of these must have fled in panic, never to return, on seeing in the dentist's office — having opened the wrong door by mistake — nude models shamelessly standing or sitting about.

" The Académie Suisse was a free and easy school. There was nobody to give criticisms. It opened very early, at six in the morning in summer; then, when the afternoon class was finished, there was a class from seven to ten in the evening. For three weeks in the month there was a male model; the fourth week, a female model."

At first Cézanne saw hardly anyone except Zola and Villevielle, and not very much even of them after the first few weeks. On May 1, 1861, some ten days after Cézanne's arrival in Paris, Zola wrote to Baille:

" Last Sunday I went to the exhibition of painting with Paul. . . . I see Paul very often. He is working very hard, which sometimes keeps us apart; but I don't complain of that kind of check to our meetings. We have made no excursions yet, or rather such as we have attempted are not worthy of being honoured by the pen. Tomorrow, Sunday, we intended to go to Neuilly to spend the day on the banks of the Seine, bathing, drinking, smoking, etc., etc. But now the sky is overcast, the wind is howling, it is cold. Good-bye to our fine day; I don't know how we shall spend it. — Paul is going to paint my portrait."

Cézanne made several attempts to paint Zola's portrait during that summer, but each time he gave up in despair and impatiently threw down his brushes. Although the portrait was never finished, two sketches for it have survived, one of which is reproduced here (Plate 10).

A month later Cézanne had withdrawn more into himself, and Zola saw him only at rare intervals. It was a bitter disappointment to Zola, who for three years had looked forward so eagerly to Cézanne's visit; and he could not help pouring out his disillusionment, together with a penetrating analysis of his friend's baffling character, in a letter to Baille dated June 10, 1861:

" I see Cézanne very seldom. Alas! it is no longer as it was at Aix, when we were eighteen, when we were free and had no worries about the future. Now the conditions of life, of work, separate us, alienate us. In the morning Paul goes to Suisse, I stay in my room to write. At eleven o'clock we have lunch, each by himself. Sometimes at noon I go to his room, and then he works at my portrait. Then he goes to Villevielle's to work for

106

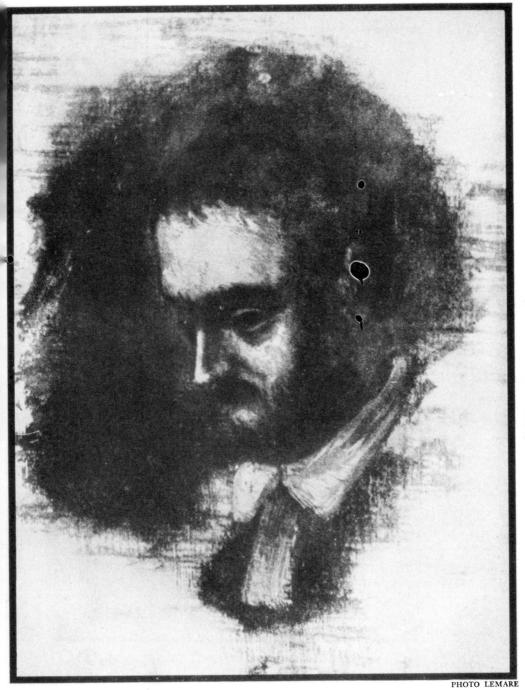

10. ÉMILE ZOLA AT TWENTY-ONE

1861. UNFINISHED SKETCH BY CEZANNE. VOLLARD COLLECTION

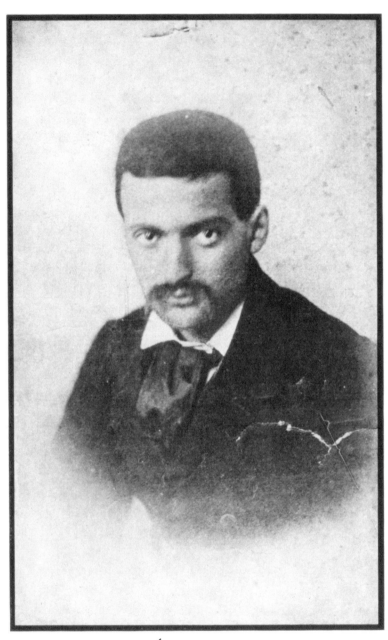

11. PAUL CÉZANNE ABOUT 1860

FROM A PHOTOGRAPH

the rest of the day; he has supper, goes to bed early, and I don't see any more of him. Is this what I had hoped for? — Paul is still the same excellent capricious fellow that I used to know in school. As proof that he has lost nothing of his eccentricity, I have only to tell you that no sooner had he arrived here than he talked of returning to Aix; to have struggled for three years to make this trip and then to throw it away like a straw! With such a character, before such unlooked-for and unreasonable changes of face, I admit that I am at a loss and must cast aside my logic. To convince Cézanne of anything is like trying to persuade the towers of Notre-Dame to dance a quadrille. He might say yes, but he would not budge a hair's breadth. And remember that age has increased his stubbornness, without giving him reasonable material to be stubborn about. He is made all of a piece, rigid and hard; nothing bends him, nothing can drag a concession from him. He will not even discuss his thoughts; he has a horror of arguments, firstly because talking is tiring, and also because he might have to change his opinion if his opponent were in the right. So there he is, thrown into life, bringing to it certain ideas, unwilling to change them except on his own judgment; at the same time remaining the kindest fellow in the world, always agreeing with you in speech, because of his dislike of arguments, but thinking his own thoughts just as firmly. When his lips say yes, most of the time his judgment says no. If by chance he advances an inconsistent opinion and you challenge it, he flies into a rage without trying to look into the question, shouts that you don't understand anything about the matter and jumps to something else. There is no use in arguing — what am I saying? — no use even in conversing with a fellow like that; you do not win a foot of ground, and all you gain is the privilege of observing a very strange character. I had hoped that age would modify him a little. But I find him the same as I left him. So my line of action is very simple: never to impede his fancy; at most to give him advice very indirectly; to put the fate of our friendship at the mercy of his own good nature, never to force his hand to clasp mine; in a word, to

efface myself completely, always greeting him cheerfully, seeking him out without forcing myself on him, and letting him decide what degree of intimacy shall exist between us. My language may surprise you, nevertheless it is logical. To me Paul is always a good soul, a friend who can understand me and appreciate me. Only, as each of us has his own nature, it is the part of wisdom for me to conform to his moods, if I do not want to lose his friendship. Perhaps in order to keep yours I would use reasoning; with him it would mean the loss of everything. Don't think there is any cloud between us; we are still very close to each other, and all I have just said does not take into consideration the accidental circumstances which separate us more than I should like."

Zola's exasperated epigram: " To convince Cézanne of anything is like trying to persuade the towers of Notre-Dame to dance a quadrille," neatly sums up one aspect of Cézanne's character. There was in him a streak of obstinacy that amounted sometimes to pig-headedness; when he was in a stubborn mood, arguments and remonstrances, however reasonable, either had no effect whatever or sent him off into a perfect cyclone of nervous rage. This touchiness, this inability to brook the slightest contradiction, were both a curse and a blessing to him. On Paul Cézanne the man the effect of his own intransigence was almost wholly disastrous. For the greater part of his life, until old age brought a certain measure of gentleness, his temper cut him off from the joys of peaceful understanding friendship, from the relaxations of social life, the pleasures of good, idle, rambling talk over a glass of wine and a pipe. Few of his acquaintances were as patient with his frequent tantrums as Émile Zola or Philippe Solari. He was doomed to loneliness; partly, of course, because a love of solitude and a profound dislike of chattering crowds were among the most fundamental qualities of his nature; but also in part because his reputation for bad temper drove away many potential friends whom he might have found congenial. His inability to " get along " with people, even with those of whom he was genuinely

fond, only served to aggravate the sense of inferiority he so often felt in company. Cézanne was far too intelligent, as well as too fair-minded under his sometimes prickly exterior, not to realize perfectly well that his outbursts were not only undignified but generally uncalled for. But he could not help them; and rather than cause embarrassment to himself and his companions, he chose to be alone most of the time.

But however much the pepperiness of Cézanne's disposition contributed to the loneliness and sadness of his life, the effect on him as a painter was not entirely harmful. His very friendlessness, the almost total absence of deep personal attachments, freed him from the distracting influences of society and enabled him to focus his attention on the problems connected with his art. Few men have lived so consistently detached from the outside world as Paul Cézanne. He took absolutely no interest in public affairs or politics; he knew nothing about business, and he was rich enough to be spared financial worry practically all his life; his health gave him no concern at least until he reached his fiftieth year; his love-affairs were both fewer in number and less devastating in their intensity than those of most men; and though he had his share of minor domestic difficulties, they seem to have left no very deep scars on his soul. It might almost be said that he and his painting were enclosed in a sort of vacuum, from which everything else in life was excluded. But within that vacuum, what titanic struggles took place!

Cézanne was not only stubborn and irritable; he was excessively suspicious and shy. His morbid fear of entanglements is indicated by his own often repeated expression: " *On me mettrait le grappin dessus* — they might get their hooks into me." A *grappin* is, literally, a grappling-hook; and to the timid and misanthropic painter it symbolized any relationship, however pleasant or desirable in itself, which might conceivably upset his life or disturb the peace of mind which was so essential to his work.

There were so many of these *grappins* to be avoided. Other artists, for example, who tried to influence him with their theories

109

and their opinions. His family was a *grappin;* on the one hand because he was financially dependent on his father, and on the other because of the real affection that existed between his mother and himself: a tie which was on the whole a source of strength to him, something to count on when everything else failed, but at the same time slightly irksome just because it was a tie. Friendship was a *grappin* too; even Zola found out, as we have seen, that intimacy with Cézanne could never go beyond a certain point. Whenever Zola imprudently sought to penetrate too deeply into his friend's mind, Cézanne would slip away from him into a world of his own, where neither Zola nor anyone else could follow. It must have been hard for Zola to learn to keep his distance; his early letters show him to have been a rather interfering young man, who prided himself on his broad understanding and who was ever ready to proffer unasked-for advice. It is only fair to acknowledge that his understanding was genuine and his advice generally sound; but his assumption of a protective attitude and his somewhat obvious forbearance must have been, at times, irritating to Cézanne, who saw the menace of the grappling-hook lurking behind even such well-meant interference.

In Zola's next letter to Baille, written on July 18, there is only a short reference to Cézanne:

" For some time I have been seeing Cézanne rarely enough. He works at Villevielle's studio, goes to Marcoussis, etc. Nevertheless there has been no break between us."

But in his following letter, which is not dated but which, from the context, must have been written in August 1861, Zola takes up anew the vagaries of Cézanne's balky temperament:

" Nothing is so repugnant to me as to pass a definite judgment on anyone. If I am shown a work of art, a picture, a poem, I will examine it with care and will not be afraid to declare my opinion;

if I make a mistake, my good faith is my excuse. This picture, this poem are things about which one should not change one's mind; they have but one quality; if they are good, they will be good for ever; if they are bad, eternally bad. If I am told about a single act of a man, even, I will judge without hesitation whether he has done well or ill in this separate act of his life. But if I am then asked the general question: ' What do I think of this man? ' I should try to be politely evasive in order not to have to answer. And, in fact, what judgment can be passed on a human being who is neither just brute matter, like a picture, nor something abstract like an action? How can you come to a decision concerning the mixture of good and evil that makes up a life? What scales can you use to weigh exactly what you should praise and what you should condemn? And above all how are you going to collect all of a man's actions? — for if you omit a single one, your judgment will be unjust. Finally, if this man is not dead, what favourable or unfavourable decision can you make about a life that may still produce evil or good? This is what I have been saying to myself on thinking over my last letter in which I spoke to you about Cézanne. I was trying to judge him, and in spite of my good faith, I repent of having drawn a conclusion which is after all not the true one. — As soon as he came back from Marcoussis, Paul came to see me, more affectionate than ever; since then we have spent six hours a day together; our meeting-place is his little room; there he paints my portrait; while that is going on, I read or we chat together; then, when we have worked long enough, we generally go out to smoke a pipe in the Luxembourg gardens. Our conversations touch on various subjects, particularly painting; our memories also have a considerable place in them; as to the future, we dismiss it with a word in passing, either to hope for the reunion of all three of us or to bring up the terrible question of our success. Sometimes Cézanne reads me a lecture on economy, and to conclude it forces me to drink a bottle of beer with him. At other times he recites silly verses with words and music, by the hour; then I declare emphatically that I prefer the lectures

111

on economy. We are seldom disturbed; from time to time a few intruders come in to bother us; Paul takes up his painting again furiously; I pose like an Egyptian sphinx; and the intruder, quite disconcerted by so much work, sits down for a moment, dares not stir, and takes himself off with a whispered farewell, closing the door softly behind him. — I should like to give you still more details. Cézanne has frequent spells of discouragement; in spite of the slightly exaggerated contempt he pretends to feel for glory, I can see that he would like to make a success. When his work turns out badly, he talks of nothing less than of returning to Aix and becoming a clerk in some business establishment. Then I have to lecture him at great length to convince him of the folly of such a step; he agrees readily and goes back to work. Nevertheless he is bitten with the idea; he has already been on the point of leaving twice; I fear that he will run away from me any minute. If you write to him, try to tell him about our approaching reunion in the most glowing colours; it is the only way to keep him here. — We have made no excursions yet, money prevents us; he is not rich and I still less so. Nevertheless, one of these days we hope to get away and go somewhere to dream. — To sum up all of this, I shall say that in spite of its monotony, the life we lead is not as boring as it might be; our work keeps us from yawning; and a few of our memories gild everything with a ray of sunshine. — Join us and we will be still less bored.

"I take up this letter again to support what I have written above with an account of something that happened yesterday, Sunday. Some time ago I had gone to Paul's and had heard him announce coolly that he was packing his trunk to leave on the following day. Then we had gone to a café. I had not lectured him; I had been so astounded and so firmly convinced that my arguments would be useless that I had not raised the slightest objection. Nevertheless I had searched for a pretext to hold him back; at last I thought I had found one and had asked him to paint my portrait. He had taken up the idea with enthusiasm, and for the time being there had been no more talk of departure. But

112

yesterday this cursed portrait which I had expected would keep him in Paris came within an ace of causing him to leave. After having begun it twice, always dissatisfied with himself, Paul wanted to be done with it and asked me to give him a final sitting yesterday morning. So yesterday I went to his room; as I entered, I saw the trunk open, the drawers half open; Paul, with a gloomy face, was throwing things about and cramming them pell-mell into the trunk. Then he said calmly: ' I'm leaving tomorrow.' ' And my portrait? ' I said. ' Your portrait,' he replied, ' I have just destroyed it. I tried to retouch it this morning, and as it only got worse and worse, I demolished it; and now I'm going.' Still I refrained from making any comment. We went out to lunch together and I did not leave him until the evening. During the day his ideas grew more reasonable, and at last, when he left me, he promised to stay. — But the matter is only patched up; if he does not leave this week he will leave the next; you may expect to see him go at any minute. — I really believe it would be the best thing. Paul may have the genius of a great painter, but he will never have the persistence to become one. The slightest obstacle crushes him. I repeat, he had better go, if he wants to spare himself many vexations."

The letter ends with a postscript:

" Paul will surely remain in Paris until September; but is that his final decision? Yet I have hopes that he will not change it."

Though Zola expressly disclaims 'any intention of passing judgment on Cézanne, he certainly appears to do so in the phrase: " Paul may have the genius of a great painter, but he will never have the persistence to become one." Time has shown how mistaken this prophecy was. Cézanne was tormented all his life by intermittent fits of profound discouragement; but they seldom lasted very long. His grim determination to succeed and the

furious energy with which he worked kept him at his easel from early morning until dusk, day in, day out. Whatever Cézanne's shortcomings may have been, a lack of perseverance was not one of them. With all his temperamental quirks there was something essentially steady and sturdy in his make-up that always carried him through. He had no sympathy for the weakness of character that made Claude Lantier, in *L'Œuvre,* whose prototype he was, hang himself because his picture was a failure. When Cézanne himself was dissatisfied with one of his paintings, as often happened, he simply hacked it to pieces and began another.

Perhaps Zola was not so much to blame for his failure to sense the underlying ruggedness of his young friend's nature. Cézanne's moods were so violent, so sudden in their alternations of feverish enthusiasm and black despair, he was in such a constant state of indecision as to whether he would stay in Paris or return to Aix, that Zola must be forgiven for writing that he was doomed to failure by his own instability. Zola did recognize the greatness of Cézanne's talent, to a certain extent, though his own literary conception of painting always kept him from appreciating the full measure of his friend's abilities; but all his life, and with sincere regret, he felt that the development of Cézanne's potential genius was fatally hampered by the weaknesses of his erratic character. His judgment is reflected in his own creation, Claude Lantier. Lantier is far more unstable, emotionally, than Cézanne ever was; at the end of the book he goes raving mad and hangs himself in front of his unfinished — and unfinishable — picture. Obviously Zola did not intend the Lantier of the latter part of *L'Œuvre* to represent Cézanne as he was or ever could have been. But it is none the less probable that the fictitious character of Lantier, hysterical and morbid as it was, bore some resemblance to Zola's inner conception of Cézanne; a much closer resemblance, in fact, than it did to the real Cézanne.

It was altogether characteristic of Cézanne to yearn for Paris when he was in Aix, and for Aix when he was in Paris. He was perennially restless and spent the greater part of his life shuttling

back and forth between the two cities until his final retirement to Aix a few years before his death. Sometimes he would remain quietly in Paris or its environs for a year or two without returning to Provence, and *vice versa;* at other times he would tire of his surroundings in a few weeks and dash north or south in response to his changing moods.

If Cézanne's first trip to Paris was a disappointment to Zola, it must have been a far more bitter one to Cézanne himself. For three years he had pinned all his hopes on Paris, alternately pleading with and defying his father in his efforts to win his consent to the journey; and what had he gained by it? The conviction that he would never be able to paint, and a definite weakening of the ties that bound him to his dearest friend. He returned to Aix in the fall of 1861. He was beaten — for a little while.

Though his friendship with Zola had suffered during this interlude in Paris, it was by no means extinct. After Cézanne's departure they continued to correspond; but the intervals between letters were somewhat longer than before. On January 20, 1862, Zola wrote:

" My dear Paul,
" I have not written to you for a long time, I don't know exactly why. Paris did our friendship no good; perhaps it needs the sunshine of Provence in order to flourish vigorously? Doubtless it is only some unfortunate misunderstanding that has caused a coolness between us; some untimely incident, or perhaps a sharp word to which too much importance has been attached. I do not know and I never want to know; stirring up mud always soils the hands. — Never mind, I still consider you my friend; I believe that you judge me incapable of a low action and that you think as much of me as ever. If it be otherwise, you would do well to explain and tell me frankly what you have against me. — But I do not want to go into explanations in this letter. I only want to reply to your letter as a friend, and chat with you a little, as if your trip to Paris had never taken place."

CHAPTER XIII

AIX, AND PARIS AGAIN:
1861–1863

FROM 1861 until the outbreak of the Franco-Prussian war in 1870 Paul Cézanne spent part of almost every year in Aix and part in Paris. These years are much less fully documented than the period immediately preceding them. Zola's letters to Cézanne and Baille, which have been the principal source of information concerning Cézanne up to this point, are no longer available; all but one of them subsequent to 1862 appear to have been lost or destroyed. No letters from Cézanne to Zola written between 1859 and 1877 have been found, and there are but few letters from him to anyone else to bridge the gap.

The eighteen-sixties were an important epoch in Cézanne's life. The beginning of the decade found him hesitating, uncertain, torn between the legal or business career mapped out by his father and his own dreams of a future devoted to art; the end saw him fully launched as a painter.

When he came back to Aix in the autumn of 1861 he was welcomed by his family as a returned prodigal. Louis-Auguste rejoiced to see that his son had no more childish illusions regarding the joys of life in Paris, and he must have been equally pleased

116

to find him in a mood of profound discouragement about his painting. Probably the air was full of I-told-you-so's for a few weeks; tact was never one of Louis-Auguste's salient qualities. And Paul's relief at having escaped from Paris to the familiar surroundings of his native town was so great that he was inclined to be unusually docile at first. He did not resume the study of law; that was finished for good; nor did he stop painting altogether. But he allowed himself to be persuaded to take a position as a clerk in his father's bank, and Louis-Auguste serenely looked forward to the day on which he could retire and leave his business in his son's hands.

It was a vain hope. As soon as the novelty of his homecoming had worn off, Cézanne realized that he hated the counting-house and everything connected with it as much as he had hated the law. Figures meant nothing to him; he was not interested in money-lending and percentages and promissory notes. His whole nature rebelled against the routine of a business office. He relieved the tedium of bookkeeping by scribbling drawings and verses on the margins of the bank's ledgers. One such couplet is quoted in Marie Cézanne's letter to her nephew, dated March 16, 1911:

" *Mon père le banquier ne voit pas sans frémir*
Au fond de son comptoir, naître un peintre à venir."

A slightly different version of these lines, quoted by Vollard, is given in Appendix B.

Cézanne began to paint seriously again, and from now on, though he was often desperately discouraged, there was no more actual backsliding. Among other subjects he started a landscape in the neighbourhood of the dam that formed part of the water system planned by Zola's father. Zola mentions it in a letter dated September 29, 1862 — with one exception the last letter from him to Cézanne that has survived:

" As to the view of the dam, I deeply regret that the rain has kept you from going on with it. As soon as the sun comes out, take the path by the cliffs again and try to finish it as soon as possible."

Cézanne remained in Aix for a whole year, long enough for the disappointments he had suffered in Paris to fade out of his memory. Once more his thoughts turned to the north. He wanted to try his luck in Paris again; but he had given up the idea of living there permanently; he intended to divide his time between Paris and the Midi. And that is exactly the way in which he afterwards arranged his life. In the same letter Zola writes:

" There is one hope that has doubtless helped to cure my blues, that of soon being able to clasp your hand. I know that it is not quite certain yet, but you allow me to hope, that is something. I entirely approve of your idea of coming to work in Paris and retiring to Provence afterwards. I believe it is a good way to escape academic influences and to develop any originality one may have. — So, if you come to Paris, all the better for you and for us. We will plan our lives, spending two evenings a week together and working all the others. The hours together will not be wasted; nothing encourages me so much as chatting with a friend for a while. — So I shall expect you."

About the beginning of November 1862 Cézanne made his second trip to Paris. If there were any opposition on his father's part this time, it was less determined and more easily overcome than before. Louis-Auguste was no more in sympathy with Paul's ambitions than he had ever been, but apparently he had made up his mind that if his son insisted on making a fool of himself he would do nothing more to stop him.

Cézanne took lodgings in the heart of the Quartier Latin, just off the present boulevard Saint-Michel, which was not cut through until two or three years later. He resumed his work at the Académie Suisse, painting there in both the morning and the evening classes. This time he was able to adjust himself more successfully to life in Paris; he was more content, less subject to violent changes of mood. In a letter to Numa Coste which forms part of

118

the correspondence published by Marcel Provence in the *Mercure de France* of April 1, 1926, he writes:

> *"5 January 1863. Paris*
>
> *" Mon cher,*
>
> " This letter is intended both for you and for M. Villevielle at the same time. And first let me say that I should have written to you long ago, for it is now two months since I left Aix.
>
> " Shall I speak of the fine weather? No. Today for the first time the sun, heretofore hidden by clouds, has put his head in the dormer window and, trying to end this day gloriously, is sending us a few pale beams before setting. . . .
>
> " As in the past (for it is proper that I should tell you what I am doing), I go to Suisse in the mornings from eight to one and in the evenings from seven to ten. I work calmly, I eat and sleep in the same way.
>
> " I often go to see M. Chautard, who is kind enough to criticize my studies. . . ."

Chautard was a painter, a friend of Villevielle's. The letter contains a short bit of verse, one of the best (and probably one of the last) that Cézanne ever wrote, which will be found in Appendix B.

Cézanne's second visit to Paris lasted about a year and a half; that is, until the summer of 1864. If he made any trip to Aix during this time there is no record of it. It was a momentous period. It brought him into contact for the first time with the group of young painters who were later to become the leaders of the Impressionist school. Heretofore his training under the uninspired and uninspiring Monsieur Gibert at the École des Beaux-Arts at Aix, and later in the casual atmosphere of his first months at the Atelier Suisse, had been academic enough. His spirit was already in revolt against the hard and fast traditions that were throttling French painting at the time, but the rebellion was vague and without direction. He felt that he knew what was wrong with the teach-

ings of the academicians, but he did not yet know how to set them right. He was still floundering, and as far as he knew, he was floundering alone.

But during the years 1863 and 1864 he became aware that there was already a considerable gathering of young men in Paris who not only shared his contempt for the hidebound rules of official painting, but who were already making some progress towards the development of a new system which was eventually to overthrow the academicians after a long and bitter struggle.

THE SALON DES REFUSÉS: 1863

AT the time of Cézanne's first two sojourns in Paris official French art was still almost completely dominated by the tradition of David and the all-powerful dictatorship of the aged Dominique Ingres. Both were great painters; but in the hands of their mediocre successors their teachings had been crystallized into a series of lifeless rules and regulations, of prohibitions and tabus. Delacroix, the leader of the romantic school, and Courbet had achieved some degree of public recognition, and the Barbizon group was building up a new tradition of landscape painting; but the bureaucracy, the Academy, the official arbiters of the artistic world, stood solidly behind the bankrupt classicism of the followers of Ingres.

The young insurgents won their first victory with the inauguration of the famous Salon des Refusés in 1863. For some reason the jury that chose the pictures for the official Salon of that year had turned out to be even more reactionary than usual. Every painting that showed the slightest tendency to depart from strict academic principles was ruthlessly rejected. Among the painters whose works were refused were Fantin-Latour, Legros, Manet, Whistler, Jongkind, Braquemond, Jean-Paul Laurens, Vollon, Cazin, and Harpignies. The bias of the jury was so flagrant, the

protests of the rejected painters and their partisans so vehement, that Napoleon III was prevailed on to interfere. The imperial decree establishing the Salon des Refusés was published in the *Moniteur des Arts* for April 24, 1863:

" Numerous protests have reached the Emperor concerning the works of art rejected by the jury of the Salon. His Majesty, wishing to let the public judge as to the legitimacy of these protests, has decided that the rejected works of art will be exhibited in another part of the Palais de l'Industrie.

" This exhibition will be optional, and the artists who do not wish to participate have only to notify the administration, which will return their works at once.

" The exhibition will open on May 15. The artists will have until May 7 to withdraw their works. After that date their pictures will be considered as not withdrawn, and will be placed in the galleries."

Evidently a good many of the rejected painters considered it beneath their dignity to take part in the nonconformist exhibition and hastened to withdraw their offerings. In the catalogue appears the following note:

" The committee . . . desires to express the profound regret with which it has noted the large number of artists who have not seen fit to allow their works to be shown at the counter-exhibition."

In spite of wholesale withdrawals by the more conservative and timid candidates the size of the Salon des Refusés was decidedly impressive. Over six hundred canvases by more than three hundred painters were exhibited, as well as several roomfuls of drawings, engravings, and sculpture. Of course the controversy had received an enormous amount of publicity in the press, and all Paris came to see the show. Joseph Pennell writes in his *Life of James McNeill Whistler:*

" The success was as great as the scandal. The exhibition was the talk of the town, it was caricatured as the *Exposition des Comiques,* and parodied as the *Club des Refusés* at the *Variétés;* everyone rushed to the galleries. The rooms were crowded by artists, because, in the midst of so much no doubt weak and foolish, the best work of the day was shown; by the public, because of the stir the affair made. The public laughed with the idea that it was a duty to laugh, and because the critics said that never was a *succès pour rire* better deserved."

The greatest sensation of the Salon des Refusés, the focal point for the vituperation of the critics and the ridicule of the mob, was the painting by Édouard Manet called *Le Bain,* afterwards better known as *Le Déjeuner sur l'Herbe.* It portrays two men in ordinary clothes seated on the grass beside a nude woman. In the background another woman is bathing or preparing to bathe in a lake, which can be glimpsed through a screen of trees. A corner of the foreground is occupied by a picnic basket and the remains of an outdoor repast.

Today this picture seems innocuous enough. Why did it cause such a resounding scandal in 1863?

There were two reasons. In the first place the subject was attacked on moral grounds. The puritanical French bourgeoisie was profoundly shocked by the spectacle of nude female figures and men in contemporary dress grouped in a single composition. Not that nudity in itself was considered disreputable as a subject for a picture; on the contrary; but nude figures were appropriate only in a picture illustrating some heroic episode of antiquity, according to the classicists; or according to the romanticists, in exotic or " picturesque " surroundings. *Le Déjeuner sur l'Herbe* was neither heroic, exotic, nor picturesque; it was merely shameless. Manet defended his painting by pointing out that Giorgione had portrayed a similar group of clothed men and naked women three hundred and fifty years earlier, and that this picture scandalized nobody; it was accepted as a great work of art. The critics

retorted that Giorgione had idealized his nudes, whereas Manet's figures were nothing but a pair of realistically painted Parisian hussies; and in any case, Giorgione was an Old Master and Manet no better than an insolent young upstart.

The second cause of the outcry against Manet was a more technical one: his method of handling colour. For years there had been a firmly established convention among painters that patches of light on a canvas should be separated by areas of dark; that one strong or intense colour should be connected with another only by means of an intermediate series of graduated semitones; and that shadows in a picture should be rendered in browns, blacks, and greys, no matter where the shadows occurred nor by what objects they were cast. This convention was adhered to and defended by classicists, romanticists, and realists alike, and even by the Barbizon group of landscape painters.

Le Déjeuner sur l'Herbe violated every one of these canons. In this picture Manet daringly placed one area of light directly beside another, without interposing the prescribed expanses of dark, and omitting all intervening semitones; and instead of painting the shadows of his trees in the orthodox muddy brown or bituminous black, he introduced clear blues and greens and yellows to indicate the effects of reflected sunlight. Thus the whole canvas glowed with light and life. But the critics and the public, accustomed to pictures in which dull brown half-tones predominated, were nearly blinded by what seemed to them the crudity, the rank vulgarity, of so much intense colour.

The scandal caused by *Le Déjeuner sur l'Herbe* was repeated two years later when Manet's *Olympia* was accepted by the more liberal jury of 1865 and exhibited in the official Salon of that year. The realistic portrayal of the nude *demi-mondaine* reclining indolently on her bed, the same unconventional juxtaposition of light patches of colour without half-tones that had distinguished the *Déjeuner,* the same luminosity in the shadows, brought forth another storm of abuse. It is not easy for a generation which is familiar with the work of the Impressionists and the

still more intense colour of most of the painting of the present day to understand what all the hubbub was about. To us Manet's colour seems mild, even subdued; it is difficult to realize that it was ever considered violent, especially when we realize that at this time Manet had not yet committed the heresy of painting his pictures in the open air. Though he had observed the play of reflected light under trees and had made use of his discoveries in his revolutionary handling of colour in shadows, he did his actual painting in his studio. It was not until after 1870 that Manet began to paint out of doors, and then only to a limited extent, after Pissarro and Monet had already started the movement towards the open.

Cézanne was deeply moved by the Salon des Refusés. It was the first opportunity he had had to see a large exhibition of the work of the younger painters, his own immediate predecessors, and needless to say he was heart and soul on the side of the insurgents. The relatively brilliant colouring of the *Déjeuner sur l'Herbe* delighted him, and his enthusiasm for the *Olympia,* two years later, was still more fervent.

THE REBELS

In 1863 Cézanne began to mingle with the little group of young painters who were to become the founders of the Impressionist school a few years later. Accounts differ as to how and where he met the various members of the coterie, and there is little documentary evidence to confirm or refute the various contradictory tales.

Camille Pissarro sometimes painted at the Atelier Suisse, and it was probably at that studio that Cézanne first became acquainted with him. Pissarro was the oldest of all the future Impressionists. He was born in 1830 on the island of St. Thomas, one of the Virgin Islands purchased from Denmark by the United States in 1917. His parents were Jews of Spanish descent. As a boy he was sent to France to be educated, but at the age of seventeen he was recalled to St. Thomas by his father, who had planned a business career for the young man. A domestic struggle ensued which resembled in many particulars the later conflict between Cézanne and Louis-Auguste. And in both cases the outcome was the same. When he was twenty-two Pissarro accompanied Fritz Melbeye, a Danish painter, to Carácas in Venezuela, and the following year he returned to France.

Thenceforth he devoted himself entirely to painting. He met

Corot and was deeply influenced by him; but he was never actually a pupil of Corot, nor in fact of anyone. Pissarro painted out of doors, from nature, a habit which he had acquired in the Antilles and which he was the first to introduce into France. When he worked in a studio he chose one like the Atelier Suisse, where a model was provided but no formal instruction was offered. One of his landscapes was exhibited at the Salon of 1859, but in 1861 he was rejected, and again in 1863. His landscapes were accorded a prominent place in the Salon des Refusés, where they came in for their share of the general criticism. But Pissarro's landscapes were mild compared to such outrageous pictures as *Le Déjeuner sur l'Herbe* and caused no individual scandal. He was still painting in a relatively low key; his colour did not shock the sensitive critics. Between 1864 and 1870 his landscapes were admitted to nearly all of the official Salons.

Another habitué of the Atelier Suisse was Armand Guillaumin, who started to work there in 1864. He soon became a close friend of Pissarro and Cézanne, particularly of the latter. He was two years younger than Cézanne. Born in Paris, he was brought up in the provinces at Moulins-sur-Allier. At the age of sixteen he was sent back to Paris and apprenticed to his uncle, who owned a linen-shop. Here again history repeated itself. Guillaumin had no more aptitude for business than Pissarro or Cézanne; like them he wanted only to be a painter. The usual family quarrel followed, with the usual result. Guillaumin struck out on the path he had chosen. But unlike Cézanne, who had a liberal allowance from his father, or Pissarro, who was able to sell enough pictures after the first few years to support himself on a very modest scale, Guillaumin could neither depend on assistance from his family nor exist on the proceeds of an occasional sale of a picture at a pitiful price. He was forced to earn a living on the side. Until 1868 he was employed by the Compagnie d'Orléans; after that in the Bureau of Roads and Bridges of the city of Paris. It was not until he reached the age of fifty that a windfall of a hundred thousand francs enabled him to give up the work he detested and ap-

127

ply himself exclusively to art. But during all the preceding years, while he was supporting his wife and children by his drudgery in a stuffy municipal office, Guillaumin continued to paint, taking advantage of every free hour to set up his easel on the quais of Paris or in the nearer suburbs. Cézanne was his companion on many of these modest excursions.

At about the same time, or possibly a year earlier, Cézanne made the acquaintance of Francisco Oller y Cestero. Oller was a native of Puerto Rico, born in 1833. At sixteen he was sent to Madrid to study painting, and in 1857 he came to Paris to continue his artistic education under the guidance of Couture, and later of Courbet. Influenced by Manet and Pissarro, Oller forsook realism and joined the little band of future Impressionists. But his place in the Impressionist ranks was always a minor one, and his work is little known in France. Today he is remembered chiefly as a painter of numerous portraits in Puerto Rico and Spain, including an equestrian painting of Alfonso XII. An exhibition of his work was held in Madrid in 1883.

During his first years in Paris Cézanne occasionally went on painting expeditions with Oller. On March 15, 1865, he wrote to Pissarro:

" Forgive me for not having come to see you, but I am going to St. Germain this evening and will come back on Saturday with Oller to help him carry his pictures to the Salon, for he has done, he wrote me, a Biblical battle-scene I think, and the large picture you know about. The large one is very good, the other I have not seen.

" I should like to know if you have done, in spite of the misfortune you have suffered, your pictures for the Salon. — If you should ever wish to see me, I am at Suisse's in the mornings and at home in the evenings, but fix an appointment at any place that is convenient for you and I shall be glad to meet you there when I return from Oller's. — Saturday we are going to the barracks in the Champs-Élysées [the Palais de l'Industrie, where the Salon

was held] to deliver our pictures, which will make the Institute howl with rage and despair. I hope that you have painted a fine landscape, I greet you cordially."

The howls of the Institute were comparatively mild in 1865, for the jury accepted two of Pissarro's offerings and one of Oller's pictures, entitled in the catalogue *Ténèbres*. But if Cézanne himself submitted a picture that year, as his letter seems to suggest, it was rejected. The nature of Pissarro's " misfortune " referred to by Cézanne is a mystery.

According to Vollard, it was Oller who introduced Cézanne to another member of the insurgent group, Jean-Baptiste-Antoine Guillemet. Guillemet was four years younger than Cézanne and at the time of their first meeting could have been no more than twenty years old. He was a pupil of Corot and Oudinot, specializing in landscapes and seascapes. He was never more than a mediocre artist, and today he holds but an obscure position as a minor painter; but during his lifetime he was awarded — perhaps because of his very mediocrity — a considerable amount of official recognition in the form of medals, ribbons of the Legion of Honour, and other decorations. It may have been Guillemet's ability to please the public taste at a time when his more able colleagues were the objects of the same public's ridicule and scorn that caused Zola to pillory him in *L'Œuvre* in the guise of the facile, vain, snobbish, dandified opportunist Fagerolles. It must be remembered however that like all the other characters in the book, Fagerolles is not a faithful portrait, but merely a character created by Zola for the purposes of his story. There is no reason to believe, or to suppose that Zola believed, that the real Guillemet was actually the hypocritical prig whose toadying to popular taste is made so despicable in the novel.

A far more sympathetic picture of Guillemet is painted by Georges Rivière in his biography of Cézanne:

" Guillemet . . . who played a very active part in the events that marked the beginning of Cézanne's career, remained the

young painter's favourite companion during his hours of relaxation. Guillemet was a robust youth, jovial, fond of good living, with plenty of money, thanks to the allowance given him by his father, a wholesale wine-merchant at Bercy. His Rabelaisian jokes entertained Paul Cézanne, and his friendship for him was demonstrated on all occasions."

Vollard relates that Guillemet accompanied Cézanne on one of his periodical migrations to Aix and pleaded with Louis-Auguste to allow his friend to return to Paris with him; but he does not indicate which of Cézanne's many homecomings is referred to, or why Guillemet's intervention should have been necessary.

Guillemet did more for Cézanne than amuse him with his good-humoured ribaldry. It was probably through Guillemet that Cézanne was presented to Manet, then hailed as the undisputed leader of the younger painters. The meeting must have taken place early in the spring of 1866; Valabrègue wrote the news to his friend Marion, who passed it on to Morstatt in a letter dated April 12 of that year. According to this letter, Cézanne visited Manet, and Manet returned the compliment by going to see Cézanne's still lifes at Guillemet's studio. Valabrègue reported that Manet had found his young colleague's work " boldly handled," and that Cézanne was delighted, but kept his joy under control, as was his habit when he was really pleased. In conclusion Valabrègue predicted that the two painters would surely understand each other, as they had " parallel temperaments."

Valabrègue's wish may have been father to his thought, but in this prophecy he showed more good nature than psychological insight. While Cézanne sincerely admired Manet's work and was whole-heartedly in sympathy with his revolt against the Academy, the two artists never became warm personal friends. Their temperaments, far from being " parallel," were in reality poles apart. Manet was a polished man of the world with the elegant manners and quick wit of the upper-class Parisian, fond of company, and at his best when surrounded by a group of attentive and admiring

disciples; Cézanne was an awkward young provincial, incorrigibly shy and moody, conscious of his thick Provençal accent, and quite unable to hold his own among the sprightly conversationalists who clustered around Manet.

It may also have been Guillemet who introduced Cézanne to the talented young artist Frédéric Bazille, a native of Montpellier, whose promising career was cut short in 1870 on the battlefield of Beaune-la-Rolande. Bazille in turn is said to have presented Cézanne to his fellow-students at the Atelier Gleyre: Claude Monet, Auguste Renoir, and Alfred Sisley. So that by 1866 Cézanne was on more or less intimate terms with practically all of the young painters who were later to become famous as the leaders of the Impressionist movement.

Curiously enough, there is no record of any meeting between Cézanne and Berthe Morisot either at this time or later. Yet they must have become acquainted during the seventies, if not before. Both took part in the Impressionist exhibitions of 1874 and 1877, and since they had so many friends in common it is highly probable that they came to know each other at least casually. But it is unlikely that they were ever more than mere acquaintances; Berthe Morisot's world, like Manet's, was too social and too sophisticated for Cézanne.

The young insurgents met frequently to exchange ideas about painting and to think up new ways of undermining the power of the reactionary authorities. Sometimes these reunions were held at Fantin-Latour's studio in the house on the rue des Beaux-Arts in which Renoir and Bazille also lived; occasionally Manet's studio was the meeting-place; but from 1866 until the war of 1870 broke up the gatherings and scattered the painters and writers who attended them, the favourite rendezvous was the Café Guerbois on the avenue de Clichy.

Théodore Duret, one of the art critics who as a young man frequented the Café Guerbois, describes these meetings in his book *Les Peintres Impressionistes:*

" The reunions inaugurated at the Café Guerbois in 1866, spasmodic at first, soon became a habit. The group of which Manet was the principal link, composed of painters who adopted his æsthetic principles, soon attracted other artists of a different school, as well as men of letters. Fantin-Latour, who held to his own methods of painting, was often seen there. Guillemet the landscape painter of the naturalist school, the engravers Desboutin and Belot, Duranty the novelist and critic of the realist school, Zacharie Astruc, sculptor and poet. Émile Zola, Degas, Stevens, and Cladel the novelist appeared there frequently. Vignaud, Babou, Burty were the most regular attendants among men of letters. These, together with the painters allied directly with Manet, formed the nucleus of the group; but after the reunions became well known the friends and acquaintances of the habitués came as well and on some evenings the Café Guerbois was crowded with a gathering of artists and writers. Manet was the dominant figure among them; with his animation, his wit, the authority of his artistic judgment, he set the tone of the discussions. His position as a persecuted artist, rejected by the Salons, abused by the champions of official art, made him the leader of the men assembled there, whose bond was the spirit of revolt in art and literature.

" Thus during the years 1868, 1869, and 1870, until the war, the Café Guerbois was a centre of intellectual life, where the young men encouraged each other to continue the good fight and defy the serious consequences to be expected therefrom. For it entailed nothing less than a revolt against the rules and systems generally accepted and respected. It was at the time of the Second Empire, when the idea of authority, deeply implanted in institutions, gave to official bodies of all kinds, academies, juries of the Salons, an immense power, permitting them to exercise an actual dictatorship over artistic matters. But when new forms and methods are ready to blossom forth, youth adopts them and from that time on is possessed by a sort of sacred fire, so that obstacles are no longer seen and resistance only stimulates a further advance.

Manet and his friends confirmed each other's opinions so well, they encouraged one another so heartily, that opposition, ridicule, insults, sometimes starvation, could never make them yield or deviate from the path they had chosen."

Cézanne was not often present at these assemblies. He was shy and ill at ease in a crowd, and the sincerity of his opinions was at once too deep and too humourless for him to be able to relish the clever talk that floated over the coffee-stained tables of the Café Guerbois. He had no use for Parisian wit, for epigrams, for *bons mots*. " *L'esprit m'emmerde,*" he would say contemptuously; and if by chance he did become involved in an argument with other members of the group, the discussion generally ended in a burst of furious temper and the abrupt departure of Cézanne. At the heart of his aloofness was his eternal dread of the *grappin* in another form: the fear of becoming too closely involved with any group which might sap his individuality and interfere with his fiercely cherished independence. Naturally the more superficial habitués of the Café Guerbois came to look on him as an ill-mannered barbarian. Actually he was both courteous and gentle by nature; but he was hypersensitive, and his nerves were easily rasped. When he did appear at the café, he would often sit quietly for hours in a corner, listening attentively and gravely to the effervescent, brilliant conversation that went on around him, contributing little himself; until a casual spark would set him suddenly ablaze, and his frayed nerves would betray him into an unintended explosion of wrath.

CÉZANNE, ZOLA, AND THE JURIES: 1866

MEANWHILE Cézanne was painting diligently at the Atelier Suisse, at Villevielle's studio, at home, at the Louvre, and in the environs of Paris with Oller or Guillaumin. He applied for admission to the Beaux-Arts, but failed to pass the tests and was rejected. Probably this rebuff occurred in 1863 during his second visit to Paris, but the absence of any record of the incident in the archives of the Beaux-Arts makes it impossible to fix the date definitely. It seems strange that Cézanne the rebel should have thought seriously of entering so conservative a school as the Beaux-Arts of that day; but the attempt was characteristic of one angle of his inconsistent nature. Side by side with his enthusiastic championship of the new movement in painting and his contempt for the bigotry of the academies and the juries lay a deeply imbedded streak of genuine respect for tradition, for constituted authority *per se*. Not only was he willing to submit to the rules and regulations of the Beaux-Arts — at least for a time — but he sent pictures year after year to the official Salon in spite of his scornful and sometimes ribald references to " *le Salon de Bouguereau.*" The pictures were invariably rejected, but Cézanne

seemed almost perversely determined to secure the approval of the juries which at heart he despised.

In 1866 he submitted two canvases to the Salon, *Un Après-midi à Naples* and *La Femme à la Puce*. Both pictures were probably painted in 1865. Of the *Après-midi à Naples* Vollard writes:

" The model who posed for this painting was an old nightsoil-remover whose wife kept a little creamery where she served a beef soup much appreciated by her ravenous young patrons. Cézanne, who had won his confidence, once asked him to pose. The scavenger reminded him of his job.

" ' But you work at night; you have nothing to do in the day-time! '

" The nightman replied that during the day he slept.

" ' All right, then, I'll paint you in bed! '

" The old fellow was put under the covers, with a neat cotton nightcap on his head in honour of the painter; but since there was no need to stand on ceremony among friends, he first took off the nightcap, then threw back the sheets, and finally posed quite naked; his wife appeared in the picture, handing a bowl of wine to her husband. . . . For the study of the scavenger Cézanne's friend Guillemet came to the rescue by suggesting the title: *Un Après-midi à Naples,* or *Le Grog au Vin.*"

The two studies were rejected by the jury. Cézanne wrote a letter of protest to Monsieur de Nieuwerkerke, superintendent of the Beaux-Arts. The protest was ignored. Cézanne wrote again. His second letter is quoted by Vollard; unfortunately the document itself has been lost or mislaid in the archives of the Louvre so that I have been unable to consult the original:

" *19 April, 1866*

" Monsieur,

" Recently I had the honour of writing to you concerning two canvases which the jury has just refused.

" Since you have not yet replied, I feel that I must insist on the motives which caused me to address myself to you. Since you have no doubt received my letter, I need not repeat here the arguments which I thought it necessary to put before you. I shall content myself with saying once more that I cannot accept the unfair judgment of colleagues to whom I myself have not given the authority to appraise me.

" I write to you then to emphasize my demand. I wish to appeal to the public and to have my pictures exhibited in spite of the jury. My desire does not seem to me extravagant, and if you ask any of the painters who find themselves in my position, they will all reply that they disown the jury and that they wish to take part in one way or another in an exhibition which should be open as a matter of course to every serious worker.

" Therefore let the Salon des Refusés be re-established. — Should I find myself alone in my demand, I sincerely desire that the public at least should know that I no longer wish to have anything more to do with these gentlemen of the jury than they seem to wish to have to do with me.

" I hope, Monsieur, that you will not choose to remain silent. It seems to me that any polite letter deserves an answer.

" Accept, I beg you, the assurance of my most cordial regard.

<div align="right">Paul Cézanne</div>

22 rue Beautreillis "

Whether Cézanne ever received a reply to this second letter is unknown. A curt note was written on the margin:

" What he asks is impossible. We have come to realize how inconsistent with the dignity of art the Exhibition of Refusés was, and it will not be re-established."

In spite of the indignant tone of his letter, Cézanne does not seem to have taken his own determination not " to have anything more to do with these gentlemen of the jury " very seriously. His

desire for official recognition was stronger than his sense of injustice. The following spring he sent his offerings to the Salon as before, and he continued to send pictures more or less regularly for many years thereafter. The result was always the same. Zola wrote to Antony Valabrègue on April 4, 1867:

" A few items of news to end with: Paul is rejected, Guillemet is rejected, everyone is rejected; the jury, irritated by my *Salon,* has thrown out everybody who follows the new road."

The *Salon* referred to was a series of articles on contemporary art and artists contributed by Zola to the review *L'Événement* in 1866. It is said that the notes for these articles were supplied by Guillemet, who was a far better critic than he was a painter. The essays were printed over the pseudonym " Claude." In them Zola vigorously attacked and successfully demolished — at least in his own eyes and the eyes of the young painters who surrounded him, including of course Cézanne — the idols of the Academy: Meissonier, Signol, Cabanel, Robert Fleury, Olivier Merson, Debufe, and others. He even went so far as to declare that Courbet, Millet, and Rousseau, who had just begun to attain some sort of official prestige, were already out of date. At the same time he put himself on record as the valiant champion of Manet, whose work he praised in the most glowing terms; he hailed Manet as " one of the masters of tomorrow " and predicted that the *Olympia* would one day hang in the Louvre. He was a good prophet; but in 1866 this was rank heresy, and naturally Zola's articles were greeted by a storm of protest. At first the owner of *L'Événement* tried to counteract the threatened loss of circulation by publishing, concurrently with Zola's diatribes, a second series of articles by Théodore Pelloquet in which the academic painters were eulogized as unequivocally as they were damned by Zola. But this laudable display of impartiality failed to produce the desired results, and Zola's contributions were discontinued.

In 1867 Zola again took up the cudgels for Manet in an essay

published in *La Revue du XIX ᵉ Siècle,* which was reissued in the form of a pamphlet. Later this article together with those written for *L'Événement* was published under the heading *Mon Salon* in a volume of Zola's essays entitled *Mes Haines,* which he dedicated to Paul Cézanne. Zola's outspoken defence was of great benefit to Manet and to the entire movement he represented. If the writer's praise did not do much to soften the harsh judgment of the official juries, it did serve to crystallize the sometimes lukewarm and wavering support of the entire insurgent group of painters, writers, and critics.

It may seem difficult to reconcile Zola's championship of Manet in 1866 with his ardent admiration for Ary Scheffer in 1860. But in six years Zola had outgrown a great deal of his youthful sentimentality, largely through the influence of Cézanne and the other radical painters with whom he was thrown into contact. Moreover, it must be remembered that Zola's articles in *L'Événement* were inspired less by a genuine enthusiasm for the new methods of painting in themselves than by the revolt of his independent spirit against the dictatorship of established authority, whether that dictatorship manifested itself in art, literature, or politics. It was the same sort of indignant championship of the under dog that led him, years later and under vastly different circumstances, to undertake his courageous defence of Alfred Dreyfus.

PAINTING: THE FIRST DECADE: 1860–1870

To anyone familiar only with his later work, few of the pictures painted by Cézanne before 1872 would appear to exhibit any of the qualities characteristic of his fully developed style. Nearly all of his early canvases were painted with an excessively thick medium. He often used a palette-knife to flatten and spread the heavy blobs of colour, cutting into and modelling the paint with bold strokes. He called this method of painting *couillarde* — a word which is difficult to translate exactly, but which may be rendered approximately as vigorous, bold, hearty, or daring. Nothing could be more unlike the *couillarde* technique of his youthful pictures than the slow, carefully placed small brush-strokes of his maturity, laid thinly and with infinite patience one over the other, touch by touch. Fortunately the extreme *couillarde* phase lasted only about ten years. Practically all of Cézanne's really great pictures were painted after he reached the age of thirty. And fortunately too, his later canvases have survived in a far better state of preservation than the earlier ones. Today the thick unevenly dried surfaces of the older paintings are criss-crossed with innumerable cracks and seams, while in the more

139

recent ones each successive glaze of colour was put on so thinly that it dried almost instantly, before the next layer was applied, and the resulting surface is now almost as hard and imperishable as enamel.

Cézanne changed more than his technique after 1870; he modified his choice of subjects as well. During his first decade of painting, a large proportion of his canvases portrayed literary, historical, or religious scenes. Even in these early days the telling of a story was never uppermost in his mind; he was concerned primarily with the problems of painting, not of illustration. But he did make use of a literary framework in a great many instances. In the seventies even this vague leaning towards literature began to disappear. More and more he turned to the painting of landscapes, still lifes, portraits, and those strange studies of the nude known, for lack of a better name, as *Bathers* — all without any literary significance whatever.

Thus out of about seventy pictures known to have been painted before 1871 about twenty, or approximately thirty per cent, represent literary, religious, or historical subjects; whereas only fifteen of the hundred and forty-odd canvases produced during the next ten years — about ten per cent — can be said to have any such associations. And of that ten per cent the greater part are simply variations on themes which he had used before — new versions of old subjects such as *La Tentation de Saint-Antoine, La Léda au Cygne, Le Déjeuner sur l'Herbe,* and *Olympia.*

After 1880 literature vanished almost completely from Cézanne's painting. There is henceforth only an occasional unimportant reminder that he once painted pictures to which a story could, however incidentally, be attached.

The subjects of Cézanne's early " literary " pictures were of two kinds. They were either romantic, under the influence of Delacroix, or realistic in the vein of Courbet or Manet. Under the first heading come the *Jugement de Pâris,* one of his first paintings, about 1860; *L'Enlèvement, Le Festin* (which shows traces of the influence of both Rubens and Veronese) , and the

first *Léda au Cygne,* all three about 1868; and the first *Tentation de Saint-Antoine,* about 1870. Gasquet tells us that the subject of the *Tentation* was suggested by the poet Gilbert de Voisins, who urged Cézanne to draw a series of illustrations for Flaubert's *Tentation de Saint-Antoine.* Cézanne abandoned the project after making two drawings, but the subject evidently had a curious fascination for him, for he returned to it again and again.

Among Cézanne's less exotic, more realistic early " literary " paintings are the *Après-midi à Naples* and *La Femme à la Puce,* already mentioned; the strangely sinister picture known variously as *L'Autopsie, Pietà, La Mise au Tombeau,* and *La Toilette Funéraire,* which is ascribed by Eugenio d'Ors to 1860, by Meier-Graefe to 1869, and by Georges Rivière, in his chronological list of Cézanne's works, to 1864; *Le Déjeuner sur l'Herbe* (1867), whose title was obviously inspired by Manet's painting, but which bears little resemblance in other respects to its more famous prototype; several versions in various mediums of an *Olympia* which, like the *Déjeuner,* owes little more that its name to Manet; *Le Meurtre,* and the curious composition known as *L'Âne et les Voleurs,* both painted about 1870.

There is a strange, somewhat repellent mysticism about some of these early pictures that is almost entirely lacking in Cézanne's later work. The wildness of many of these imaginative compositions, the tortured attitudes of the figures, betray the feverish turmoil of his spirit at this time; the furious strokes and slashes of colour reveal the intensity of his struggle to express his emotions in a recalcitrant medium. The choice of some of his subjects also bears witness to the streak of morbidity in the young Cézanne which is so ruthlessly exposed by Zola in the character of Claude Lantier. But whereas Lantier's gloom became intensified as he grew older, Cézanne soon outgrew his tendency towards the macabre.

The remaining seventy per cent of the pictures of this first decade are not even faintly " literary." He painted a long series of portraits in the sixties, including one or two of himself (prob-

ably no other painter except Rembrandt executed as many self-portraits as Cézanne); two or three of his mother; a portrait of his father seated in an armchair, full-face, reading a paper; a small sketch of his sister Marie; two portraits of Antony Vala-brègue and two of Fortuné Marion; the fine study, painted about 1865, of the Negro Scipio, who was also the model for Philippe Solari's ill-fated statue of the *Nègre Endormi;* the magnificent portrait of the dwarf Achille Emperaire (Plate 5), painted at Aix about 1868; and portraits of Zola and of Mademoiselle Alex-andrine-Gabrielle Meley, with whom Zola was living and whom he married in 1870.

Cézanne also produced a few still lifes during these years. His fondness for this type of painting manifested itself early and lasted until his death. To a man of his nervous, high-strung tem-perament the *nature morte* offered numerous advantages over the living model. Apples and pears, flowers and napkins, knives and bottles " stayed put "; they did not get tired at inconvenient moments, they did not lose the pose or distract the painter by chattering, they were always on the spot when wanted. And they presented the same fascinating, elusive problems of composition, colour, and texture as the human figure. One of the earliest sur-viving still lifes is the *Pain et Œufs* painted about 1866; this was followed by the *Tête de Mort et Bouilloire* about 1868 — the skull always attracted Cézanne as a subject, not so much for its gruesome associations as for the problems of light and shade and volume presented by its rounded form — and the *Nature Morte à la Pendule* about 1870.

On his excursions to the environs of Paris Cézanne made nu-merous sketches for landscapes, but practically none of them were developed into finished pictures at this time. He did paint several landscapes at L'Estaque, a manufacturing suburb of Marseilles, during his periodic trips to Provence between 1866 and 1870; but it is probable that these pictures were executed in his studio from notes made out of doors. The colouring of these early land-scapes — indeed, the colouring of all of Cézanne's pictures at

this period — is generally very subdued and low in key. It was not until 1872, when he began to paint regularly in the open air with Pissarro, that Cézanne adopted a palette of lighter tones.

At least one or two studies of *Bathers* — nude figures posed against a background of trees — were painted as early as 1866. One of these studies was probably submitted to the Salon of 1865 or 1866; possibly it was the picture referred to in Cézanne's letter to Pissarro quoted above, but the suggestion cannot be verified. Thus every category of painting which was to make up the sum total of Cézanne's later work — landscapes, still lifes, portraits, and nudes — had begun to make its appearance, at least in embryo, during the sixties, in addition to the more literary type of picture which he abandoned almost entirely after 1872.

Cézanne also produced a quantity of water-colours and drawings during these early years, and water-colour continued to be a favourite medium for notes and sketches throughout his life. He spent much time in the Louvre and frequently copied there, but as only one or two of these early copies seem to have survived we do not know which paintings he elected to reproduce. We do know however from his own statements that the masters he admired with the greatest enthusiasm were Rubens, Tintoretto, Veronese, and Poussin. These four, with the more nearly contemporary Delacroix, Courbet, and Manet, and afterwards Pissarro, were the painters who influenced Cézanne most profoundly. There are also many traces of Daumier in his early work, notably in such canvases as *Don Quichotte, Le Meurtre, and L'Âne et les Voleurs.*

There remains one curious group of paintings belonging to Cézanne's early period. This is the series of panels painted in oils on the walls of the large salon in the Jas de Bouffan between 1862 and 1869, some on canvas and some directly on the plaster panels.

In 1907, the year after Cézanne's death, Monsieur Granel — who had purchased the Jas in 1899 — generously offered to present these early murals to the State with the idea of having them

placed in the Luxembourg. Léonce Bénédite, curator of the Luxembourg, who was spending the summer in Provence, was delegated by the Director of the National Museums to inspect the paintings in order to determine whether or not the offer should be accepted. The correspondence preserved in the archives of the Louvre reveals an amazing ignorance concerning Cézanne on the part of the Director. He does not know whether the pictures in question are in Paris or at " Pas de Bouffan " (*sic*), which he seems to think is the name of a town. Such was Cézanne's fame in official circles as late as 1907!

Monsieur Bénédite wrote a long report (*Archives du Louvre, P. 30, 1907, 3 décembre*) to his superior, strongly recommending that the murals be refused. Though he is careful not to commit himself too definitely as to Cézanne's status as a painter — still a subject of bitter controversy at that time — his own unfavourable opinion of Cézanne's work is but thinly disguised beneath the suave phrases of the letter.

It is not however for the purpose of holding up to the ridicule of a later generation the curator's failure to appreciate Cézanne that I reproduce his report here. Happily Cézanne's reputation is no longer in need of defence by such tawdry methods. But the report deserves publication on quite different grounds: it contains a clear and detailed description of the paintings in the salon of the Jas de Bouffan, which enables us to visualize the room as it must have looked when the house was occupied by the Cézanne family.

And as a matter of fact Monsieur Bénédite — however bigoted his views concerning Cézanne's work may appear to us today — was quite right when he said that " to represent him by empty and banal productions . . . would be a strange way to do him honour." While his judgment of Cézanne's youthful efforts may seem unduly harsh, the pictures in question were certainly painted long before Cézanne had begun to find himself and are in no sense representative of his best work. If the function of a public museum be solely the exhibition of the finest available examples

144

of the work of the masters, then the curator was justified in rejecting the murals of the Jas de Bouffan on behalf of the Luxembourg. Undoubtedly there is much to be said for this viewpoint; at the same time it cannot be denied that even the immature, imperfect works of a great artist are of considerable interest and genuine value to students, if not to the general public. A study of such early, often crude attempts to solve the problems of painting — or of any art — often leads to a deeper understanding and appreciation of the productions of riper years. From this angle Monsieur Bénédite's short-sighted refusal to accept Cézanne's murals for the State must always be regretted.

The report follows:

> *" 25 November 1907*
> *National Museum of the Luxembourg*

" The Curator of the National Museum of the Luxembourg, to the Director of the National Museums and of the School of the Louvre, Member of the Institute,

" I have visited Aix-en-Provence, near Marseilles, from August 23 to 25, for the purpose of inspecting the paintings by Cézanne which M. Granel, wine-grower, residing at the Jas de Bouffan, has offered to the Luxembourg Museum.

" The Jas de Bouffan is Cézanne's own house, and the paintings in question are intended as part of the decoration. They are all located, in fact, in the same room, a fine large salon in the style of Louis XIV, which still retains a few delightful traces of the time when this property was a country-house belonging to the Maréchal de Villars, a marble medallion of whom crowns the entrance doorway.

" At the end opposite the windows this large salon is terminated by a semicircular alcove. This apse is decorated with five tall narrow paintings.

" In the middle, a portrait of a man dressed in black, with a cap on his head, seated with his profile turned towards the left, painted in practically two colours only, and executed in an alto-

gether wild [*farouche*] manner. It is Cézanne's father.

" Alongside of this picture are four panels representing the four seasons.

" *Spring* is symbolized by a young woman, in a red dress, descending the steps of a garden and holding a garland of flowers. In the background is seen a decorative urn under an early morning sky in graded tones, running from rose to blue.

" *Summer* is a seated woman, a sheaf of wheat on her lap, with a heap of fruit, melons, figs, etc., piled at her feet.

" *Autumn* carries a basket of fruit on her head, and *Winter* is a woman seated before a fire, at night, under a cloudy sky, part of which is sprinkled with stars.

" These paintings, awkwardly and immaturely executed, in a conventional manner closer to the detestable imitations *à la* Léopold Robert than to the modern so-called ' Impressionist ' tendencies, were painted on the wall at an early date. And the artist, who does not seem to have had any illusions about their value, which is to his credit, has signed them derisively: *Ingres.*

" Near the fireplace, to the right, on the wall opposite the entrance, a *scène galante* in the style (?) of Lancret [it was a copy of *Le Bal Champêtre* by Lancret], but of unusual dimensions, entirely fills one panel, an enlargement or interpretation of some old engraving. The figures, half life-size, are seated under a group of trees, near a tall pedestal supporting the bust of a woman. In the foreground two figures, a man and a woman, appear to be executing a dance step.

" To the left of the doorway of the salon — that is, on the wall opposite the fireplace — the panel is completely covered by an immense landscape also in the style of the eighteenth century, great leaning cedars, with excessively thick trunks, painted in the spirit of Boucher's decorative backgrounds. Farther to the left, against a heavy black background, there stands out obtrusively the nude torso of a man, seen from behind, executed in a coarse manner.

" To the right of this doorway, also on a blackish background,

146

is a religious scene: Christ bending over a group of kneeling beggars; a scene painted apparently under the influence of El Greco, in whites and greys on a black background. These figures are a little less than life-size. At the bottom of this picture, to the left, two life-size heads representing a bearded man and a woman, which have no connection with the preceding scene. On the right is still another figure, also life-size, in an attitude of prayer.

" Finally, beneath the *scène galante* described above, is a large head with long hair, moustaches, a tuft of hair under the lower lip, and a small beard on the chin, which is the portrait of a painter of Aix, a sick little dwarf, of the name of Emperaire, of whom Cézanne painted several other portraits, among them the one exhibited at the last Salon d'Automne.

" In addition to this collection of ' decorations,' I may also mention, in the studio located on the top floor of the villa, a small canvas representing women dressed in the fashion of the Second Empire, out for a walk, which seems to have been painted from some reproduction in an illustrated paper.

" With the exception of this last canvas, all of the pictures are painted directly on the walls. But M. Granel, whose generosity is beyond question — for he has been offered a very large price for these pictures: 100,000 francs, he told me, for the *Four Seasons* — M. Granel . . . has offered to have them taken off the walls.

" I have dissuaded him from doing so. For I am obliged to decide absolutely against the acceptance of this liberality. I do not wish to discuss here either the talent or the works of Cézanne. Moreover, is he not already represented in the Luxembourg in the Caillebotte bequest?

" I abstain therefore from venturing on this ground, but whatever may be one's opinion of the work of this painter, one cannot deny that to represent him by empty and banal productions which he does not appear to have taken seriously himself, would be a strange way to do him honour.

<div align="right">Léonce Bénédite "</div>

<div align="right">147</div>

Having been thus effectively snubbed by the curator of the Luxembourg, Monsieur Granel very wisely accepted the offers of the various private collectors who were willing to pay good money for the pictures he had tried unsuccessfully to give away. One by one the painted plaster panels were carefully stripped from the walls, backed with canvas, and sold. Today only one of these early murals remains in place: the enlarged, rather free copy of Lancret's *Bal Champêtre*. The plaster is badly cracked and warped by dampness, and the picture is in imminent danger of disintegration.

Coquiot tells us in his biography of Cézanne that when Monsieur Granel took possession of the Jas de Bouffan he found a number of pictures and drawings by Cézanne piled up in the studio, where they had been abandoned by the painter; and that the new owner, believing them to be worthless, had them all destroyed. Only the frames were saved, because they were of wood and could be used again. This story does not ring true. The Bénédite report proves, on the contrary, not only that Monsieur Granel appreciated Cèzanne's paintings so highly that he considered even the most immature of them entitled to an honoured place in the Luxembourg, but also that he was fully aware of their value in hard cash.

The four panels of the *Seasons* described by Monsieur Bénédite are unusual in that the outlines of the figures and of their decorative and symbolic attributes are rigidly, even meticulously drawn; they are in marked contrast to Cézanne's other paintings, youthful or mature, in all of which the contours are relatively vague and indistinct. At first sight this uncharacteristic emphasis on the carefully drawn line suggests that Cézanne at the very beginning of his career was genuinely influenced by the neoclassic doctrines of the academies. It is quite possible that the *Seasons* were an experiment undertaken in all seriousness; but if so, the young painter's academic mood did not last long. The irreverent signature *Ingres* at the bottom of each panel certainly

seems to have been added in a spirit of mockery rather than of emulation. It was a gesture not only of contempt but of defiance: the nose-thumbing of a rebellious youth in the face of the aged but still powerful dictator of French official art.

The *Seasons* have generally been ascribed to 1863, but it is doubtful if Cézanne spent any part of that year in Aix. There is no documentary record of a visit to Provence between November 1862 and July 1864. If he was in Aix at all in 1863 it can only have been for a very short time. Hence either 1862 or 1864 is a more likely date for these panels. Rivière says that Cézanne's sisters posed for the figures of the *Seasons*. It is probable that his older sister Marie did sit for him; but it is unlikely that Rose, who was born in 1854, could have served as a model.

Whether or not the *Four Seasons* were intended as a joke, Monsieur Bénédite was hardly justified in his assumption that Cézanne did not take any of these murals seriously at the time he painted them. The religious painting certainly shows every evidence of deep sincerity, especially if we bear in mind Cézanne's simple piety; it is exceedingly unlikely that he would have painted a religious subject in anything but a reverent spirit. The portrait of Louis-Auguste, set in the place of honour in the centre of the alcove between the two pairs of *Seasons,* also has all the earmarks of sincerity. Even had he felt so inclined, the young Cézanne, dependent as he was on his father's bounty and always somewhat in awe of the domineering old man, would scarcely have dared to portray him on the walls of his own salon without invoking all the soberness of mind at his command. The portrait is, in fact, a perfectly serious study. Judging from photographs of Louis-Auguste it is also an excellent likeness, and both the pose and the expression are characteristic of the old banker. The brushwork is bold and vigorous, but Monsieur Bénédite's description of the technique as " *farouche* " seems decidedly exaggerated.

The portrait of Achille Emperaire mentioned in the report is not the familiar one reproduced in this book (Plate 5). The

149

latter canvas is a full-length portrait of the dwarf seated in a high-backed armchair, while the smaller and presumably earlier wall painting depicts the head only.

The " nude torso of a man, seen from behind, executed in a coarse manner " is no doubt the picture that provoked Louis-Auguste's scandalized protest, as reported by Coquiot: " See here, Paul, you have sisters; how could you paint a large nude figure on the wall? " To which Paul is said to have replied: " Well, haven't my sisters got bottoms like you and me? " Coquiot, however, says that the offending nude was a woman, which is probably an error. Bénédite's official report is more likely to be accurate.

It is curious that the curator of the Luxembourg gallery did not recognize the source of the religious painting which he describes as " Christ bending over a group of kneeling beggars; a scene painted apparently under the influence of El Greco." This picture, which is generally called, erroneously, *La Résurrection de Lazare,* is in fact derived from Sebastiano del Piombo's *Christ in Limbo,* of which masterpiece Cézanne's wall panel — or, more accurately, the left half of it — is almost a direct copy. The figures of the bearded man and the woman in the lower left-hand corner of the picture, far from having " no connection with the preceding scene," represent Adam and Eve in the Italian original, and presumably in Cézanne's copy as well.

Obviously El Greco had nothing to do with the *Christ in Limbo,* but the introduction of his name in the Bénédite report brings up an interesting point. Several of Cézanne's early pictures do seem to bear a distinct, if superficial, resemblance to the works of the great Cretan, not only because of the predominance of blacks and greys, but also in the strangely distorted and attenuated drawing of some of the figures. Perhaps the most striking example of this likeness is to be found in one version of *Le Déjeuner sur l'Herbe.* The standing figure in particular might have stepped directly out of a canvas by El Greco. Yet it is most unlikely that Cézanne had ever seen an original painting by El Greco at that time. Of the three Grecos now in the Louvre, the

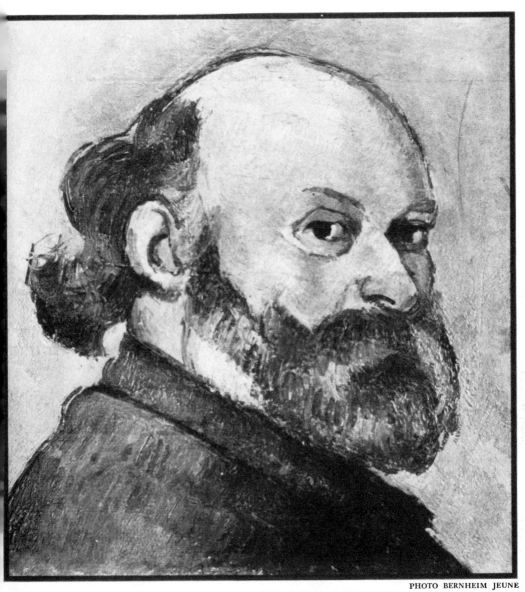

13. PORTRAIT OF THE ARTIST
ABOUT 1880 (?)

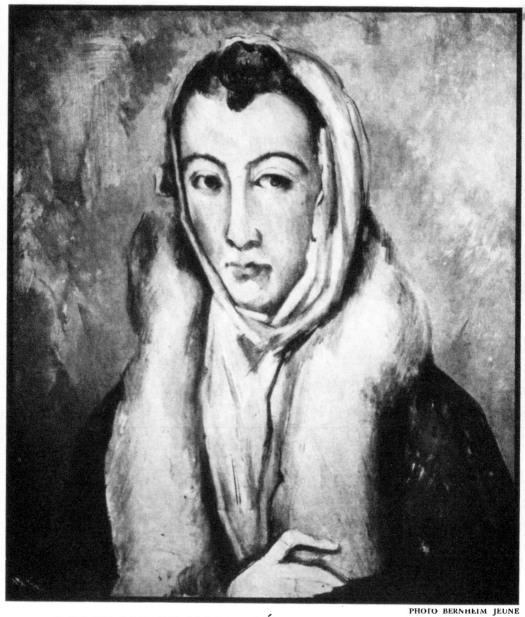

14. PORTRAIT OF MARIE CÉZANNE WITH A FUR BOA

ABOUT 1879

first was not acquired until 1893. Cézanne never went to Spain, so it is hard to see how he could have studied the works of that master at first hand. El Greco was scarcely known outside of Spain in the eighteen-sixties, and reproductions of his work must have been exceedingly rare at that time, if they existed at all. Possibly Cézanne had acquired some slight knowledge of El Greco through Manet, who had visited Spain; but Manet appears to have been much more deeply impressed by Velázquez and Goya than by the Cretan mystic. All in all, a more plausible source of the Grecoesque quality in these early paintings is Tintoretto, who also painted distorted figures at times, who exerted a profound influence on El Greco himself, and with whose work Cézanne was certainly familiar both in the original and in reproductions.

There is evidence that Cézanne did become acquainted with El Greco's painting at a somewhat later date. One of his pictures (Plate 14), a portrait of his sister Marie with a scarf around her head and a fur boa draped over her shoulders (ascribed by Rivière to 1879), is almost unquestionably derived from El Greco's *Lady of the Ermine*. It is not a direct copy, but a very free interpretation; yet the general pose, the draping of scarf and neckpiece, and the unusual position of the hand are all so much alike in the two canvases that the source of Cézanne's composition can hardly be doubted. This is not conclusive proof, however, that Cézanne was actually an admirer of El Greco. For many years the authorship of *The Lady of the Ermine* was uncertain; it was frequently ascribed to Tintoretto, and when Cézanne copied the pose in his own picture he may well have been unaware that he was using an El Greco as his model.

PARIS AND PROVENCE:
1863–1869

DURING the winter of 1863–1864 Cézanne worked from time to time at a copy of a painting by Delacroix. Rivière believes this to have been *Agar dans le Désert,* but it is impossible to identify the picture definitely. Cézanne admired Delacroix above all other nineteenth-century painters. It is significant that he made copies — or rather more or less free interpretations — of a number of canvases by Delacroix, whereas he was never tempted to copy the works of other modern painters, such as Courbet or Manet. The copy of the Delacroix is mentioned in a letter from Cézanne to his friend Numa Coste, who was unfortunate enough to have been drawn for military service according to the system of selective draft by numbers then in use. Cézanne himself had escaped the draft a few years earlier; either his number had not been drawn or a substitute had taken his place. The *" école des bozards "* is of course a contemptuous reference to the Beaux-Arts; the tone suggests that the rejection of Cézanne's application for admittance to the school had occurred a little while before:

<div align="right">

" Paris, 27 February 1864
</div>

" *Mon cher,*

" You must excuse the paper on which I am answering your

letter. At the moment I haven't any other. — What shall I say about your bad luck, it is a great calamity that has befallen you, and I can understand what a nuisance it must be for you. . . .

" A suggestion (Baille was with me yesterday evening when I received your letter): if by any chance you wanted to forestall the draft and could come to Paris to enter the military service here, he (Baille, I mean) could recommend you to the lieutenant of your corps, as he tells me he knows a number of officers who graduated from the same school as himself, and also from the school of Saint-Cyr. What I am saying here applies only in case you are thinking of coming here, where you would have, even while in the army, more opportunities in every way, both on furloughs and during spells of light duty, to devote yourself to painting. It is for you to decide, and see if the idea pleases you, and yet I know that the prospect is not at all cheering. . . .

" As for myself, *mon brave,* my hair and beard are longer than my talent. Still, no discouragement about painting, one can do one's own little bit, even though one is a soldier. I have seen some of them here who attend the anatomy lectures at the *école des bozards* (which, as you probably know, has been mightily changed and which has been separated from the Institute). . . . I haven't touched my [illegible word] after Delacroix for the last two months.

" I shall work at it again however before I go to Aix, which I do not think will be before the month of July, unless my father sends for me sooner. In two months, that is to say in May, there will be an exhibition of paintings like that of last year, if you were here we could visit it together. . . ."

Coste followed Cézanne's advice and passed the seven years of his military service in Paris. The beard that Cézanne describes modestly as being " longer than his talent " evidently did not find favour in the eyes of his lady friends — such as they were — for in a letter to Valabrègue dated April 21, 1864, Zola inserts the gossipy item:

" Cézanne has had his beard cut off and has sacrificed the tufts on the altar of victorious Venus."

Cézanne returned to Aix about the beginning of July 1864. This time there was no more talk of law or the bank; Louis-Auguste had swallowed his disappointment and had resigned himself to the idea that his son was going to be a painter. The banker's capitulation was never more than passive. He could not bring himself to approve whole-heartedly of Paul's unfortunate choice of a career, nor did he ever take the least interest in, or show the least understanding of, the painter's work, theories, and ideals.

But if Cézanne received no active encouragement from his father, and only a vague, uncritical, though sincerely affectionate support from his mother and sisters, at least he was let alone and allowed to paint as and where he pleased. He had his studio on the top floor of the Jas de Bouffan, where he could work undisturbed and which nobody was allowed to enter even to straighten up the disorderly jumble of easels, paints, brushes, and still-life properties that filled every corner of the room. He painted on the walls of the salon downstairs, in the garden, in the environs of Aix, at L'Estaque near Marseilles, where the combination of red tile roofs and factory chimneys with the flat expanse of blue sea and the distant hills offered him an endless series of *motifs,* as he called his outdoor subjects. In general he was contented in the Midi, except when a fit of discouragement seized him and in a sudden rage he slashed his unlucky canvas through and through with a knife because he felt himself incapable of translating into coloured forms the scene or object he was painting.

Yet his sojourns at home were not altogether free from minor annoyances. His eccentricities did not fit well into the conventional frame of bourgeois family life. He was not, in practice, at liberty to come and go entirely as he pleased, without explanation; he was not his own master. At times his mother's affectionate solicitude was no less oppressive than his father's severity. His

parents could not understand the restlessness that sent him flying off to Paris periodically after a few months in the south. Each time he left, there was something of a scene; and each time he stayed away, he was urged to come home. Vollard quotes the following extract from a letter to his family; the date is not given:

" It is only that when I am at Aix I am not free; that whenever I want to return to Paris, there is a struggle to be gone through, and although your opposition is not very tyrannical, I am greatly upset by the resistance I feel on your part. I could wish with all my heart that my liberty of action were not interfered with, and then I could hasten my return to you with all the more joy; for I should very much like to work in the Midi, where the views offer so many opportunities, and I could make the studies I should like to undertake."

The *grappin* again.

Early in 1865 he was in Paris once more. This time he took lodgings on the right bank near the Bastille, at 22 rue Beautreillis. Here he lived for the next two years. Apparently his friend Oller had a room in the same house for a while; in the catalogue of the Salon of 1865 — the Salon to whose doors Cézanne had helped him to carry his *Tenèbres* — Oller's address is given as 22 rue Beautreillis. But on the whole Cézanne preferred the other side of the river. In 1868 he moved to the rue de Chevreuse, and a little later to the rue de Vaugirard, where he remained until the outbreak of the war in 1870.

Cézanne spent the winter of 1865–1866 in Provence, returning to Paris in the spring. The periodic changes from city to country, the alternations of north and south, seemed to satisfy some need of his uneasy spirit. Each time he moved he felt refreshed for a while; when his surroundings began to pall he was off again. Even when he made Paris his headquarters he made frequent trips to the suburbs or the nearby countryside to paint.

Much more rarely he laid his brushes aside for a few days and

155

went off with his friends for a simple holiday. One such excursion took place during the summer of 1866 in the company of Zola, Baille, Solari, Valabrègue, and Marius Roux. They went to Bennecourt, on the Seine between Paris and Rouen, and spent a gay week or two canoeing on the river, swimming, fishing, and walking. It was almost like the old days at Aix, and all did their best to recapture the spirit of those youthful expeditions and to forget that they were now dignified grown men of twenty-five or so. The holiday at Bennecourt provided Zola, twenty years later, with the background of the most idyllic episode in *L'Œuvre,* the honeymoon of Claude and Christine. And as a matter of fact there really was a sort of honeymoon on the excursion to Bennecourt, but it was Zola's honeymoon, not Cézanne's. The party included Mademoiselle Meley, with whom Zola was living and to whom he already referred as his wife, although they were not married until 1870.

Earlier in the summer of 1866 — on June 14 — Zola had written to Numa Coste:

"I am leaving immediately for the country, where I shall meet Paul. Baille is going with me, and we shall be away from Paris a week. . . .

"Paul has been rejected [at the Salon] as was to be expected, also Solari and everyone else you know. They have gone back to work, feeling certain that they will have another ten years to wait before they are accepted."

On July 26, after his return from Bennecourt, Zola wrote to the same friend:

"Three days ago I was still at Bennecourt with Cézanne and Valabrègue. They are both remaining there and will not be back until the beginning of next month. The place, as I have told you, is a regular colony. We have taken Baille and Chaillan there; we will take you there too. . . .

" Baille left for Aix last Saturday. He will come back October 2nd or 3rd. He has completed a book on physics for Hachette, the publishers, about which I think I have written you. The book will come out about the end of the year."

We do not know when the triple friendship between Cézanne, Zola, and Baille finally broke up, but evidently it had not yet come to an end at this time. The letter continues:

" Cézanne is working; he is becoming more and more firmly fixed in the eccentric course into which his nature forces him. I have great hopes for him. At the same time we expect that he will be rejected for the next ten years. At present he is trying to paint huge pictures, canvases of four or five metres. He is going to Aix soon, perhaps in August, perhaps not until the end of September. He will stay there two months at most."

Zola was too optimistic. Most of the painters who were his friends were doomed to a good deal more than ten years of waiting before they were accepted either officially or by the general public. Of them all Cézanne had to wait the longest. By the time full recognition came, more than forty years later, he was dead.

* *

In August Cézanne returned to Aix as usual, but he was back in Paris about the first of the year. On February 19, 1867, Zola wrote to Valabrègue:

" Paul is working very hard, he has already completed several canvases, and he is dreaming of immense pictures; I greet you in his name."

But soon after another repulse by the jury of that spring he was ready once more for the consolation that only his native Provence

157

could give. Zola wrote to Valabrègue again on May 29:

"Cézanne is going back to Aix with his mother in about ten days. He says he will spend three months in the depths of the country and will return to Paris in September. He is greatly in need of work and courage."

Cézanne did come back to Paris in the autumn and spent the winter there and the following spring. In May 1868 he went south again. A few days before he left he wrote to Numa Coste, who was still performing his military service in Paris, suggesting a meeting and a farewell dinner. The letter is of little interest except as an illustration of one of Cézanne's idiosyncrasies: his vagueness about places and place-names. After seven years in Paris he still confused the Pont Royal with the Pont de la Concorde. Most of the time he was equally hazy about dates, though in this particular instance he seems to have made a great effort to be precise, even to the point of fixing the exact time to the minute:

"Wednesday 13 May 1868

"My dear Numa,

"I have lost the address you gave me. I imagine that if I send this note to the Place Dupleix (in spite of the inaccuracy of the address) I shall be lucky enough to find that it will reach you. Therefore I beg you to meet me Thursday the 14ᵗʰ at 2 and a half minutes past 5 or thereabouts at the Pont Royal, I think, at the point where it goes into the Place de la Concorde, and from there we shall go to dinner together, for on Saturday I am leaving for Aix.

"If you have a letter or anything else to send to your family I shall be your faithful Mercury. . . ."

From Aix Cézanne wrote another letter to Coste which reveals

158

his sense of the isolation in which he lived and the incurable shyness that overpowered him even among old friends:

" My dear Coste,

" Several days have passed since your letter arrived and I am at a loss to know what news to tell you concerning your distant native land.

" Since my arrival I have been out to pasture in the country. But I have pried myself loose several times. I called on your father one evening, and then went there again, but did not find him in, but one of these days, at noon, I think I shall catch him at home.

" As for Alexis, he was kind enough to come to see me, having learned through Valabrègue of my return from Paris. He even lent me a little review of Balzac's of 1840, he asked after you, if you were still painting, etc. — you know, all the things one says while chatting. He promised to visit me again; I haven't seen him for more than a month. For my part, and especially since I received your letter, I have been turning my steps towards the Cours in the evenings, which is a little contrary to my solitary habits. Impossible to find him there. Nevertheless, urged on by a strong desire to fulfil my duty, I shall attempt a visit to his house. But on that day, I shall first take care to change my shoes and shirt. . . .

" I have seen Aufan a few times, but the others seem to be in hiding, and a great void seems to be created around one when one has been away from home for some time. I shall not write to you about him. I don't know whether I am living or only remembering, but everything makes me think. I wandered off by myself as far as the dam and Saint-Antonin. I slept there on the straw at the mill, good wine, good hospitality. I remembered our attempts at climbing. Shall we ever make them again? How strange life is, what changes take place, and how difficult it would be right now for the three of us and the dog to be together in the place we were in only a few years ago.

159

" I have no diversions, except the family, a few numbers of the *Siècle* from which I gather only more anodynes. Being alone, I am unwilling to venture often into a café. But behind all that, I am very hopeful. . . .

" P. S. I had left this letter unfinished when in the middle of the day Dethès and Alexis came tumbling in on me. You may well believe that we talked literature, and that we took some refreshment for it was very hot that day.

" Alexis was good enough to read me a bit of poetry that I found really very good, then he recited to me from memory several strophes of another poem, entitled *Symphonie en la mineur.* I found these verses more unusual, more original, and complimented him on them. I also showed him your letter, he said he would write to you. In the meantime I send you greetings from him, as well as from my family to whom I read your letter for which I thank you heartily, it is like a cool shower in the midst of burning sunshine. . . ."

Paul Alexis was about eight years younger than Cézanne, too young to have been numbered among his boyhood friends. Alexis entered the seventh form at the Collège Bourbon in 1857, when Cézanne was just beginning his last term there and a few months before Zola left the school to go to Paris. Influenced by Antony Valabrègue, he became an ardent admirer of Zola several years before he met him in the flesh. In 1868 Alexis sent Zola some of his verses — possibly the same ones he had been reciting to Cézanne — which Zola liked so well that he sent them to the *Gaulois,* whose critic reviewed them favourably. The following year Alexis went to Paris, where he was warmly received by Zola. He soon became Zola's closest friend and confidant and remained so until his death in 1901, a little more than a year before Zola himself died. Alexis was a minor writer of some distinction; among his works is a biography of Zola published in 1882 under the name of *Notes d'un Ami.*

Cézanne found the young writer excellent company and saw a great deal of him for about twenty years. He always referred to him affectionately in his letters to Zola as "*mon compatriote Alexis.*" On his side Alexis was sincerely fond of Cézanne, but he was even more deeply attached to Zola, and his friendship with the painter cooled somewhat after the break between Zola and Cézanne in 1886. It did not come to an end altogether; Gasquet tells us that Cézanne was occasionally to be seen drinking a glass of wine with Alexis, and as Gasquet did not become acquainted with the painter until 1896, we may assume that some degree of friendship still existed between Cézanne and Alexis until the latter's death.

The young Dethès mentioned in the above letter was a descendant of the wool-merchant in whose firm Louis-Auguste Cézanne had found his first employment at Aix fifty years before.

Late in the autumn Cézanne wrote to Coste again to announce another approaching journey to Paris. There is something pathetic as well as amusing in Cézanne's naïve efforts to remember all of the things he should do and all of the people he should call on before his departure. He was well aware that he was apt to become so deeply absorbed in his work as to neglect everything else; hence his careful, methodical little list of items to be checked off conscientiously:

"*Aix towards the end of November.*
It is Monday evening.

"My dear Numa,

"I cannot tell you the exact date of my return. But it will be very probably during the first days of December somewhere about the 15th. I shall not fail to call on your parents before I leave and I shall bring you anything you want. . . .

"I saw your father some time ago, and we went to see Villevielle. Writing about him to you made me think of going to see him and above all not to forget him at the time of my departure. But I shall write out on a piece of paper everything that I ought

161

to do and all the people I ought to see and I shall check them off as I get around to them, in that way I shan't forget anything. Your letter has given me a great deal of pleasure, it rouses one from the torpor into which one ends by falling. The fine excursion to Sainte-Victoire that we had planned fell through this summer on account of the excessive heat, and in October because of the rain, you can see clearly how much the will-power of our boyhood comrades is beginning to weaken, but what can you expect, things are like that, it appears that one does not remain full of energy for ever, one would say in Latin *Semper Virens,* always vigorous, or better yet, willing. . . .

" M. Paul Alexis, a very excellent youth, and one may say not conceited, lives on poetry and such things. I have seen him several times during the good weather, I met him again just a little while ago and showed him your letter.

" He is burning to go to Paris, without his father's consent, he wants to borrow some money on the security of the paternal resources and fly off to other skies to which he is being lured by Valabrègue, who is showing no signs of life whatever. So Alexis thanks you for having thought of him, he returns the compliment. I accused him of being a little lazy, he said that if you knew all his worries (a poet must always be pregnant with some Iliad or rather some Odyssey of his own) you would forgive him. . . .

" I am continuing to work hard at a landscape of the banks of the Arc, it is for the next Salon, will it be that of 1869? "

Further evidence of Cézanne's retiring disposition is found in the following extract from a letter written by Zola to Théodore Duret a few weeks before the outbreak of the Franco-Prussian war. Duret, who presumably had met Cézanne several times at the Café Guerbois, had asked for his address; Zola, knowing Cézanne's shyness and his need of solitude, wisely refused to allow his friend's privacy to be disturbed:

" My dear Duret,

" I cannot give you the address of the painter you mention. He keeps himself very much hidden, he is going through an experimental phase, and in my opinion he is quite right not to want anyone to come to his studio. Wait until he finds himself."

WAR: *1870–1871*

THE PRUSSIAN armies were mobilized on July 15, 1870. It is uncertain whether Cézanne was in Paris or in Provence on that date, but if he was not already in Aix when war was declared, he went there very shortly afterwards and retired to the Jas de Bouffan to work as usual. He was not in the least interested in the war. He was not particularly pacifist in theory; it is doubtful if he had any definite convictions about war in general; he was simply indifferent, as he was about all political and social matters. The war was no concern of his; he wanted to paint. And paint he did.

For some time after war broke out he was left undisturbed. The first troops mobilized in France included only men enrolled in the reserves who had already performed their terms of military service and very young men who had not yet served but who were subject to the draft. Cézanne belonged to neither class. He was now over thirty, and he had never done a day's military service in his life. When more troops were called up a little later, Cézanne's name was on the list. But he had no intention of serving if he could help it.

It is difficult to find out for certain exactly what happened. According to Cézanne's brother-in-law Maxime Conil, the *gen-*

darmes came to the Jas de Bouffan one day with orders for him to join the colours. Cézanne told his mother to open all the doors and let the *gendarmes* hunt for him; he would guarantee to keep out of sight. Familiar as he was with every nook and corner of the big house, it was not difficult for him to elude the searchers. The police left empty-handed. That night Cézanne packed up a few things and tramped over the hills to L'Estaque, about fifteen miles from Aix. And there he remained for the duration of the war.

Whether or not this account is accurate in every detail (Monsieur Conil did not become a member of the Cézanne household until 1882 and therefore was not an eyewitness of the episode, but only heard of it afterwards), it is probably substantially in accord with the facts. It is certain that Cézanne lived peacefully in L'Estaque during the war, in a little house belonging to his mother, who visited him there from time to time. He was not in hiding, but lived and painted there quite openly. Nevertheless there seems to have been no further attempt to molest him on the part of the authorities. On the face of it this neglect appears strange; but it must be remembered that in 1870 France was so ill prepared for war that there were not nearly enough rifles, ammunition, uniforms, and other military supplies to equip the troops already mobilized; therefore it would have been a waste of energy to make too strenuous an effort to round up every potential evader.

In Provence especially, recruiting was carried on in a very perfunctory manner. The Midi was hundreds of miles from the battlefields, there was no danger of actual invasion so far from the frontier; the population was much more apathetic about the war than the people of the northern and eastern provinces. Had hostilities gone on much longer there probably would have been a change in the situation and more determined efforts would have been made to draft men for the army whether they were willing or not. In that case Cézanne might have joined the colours, or he might have made a further resistance; one guess is as good as

another. But the war was over in six months, and after the one half-hearted attempt to enlist him at the Jas de Bouffan he was left to paint in peace.

Cézanne was by no means the only member of the group of contemporary painters to evade military service. Pissarro, who was living at Louveciennes near Marly, a short distance outside of Paris, fled in such haste when the district was invaded and his house about to fall into the hands of the German troops that he was obliged to abandon all of the pictures he had painted in the last three or four years. During the occupation the building was used as a slaughterhouse, and it is said that the canvases were made into butchers' aprons and afterwards burnt; two of them escaped the flames and were found after the war, covered with the blood of the slain animals. Pissarro himself took refuge at first in the department of Mayenne, and a little later in England, where he settled down to paint at Norwood until he returned to France in 1872.

Claude Monet also found himself in the zone of Prussian occupation at Argenteuil. He escaped to Amsterdam and painted Dutch canals and windmills for the duration of the war. Early in 1871 he went to England, and did not come back to Paris until after Napoleon III had abdicated and the tumult of the Commune had subsided. Nor did the other future Impressionists, Renoir and Guillaumin, serve in the army.

On the other hand Manet saw active service as an officer on the general staff of the National Guard; the young writer Paul Alexis was a corporal in the National Army; and Frédéric Bazille was killed at the battle of Beaune-la-Rolande on November 28, 1870.

As for Zola, soon after war was declared he had accompanied his wife and mother to Marseilles, intending to return alone to Paris; but the siege of the capital forced him to remain in Marseilles, where he started a little newspaper, *La Marseillaise*, in collaboration with Marius Roux. The enterprise was a failure from the start, and in December 1870 Zola went to Bordeaux, the

temporary seat of the French government, to apply for the position of sub-prefect of Aix-en-Provence. At this time he was desperately hard up; his family, waiting anxiously in Marseilles, was almost penniless. Zola's application for the sub-prefecture was rejected; but by pulling strings he was able to secure a poorly paid berth as secretary to one of the ministers in Bordeaux. The armistice was signed on January 28, 1871, and Zola returned to Paris in March in time to be twice arrested and twice released under the Commune. Since Zola spent most of the summer and autumn of 1870 in Marseilles and Cézanne was living only five or six miles away at L'Estaque, it is probable that they saw each other at times during the war, but we have no record of any specific meeting. The following summer Zola wrote to Cézanne; this is his only letter to the painter written later than 1862 that has come to light:

" Paris, 4 July 1871

" My dear Paul,

" Your letter gave me great pleasure, for I was beginning to feel uneasy about you. It is four months since we have had news of each other. About the middle of last month I wrote to you at L'Estaque. Since then I learned that you had left and that my letter had gone astray. I was really at a loss to know how to find you again when you solved the problem for me.

" You ask for news of me. Here is my story in a few words. I wrote you, I think, a short time before my departure from Bordeaux, and promised you another letter after my return to Paris. I arrived in Paris on March 14. Four days later, on March 18, the insurrection broke out, the postal services were suspended, I no longer thought of getting in touch with you. For two months I have been living in a furnace, night and day the cannon, and towards the end shells too, whistling over my head in my garden. Finally, on May 10, as I was threatened with arrest as a hostage, I took flight with the aid of a Prussian passport and went to Bonnières to spend the most critical days. Now I find myself quietly

167

at home again in the Batignolles quarter, as if I had just awakened from a bad dream. My little garden-house is the same as ever, my garden is untouched; not a stick of furniture, not a plant has been damaged and I could almost believe that the two sieges were bad jokes invented to frighten children. . . ."

15. MADAME PAUL CÉZANNE ABOUT 1900
FROM A PHOTOGRAPH

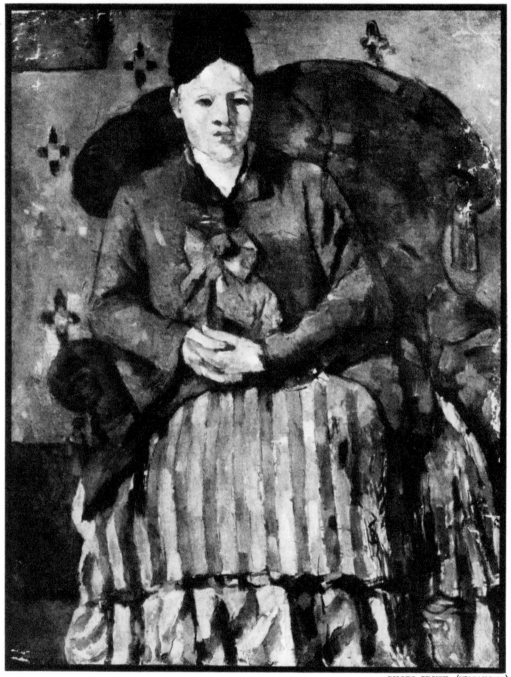

16. PORTRAIT OF MADAME PAUL CÉZANNE

ABOUT 1880 (?) . ROBERT TREAT PAINE 2ND COLLECTION, BOSTON

HORTENSE FIQUET

ZOLA's letter informs us that Cézanne left L'Estaque very soon after the armistice, but it does not tell us where he went. It is almost certain, however, that he returned to Paris early in the spring of 1871; in any case we know that he spent the greater part of that year either in the capital or in the nearer suburbs. This time he was drawn to the north by something more than his usual restless desire for a change of scene. A woman was waiting for him in Paris, the woman who afterwards became his wife: Hortense Fiquet.

They had met before the war, but practically nothing is known of the circumstances in which they first became acquainted. Marie-Hortense Fiquet was born in the village of Saligneil, in the Jura, on April 22, 1850. Her father, Claude Antoine Fiquet, was employed in a bank; probably as a clerk or in some similar minor capacity, though Hortense, whose naturally lively imagination was stimulated by the constant reading of romantic novels, was inclined to exaggerate the importance of her father's position whenever she talked of him in after years. The Fiquet family moved to Paris when Hortense was a child. Her father's income was small and Hortense earned her own living by sewing hand-made books. According to some accounts she supplemented her

wages by posing as a model; but whether this is a fact or merely a legend invented to account for her first meeting with Cézanne has never been definitely established.

For several years Cézanne kept his father in ignorance of his relations with Hortense. He knew that Louis-Auguste was not likely to consent to his marriage to a dowerless girl, and that he would disapprove of any irregular arrangement; the old banker would be sure to assume that his son was in the clutches of a designing woman who was after his money, and he was quite capable of cutting off the allowance that made it possible for Cézanne to go on painting. He did however take his mother into his confidence; she could be trusted to keep the secret. Probably most of Cézanne's friends also knew all about the situation. Certainly Zola did, on the evidence of later correspondence between him and the painter.

Cézanne's only child was born in Paris on January 4, 1872. The baby was named Paul after his father and immediately registered at the *mairie* of the fifth *arrondissement,* just as Cézanne himself had been acknowledged by Louis-Auguste thirty-three years before. Cézanne adored his son. His letters to Zola betray his tender solicitude for the boy's health; every childish ailment alarmed him intensely. And later as young Paul grew to manhood Cézanne came to depend on him more and more, to rely on his judgment in business transactions and all other matters in which he felt himself to be " *faible dans la vie.*" For Paul junior inherited no trace of either Cézanne's genius or his temperament. In character he resembled his mother: he was cool, conventional, and matter-of-fact.

In spite of frequent separations the relationship between Cézanne and his son was exceedingly close. Hortense was never very happy in the Midi; she preferred the more sociable atmosphere of the capital to the provincial dullness of Aix, which she found depressing. Therefore she spent a considerable part of her time in Paris, and naturally young Paul remained with her rather than with his father. He went to school in Paris; but during the sum-

mer vacations the family was generally reunited at Aix when Cézanne was painting there, and at other times of the year whenever Cézanne paid one of his periodic visits to the north.

Cézanne carried on a constant correspondence with his son. He wrote to him every few days, but unfortunately all of these letters except the last sixteen have been destroyed. The few that survive cover the last three months of Cézanne's life, and their tone bears witness to the deep affection existing between the two as well as to the dying painter's dependence on young Paul. Thus on August 14, 1906, he writes: " It is always up to you to manage our affairs "; on September 22: " I find myself more and more obliged to lean on you, and to be guided by you "; and on September 28: " You are the only one who could comfort me in my unhappy state of mind. So I commend myself to you."

Very little has been written about Cézanne's marriage, but there have been a great many more or less veiled insinuations concerning Hortense's shortcomings as a wife. It has been suggested that she was selfishly indifferent to Cézanne's wishes, that she neglected him, that in short the marriage was an unhappy one. It is practically impossible to determine how much truth there is in these vague charges, but there is very little evidence to support them. It is almost certain that Hortense took only the most casual interest in Cézanne's work, and that she had no conception of his genius; but she seems to have understood her husband's difficult character well enough, and on the whole their life together appears to have been at least reasonably harmonious. If Hortense elected to lead her own life in Paris for several months at a time, the arrangement probably suited Cézanne quite well. From what we know of his intense need of solitude, of his irritable fretting at any tie or bond that threatened his own-freedom of action, we may safely assume that a more clinging, less independent wife would have proved an intolerable *grappin*.

None of the correspondence between Cézanne and Hortense has been preserved, but his references to her in his last letters to young Paul are invariably affectionate. Nearly all of the letters

end with the phrase: " I embrace you and your mother with all my heart "; and on July 25, 1906, he wrote on hearing that Hortense had been ill:

" Yesterday I received your letter giving me news of yourselves, I am distressed to hear of your mother's condition, give her every possible care, look out for her comfort, seek a cool temperature and such diversions as are appropriate in the circumstances."

Although Hortense failed to appreciate Cézanne's painting, she did render an immense service to his art by consenting to pose for him as often as he wished. He painted her at least a dozen times between 1874 and 1891, in different dresses and against various backgrounds. In the earliest portraits she is depicted as a slim young girl with a delicate oval face; in the succeeding ones as a woman in early middle age with a squarer, heavier jaw and a more matronly figure. And in all of the pictures there is the same grave, calm, almost stolid look about the mouth and eyes. But the placidity which seems so characteristic of Hortense in her portraits was really only skin deep. She was actually far more animated and volatile than her pictures suggest. She loved to talk, and she talked a great deal. And she detested posing, hated the long hours she was obliged to spend sitting rigidly — and what was worse, silently — in one position. As a matter of fact her apparent serenity was no more than bored resignation. But she realized that it was almost impossible for Cézanne to find a model who neither irritated him to frenzy by wriggling about and chattering nor frightened him by a display of overbold manners — for he was morbidly nervous and timid with women all his life. Hortense felt that it was her duty to pose for him, however much it might bore her. She could force herself to sit still and keep her tongue quiet if she had to, and moreover she was generally available when Cézanne needed her — a vital consideration to a painter who worked so slowly and who required so many sittings to complete a picture.

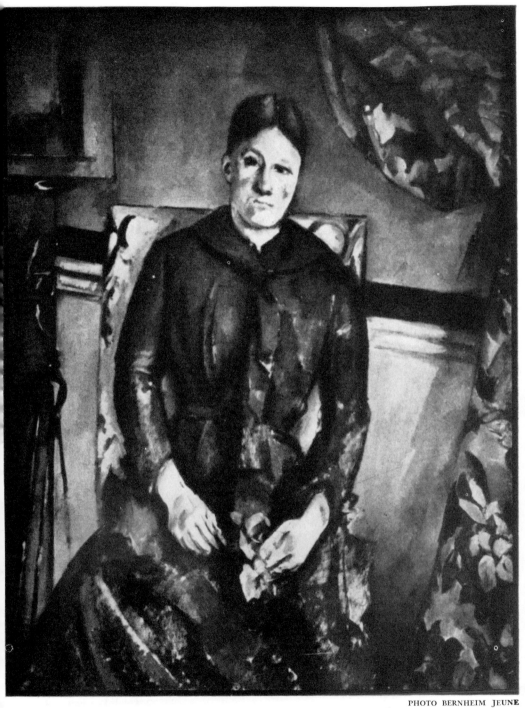

17. PORTRAIT OF MADAME PAUL CÉZANNE
ABOUT 1888. PELLERIN COLLECTION

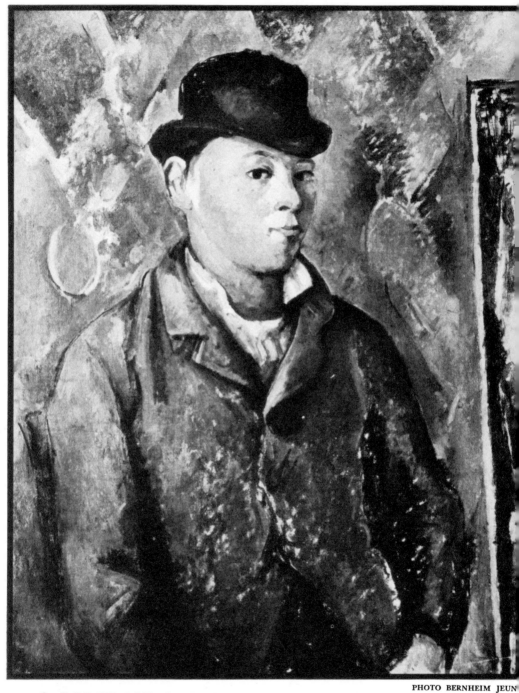

18. PORTRAIT OF THE ARTIST'S SON AT THIRTEEN
1885. CHESTER DALE COLLECTION, NEW YORK

It has been claimed that many of the portraits labelled *Madame Cézanne* are not portraits of Hortense at all; that they are really pictures of Cézanne's sister Marie. With one or two possible (though not probable) exceptions among the earlier portraits, I can find no adequate support for this suggestion. The face of Marie Cézanne in the photograph on Plate 2 is obviously not that of the model who posed for the portraits. Unfortunately no satisfactory photograph of Hortense as a young woman exists for purposes of comparison; but the one reproduced on Plate 15, though taken about ten years after the last of Cézanne's portraits of her was painted, still bears such an unmistakable resemblance to nearly all of the paintings in the series that one cannot fail to identify the sitter as the artist's wife.

AUVERS–SUR–OISE: 1872–1874

WHEN Cézanne returned to Paris in 1871 he found that the little group of painters with whom he had been more or less closely associated had been scattered by the war. There were no more reunions at the Café Guerbois. Manet remained in Paris, but Cézanne had never been really intimate with Manet; their relations were always somewhat formal and they saw each other rarely. Monet went back to Argenteuil after his sojourns in Holland and England. Sisley was at Voisins; Pissarro at Pontoise; Bazille was dead.

Cézanne was not content to remain in Paris for many months at a time. The noise and bustle of the city disturbed him; he wanted to spend at least part of the year in the country, painting landscapes. Heretofore his desire for rural surroundings had been satisfied by periodical trips to Provence. But now he could no longer move about so freely. He did not want to leave Hortense and little Paul, and he could not very well make the long journey to the Midi with a small baby; moreover, if he had taken his family south his father would certainly have learned all about his domestic arrangements. In 1872, therefore, he made up his mind to move with Hortense and the child to Auvers, a village on the banks of the Oise about twenty miles from Paris.

174

His decision was influenced by the fact that Pissarro was living with his wife and children at Pontoise, within easy walking distance of Auvers. Cézanne had always found the dignified, simple painter more congenial than most of his other contemporaries, and during the next two years he paid frequent visits to Pissarro at Pontoise, where he was received without ceremony and treated as one of the family. It was a peaceful, unpretentious household and Cézanne, shy as he was, felt more at ease there than he generally did in the homes of his acquaintances. Pissarro himself was an unusually tactful, kindly man, who understood his friend's quirks and thorny temper and who skilfully avoided discussions that were likely to cause explosions; and Madame Pissarro seems to have been equally considerate of her guest's sensitive feelings. There was no ominous *grappin* here to frighten him into his shell.

The following note, unimportant in itself, indicates by its reference to domestic details the simple informality of Cézanne's relations with the Pissarro family. Lucien and Georges were Pissarro's sons, then small children:

" Monsieur Pissarro,

" I am using Lucien's pen, at an hour when the railway should be bearing me towards my *penates*. This is a roundabout way of telling you that I have missed the train. — Needless to add I am your guest until tomorrow Wednesday.

" Now then, Madame Pissarro requests you to bring back from Paris some farina for little Georges. Also Lucien's shirts which are at his Aunt Félicie's.

" I wish you a good evening.

P. Cézanne

11 December 1872
In the town of Pontoise "

Evidently Cézanne's vagueness with regard to the time of day was incorrigible. There are other references to missed trains in some of his later letters to Zola.

At the bottom of the note to Pissarro is an amusingly misspelled postscript in little Lucien's childish handwriting:

" Mon cher papa

" Mamman te fait dire que la porte est cassée que tu viene vite parceque les voleur peuve venir.

" Je te pris si tu veux bien m'apporté une boite a couleur Minette te pris que tu lui apporte une baigneuse. Je n'est pas bien écrit parceque je n'était pas diposée?

<div align="right">

Lucien Pissarro

1872 "

</div>

It was probably through Pissarro that Cézanne became acquainted with Dr Gachet, who had a house at Auvers. Gachet was an extraordinary character. He combined the humdrum existence of an obscure country doctor with the most intense enthusiasm for the art of the young insurgent painters, an enthusiasm which he thought it necessary to justify, to himself as well as to anyone who would listen to him, on sociological and psychological rather than on æsthetic grounds. Occasionally he painted little pictures himself; he also tried his hand at etching in the studio he had arranged in an old barn. His dress was inclined to be bizarre, and he dyed his hair so vivid a yellow that he was known about the neighbourhood as " Dr Saffron." With all his eccentricities he was a generous and charitable soul. It was Dr Gachet who looked after the insane Van Gogh during the last tragic months that preceded his suicide in July 1890.

Dr Gachet, already an admirer of Pissarro's work, made Cézanne welcome at his house, and even carried his friendliness to the point of buying one or two of his pictures. It was the first time that Cézanne had ever found a purchaser for his canvases, and though the sums he received for them were exceedingly small the patronage of the odd little medico was encouraging. At about the same time he sold a few pictures to other local collectors: Monsieur Rouleau, a former schoolmaster, and Monsieur Rondès, a grocer of Pontoise. It is said that Cézanne was a cus-

tomer of Rondès, and that the picture was accepted in payment of a grocery bill.

Other painters besides Pissarro and Cézanne had drifted to the neighbourhood of Auvers after the war. Guillaumin was often there, as well as Cordey and Vignon. Cézanne found the society of these young artists pleasant. Moreover, the countryside of the Île-de-France with its rich wet greens and hazy blues offered a welcome change, for a time, from the hotter, more strident colouring and sharply defined shadows of Provence. All in all, the two years at Auvers were among the happiest of his life. His contentment was reflected in the pictures he painted at this time, both in their quantity and in their nature. Rivière ascribes no less than twenty-five pictures to the Auvers period, which indicates not only that he painted more steadily and energetically than usual during those years, but that he was better pleased with the results and destroyed fewer unsuccessful canvases. At the same time the character of Cézanne's pictures underwent a radical change. The macabre turn of mind which had produced such works as *L'Autopsie* and *Le Meurtre* was gone, and gone for good. The sombre blacks and browns and the heavy *impasto* of the previous decade soon disappeared in its wake.

Under the tactful guidance of Pissarro, who had been painting out of doors for a number of years, Cézanne began to work in the open air. Before he moved to Auvers he had been in the habit of making landscape sketches from nature and using them as studies from which to paint his finished pictures in the studio; now he painted the entire canvas out of doors. For the first time the major portion of his work consisted of landscapes. Whereas of the sixty-five-odd listed canvases painted before 1872 only thirteen, or one fifth, were landscapes, fourteen out of twenty-five — almost three fifths — of his output at Auvers belonged to this category. Cézanne had joined the ranks of the Impressionists.

* *

The Impressionists — if we may be permitted to anticipate the

name, uncoined as yet, by a few years — were preoccupied with the problem of painting objects, such as houses, trees, fields, water, and so forth, as seen in natural daylight. In many respects it was a new problem, involving much intense observation of nature and the gradual evolution of an entirely new technique. The Barbizon painters had worked indoors in the carefully arranged and conventionally modified light of their studios. Manet, though he had noted and introduced into his pictures, to the horror of the academicians, the effects of reflected light on the colour of shadows, did not paint in the open air until led to do so by the experiments of Pissarro and Monet. Nevertheless his observations and researches had paved the way for the Impressionists. The high key and airy unsubstantiality of Turner's pictures, in which the solid outlines appear to dissolve in a sea of mist and light, also exerted considerable influence on the young French painters.

The Impressionists aimed not only to portray as nearly as they could the actual colours of objects as seen under various conditions of outdoor light, but also to reproduce the fullest possible intensity of that light. Now, most pictures are meant to be hung indoors, in a relatively subdued light; and under such conditions the intensity of even the finest pigments cannot approach the intensity of light reflected from coloured surfaces out of doors. So that even when using nothing but pure colours, the painter must adopt a convention: since he cannot hope to *imitate* the full intensity of natural light, he must *suggest* it within the relatively limited range of intensity of the synthetic pigments at his disposal.

But there is another difficulty. Manufactured colours in their pure state seldom correspond exactly to the colours of natural objects. The painter is obliged to mix his pigments in order to obtain the desired tones; and the moment he mixes them their intensity is further reduced. For light-rays and pigments do not behave in the same way when they are mixed. For example, if the beam from a red lamp and the beam from a green lamp are projected so as to fall on the same spot on a white screen, the result will be an intense yellow; but if a red pigment and a green one are

mixed on a palette or a canvas they will produce only a dull muddy brown. To carry the illustration a step farther, a beam of light containing all the colours of the visible spectrum in the proper proportions will be a clear brilliant white; a mixture of pigments of the same colours and in the same proportions will be a dark dirty grey. In other words, light-rays of different colours can be combined without loss of intensity; pigments cannot.

The problem of the Impressionists, then, was to reproduce on their canvases the mixed colours of nature — that is, of reflected daylight — without unduly reducing the intensity of those colours by mixing the pigments. Of course they realized that the intensity of a landscape painted even in pure colours could never attain that of nature, for the reasons given above. That could not be helped; it was a limitation inherent in the medium and had to be accepted as such. But it was possible to avoid a great deal of the additional reduction in intensity caused by the mixture of pigments, and it was on this point that the Impressionists concentrated their efforts. To accomplish this they evolved a new method of applying their colours. Instead of mixing two pigments (red and green, let us say) on a palette, they placed small strokes or dots of pure red and pure green close together directly on the canvas. When seen from a certain distance these contiguous spots of pure colour would blend *without appreciable loss of intensity* to produce on the retina the effect of a single spot of brilliant yellow. The pigments themselves were not mixed; the separate rays of coloured light reflected from the canvas were fused by the eye of the observer.

Of course the Impressionist painters were artists, not scientists, and they made use of the recent discoveries of Helmholtz and other physicists in the field of optics only incidentally, without knowing or caring much about the scientific principles involved. Nor was the new technique perfected overnight. There were countless experiments and false starts. Lighter colours and increased intensity came slowly; dots and touches of pure colour gradually took the place of broad brush-strokes of brown and grey.

179

By the time the first Impressionist exhibition opened in 1874 the work of the painters who led the new movement had departed so far from established academic principles as to shock the public as it had not been shocked since the Salon des Refusés of 1863.

While the Impressionist painters freed painting from the dullness of soupy browns and muddy greys and substituted clear, vibrant, sparkling colours that infused their pictures with new life; while they thus overcame successfully one set of limitations, they allowed the pendulum to swing so far that another set almost immediately took its place. The Impressionists were so exclusively preoccupied with the painting of light, of the momentary, evanescent effects of light reflected from the surfaces of objects in the open air, that they painted nothing else. In practice many went so far as to ignore the existence, as far as painting was concerned, of anything except the surface appearance of a tree, a house, or a haystack at a given moment. There was no distinction between an accidental shadow or reflection and enduring form. Local colour, outline, and solidity were neglected; atmosphere was all-important.

* *

It was Cézanne who, after first adopting the ideals and methods of the Impressionists, went beyond them and re-established the significance of local colour and the third dimension. In doing so he did not renounce anything that was truly valuable in Impressionism. He had learned from Pissarro to use light, fresh, pure colours and to apply them in little strokes and patches to suggest the vibrant intensity of actual light. But after he had mastered the new technique he was not satisfied with the results. There seemed to be something lacking. His fellow-Impressionists were concerned only with the superficial, the surface appearance of the things they painted. Cézanne looked for something deeper: the solid, permanent form beneath the surface, the essence of the thing itself.

He admired the work of Monet — the most ethereal, the least

solid of all the Impressionists. But he was acutely conscious of the limitations inherent in Monet's conception of objects as mere surfaces seen under changing lights and varying atmospheric conditions. Vollard reports that Cézanne summed up Monet in the phrase: " Monet is only an eye. But good God, what an eye! "

The essential difference between the painting of Cézanne and that of Monet is well illustrated by Monsieur Louis Vauxcelles in an article quoted in *La France de Nice* of February 29, 1929:

" When Monet paints a haystack, a cathedral, the picture is a delight; there is light, but there is no haystack; there is no cathedral. When Cézanne paints an apple, there is the play of light; there is also the apple — "

In Cézanne's work, then, the luminous colour of the Impressionists is combined with a presentation of the more permanent and elemental attributes of the subject. The orthodox Impressionists arrived at their results by a process of analysis; Cézanne reached his by building up, by synthesis. But the full implications of this difference in viewpoint can best be understood in connection with a study of Cézanne's mature, fully developed work, and will be taken up in a later chapter. For he advanced slowly, timidly, with many hesitations and backslidings.

When he began to paint in the open air with Pissarro in 1872 his conversion to the Impressionist method of painting in small broken-up dots and touches was very gradual. He did not relinquish his thick brush-strokes and his palette-knife all at once. The best-known and perhaps the most important picture of his Auvers period is *La Maison du Pendu*, painted about 1873 and now hanging in the Camondo collection in the Louvre. In this canvas the colours are distinctly lighter and fresher than in any of his earlier paintings, though as yet they exhibit little of the clear luminosity that distinguishes the pictures painted ten years later. But the pigment is still plastered on in thick bumps and ridges in many parts of the canvas, and the palette-knife is still

in evidence in the sky and on the walls of the building. Yet at the time this picture was painted Pissarro had already developed his technique of small juxtaposed dots. Coquiot quotes the remark of a peasant who had watched both painters at work: " Monsieur Pissarro, when he painted, dabbed [*piquait*] and Monsieur Cézanne smeared [*plaquait*]."

In the same way the other landscapes of this period — more than a dozen canvases depicting houses, roads, and fields in or near the village of Auvers — bear witness to Cézanne's reluctance to abandon his thick and lumpy method of painting for the lighter, more vibrant brush-strokes of Pissarro and the other Impressionists. As a matter of fact he never did adopt completely the system of painting in tiny dots that characterized the later work of the typical Impressionists, especially Pissarro and Monet — a system that foreshadowed the *pointilliste* technique of Seurat. By the time the last traces of the heavy, trowelled surfaces of his early pictures had disappeared Cézanne had acquired a characteristic " handwriting " of his own, quite different from that of any of his contemporaries. After 1880 Cézanne covered his canvases with a pattern of small, elongated parallel brush-strokes, each individual touch laid on very thinly, almost like water-colour, but built up of layer upon layer of transparent luminous colour. At first the strokes ran in approximately the same direction over the entire canvas — generally from upper right to lower left — but in his later pictures Cézanne adopted a·more flexible system of surfaces broken up into smaller areas or patches; in each area the strokes were parallel to one another, but the different areas were slanted in various directions.

It was a system admirably adapted to Cézanne's purpose. The superposition of one thin glaze of colour over another, each coat or layer made up of innumerable small strokes of a definite shape running in a definite direction, enabled him to build up the effect of solidity, of the third dimension, which he felt to be so essential and which the other Impressionists ignored or consciously dismissed; yet he lost none of the delicate, subtle brilliance of sur-

face colour and reflected light on which his fellow-painters laid such stress. Of course this technique was infinitely laborious and slow; but for that very reason it was peculiarly well suited to Cézanne. Except during the first few years, when he plastered on his colours with a sort of slapdash ferocity, Cézanne almost always painted slowly, with the utmost deliberation, rarely placing one stroke beside another until he had decided — often after long minutes of observation and reflection — that it was exactly right in relation to the picture as a whole.

In addition to the landscapes that made up the bulk of Cézanne's output during the two unusually productive years at Auvers-sur-Oise, he painted at least ten or twelve pictures of other subjects. Two of these, as listed by Rivière, were *Bathers,* one picture containing five nude figures and the other a single figure; one was a still life of a sugar-bowl and some pears; and two were pictures that still retained a faint suggestion of " literature ": one a water-colour entitled *Une Nuit à Venise* or *Le Punch au Rhum,* a confused, crowded composition, an anachronism apparently intended as a companion piece to the earlier *Après-midi à Naples;* the other a new version of *La Tentation de Saint-Antoine.*

The remaining works of the Auvers period were portraits: one of Cézanne himself; one of an itinerant pedlar of the district, Chailhan, which, according to Rivière, was sold at auction at the Hôtel Drouot in 1875 for the sum of fifteen francs; one of a man named Boyer, better known as *L'Homme au Chapeau de Paille;* the *Femme et Enfant,* for which Hortense and little Paul may have served as models; and the first of the well-known portraits of Monsieur Choquet, probably painted in 1874.

Choquet was a minor government official, a chief clerk in the Custom House. Though not a wealthy man, he was passionately devoted to art and collected as many examples of the work of the younger painters as his means allowed. Vollard tells us that Cézanne was presented to him by Renoir, and that the painter and the collector immediately found themselves on common ground

in their enthusiastic admiration for Delacroix. Renoir had already persuaded Choquet to buy a study of *Bathers* by Cézanne; but knowing that his wife would disapprove, Choquet arranged that Renoir should bring the picture to his house and pretend to forget to take it away again, so that Madame Choquet should have time to get used to it before the news of the purchase was broken to her. The trick worked. Madame Choquet came to tolerate, if she did not really admire, the *Bathers;* and later on Choquet bought several other pictures from Cézanne. In addition to the small head of Monsieur Choquet painted in 1874, Cézanne painted at least two other portraits of him, one about 1877 and the other — a half-length figure executed in Choquet's garden at Hattenville in Normandy — in 1886. Choquet was not only a loyal friend to Cézanne, but a sincere believer in his genius. He made heroic efforts to convert his acquaintances and would talk about Cézanne's work by the hour to anyone who would listen. But he rarely succeeded in convincing anybody.

It was at Auvers that Cézanne tried his hand at etching for the first and last time. Dr Gachet etched occasionally and probably kept the necessary apparatus in the studio-barn which he placed at the disposal of his friends. Guillaumin etched several plates there; so did Pissarro. Evidently Cézanne did not find the medium a congenial one, for he dropped it after having pulled three plates: a landscape, the head of a woman, and a portrait of Guillaumin seated on the ground. None of them is of any particular interest, and on the whole it is not surprising that Cézanne should have found the etched line unsatisfactory as a means of expression. His conceptions demanded the warmer and richer qualities of colour. It is true that he made endless pencil drawings, some merely rough scribbles while others, more highly finished, are beautiful and sensitive and yet full of the extraordinary vitality that pervades all of his work. The latter disprove the absurd charge — often made during Cézanne's lifetime — that he could not draw, that the distortions in his pictures were unintentional, and that they were due either to defective eyesight or to some

19. LA MAISON DU PENDU

ABOUT 1873. LOUVRE, CAMONDO BEQUEST

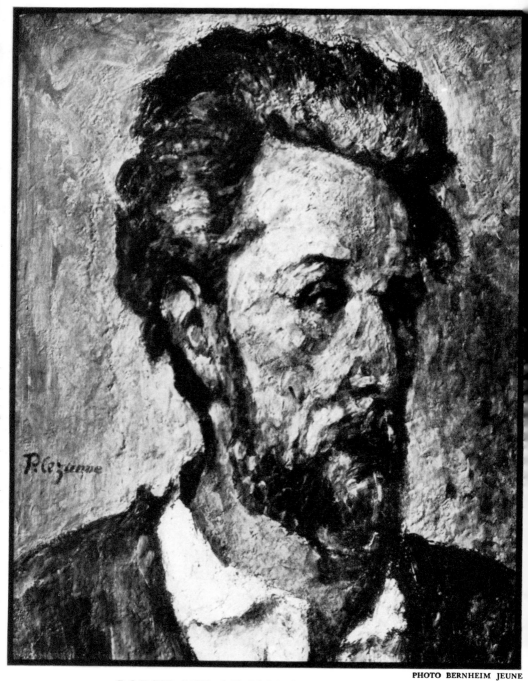

20. PORTRAIT OF MONSIEUR CHOQUET

ABOUT 1874

inherent inability to delineate forms accurately. But to Cézanne himself his drawings in black and white were only sketches, made either for practice or as more or less rough notes for a contemplated painting. They were never an end in themselves. It was only in colour that he could really set down what he felt.

THE FIRST IMPRESSIONIST
EXHIBITION: 1874

To the academicians the first exhibition of the Impressionists seemed nothing less than a scandal. The public took it as a gorgeous joke. But to the young painters who participated in it, and to the very few critics and collectors who sympathized with their aims, the exhibition was an epoch-making event.

Until 1870 most of the painters of the insurgent group had had their works accepted with more or less regularity by the official Salons. The young rebels were still feeling their way and in most cases their pictures were painted in a relatively low key, so that they did not stand out unduly on the crowded walls of the Palais de l'Industrie; especially as these mildly daring canvases were scattered and isolated among the academic paintings that made up the bulk of the exhibitions, and whatever novel characteristics they had in common could be distinguished only with difficulty. They were not yet a definite menace to art in the eyes of the official arbiters.

Of course the attitude of the juries towards the younger painters varied from year to year. Sometimes their offerings were admitted in a fairly tolerant and liberal spirit; in other years, whenever the jury happened to be more reactionary than usual,

the doors of the Salon were closed in their faces. In the Salon of 1859 Pissarro, the oldest of the group and the only one except Manet who had advanced beyond the student phase at that time, was represented by a landscape. In 1861 two portraits by Manet were exhibited without attracting any particular attention or comment. In 1863, however, as we have seen, every picture with the slightest taint of unconventionality was summarily rejected; as it turned out, a fatal error of judgment on the part of the jury, a blunder that resulted in the boomerang of the Salon des Refusés. In that exhibition of protest Manet and Pissarro were each represented by three canvases. As a consequence of the extraordinary amount of publicity received by the Salon des Refusés the juries for the next three years, anxious to avoid a repetition of so effective a protest, adopted a more liberal policy. Thus in the official Salon of 1864 there were two paintings by Manet, two by Pissarro, two by Berthe Morisot, and one by Renoir. In 1865, again two Manets — one of them the famous *Olympia* that caused a scandal as resounding as that produced by *Le Déjeuner sur l'Herbe* two years before — two Pissarros, two Morisots, two Monets, and one Renoir. Similarly in 1866 Monet, Morisot, and Sisley were represented by two canvases each, and Renoir by one. These were fair showings considering the youth of the painters in question — all except Pissarro and Manet were under twenty-five — and the unconventionality, temperate as it still was, of their works.

But in 1867 the pendulum swung towards reaction again. A single canvas by Berthe Morisot was the only exception to the wholesale rejections of that year. The jury of 1868 was more liberal: Manet and Pissarro were admitted with two pictures apiece, and Monet, Morisot, Renoir, and Sisley with one each. In 1869 there were two Manets, one Pissarro, and one Sisley; in 1870, two canvases each by Manet, Morisot, Pissarro, Sisley, and Renoir. Thus by the end of the sixties every one of the painters who were to become the leaders of the *plein-air* movement had been represented in at least three official Salons, except Cézanne and Guillaumin.

187

After 1870 the wind veered once more, and this time its direction seemed likely to remain fixed for some time. Outdoor painting with its light tones and brilliant colours, its luminous shadows and its novel technique, was beginning to come into its own; its revolutionary character could no longer be ignored by the authorities. Henceforth the official ban on the works of the younger painters was practically absolute; the juries were determined to check the spread of any further heresies. No Salon was held in 1871 on account of the recent disastrous war with Prussia and the succeeding disorders of the Commune; when the exhibitions were resumed in 1872 and 1873 the only members of the insurgent group to be admitted were Manet and Berthe Morisot.

As a matter of fact none of the others, except Renoir and Cézanne, had even sent pictures to these post-war Salons, and so were spared the rejections their offerings would certainly have encountered. For if the works and doctrines of the Impressionists were anathema to the juries, it was becoming increasingly evident to the rebels themselves that the official Salon was a poor place in which to exhibit their pictures if they were ever to achieve public recognition. The very dispersion which had kept their works inconspicuous enough to be admitted at all was now, paradoxically, seen to be a drawback. Even if a few paintings by the nonconformists had been accepted and hung in the Salons after the war, they would only have been scattered and lost in the crowd; the qualities that were common to the whole school would have gone unnoticed. Hence the decision of the majority of the group to abstain from presenting any more pictures to the juries.

But they had to find some way of getting their works before the public. No reputable dealer was willing to sponsor so hazardous an undertaking as a radical exhibition; the only solution was an independent show organized and financed by the painters themselves, with the aid of a few sympathetic critics and collectors.

The first exhibition of the Société Anonyme des Artistes Peintres, Sculpteurs et Graveurs, as it was called, opened in April 1874.

All of the painters who are now known as the founders of Impressionism took part: Pissarro, Monet, Renoir, Sisley, Berthe Morisot, Guillaumin, and Cézanne. For the last two the exhibition of 1874 offered the first opportunity they had ever had of showing their works in public.

Manet, though he was sincerely in sympathy with the aims of the younger painters who were to some extent his disciples and many of whom were his warm personal friends, did not participate in the exhibition. He had succeeded in forcing his way into the Salon after a bitter struggle and was now beginning to be accepted and recognized officially. Manet's defection was unfortunate in that it deprived the Impressionists of their best claim to public consideration; yet he can hardly be blamed for his unwillingness to relinquish all of the ground he had won so painfully in order to throw in his lot with his outcast younger colleagues.

The exhibition of 1874 was not restricted to the true Impressionists. The cost would have been prohibitive: most of these young men were poor, and some of them — in particular Sisley and Guillaumin — almost destitute. Moreover, it was thought that the participation of a few relatively well-known painters who, if not so radical as the Impressionist nucleus of the group, were at least on the liberal side of the fence would do much to attract the public. In all, thirty artists were represented, including in addition to the seven Impressionists already mentioned the more conservative and therefore more respectable names of Degas, de Nittis, Boudin, Braquemond, Cals, Levert, and Rouart. The only sculptor was Auguste Ottin, who exhibited a number of marble, bronze, plaster, and terracotta statuettes.

Perhaps some explanation is needed for my inclusion of Cézanne and Renoir among the true Impressionists. Certainly both painters branched off from the main path a little later and blazed new trails, each in his own way. But at the time of the exhibition of 1874 these divergences were not yet apparent. Both Cézanne and Renoir still considered themselves, and were considered by the public, as orthodox members of the Impressionist group.

The exhibition was inaugurated on April 15 and remained open for a month " from 10 to 6, and from 8 to 10 in the evenings," according to the catalogue. The gallery was a suite of offices at 35 boulevard des Capucines, formerly occupied by a well-known photographer, Nadar. The rooms were located on the *entresol*, and as the boulevard des Capucines was, and still is, one of the busiest thoroughfares in Paris, the exhibition could hardly fail to attract the attention of the passers-by. And attract attention it did, though not precisely of the sort the exhibitors had hoped for. The number of visitors was enormous, in spite of the one-franc entrance fee. But once upstairs in the midst of the array of " horrors " that covered the walls, the sensation-seekers either gave way to furious indignation or exploded in paroxysms of laughter.

Cézanne made his debut at this exhibition with three offerings. Two were landscapes painted at Auvers a year or two earlier: *La Maison du Pendu* (Plate 19) and *Paysage à Auvers*. The first is now in the Camondo collection in the Louvre; the second cannot be identified with any degree of certainty.

Cézanne's third entry was listed in the catalogue as " *Une Moderne Olympia (esquisse appartenant à M. le Docteur Gachet)*." We know that Cézanne had been deeply impressed by Manet's *Olympia* in the Salon of 1865, and that subsequently he painted a number of his own versions of the same subject, none of which bore much resemblance to Manet's naked courtesan in anything but the name. Rivière lists one study of *La Nouvelle Olympia* belonging to Dr Gachet as having been painted in 1868, but qualifies his dating by adding that " some critics believe that Cézanne did not execute this work until 1872. Perhaps he retouched it at that time, as he did in the case of other pictures which remained in his possession." Unfortunately there is no reproduction in Rivière's book to enable us to identify this canvas.

Cézanne's *Olympia* was not received kindly by the critics. Monsieur Marc de Montifaud, writing in *L'Artiste* for May 1874, reviewed it in these gentle terms:

190

" On Sunday the public found material for laughter in the fantastic figure who exhibits herself, surrounded by a sickly sky, to an opium-smoker. This apparition of pink naked flesh thrust forward by a sort of demon into the smoky heavens, a corner of artificial paradise in which this nightmare appears like a voluptuous vision, was too much for the most courageous spectators, it must be admitted, and Monsieur Cézanne can only be a kind of madman, afflicted with delirium tremens while painting. . . . In truth it is only one of the weird shapes generated by hashish, borrowed from a swarm of absurd dreams. . . ."

Nor was the same writer much kinder to Cézanne's landscapes:

" No audacity can astonish us. But when it comes to landscapes. Monsieur Cézanne will permit us to pass in silence over his *Maison du Pendu* and his *Etude à Anvers* [*sic*]; we confess that they are more than we can swallow."

Yet this was a comparatively advanced and liberal critic, who in the same article allowed himself to wax mildly enthusiastic about Degas, Renoir, and Monet, though he considered Monet a better painter of *genre* than of landscapes! He treated Guillaumin briefly, but with a certain amount of respect, and could see possibilities even in Sisley and Pissarro: " Sisley is one of those who are making progress — perhaps he sees nature with too narrow a vision. . . . *Les Châtaigniers à Osny* by Camille Pirsarro [*sic*], rather crude in colour; but the richly painted portions indicate the good intentions beneath a still uncultivated surface." But Cézanne was more than he could swallow.

As a matter of fact the *Olympia* in any of its variations was not a particularly happy choice for a first showing of Cézanne's work. All of his oil studies of this subject — including the one known as *Le Pacha,* dated by Rivière as late as 1875 — were painted in the thick, heavy manner of the previous decade, a manner which

Cézanne had already thrown into the discard. In 1874 the *Olympias* were anachronisms, hold-overs from an earlier period, not to be compared with the best work he was doing at that time. The compositions were violent and confused, the figures awkwardly posed, and the general conception brutal. Even so, the contemporary critic's suggestion that the *Olympia* resembled the work of a madman under the influence of hashish seems fantastic enough today; but we must admit that the series does not rank high in the list of Cézanne's productions.

It is harder to see why the two landscapes should have seemed so offensive to a critic who could tolerate Monet, Guillaumin, Pissarro, and Sisley. Surely they can have been no more startling to the scoffers of 1874 than any of a dozen canvases by Cézanne's fellow-exhibitors. Today the *Maison du Pendu* seems mild and almost dull in comparison with the dynamic paintings of Cézanne's maturity.

Of course the critics were not quite unanimous in their execration of the work shown on the boulevard des Capucines. There were driblets of praise of the exhibition, mostly by the young radical writers who had taken part in the gatherings at the Café Guerbois or its post-war successor, the Nouvelle Athènes. But these dissenting critics were few in number and largely unknown; they lacked the power and the authority to exert any considerable influence on the public taste.

One writer who might have been expected to defend the Impressionists tooth and nail was Émile Zola. Eight years earlier, in *L'Événement,* he had supported the insurgent painters and attacked the academicians with all the power of his pen; six years later, when his own fame had reached its zenith, he was to glorify the same rebels and pillory the same reactionaries in the pages of *Le Voltaire*. Why then did he remain so modestly in the background in 1874? It is difficult to account for Zola's silence at this time. He was certainly no coward: all his life he was the champion of unpopular causes, which reached a culmination in the notorious Dreyfus affair. But whatever the reason, the fact remains that

Zola did little or nothing to help the cause of the Impressionists at the time of their first exhibition.

Fortunately, among the crowd of visitors who laughed at Cézanne's pictures a little more loudly than at any of the others, there were a few who were sufficiently advanced to take his work seriously. One of these rare individuals was Comte Doria, a financier who possessed a small private collection of contemporary paintings. Doria did not join in the general merriment; instead of laughing, he actually bought the *Maison du Pendu*.

The exhibition of the Société Anonyme des Artistes Peintres, Sculpteurs et Graveurs in 1874 did more than provide an opportunity for the Parisian public to see (and chuckle over) the work of the nonconformist painters *en masse*. It gave the group something it had always lacked: a name. Until that date the insurgents were referred to simply as the *plein-air* school, or sometimes the *Intransigeants*. But neither of these designations really took the popular fancy. In 1874, however, Monet exhibited, among other pictures, a landscape which he called *Impression — Soleil Levant*. The word *Impression* epitomized so perfectly the character, not only of this particular work, but of nearly all of the pictures of the outdoor painters that it caught on at once as a convenient and appropriate label. The name *Impressionists* was first used in print in an article by Louis Leroy that appeared in *Charivari* for April 25, 1874, ten days after the opening of the exhibition. The review, entitled *L'Exposition des Impressionistes*, was of course a satirical attack on the new style, in which the critic could see no virtue whatever. In his article the witty Monsieur Leroy describes a visit to the exhibition in the company of a friend, a landscape painter of the old school. After making a tour of the galleries the friend is so deeply " impressed " by the sight of so many horrible " impressions " that he suddenly goes raving mad, renounces all of his lifelong principles of " good " painting, and thenceforth sees everything in the room as an " impression " — including the uniformed guard at the door, whom he criticizes as an academic production because he has two distinct eyes and a recog-

nizable nose instead of an arrangement of vague smears. It is all very good satire in its way, and Monsieur Leroy must have enjoyed writing it. We can only wonder whether he lived long enough to realize that his own chief claim to immortality would be the few lines of buffoonery that launched the name of Impressionism into the world.

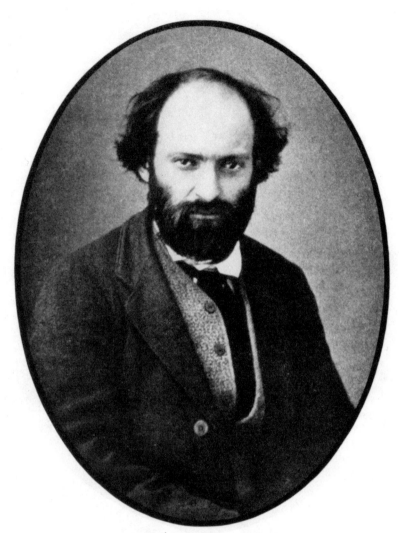

21. PAUL CÉZANNE ABOUT 1875
FROM A PHOTOGRAPH

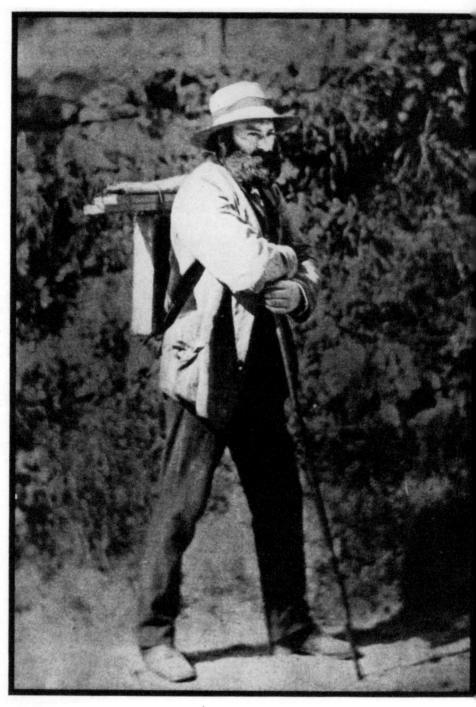

22. PAUL CÉZANNE ABOUT 1875
FROM A PHOTOGRAPH

INTERLUDE: 1874–1876

THE EXHIBITION closed on May 15, and a few days later Cézanne returned to Aix. He had been away from home for about three years — for there is no record of any visit to Provence since he left L'Estaque early in 1871, after the war. This was the longest uninterrupted absence from Aix of his entire life; only once again, from the spring of 1879 to the autumn of 1881, did he remain away for more than two years at a stretch.

He settled down to paint at once, which is enough to indicate that he was in a relatively contented mood. No doubt his mother and sisters made more of a fuss over him than he liked, but he was used to that particular *grappin* and knew how to escape it by spending his days away from the house, painting landscapes, or by shutting himself into his top-floor studio with his still lifes when the weather was bad. Moreover, he could always return to Paris if he felt the urge; his father might growl and object, but the old banker no longer threatened to cut off his allowance if he did not stay home, so the growls did not matter.

Cézanne knew what would happen, however, if Louis-Auguste found out about his domestic arrangements, so Hortense and the baby remained in Paris. Cézanne took lodgings for them at 120 rue de Vaugirard. It was not safe even to receive letters which

might arouse his father's suspicions; Cézanne was dependent for news of his family on such of his friends as were in the secret.

Shortly after his arrival at Aix Cézanne wrote to Pissarro:

"June 24, 1874

" My dear Pissarro,

" Thank you for thinking of me while I am so far away, and for not being annoyed with me because I did not keep my promise to come to Pontoise to say good-bye to you before my departure. — I started to paint directly after my arrival, which took place on a Saturday night towards the end of May. And I understand all the difficulties you must be going through. You really have had bad luck: — always someone ill in your house, still I hope that by the time my letter reaches you little Georges will be well again.

" But what do you think of the climate of the country you are living in? Are you not afraid that it will be bad for your children's health? I regret that present conditions are keeping you from your work, for I know what a privation it is for a painter, not to be able to paint. — Now that I have seen this country here once more I think that it would satisfy you completely, for it bears an astonishing resemblance to your study of the Railway Crossing in the full sunshine of summer.

" I have been left without news of my child for several weeks, and I have been very uneasy, but Valabrègue has just arrived from Paris and yesterday, Tuesday, he brought me a letter from Hortense, which tells me that he is getting along all right.

" I have read in the papers about Guillemet's great success and the good luck that has befallen Groseillez, whose picture has been bought by the Administration after having been awarded a medal. Which proves clearly that by following the path of Virtue, one is always rewarded by man, but not by Painting. . . .

" When the time comes I shall let you know about my return, and about the amount I shall have obtained from my father, but he will surely allow me to return to Paris. — That is something,

196

at least. — A few days ago I saw the Director of the Museum of Aix, who, impelled by a curiosity which has been fostered by the reports of the co-operative in the Paris papers, wished to see for himself how far the danger to Painting had gone. But when I assured him that the sight of my own productions would not give him a very good idea of the progress of the evil, and that he would have to see the works of the real criminals of Paris, he said: ' I shall be able to get an idea of the risks that Painting is running by looking at your offences.' With which he came in, and when I told him that you, for example, were substituting the study of tones for modelling, and when I tried to make him understand by illustrating from nature, he closed his eyes and turned his back. — But he said he understood, and we separated well pleased with each other. But he is a good fellow, and advised me to persevere because patience is the mother of genius, etc.

" I almost forgot to tell you that Mamma and Papa have asked me to send you their affectionate greetings.

" A word for Lucien and Georges whom I embrace. My respects and thanks to Madame Pissarro for all the kindnesses she has shown me during my stay at Auvers, warm greetings to yourself, and if good wishes have any power to make things prosper, be assured that I shall not fail to give expression to them.

<div align="right">Always yours
Paul Cézanne "</div>

Cézanne's sense of humour is not often so apparent as in this genial description of his encounter with the provincial Director who asks to see his " offences," turns his back on his explanations, and gives him platitudinous advice. This is Cézanne in one of his tolerant moods; he was not always so patient with those who could not, or would not, see.

The " co-operative " was a new organization of artists, independent of the Impressionists, though its membership was made up largely of the same painters. Cézanne refers to the co-operative at greater length in a later letter to Pissarro.

In the autumn Cézanne returned to Paris. He was feeling more confident about his painting now; he was convinced that he was on the right track. Henceforth, until the end of his life, this conviction upheld him, gave him the courage to go on working. He was certain that recognition would come — if not during his lifetime, then after his death. What did it matter? Naturally, he could not stay perpetually on so serene a plane; there were to be many intervals of depression, of discouragement, of resentment against the smug obtuseness of juries, critics, and public. But from now on he met the constant rejections, the bitter attacks, and, worst of all, the indifference of his contemporaries with a certain calmness. The hot rebellion of his youth was over: he was thirty-five, and the years had brought some measure of philosophy and resignation. Since he could not hope to please the public, he would paint only to please himself. Whenever he succeeded in doing that, he was content. But such moments of satisfaction were rare; more often he would feel that the solution of his problem had eluded him, and he would leave his canvas unfinished, or destroy it in a sudden rage at his failure to " realize," as he expressed it, his conception. Whereupon he would begin a new picture. There was always hope that he would " realize " the next time.

Cézanne's newly acquired philosophy is apparent in a letter to his mother written from Paris on September 26, 1874, part of which is reproduced in Coquiot's life of Cézanne:

" My dear Mother,
" First I must thank you for having thought of me. For several days the weather has been bad and very cold. — But I am not suffering, and have a good fire.
" I shall be glad to get the box you mention, you can always send it to 120 rue de Vaugirard, I expect to stay there until the month of January.
" Pissarro has not been in Paris for the last month and a half, he is in Brittany, but I know that he has a good opinion of me, and

I have a very good opinion of myself. I am beginning to find myself stronger than any of those around me, and you know that the good opinion I hold of myself has not come to me without good reason. I must go on working, but not in order to attain a finished perfection, which is so much sought after by imbeciles. And this quality which is commonly so much admired is nothing but the accomplishment of a craftsman, and makes any work produced in that way inartistic and vulgar. I must not try to finish anything except for the pleasure of making it truer and wiser. And you may be sure that there will come a time when I shall come into my own, and that I have admirers who are much more fervent, more steadfast than those who are attracted only by an empty outward appearance.

" This is a bad time to sell pictures, all the bourgeois are grumbling about letting go of their pennies, but that will change. . . ."

Whether Cézanne did or did not return to Aix in January is uncertain. There is no documentary record of his movements during the next eighteen months: the year 1875 is a blank. Rivière tells us that Cézanne sent a water-colour of the Jas de Bouffan to the Salon of 1875, where of course it was rejected. A letter to Pissarro indicates that another of Cézanne's offerings was thrown out by the jury of the following year. The letter is dated simply " April 1876 " and appears to have been written from Aix:

" I almost forgot to tell you that I have received a certain letter of rejection. That is neither new, nor surprising. — I hope you are having good weather, and if possible a successful sale."

Cézanne's hope that Pissarro will have a " successful sale " refers to the second exhibition of the Impressionists, which opened in April 1876 at the Durand-Ruel galleries at 11 rue Le Peletier. No exhibition had been held in 1875. Why did Cézanne continue to send his pictures to the Salon year after year, knowing perfectly well that they would be refused as often as they appeared before the jury? All of the other members of the group had abandoned

the struggle for official recognition long ago and were now concentrating their efforts on reaching the public through independent exhibitions. And why, on the other hand, was Cézanne not represented at the second Impressionist exhibition of 1876, where he belonged?

It is not difficult to answer the first question if we take the trouble to understand the character of Paul Cézanne. In spite of the radical innovations he introduced into his painting — innovations that were to affect in some measure the work of practically every important painter who came after him — Cézanne himself was far from being a revolutionary at heart. As a man he was as conservative in his ideas as any solid bourgeois. He was not one of those fire-eating rebels who love insurrection and conflict for their own sakes, but a timid, sensitive soul with a profound respect for authority. Though his work was uncompromising in its nonconformity to the rigid academic conventions of his day, his spirit was never that of the missionary or the doctrinaire reformer. A true revolutionary would have scorned official recognition even if it had been thrust upon him; Cézanne felt — for some years at least — that all his work was incomplete without the jury's stamp of approval. Hence his doggedly persistent, always unsuccessful attempts to storm the citadel of the Salon.

The second problem — the cause of his failure to participate in the Impressionist exhibition of 1876 — remains unsolved. We have no documents that might throw light on the matter, no letters or other contemporary records to explain his abstention from a show in which all of the other important members of the group (except Guillaumin) were represented. Monet and Pissarro exhibited eighteen pictures apiece; Berthe Morisot, seventeen; Pissarro, thirteen; and Sisley, eight. Evidently the organizers of the exhibition realized that it had been a mistake to include so many painters who were not true Impressionists in their first show two years before; this time the total number of participants was reduced from thirty to nineteen. Among the non-Impressionists were several who had taken part in the earlier exhibition:

Degas, Bureau, Cals, Levert, Rouart, and the sculptor Ottin. There was also a newcomer, Gustave Caillebotte, who was to achieve posthumous notoriety twenty years later: not as a painter, but as the collector and donor of his famous bequest to the Luxembourg.

Cézanne's absence from the exhibition was certainly not due to any lack of pictures to show. The two years that had elapsed since the first exhibition were among the most productive he had ever known. During the interval he had painted at least thirty canvases, and probably a good many more whose dates are doubtful but which can be ascribed with a fair degree of certainty to that period. The paintings were of all kinds: landscapes, some executed in the garden of the Jas de Bouffan and others in the environs of Paris; still lifes, mostly of flowers; several studies of nudes; portraits of himself, his father, his sisters, Valabrègue, Choquet, Hortense, *L'Avocat,* and *L'Oncle Dominique* (a younger brother of Cézanne's mother) ; and a few semi-literary subjects such as *Le Tournoi, Don Quichotte* (which appears to have been suggested by Daumier's drawings) , and *La Caverne des Brigands.* There could have been no difficulty in finding suitable pictures to send to the exhibition, with such variety and profusion to choose from.

Nor is it likely that Cézanne was deliberately barred from participation by hostility on the part of the other exhibitors. It is true that in the previous show Cézanne's pictures had come in for harsher criticism and more blatant ridicule than those of any of his fellows; and there may well have been a few of the more conservative painters who felt that the presence of such extreme works reacted unfavourably on the exhibition as a whole. We know that Degas, for example, did not like Cézanne's painting, nor on the other hand did Cézanne find Degas's work to his taste. But there is no reason to believe that either Degas or any of the others openly resented Cézanne's participation, or that they made any attempt to keep him out of the second exhibition. And it is inconceivable that the true Impressionists, the more radical

painters who were the leading spirits among the exhibitors, would have countenanced the exclusion of Cézanne had such a thing been suggested. They were all sincere admirers of his work as well as warm personal friends. The tone of two letters from Cézanne to Pissarro — one written in April just after the opening of the exhibition, the other in July — is extremely cordial, as it hardly would have been had there been any discrimination against Cézanne when the list of participants was made up. Moreover, he took a prominent part in the Impressionist exhibition of the following year, in which his pictures were given the best space in the galleries.

It is obvious, therefore, that Cézanne did not exhibit in 1876 because he did not want to. But why should he not have wanted to? He had had only one previous chance to show his work to the public, and he must have known that he was not likely to be given any other opportunities except by the Impressionists. Rivière suggests that he refused to participate in 1876 because the exhibition was held in the gallery of a private dealer, Durand-Ruel, whereas the exhibitions of 1874 and 1877 were installed in quarters rented for the purpose. Even though Durand-Ruel was sympathetic to the new movement — indeed, he must have been more than sympathetic to risk his reputation as a dealer by offering the hospitality of his gallery to a group that was proscribed by the officials and by all of the prominent art critics — Rivière holds that Cézanne was unwilling to show his work anywhere except in a completely independent exhibition or in the official Salon. This sounds like a very thin explanation, even if we take into account Cézanne's suspicious nature and his flair for detecting imaginary *grappins.* But it is the only solution that has been offered, and it may be the true one.

* *

Cézanne spent part of the summer of 1876 at L'Estaque. In July he wrote again to Pissarro. In this letter he not only writes more fully about his painting than is usual with him, but he dis-

plays a new facet of his character. In general Cézanne was inclined to be unworldly, unconcerned with the practical details of everyday life — with which, moreover, he felt himself unable to cope successfully. He lived in a little world of his own, a universe that contained nothing but his colours, brushes, canvas, his *motif* or model, and his imagination. Just as he had held himself aloof from the war, so he remained detached from political and social problems, even from the matter-of-fact details of policy and strategy involved in the organization of exhibitions of painting.

The letter to Pissarro proves that his detachment was neither so complete nor so consistent as it appeared to be. There was a streak of native shrewdness, of practical common sense, that cropped out occasionally as it does in his criticism of the co-operatives in this letter. The reference to Dufaure and the Senate betrays an interest in politics which, mild as it is, is unique in Cézanne's correspondence. Dufaure, the Minister of Justice under President Thiers, became President of the Council in March 1876:

<div align="right">

" L'Estaque, 2 July 1876

</div>

" My dear Pissarro,

" It is with an iron point (that is to say a metal pen) that I must reply to the charm of your magic pencil. — If I dared, I would say that your letter is marked by sadness. Things are going badly in the world of painting, I am much afraid that present conditions are causing you to look on the dark side of things, but I am convinced that the mood will pass.

" I don't like to talk about impossibilities and yet I am always making plans that probably will never come off. I believe that this country I am in would suit you to perfection. — There are plenty of irritations, but I consider them merely accidental. This year it has rained two days out of every seven. It's astonishing in the Midi. — Such a thing is unheard of.

" I must tell you that your letter reached me unexpectedly at

L'Estaque, by the sea. I have not been in Aix for a month. I have begun two small studies with the sea in them for Monsieur Choquet, who had suggested them to me. — They are like playing-cards. Red roofs against the blue sea. If the weather improves perhaps I shall be able to finish them up. As it is I have done nothing yet. — But there are *motifs* to be found that would require three or four months of work, for the vegetation does not change here. The olives and pines always keep their leaves. The sunlight here is so intense that it seems to me objects stand out in silhouette not only in black or white, but in blue, in red, in brown, in violet. I may be mistaken, but it seems to me the antithesis of modelling. How happy our gentle landscapists of Auvers would be here, and that great — (a word of three letters here)[1] — of a Guillemet. As soon as I can, I shall spend at least a month around here, for I want to paint canvases of at least two metres, like the one you sold to Fore.

" I hope that the exhibition of our co-operative will be a washout, if we are also to exhibit with Monet [at the forthcoming Impressionist exhibition of 1877]. — You will think me a swine, possibly, but one must consider one's own interest before anything else. — It seems to me that Meyer, who hasn't the qualifications necessary to lead the members of the co-operative to success, has become a *bâton merdeux*, and is trying to injure the Impressionist exhibition by anticipating it. — He may exhaust the public, and bring about confusion. — In the first place too many successive exhibitions seem to me unwise, in the second place people who think they are visiting the Impressionists, and who see only the works of the co-operative instead — there will be a cooling off. — But Meyer must be extremely anxious to injure Monet. — Has Meyer made a few sous? Another question — since Monet is making some money, why, since his exhibition is a success, should he fall into the trap of the other one? Once he has made a success, he is on the right side. — I say ' Monet,' but I mean all the Impressionists.

[1] The parenthesis is Cézanne's.

204

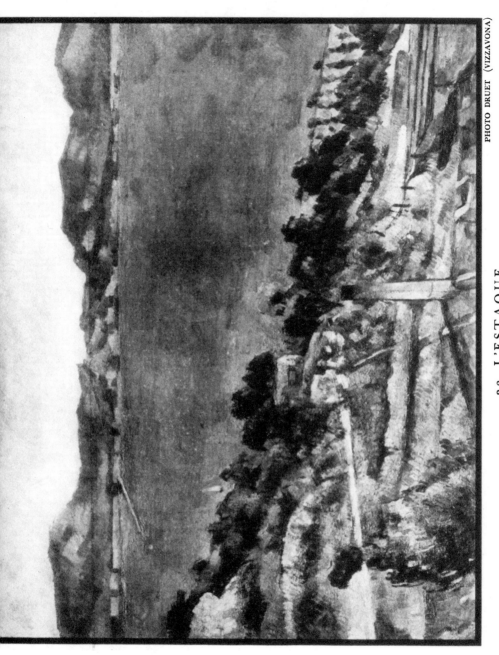

23. L'ESTAQUE

ABOUT 1883 (?). LOUVRE, CAILLEBOTTE BEQUEST

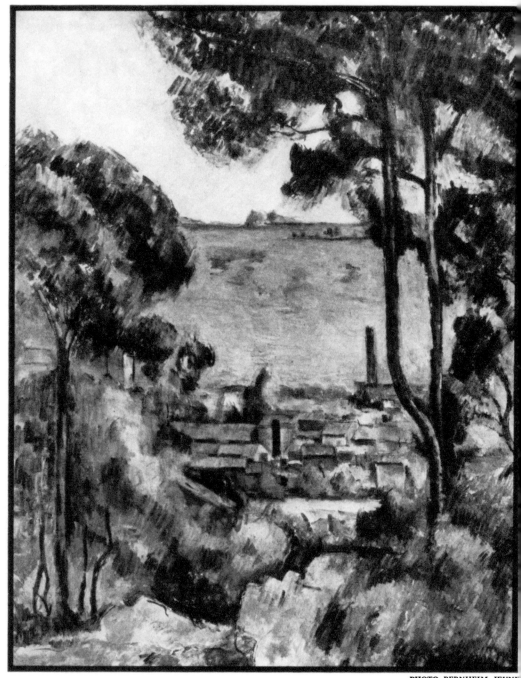

24. L'ESTAQUE
1885-1890

" Meanwhile I like the idea of the noble Monsieur Guérin, the ass, degrading himself by mixing with the rejected members of the co-operative. — Perhaps I present these few ideas of mine a little crudely, but I haven't much subtlety at my command. Don't hold it against me and when I return to Paris we will discuss the matter, we can hold with the hare and run with the hounds. — Since the notoriety of the Impressionists may be of use to me, I shall exhibit my best works with them, and something commonplace with the others.

" My dear friend, I shall end this by saying as you do, that since there is a common tendency among some of us, let us hope that necessity will force us to act in concert, and that self-interest and success will strengthen the bond that goodwill is often insufficient to hold together. — I am very glad that Monsieur Piette is on our side. — Give him my regards, my respects to Madame Piette, to Madame Pissarro, my greetings to all the family, a warm clasp of the hand for yourself, and best wishes for fine weather. — Just think, I am reading the *Lanterne de Marseille,* and I shall subscribe to *La Réligion Laïque.* What do you say to that!

" I am waiting for Dufaure to fall, but between the present moment and the partial replacement of the Senate, what a length of time and what pitfalls.

<div style="text-align:center">

Always yours,
Paul Cézanne

</div>

" If the eyes of the people hereabouts could send out murderous glances, I should have been done for a long time ago. My looks do not please them.

<div style="text-align:center">

P. C."

</div>

Cézanne's very sensible objections to the proposed co-operative exhibition seem to have been shared by a number of the other painters who were invited to participate, and the ill-advised scheme fell through.

THE THIRD IMPRESSIONIST EXHIBITION: 1877

THE THIRD exhibition of the Impressionists opened its doors at the beginning of April 1877, at 6 rue Le Peletier — the same street but not the same gallery that had housed the exhibition of the preceding year. The new quarters, rented for the occasion, were located on the second storey (the French *premier étage*) of an empty house that was being remodelled. There was plenty of room at the disposal of the exhibitors, and the show was larger than either of its predecessors. No less than 241 pictures, including water-colours and drawings, were hung on the walls of the spacious suite. But if the number of entries was larger than before, the list of exhibitors was shorter. Thirty artists had taken part in the exhibition of 1874, and nineteen in 1876; in 1877 the number was reduced to eighteen.

Hitherto the paintings of the true Impressionists — among whom Cézanne and Renoir must still be included, though their work was already beginning to show marked indications of the independent development that was to carry them farther and farther from the original group and from each other — had composed only a relatively small proportion of the total number of

canvases exhibited; by far the most spectacular portion, it is true, but still numerically a minority. In 1877, however, so many of the less advanced painters had been weeded out — or in many cases frightened off — that the works of the Impressionist nucleus now dominated the exhibition in quantity as well as quality. For the second (and last) time all of the important radicals were united in a single exhibition: Cézanne, Guillaumin, Monet, Berthe Morisot, Pissarro, Renoir, and Sisley.

Of the other exhibitors a few were genuine believers in and followers of the Impressionist movement, notably Caillebotte and Cordey; the rest — Cals, Degas, Jacques-François, Franc Lamy, Levert, Maureau, Piette, Rouart, and Tillot — though sympathetic and " liberal " in varying degrees, remained outside the fold.

The committee in charge of hanging the pictures was composed of Renoir, Monet, Pissarro, and Caillebotte. Georges Rivière, who was present at the exhibition as a young critic on the side of the *avant-garde,* describes the arrangement of the principal rooms in his biography of Cézanne:

" In the first room were hung canvases by Renoir, Monet, and Caillebotte. The second gallery contained Monet's large picture *Les Dindons Blancs,* Renoir's *La Balançoire,* landscapes by Monet, Pissarro, Sisley, Guillaumin, Cordey, and Lamy. In the great central salon were placed *Le Bal du Moulin de la Galette* by Renoir, a large landscape by Pissarro, pictures by Berthe Morisot, and Cézanne's canvases, the latter occupying one of the large wall spaces.

" The next large room was devoted to Sisley, Pissarro, Monet, and Caillebotte. Finally, in a little gallery at the end, were gathered together the works of Degas and Berthe Morisot's watercolours."

The wall on which Cézanne's pictures were displayed was considered the finest position in the entire show. The committee,

who sincerely admired his work, seemed to be trying to welcome him back after his defection of the previous year by giving him the place of honour. Cézanne exhibited sixteen canvases: five still lifes, including two flower studies; four landscapes; two portraits, one of Monsieur Choquet, the other of a woman; one study of *Bathers;* a *Tiger* (after Delacroix?) ; and three water-colours, of which two were landscapes and the third a still life of flowers.

The Impressionists were now well past the experimental stage; there was nothing timid or apologetic about the pictures that figured in the exhibition of 1877. It was a challenge that could not be ignored, and the public flocked to the rue Le Peletier in greater numbers than to either of the earlier shows. The crowd was attracted more by curiosity than by any real appreciation of the paintings, but it was a more sympathetic curiosity than had been evident before. There was more interest in the new works, a more sincere desire to understand them, and the laughter, though still hearty enough, was more subdued. There was also more of an attempt to discriminate between the different painters; the crowd showed itself disposed to accept many of the milder pictures without much question. As usual with works of art, familiarity was beginning to breed, not contempt, but tolerance. Moreover, there was a certain amount of active propaganda to stimulate the appreciation of the public. One of the leading spirits in this campaign of education was Monsieur Choquet, who haunted the galleries during the month the pictures were on view and took advantage of every opportunity to point out to visitors the beauties of Impressionism.

He did convince a number of his acquaintances that the new movement was something more than a perverted joke, and even succeeded in persuading a few of them to buy canvases by Renoir, Monet, and Pissarro at absurdly low prices, often less than a hundred francs apiece; but all of Monsieur Choquet's eloquence and enthusiasm could not induce anyone to accept a picture by his favourite painter, Cézanne, at any price. Cézanne was still, and for a long time remained, the *bête noire* of the collectors. Opinion

was divided as to whether he was a madman or a monster; but it was practically unanimous in placing him beyond the pale. The enormous vitality of his works, the solidity and depth of his painting, the complete absence of prettiness in the treatment of his subjects, bewildered and shocked even those who had begun to accept, however hesitatingly, the more subdued, less forceful canvases of his associates.

If the general public came to the exhibition of 1877 in a slightly more receptive frame of mind than in former years, the majority of the professional critics denounced the Impressionists and all their works with undiminished vigour. *Charivari* and *Le Figaro* were particularly venomous. The following extract from an article by Roger Ballu in *La Chronique des Arts et de la Curiosité* for April 14, 1877, is typical of the newspaper attacks of the time:

" Messieurs Claude Monnet [*sic*] and Cézanne, happy to find themselves in the limelight, have exhibited, the former thirty canvases and the latter fourteen [*sic*]. One must have seen them to imagine what they are like. They induce laughter, and yet are lamentable; they display the most profound ignorance of drawing, of composition, of colour. When children amuse themselves with paper and colours they do better than this. Messieurs Levert, Guillaumin, Pissarro, Cordey, etc., do not deserve to have anyone pause in front of their works."

Obviously a fair evaluation of the paintings on view was not to be expected from such critics. In order to defend the insurgent artists and to present their point of view to the public, the more enthusiastic radical writers issued a tiny weekly review of their own, *L'Impressioniste*. Only four numbers of the little paper appeared, just enough to cover the duration of the exhibit. Even Cézanne came in for his share of praise in its sympathetic pages. The second number, published on April 14, contains an appreciation of the despised painter:

" The artist who for the last fifteen years has been most bitterly attacked and ill-treated by the press and the public is Cézanne. There is no outrageous epithet that has not been applied to him, and his works have acquired a reputation for inducing laughter, a reputation that still persists.

" One newspaper called the portrait of a man exhibited this year a *Billoir en Chocolat* [the portrait of Choquet. Billoir was a famous murderer of the day who had been guillotined for chopping a woman in pieces]. People stand in front of Cézanne's pictures in order to have a good laugh. But the laugh is forced. . . .

" Monsieur Cézanne is a painter and a great painter. Those who have never held a brush or a pencil have said that he does not know how to draw and have accused him of ' imperfections,' which are only subtle refinements derived from an enormous knowledge.

" I know very well that in spite of all this Monsieur Cézanne can never have the success of a fashionable painter. Between the *Bathers* and the little soldiers of Épinal there is no hesitation, the crowd will make a dash for the little soldiers. . . .

" Nevertheless, Monsieur Cézanne's painting has the undefinable charm of Biblical or Greek antiquity, the movements of his figures are simple and grand as in antique sculpture, his landscapes have a dominating majesty and his still lifes, so beautiful, so precise in their colour relations, are impressive for their truth. In all of his pictures the artist succeeds in moving us because he himself feels a violent emotion in the presence of nature which his science transfers to the canvas."

To say that Cézanne had been reviled by the press and the public " for the last fifteen years " was something of an exaggeration at this date. His works had not been on view prior to 1874, nor had they been commented on in the papers. But the courageous little *Impressioniste* must be given credit for its good intentions. In the same number appears an article by Cordey concerning Cézanne's *Bathers:*

" I do not know what qualities one could add to this picture to make it more moving, more passionate, and I look in vain for the faults of which it is accused. The painter of the *Bathers* belongs to the race of giants. Since he does not lend himself to comparison with ordinary painters, it has been found convenient to deny him altogether; nevertheless he has respected his fore-runners in art, and if his contemporaries do not do him justice, future ages will rank him among his peers, beside the demigods of art."

The defence was sincere and emphatic, but unfortunately the valiant little paper's circulation was restricted almost exclusively to the few left-wing readers who were already in sympathy with the new style, and its effect on the general current of opinion was practically negligible. The well-meant attempt to " launch " Cézanne was a failure.

Cézanne was in Paris at the time of the exhibition and often appeared at the gallery in the rue Le Peletier, but not during rush hours. He disliked crowds and chatter; moreover, he knew that he would be infuriated beyond control by the fatuous comments he would be sure to hear on all sides. He preferred to come quietly, late in the afternoon after the mob had gone, and sit on a bench in the almost empty gallery, sometimes alone, but more often with one of his friends, Choquet or Pissarro or Renoir. He was nearly always grave and silent on these occasions. He had no illusions about the hostility of the critics and the public, though the kindly Monsieur Choquet, carried away by his own enthusiasm, often tried to cheer him up by assuring him that his gifts would soon be recognized and acclaimed. Cézanne did not argue; he understood and appreciated Choquet's friendly encouragement, but he was far too clear-headed to be taken in by it. He knew that his only real ally was time; perhaps later on he would be acknowledged as the master he already felt himself to be, but it could only be after many years.

After the exhibition of 1877 the Impressionists found them-

selves, strangely enough, in a worse position than before. The general public had been partially won over, but buyers were scarcer than ever. The painters discovered that the exhibition had brought them notoriety but not fame; and notoriety by itself is a poor lining for empty stomachs. Most of the Impressionist leaders were to a great extent dependent on their brushes for a livelihood. The exceptions were Caillebotte, who was frequently called on to help out his less fortunate comrades; Berthe Morisot, a comparatively wealthy woman; and Cézanne, whose present allowance was sufficient for his modest requirements and who could look forward to the inheritance of a considerable fortune after the death of his father, now eighty years of age. But Monet, Renoir, and Pissarro had almost no resources of their own and were obliged to sell their pictures for infinitesimal prices — sometimes as little as thirty or forty francs apiece — in order to live at all. Guillaumin drew a small salary as an employee of a municipal department, but with a family to support he was often in dire distress for want of money. Sisley, the poorest of all, spent his whole life in abject poverty and was not infrequently faced with actual starvation.

A few attempts were made to sell the works of these unpopular painters at public auctions, but the response was so disheartening that they were soon abandoned. Many of the pictures proved to be unsalable at any price and had to be withdrawn. The sums paid for the remainder were absurdly small, but the need of the artists was so pressing that almost any offer had to be accepted. In 1875 — a year in which no Impressionist exhibition was held — Monet, Sisley, Renoir, and Berthe Morisot sent seventy pictures to be sold at auction at the Hôtel Drouot. The total sales amounted to a little over 10,000 francs, an average of under 150 francs per canvas. But this total included a number of pictures that were bought back by their authors because nobody else would bid on them; hence the actual proceeds of the sale amounted to much less than the figures indicate. After the exhibition of 1877 another auction was held at the Hôtel Drouot, to

which Renoir, Pissarro, Sisley, and Caillebotte contributed forty-five pictures. They realized a total of just over 7,600 francs — about 170 francs apiece — again including a number of canvases repurchased by the painters themselves.

Obviously there was little to be gained by repeating these disastrous auctions. One courageous dealer, Durand-Ruel, continued to buy the despised works for a year or two; he paid little for them, but even so, he lost money on the transactions; he could not sell them at any price, the canvases accumulated in his storerooms, and in a short time he was obliged to stop his unprofitable purchases.

Yet not one of the Impressionists thought of yielding to the pressure of public hostility, not one of them compromised by painting pictures that would please the collectors. They were all confident that in time their paintings would be appreciated and sought after; meanwhile they grimly tightened their belts and went on working. They just managed to keep body and soul together by occasional sales to friends and sympathizers. And they continued to hold joint exhibitions whenever they could scrape together or borrow the money to pay the expenses. Such exhibitions took place in 1879, 1880, 1881, 1882, and 1886, each year in different quarters. But they were somewhat less representative of the Impressionist movement as a whole than the first three exhibitions had been. In no one of these later shows did all members of the original group take part; Pissarro and Berthe Morisot sent pictures regularly, but Monet, Renoir, Sisley, and Guillaumin were less faithful; sometimes one would be missing, sometimes another.

After 1877 Cézanne did not exhibit again with the Impressionists. Had a show been held the following year he would have participated to the extent of at least one picture, as indicated in a letter to Zola written from Aix on March 28, 1878:

" An exhibition of the Impressionists will probably take place; if so I beg you to send the still life that is in your dining-room.

I received a summons to attend a meeting [of the Impressionists] on the 25th of this month in the rue Laffitte — naturally I was not present."

But the projected exhibition was postponed until 1879, and by that time Cézanne had made up his mind that he would take part in no more of them. His decision is recorded in a short note to Pissarro — the last of Cézanne's half-dozen surviving letters to his fellow-painter:

" 1 April 1879

" My dear Pissarro,

" I think that in view of the difficulties raised by the picture I sent to the Salon, it would be advisable for me not to take part in the exhibition of the Impressionists.

" Incidentally, this would save me the trouble connected with the forwarding of my canvases. Moreover, I am leaving Paris in a few days.

" I send you my greetings, while looking forward to the moment when I may clasp your hand.

Paul Cézanne "

The bother of forwarding his paintings was, of course, a transparent excuse that must have made the gentle Pissarro smile. But after the fiasco of 1877 Cézanne had decided not to expose his pictures again to the ridicule of the public, unless by hook or crook he could manage to get them into the Salon. For some time longer he continued his yearly offerings to that institution, knowing that they would be rejected with automatic regularity. For thirteen years he stuck to his determination not to exhibit under other auspices, until he was induced to take part in a show of " advanced " painting in Brussels. And it was not until 1895, eighteen years after the last Impressionist exhibition in which he was represented, that Cézanne's pictures were again placed on view in France.

214

As far as the public was concerned, the interval was a period of complete isolation for Cézanne. He continued to see his intimate friends — Pissarro, Renoir, Monet, Choquet, and Zola — from time to time; but he was no longer a member of any group. The dealers, the critics, the collectors, and the merely curious who frequented the studios and exhibitions soon lost sight of him. His very name, for a few years a symbol of all that was monstrous and grotesque in painting, was forgotten by all except a few comrades.

During those years he withdrew more and more into himself. He lived apart from the busy world of Paris and the studios, and painted.

PÈRE TANGUY

THE YEARS 1877 to 1886 are more fully documented than any other period of Cézanne's life. Of the unpublished letters from Cézanne to Zola, already mentioned, sixty-six cover this decade; their contents enable us not only to follow the painter's movements in detail, but to reconstruct many hitherto unknown fragments of his inner life. The tone of the letters is uniformly affectionate and cordial. Cézanne still considered Zola his closest friend; he took the novelist completely into his confidence, discussed with him his most private affairs, and looked to him for advice, for sympathy, and often for concrete assistance. All of these Zola gave in full measure. The friendship which had existed between them since boyhood seemed built on the sturdiest of foundations; there is nothing in these letters to indicate that it was to come to an end suddenly, completely, and for ever.

In one respect the correspondence is disappointing. Cézanne rarely mentioned his painting when writing to Zola. He knew that Zola did not like his pictures, that he was incapable of understanding his conception of painting, that he was convinced that his poor old friend would never do anything really worth while. Cézanne made no attempt to convert Zola; he simply avoided the discussion of art and kept to more personal and less controversial subjects.

216

At the age of thirty-seven Zola had progressed a long way from the half-starved boy who worked at the docks during the day and spent his evenings in a garret writing long, homesick letters to his friends Cézanne and Baille. He was now well launched on his career as a writer. He had completed seven of the twenty-one volumes of the *Rougon-Macquart* saga; the seventh, *L'Assommoir,* had brought him notoriety. Before the novel was issued in book form it appeared serially in the pages of *Le Bien Public* during the spring of 1876. Immediately it became the most heatedly discussed novel of the day. Zola's vivid and realistic portrayal of the progressive degradation of a family through disease and drink caused so many scandalized readers to cancel their subscriptions to *Le Bien Public* that the publication of *L'Assommoir* was discontinued; after a month's interval it was resumed in another journal, *La République des Lettres.* The curiosity of the public was aroused by all this controversy, and when the book came out, thousands of copies were bought and eagerly devoured.

Zola's frankness made him the target for streams of abuse from the conservative critics. He was attacked bitterly in certain sections of the press. But he had staunch supporters as well: he was on intimate terms with most of the literary lions of the day; Flaubert, Daudet, Mirbeau, the de Goncourts, Huysmans, and Turgenev were his friends. During the next ten years Zola's fame increased rapidly. *Nana,* published in 1880, was even more popular than *L'Assommoir,* and thenceforward all of his books were assured of a large sale.

It was then to a successful Zola that these letters of Cézanne's were addressed: a Zola very much in the literary swim, the object of violent criticism and equally extravagant admiration, enormously busy, full of energy, and already comfortably well off.

Zola spent the summer of 1877 at L'Estaque, the suburb of Marseilles which was Cézanne's favourite refuge from the turmoil of Paris and the too intimate family life of Aix. Cézanne himself was still in the north. Zola, working on the eighth volume of the *Rougon-Macquart* series, *Une Page d'Amour,* paid occasional

visits to Cézanne's mother. He had always remained on friendly, even affectionate terms with her, though he seems to have come into contact with old Louis-Auguste rarely, if at all, during the years that had elapsed since his departure from Aix in 1858. Probably the banker had never quite forgiven Zola for the part he had played in persuading Cézanne to abandon his law studies for so foolish an occupation as painting.

Cézanne intended to take the risk of bringing Hortense and little Paul — now five and a half years old — to Provence with him when he returned for the winter. He dared not inform his mother directly of his plan for fear that Louis-Auguste would see the letter; but Zola appears to have come to the rescue by offering to act as intermediary. Cézanne replied from Paris:

" *24 August 1877*

" My dear Zola,

" I thank you heartily for your kindness to me. I beg you to inform my mother that I need nothing, for I expect to pass the winter in Marseilles. She will do me a great favour if in December she will take the trouble to find me a very small lodging of two rooms in Marseilles, not dear, but yet in a quarter where there is not too much murder. She might send me there a bed and whatever bedding is necessary, and two chairs, which she could take from L'Estaque in order to avoid too much expense.

" Here the weather, you must know, the temperature is very often cooled by beneficent showers (in the style of Gaut of Aix). I go to the park of Issy every day, where I am making some sketches. And I am not too discontented, but it seems that a profound desolation reigns in the Impressionist camp. Pactolus is not exactly flowing into their pockets, and their studies are withering on the walls. We are living in very troubled times, and I do not know when poor painting will regain a little of her glory. . . .

" Is the sea-bathing doing Madame Zola good, and are you yourself breasting the salty waves? I present my respects to all of

you, and greet you cordially, so good-bye until your return from the sunny shores,

> For your kindness I am the grateful painter
>
> Paul Cézanne."

There is some of Cézanne's youthful gaiety in this letter, in the not unreasonable hope that his proposed lodgings will be in a neighbourhood undisturbed by excessive assassinations, and in the burlesque of the exaggerated elegance of the Aixois poet Gaut, whose pompous style had amused the three inseparables so long ago.

Cézanne changed his mind suddenly, and four days later he wrote again to Zola:

" My dear Émile,

" I must call on you again to tell my mother not to trouble herself, I have changed my plans. As a matter of fact the arrangement would appear to be difficult to carry out. I give it up. — Nevertheless I still count on going to Aix in the month of December or rather about the beginning of January.

" I thank you — very sincerely. I add my greetings to your family. Yesterday afternoon when I went to my colour-merchant's in the rue Clauzel, I found dear Emperaire there."

The colour-merchant in the rue Clauzel was Julien Tanguy, one of the most picturesque and sympathetic figures in the Parisian world of art.

* *

Le Père Tanguy, as he was generally called, was born at Plédran in Brittany in 1825. He was a plasterer by trade, but after moving to Saint-Brieuc, where he married a woman who kept a pork-butcher's shop, he entered the employ of the Ouest railway. In 1860 the family came to Paris; Tanguy left the railway company and took a job as colour-grinder (*broyeur*) in the shop

of Édouard, a manufacturer of artists' colours in the rue Clauzel. As soon as he had learned the art of making paints, Tanguy set up a little business of his own, while his wife was installed as concierge in a private house in Montmartre.

Tanguy was too poor to open a shop; he prepared his colours at home, in the little *loge de concierge* he occupied with his wife, and peddled them to the *plein-air* painters who were scattered about the environs of Paris. He soon became a familiar and welcome figure as he trudged about the countryside with his huge box filled with tubes of paint. Among his regular customers were Monet, Pissarro, Renoir, and Cézanne. Tanguy's colours were of an excellent quality, and his clients consumed enormous quantities of them. In the hands of a shrewd man of business the trade might have become exceedingly profitable, but Tanguy was too unworldly and too generous to make the most of his opportunities. He regarded these young and unrecognized painters as his friends; nearly all of them were poor, and even Cézanne was at that time on a small allowance and generally short of ready cash. Tanguy gave unlimited credit and was generally obliged to take his payment, when he received anything at all, in pictures — which, being unsalable, were stacked in heaps in his little room. This accumulation of Impressionist canvases was due to no far-sighted conception of their ultimate value. Tanguy liked the pictures, but he did not believe that anyone would ever pay good money for them. His acceptance of these unwanted canvases in return for his colours was a gesture of pure kindliness: a generosity he could ill afford, for Tanguy, since he made so little out of his own merchandise, was dependent on his wife's meagre wages for a living.

The Commune of 1871 brought disaster to Père Tanguy. Though gentle and peaceable by temperament, his deep sympathy with the struggles of the poor and the oppressed drew him into the ranks of the revolutionaries. He was arrested, treated as a deserter, and condemned to the galleys. To make matters worse, his wife's employer threatened to dismiss her, but eventually he

took pity on her situation and allowed her to remain as concierge.

After two years of misery in a prison ship Tanguy succeeded in obtaining a pardon through the good offices of an influential friend, but he was forbidden to return to Paris for two years longer. During his exile he lived in Saint-Brieuc with his brother until he was able to rejoin his wife and daughter in Paris in 1875. The householder who had been sufficiently kind-hearted to employ Mère Tanguy during her husband's enforced absence would not, however, go so far as to permit Tanguy himself to remain in the house; and the family, now entirely without resources, was forced to move to a tiny lodging in the rue Cortot. Soon afterwards Tanguy took advantage of the closing of the Édouard establishment, in which he had worked some fifteen years before, to move back to the rue Clauzel and open his own little colour-shop in the familiar neighbourhood. It is this shop that is referred to in Cézanne's letter to Zola quoted above.

Many of Tanguy's former customers, including Cézanne, Vignon, Guillaumin, Pissarro, and Renoir, came to the dingy shop. They were followed by a number of the younger generation of painters, just beginning to appear on the horizon: Gauguin, Van Gogh, Signac, and Toulouse-Lautrec, among others. But the influx of clients, old and new, brought no financial gain to the colour-merchant. The painters were still poor, and Tanguy himself incorrigibly generous, not only with credit but with actual loans and gifts of money, when he had any. The hungry were always welcome at his table, and a refusal to share a meal was regarded as an insult. He extended his hospitality indiscriminately to impecunious artists, professional beggars, and women of the streets. His charity often drove his wife, who was called upon to provide free meals for strangers when there was nothing in the house for her own family, to protest; but though she considered her husband a fool, she loved him and for his sake performed miracles of ingenious cookery so that the scanty fare should be equal to the demands upon it.

Meanwhile the apparently worthless canvases accumulated in

the rear of the little shop. Cézanne in particular, who had given up all hope of selling his pictures and who took no interest in them once they were completed (or abandoned at some intermediate stage), was glad enough to be rid of them by turning them over to Père Tanguy in exchange for new tubes of colour. One can only guess at the number of Cézanne's paintings that Tanguy unwittingly saved from destruction in this way; for if they had remained in Cézanne's possession, he would certainly have ripped many of them to pieces with his palette-knife or burnt them in a fit of rage or discouragement.

Tanguy did more than merely preserve Cézanne's pictures from the fury of their creator: he occasionally showed them, whenever he had a visitor whom he judged worthy of the honour. Thus during Cézanne's long self-imposed isolation after the exhibition of 1877 it was Tanguy alone who kept his name and his work from being completely forgotten. The only place where Cézanne's canvases could be seen at all was in the shop at 14 rue Clauzel. There was of course no room to hang them, but when they were called for by the younger painters or by the friends and critics they brought to the shop, Tanguy would bring them out and stand them on chairs or against the walls, hoping the visitors would admire them as much as he did himself. And after the first shock had worn off, many did come to admire them. The thing most needed for an ultimate appreciation of any new departure in art is the opportunity to become familiar with good examples of the works of its originators; in time the uncomfortable sensation of strangeness disappears and the work can be judged dispassionately. In Cézanne's case it was Tanguy who provided this opportunity. While Cézanne himself dropped out of sight, through Tanguy his influence slowly but inevitably permeated the work of the younger school of painters, most of whom had never seen Cézanne in the flesh.

In his humble way, and entirely without realizing the importance of the influence he was helping to disseminate, Père Tanguy played a vital part in setting the course of modern painting. With-

out him the younger painters would never have come across Cézanne's pictures, would never have grown familiar with them, come under their influence, and transmitted that influence to the painters of the present day. Moreover, Tanguy presented Cézanne not only to the group of artists who saw his work in the little shop, but indirectly to the world. If Ambroise Vollard had not seen Cézanne's canvases at Tanguy's it would not have occurred to him to organize his epoch-making exhibition in 1895, without which Cézanne would have remained practically unknown to the public for a still longer period.

Among the young painters who saw, admired, and in time were influenced by the Cézannes stored away in Tanguy's shop were Paul Gauguin, Vincent Van Gogh, and Émile Bernard. The last-named artist, who has written much about Cézanne in the *Mercure de France* and other magazines, has also contributed a lengthy and valuable article on *Julien Tanguy* to the *Mercure de France* for December 16, 1908, from which a great deal of the foregoing account of the colour-merchant's life is drawn.

Cézanne's influence on Gauguin has, I think, been exaggerated. Some traces of it can be detected in Gauguin's early work, especially in the landscapes; but practically none is to be found in the more decorative, flat painting he adopted after his migration to the South Seas — by far the more important part of his production. Gauguin sincerely admired Cézanne, but Cézanne had little respect for Gauguin's work. He is said to have charged Gauguin with " stealing his thunder." It is difficult to see on what grounds the accusation was based. Gauguin may have been a far more obvious and facile painter than Cézanne, but he was in no sense a vulgar imitator.

Van Gogh was deeply affected by Cézanne's painting and looked up to him as a master among masters, but the two men were poles apart in temperament and totally incapable of understanding each other. Van Gogh was highly impulsive, intensely emotional, mystic, and towards the end of his life definitely unbalanced; he painted fiercely, intuitively, and with extreme ra-

pidity, sometimes completing as many as three canvases in a day. Cézanne's emotional perceptions, keen as they were, were always tempered by a sober and penetrating intelligence; he was eminently sane, and he built up his pictures slowly, deliberately, with long pauses for concentrated study between the careful brushstrokes.

The only recorded meeting between Cézanne and Van Gogh took place in Tanguy's shop in the rue Clauzel. The date is unknown, but it must have occurred after Van Gogh's arrival in Paris in 1886 and before his departure for Arles in 1888. The encounter is described by Émile Bernard in the *Mercure de France* for December 16, 1908:

" One afternoon when Cézanne came to Tanguy's, Vincent, who had lunched there, met him. They chatted together, and after having talked about art in general, they began on their own individual ideas. Van Gogh thought that he could not explain his theories better than by showing his pictures to Cézanne and asking his opinion of them. He exhibited canvases of various kinds, portraits, still lifes, landscapes. Cézanne, whose nature was timid but violent, said after he had inspected them all: ' Truly, you paint like a madman! ' "

Tanguy was a good friend to the unhappy, poverty-stricken Van Gogh. He fed him, supplied him with painting-materials — no light drain on Tanguy's slender purse, for Van Gogh painted thickly as well as rapidly — and did his best to help him sell the pictures that threatened to swamp the little shop and overflow into the rue Clauzel. Occasionally he succeeded, but the prices he received were ludicrous. In return Van Gogh immortalized Père Tanguy in two magnificent portraits. One of these, painted in 1887, shows the colour-merchant seated squarely in the middle of the canvas, full face, against a background of Japanese prints — which Tanguy sold as a side line. The head is square, sturdy,

and rugged; the eyes, set very far apart, are gentle, the nose broad and flat, and the wide mouth firm. Everything about the figure is solid, and the effect of breadth, almost of squatness, is accentuated by the short double-breasted jacket and the flat wide-brimmed hat, with the edges turned up all around like the rim of a saucer.

Tanguy also sold his Cézannes when he could. He established a standard price of a hundred francs for large canvases and forty francs for small ones, regardless of subject. Even at those prices buyers were scarce. Vollard tells us that Cézanne sometimes painted several small independent studies on a single sheet (probably in water-colour) ; for the benefit of purchasers who could not afford even forty francs or who were unwilling to risk that amount for a painting by so obscure an artist, Tanguy would cut these up with a pair of scissors and sell the scraps for what he could get. In time Tanguy was convinced by the enthusiastic younger painters that Cézanne's canvases were really worth more than the current prices; thereafter he locked them up and refused to part with them for such pitiful sums.

But his optimism was premature. After Tanguy's death in 1894 Octave Mirbeau organized a sale of pictures at the Hôtel Drouot for the benefit of the widow, who was left completely destitute. At this sale the six Cézannes brought the following prices:

Cour de Village	215	francs
Village	175	"
Pont	170	"
Village	102	"
Les Dunes	95	"
Ferme	45	"

Nor did the works of most of the other artists fare much better. A Seurat went for 50 francs, a Vignon for 22, a Van Gogh for 30. Two Sisleys were sold for 370 francs the pair; four Guillaumins ran between 80 and 160 francs each, and six canvases by Gauguin

brought less than 100 francs apiece. Only Monet and Cazin were treated with respect: a picture by the former sold for 3,000 francs, and one by the latter for 2,900.

During his last months the good Père Tanguy suffered horribly from cancer of the stomach. Unselfish to the end, he insisted on being taken to a charity hospital in order to spare his devoted wife the trouble of nursing him. But the atmosphere of an institution was more than he could bear, and after a few weeks he begged to be taken home again. He was carried to the rue Clauzel on a stretcher and died in the tiny shop surrounded by his beloved pictures and the paraphernalia of his trade.

A DIFFICULT YEAR: 1878

As announced in his letter to Zola, Cézanne returned to Provence in December 1877 or January 1878. For more than a year he remained in the Midi, dividing his time between Aix, the Jas de Bouffan, and L'Estaque. This time Hortense and little Paul came with him, but he did not dare bring them too close to Aix. He installed them in a little apartment in Marseilles, where he hoped to be able to visit them as often as he wished without revealing their existence to his father.

Cézanne's precautions were not wholly successful. He was not a very convincing liar, and moreover too many other people were in the secret. His mother — and probably his sisters, though this is not certain — knew all about the *ménage;* so did most of his friends in Paris. Louis-Auguste had no scruples about opening letters addressed to his son, and on two or three occasions he was rewarded by finding references which confirmed his suspicions. The fat was in the fire, and for a time Cézanne feared that his allowance would be stopped altogether and that eventually he would be disinherited.

The first intimation that all was not well between father and son appears in a letter to Zola dated March 23, 1878:

" My dear Émile,

" I find that I shall very soon be obliged to earn my own living, that is if I am capable of doing so. The situation between my father and myself is becoming very tense, and I am threatened with the loss of my entire allowance. A letter written to me by Monsieur Choquet, in which he mentioned ' Madame Cézanne and little Paul,' has clearly revealed my position to my father, who was already on the watch, full of suspicions, and who did not hesitate to open and read the letter which was meant for me, although it bore the address Mons. Paul Cézanne *artiste peintre*.

" Therefore I appeal to your kindly feelings towards me, to find a job for me somewhere, through your connections and your influence, if you think such a thing is possible. Relations are not yet completely broken off between my father and myself, but I think that before another fortnight has passed I shall be absolutely done for.

" Write to me — (addressing your letter M. Paul Cézanne poste restante) whatever decision you come to regarding my request.

" I present my sincere salutations to Madame Zola, and greet you cordially.

<div align="right">Paul Cézanne</div>

" I am writing from L'Estaque, but I return to Aix this evening."

If the crisis anticipated by Cézanne had materialized, no doubt Zola would have been both willing and able to secure some sort of position for his friend. But he understood Cézanne well enough to know that he was totally unfitted by temperament for any occupation except painting. Very wisely therefore he advised Cézanne to conciliate his father in every possible way in order to avoid an open rupture and the consequent withdrawal of the income on which all his happiness depended. The text of Zola's reply is lost, but its tenor can be guessed from Cézanne's next letter, dated March 28:

" My dear Émile,

" I agree with you that I should not give up the paternal allowance too readily. But by the traps that are set for me, traps which I have escaped so far, I foresee that the great discussion will have to do with money, and the way in which I should spend it. It is more than likely that I shall receive only 100 francs from my father, although he promised me 200 when I was in Paris. In that case I shall avail myself of your kindness, especially as the boy has been ill for the past fortnight, with a mucous fever.

" I am taking every precaution to keep my father from obtaining any definite proof. . . .

" If, therefore, my father does not give me enough money I shall apply to you during the first week of next month, and I shall give you Hortense's address, to which you will be kind enough to send it."

Evidently Zola had offered to lend Cézanne enough to make up the expected deficiency in his allowance. A week later the painter was forced to take advantage of his friend's liberality, although only to a very modest extent:

" April 4 1878

" My dear Émile,

" I beg you to send sixty francs to Hortense at the following address,

<div style="text-align:center">

Madame Cézanne
rue de Rome 183
Marseilles

</div>

" Notwithstanding the most solemn promises, I have been able to obtain only 100 francs from my father, and as a matter of fact I was afraid that he would give me nothing at all. He has heard from various people that I have a child, and he is trying in every possible way to catch me off my guard. He wants to rid me of the encumbrance, he says.

" I won't say any more, it would take too long to explain the old man to you, but he is not so bad as he seems to be, you may take my word for it. Write to me whenever you can, it would give me great pleasure. I shall try to go to Marseilles, I slipped away a week ago Tuesday to see the child, he is better, and I was obliged to return to Aix on foot, because the train shown on my time-table was wrong and I had to be home for dinner, I was an hour late.

" I present my respects to Madame Zola, and greetings to yourself,

Paul Cézanne."

There is something both comic and tragic in the picture of Cézanne, almost forty years old, meekly trudging the eighteen miles from Marseilles to Aix because he dared not offend his father by an unannounced absence from the family dinner-table. Obviously he was afraid of the old man; but the assurance that " he is not so bad as he seems to be " indicates that Cézanne's fear was tempered by a genuine affection.

It is impossible for us to know to what extent Louis-Auguste's suspicions really were allayed by Cézanne's rather feeble denials. The retired banker — the firm of Cézanne and Cabassol had been dissolved in 1870 — was eighty years of age, but his faculties were not impaired in the slightest degree, and it is unlikely that the shrewd old fox was taken in by such lame equivocation. It is far more probable that he was at heart fond enough of his eccentric son — and perhaps, incidentally, sufficiently afraid of open scandal — to be willing to close his eyes to the truth deliberately and pretend to be satisfied with explanations that did not explain. Thus he was able to save his face without going to the extreme length of cutting off his son without a penny, as he had threatened to do.

He kept Cézanne on a very meagre allowance, however, and for several months the latter was forced to borrow secretly from Zola. All of these loans, as well as practically the whole of his own

allowance, went to the support of Hortense and the boy. Cézanne spent almost nothing on himself during these lean months; it was at this time — on March 28, 1878 — that he complained that he was obliged to pay five sous overweight on one of Zola's letters.

In May — the letter bears no more specific date — Cézanne appealed again to Zola's generosity:

' Since you are willing to help me out once more, I beg you to send 60 francs to Hortense, at the same address, 183 rue de Rome. I thank you in advance. . . ."

And again on June 1:

" Here recommences my monthly prayer to you. I hope it does not bore you too much, and that it does not appear too indiscreet. But your offer relieves me of so much embarrassment that I am taking advantage of it again. My kind parents, who are really very good to an unfortunate painter who has never been able to accomplish anything, are perhaps a little stingy, it's a slight fault which is no doubt excusable in the provinces.

" Now comes the inevitable result of such a preamble, I beg you to be kind enough to send sixty francs to Hortense, whose health, by the way, is no worse."

Is the painter being mildly ironical at the expense of his " kind parents," or is his humility genuine? It is hard to say. At times Cézanne did think of himself as nothing more than " an unfortunate painter who has never been able to accomplish anything "; luckily such moments of self-abasement were both rare and fleeting. Probably the mood that gave rise to the above reflection was compounded of a small portion of real meekness plentifully salted with his characteristic wry humour.

At the beginning of July Cézanne again borrowed sixty francs on behalf of Hortense, who had just moved to a new lodging in Marseilles, 12 Vieux Chemin de Rome. That summer Louis-Auguste was in a mood to find fault with almost anything his son

did, however innocent. One of the incidents that upset the iras-
cible old man slipped over into sheer farce, as even Cézanne,
harassed as he was, could see:

> *" 29 July, 1878*
>
> " My dear Émile,
> " Before leaving Paris I deposited the key to my apartment
> with a fellow named Guillaume, a shoemaker. This is what must
> have happened: this chap evidently had some guests from the
> country who came to visit the Exposition, and put them up in
> my rooms — my landlord, greatly annoyed because he had not
> been consulted in advance, sends me, together with the receipt
> for my last quarter's rent, a very stiff letter informing me that my
> apartment is being occupied by certain strangers. —
> " My father reads the above letter, and concludes from it that
> I am keeping women in Paris. This is beginning to take on the
> appearance of one of Clairville's *vaudevilles*. . . .
> " I beg you to send sixty francs to Hortense as usual, though I
> am seriously hoping to relieve you of this monthly tax. If I can
> get away to Paris for a month in September or October, I shall
> do so."

The shoemaker whose misplaced hospitality almost proved
so disastrous to Cézanne was Antoine Guillaume. The Guil-
laumes were old friends of the Fiquet family; when Hortense as
a young girl had been employed at sewing books, Madame Guil-
laume had worked beside her in the same establishment.
 In spite of this latest misunderstanding a *rapprochement* be-
tween Cézanne and his father seemed to be in the air, and the
painter could look forward to the time when it would no longer
be necessary for him to borrow from Zola. A month later, however,
on August 27, he had to renew his appeal:

> " This month I am taking advantage of your kindness again,
> if you can send another 60 francs to Hortense, who will be at 12
> Vieux Chemin de Rome until September 10."

But in September the clouds suddenly lifted. Cézanne wrote the good news to Zola:

> "*14 September 1878*
>
> " My dear Émile,
> " It is in a more tranquil frame of mind that I am able to write to you at the present moment, and if I have been able to survive certain little misadventures without too much suffering, I have done so thanks to the good and solid plank you have held out to me. I must tell you about the latest blow that has fallen on me.
> " Hortense's father writes to his daughter, to the rue de l'Ouest, under the name of Madame Cézanne. My landlord hastens to forward the letter to the Jas de Bouffan. My father opens and reads it, you can imagine the consequences. I deny everything emphatically, and as Hortense's name, very luckily, is not mentioned in the letter, I insist that it is intended for some other woman. . . ."

So far this is not very promising, but the real cause of Cézanne's " more tranquil frame of mind " appears in the postscript:

> " *Nota-bene:* Papa gave me three hundred francs this month. Unheard of. I think he has been making eyes at a charming little maid we have at Aix, Mamma and I are at L'Estaque. What a result! "

If the octogenarian's roving eye really was responsible for his unusual generosity, Louis-Auguste must have been a lusty old gentleman.

Cézanne was not yet out of the woods, however. Presumably his father, temporarily restored to good humour by the charms of the pretty maid (or by some less romantic agency) , did increase the painter's allowance from this time on; at any rate Cézanne's monthly borrowings of sixty francs came to an end with the appeal of August 27. But he had no reserves with which to meet unex-

233

pected outlays, and in an emergency was obliged to call on Zola once again:

<div align="right">

"Monday 4 November 1878

</div>

" My dear Émile,

" I am sending this letter to Paris, thinking that you will have returned to town by this time. — Here is the reason for my letter. Hortense is in Paris on urgent business, I beg you to send her 100 francs, if you can advance me that amount, I am in hot water, but I hope to get out of it.

" Let me know if you can render me this additional service. If it's impossible, I'll try to find some other way out. In either case, I thank you. . . ."

Of course Zola sent the money immediately, and Cézanne acknowledged its receipt with thanks in his next letter, dated November 20. This is the last time Cézanne borrowed from his friend, if the record in the letters is a complete one. Between April and November 1878, Zola had advanced 460 francs: six loans of 60 francs each and one of 100 francs. It was not a large sum, but it was vitally important to Cézanne at the time. Whether or not he ever repaid Zola we do not know. There is no mention of such repayment in the letters, but that proves nothing one way or the other. The two friends saw each other frequently during the next seven years, and Cézanne may have given Zola the money at one of their meetings, without leaving any formal record of the transaction.

Louis-Auguste made no further attempt to cut down his son's allowance, though the tension between the two men continued until the end of the year, if not longer. One curious circumstance, however, makes Cézanne's evident fear of losing both his present income and his future inheritance difficult to explain. Both Monsieur Paul Cézanne and Monsieur Maxime Conil — respectively the son and brother-in-law of the painter — have stated that Louis-Auguste, shortly after his retirement from active business

in 1870, had divided the bulk of his fortune equally among his three children, in order to avoid the payment of an inheritance tax; he retained an income sufficient for the needs of himself and his wife for the remainder of their lives, but nothing more. Neither Monsieur Cézanne nor Monsieur Conil remembers the exact date of this transfer, but both are agreed that it took place several years before 1878, and that at the time the above letters to Zola were written Cézanne and his sisters were already technically in possession of most of their father's capital. Why then was Cézanne still so dependent on Louis-Auguste's bounty? Why was he forced to borrow small sums from Zola to eke out his own reduced income? Possibly there was a string attached to the inheritance: perhaps the deed of gift was not irrevocable, so that a false step might still have endangered Cézanne's livelihood notwithstanding the previous subdivision of the estate. This, however, is only a suggestion; the true explanation remains a mystery.

* *

What would have happened to Cézanne if Louis-Auguste had followed up his threats and left him penniless at the age of forty? It is almost impossible to suppose that one whose genius was limited so exclusively to a single field could suddenly have diverted his energies into a different channel. In spite of his youthful hesitations and backslidings Cézanne's adoption of painting as a career was no matter of mere superficial preference or taste. He was drawn into it by an inner compulsion, an irresistible force that left him no real choice. Some of the greatest painters in history (for example Leonardo and Michelangelo) were masters of many arts; had they been obliged to abandon their brushes at any time, they could have filled their lives and their pockets in other ways. Not so Cézanne: his talents were circumscribed to an abnormal degree. He could paint, and he could do literally nothing else whatever. The other arts offered him no outlet for his creative spirit; he had no flair for sculpture, architecture, literature, or music. At best he might have been able to

earn a bare living as a clerk or minor employee in some stuffy office, but it would have meant to him nothing less than spiritual death.

Nor could Cézanne have hoped to earn a living by his brush. His pictures brought only a few francs each at this time, when they could be sold at all. Had he been able to modify his work to suit the popular taste, no doubt he could have made enough to support himself and the woman and child who were dependent on him. But for Cézanne potboiling was simply out of the question. It was impossible for him to commercialize his art; so impossible that the idea of producing salable pictures as a solution of his financial difficulties never even occurred to him. He would have been willing to take a job in an office; then at least he could have painted as he wanted to paint in his spare time, as Guillaumin did. Perhaps, if he had been obliged to adopt the latter compromise, he might still have produced some masterpieces. But Cézanne painted so slowly and with such intense, exhausting concentration that it is unlikely that his vitality would have been equal to the ordeal. Certainly a large proportion of his finest pictures would never have been painted.

From a strictly ethical point of view, perhaps Cézanne may be censured for stooping to furtive deception and, on occasion, to downright lying, in order to safeguard his income. On the other hand Louis-Auguste's interference in his son's affairs was inexcusably autocratic, and his methods of obtaining information were hardly edifying. No doubt a greater display of independence on Cézanne's part would have implied a nobler character. It may be said with some truth that Cézanne showed himself spineless in his attempts to placate the old man; that he weakly chose the easiest way. But for Cézanne the easiest way, in this case, was the only way. The loss of his allowance would have meant the end of his painting. And the opportunity to paint as he saw fit was by far the most important thing in the world to Cézanne. If he could only hold on to that, what did a few lies and a little soft soap matter?

There is today a widespread popular belief that genius — especially artistic genius — can be properly nourished only on poverty; or to put it in another way, that wealth has a softening effect that prevents genius from attaining its maximum development. This conclusion seems exceedingly doubtful; the rule is riddled with so many notable exceptions in all branches of art that it will scarcely hold water. This is not the place, however, for a lengthy discussion of so highly debatable a question; it is pertinent here only in so far as it applies to Cézanne.

Certainly Cézanne was one of the exceptions. He was born to wealth, though not to extravagance or ostentation. Except for these few tense months in the summer of 1878 he was always assured of an income, small but sufficient to relieve him of the necessity of earning a living for himself; and during the last twenty years of his life he was a very rich man according to the standards of the provincial corner of France in which he spent the greater part of his time. There is not the slightest reason to believe that his relative affluence had any harmful effect on either the quantity or the quality of his work. No man was ever less in need of the spur of poverty than Cézanne. With all the money he needed in his pocket, he painted day in and day out, from dawn to dusk, year after year. It is inconceivable that an empty belly could have produced better pictures. On the contrary, it is almost self-evident that in his case, at least, extreme poverty would have been wholly injurious. He needed all the physical vitality and all the mental tranquillity that freedom from financial worry could give him. Had Cézanne been a poor man, the world today would be the poorer by some of its finest pictures. No doubt it was very wrong of him to lie to his old father. But posterity can thank its stars that Cézanne, in that critical year of 1878, chose deception in preference to destitution.

While a modest independent income was thus essential to Cézanne, he had, on the other hand, no use whatever for a great fortune. The money he inherited from his father enabled him to give his wife and son all the comforts and luxuries they wanted,

but he spent little of it on himself. He preferred modest lodgings and an unpretentious mode of life; he cared nothing for fine furniture, fashionable clothes, or expensive amusements; the amenities of social intercourse repelled him. His inheritance, when it came, made no perceptible change in his own routine. He was never tempted to lay down his brushes in order to live a life of ease and idleness. He continued to paint with the same indefatigable industry, the same grim determination, until the last days of his life.

* *

Financial worries were not the only troubles that beset Cézanne that year. For a time he was anxious about his son's health; the boy had contracted a fever, from which, fortunately, he recovered quickly. It was this illness that occasioned Cézanne's unlucky visit to Marseilles — the visit which was followed by the episode of the missed train, the long walk home, and the delayed dinner. A little later Cézanne wrote to Zola: " My mother is very ill and has been in bed for the last ten days, her condition is very serious." This letter is dated only " Wednesday evening, 1878," but it must have been written about the first of May, for on May 9 he wrote again: " My mother is out of danger now, she has been up for two days, which cheers her and makes her sleep better. She was very low for about a week. Now I hope that fine weather and good care will restore her completely."

With so much to upset him it is not surprising to find that Cézanne painted fewer pictures than usual during these months. Rivière ascribes twenty-six paintings to 1877 and six to " about 1877," while only eight are allotted to 1878 and two to " about 1878." Unfortunately it is impossible to date most of Cézanne's works within a year or two with any degree of certainty, so these figures must be taken with a grain of salt, and it would be unwise to draw very definite conclusions from them; but there is little doubt that his output did fall off considerably under the trying conditions of 1878. Still he did paint now and then; the

call of the *motif* was too insistent to be denied, even when he was preoccupied with other matters.

Cézanne's letters to Zola at this time were not entirely filled with a recital of his domestic woes. There are occasional references to art, as in this letter of April 14, 1878:

" On the way to Marseilles I was accompanied by Monsieur Gibert [the Director of the Museum at Aix]. People like that see clearly enough, but they have professors' eyes. When the train passed near Alexis's property a stunning *motif* came into view towards the east. Sainte-Victoire and the rocks that dominate Beaurecueil: I said, ' What a beautiful *motif* '; he replied: ' The lines are too balanced.' . . . For all that, in a city of 20,000 inhabitants, he is without any doubt the person most interested in, and best informed about, art."

A postscript to the same letter informs Zola that " Villevielle's pupils jeer at me when I pass, I must have my hair cut, perhaps it is getting too long." This is the first hint we have had of persecution by the impudent small boys of Aix. Other tales of similar maltreatment in Cézanne's old age are current; most of them appear to be grossly exaggerated.

During all of this period of stress Cézanne tried to keep in touch with the latest artistic developments in Paris. In May 1878 — there is no more exact date on the letter — he wrote to Zola:

" I imagine that at the moment you must be entirely absorbed in your latest book, but later, when you are able, you would give me much pleasure if you would write me about the artistic and literary situation. It would make me feel less deeply buried in the provinces and nearer to Paris."

Cézanne's interest in the doings of his painter friends in Paris was real enough, but it is unlikely that he was really anxious to hear much about the " literary situation." That was a concession

to Zola, who of course was vitally concerned with all that went on in the contemporary world of writing. Not that Cézanne was indifferent to books. He was a great reader; he read " very slowly, almost painfully," says Gasquet, but his memory was astonishing; in his old age he could recite whole pages of the Latin verses he had memorized at school half a century before. Of the Latin writers, Apuleius, Virgil, and Lucretius were his favourites. He read the philosophies of Kant and Schopenhauer; the novels of Chateaubriand, Hugo, Stendhal, and Balzac — he found a certain likeness to himself in the character of Frenhofer in Balzac's *Le Chef-d'œuvre Inconnu,* and Gasquet reports that Cézanne once assured him that " there was something of Frenhofer " in Achille Emperaire as well. He was fond of the criticisms of Sainte-Beuve, the plays of Racine and Molière, the poetry of de Vigny. But his favourite poet was Baudelaire. Gasquet tells us that Cézanne's volume of Baudelaire had been read and re-read until it was in tatters, and that the painter knew the *Fleurs du Mal* literally by heart.

But Cézanne's taste in literature was predominantly classic, and he did not care much for the novels of the realistic school of which Zola was rapidly becoming the leader. With unfailing regularity Zola sent a copy of each of his books to Cézanne as soon as it appeared, up to and including *L'Œuvre.* Generally he wrote an affectionate inscription on the title-page. Cézanne appreciated the friendliness of the gesture, but he was often at a loss to find appropriate comments that would please Zola and at the same time satisfy his own conscience. Sometimes he wrote only a bare acknowledgment of the gift with a polite but slightly formal expression of gratitude; on other occasions he made heroic efforts to discuss the book of the moment at some length.

Cézanne read Zola's novels with a painter's eye. The descriptive passages seem to have interested him more than the characters or the plot, and his comments are interlarded with terms and images derived from painting. In the letter dated " Wednesday evening 1878 " that contains the news of his mother's illness he

acknowledges the receipt of Zola's latest work, *Une Page d'Amour:*

" I thank you heartily for sending me your last volume, and for the inscription. I have not read very much of it yet. . . . I was interrupted at the end of the description of the sun setting over Paris, and the development of the reciprocal passion of Hélène and Henri.

" It is not for me to praise your work, for you may well reply with Courbet that the conscious artist can sing his own praises more aptly than anyone on the outside. What I shall say about it, therefore, is only to let you know what I see in the work. It seems to me to be a picture more delicately painted than the preceding one *L'Assommoir,* but the temperament or creative force is always the same. Moreover, if I am not being guilty of a heresy — the progress of the hero's passion is very consistently developed. Another observation that I have made seems correct, that the backgrounds are so painted in that they are suffused with the same passion that motivates the characters, and thus are more in harmony with the actors and less detached from the whole. They seem as it were to be alive and to participate in the sufferings of the living characters.

" Moreover, according to the comments in the newspapers it will be at least a literary success."

Cézanne follows this up in his next letter, dated May 9:

" I have just finished *Une Page d'Amour*. You were quite right to warn me that it should not be read as a serial. — I had not noticed the connection between one part and another at first, it seemed disjointed, while in reality the arrangement of the novel is very skilfully planned. There is great dramatic feeling in it. And I should think it would have great success. — I had not noticed either that the action takes place within a very restricted and condensed frame. — It is truly regrettable that works of art

are not better appreciated, and that it should be necessary, in order to attract the public, to paint things in a high key which is not altogether appropriate; not that it does much harm, it is true."

Early in July Cézanne moved from Aix to L'Estaque, whence he wrote to Zola on the 16th that " we have taken a different house at L'Estaque, now I am in Isnard's house, next door to Giraud's." On July 29 he announced his plans for the following year:

" I think I shall spend the winter in Marseilles, and work there, returning to Paris next spring, perhaps in March, at that season the atmospheric conditions [here] will be unfavourable and I shall not be able to make the best use of my time out of doors. Moreover I should be in Paris in time for the exhibition of painting."

The exhibition was the Impressionist show scheduled for the spring of 1879. We already know that Cézanne did not take part in it, but he was still keenly interested in the work of the other painters.

Zola, who was now quite prosperous, had recently acquired a small country-house on the Seine near Médan. " I have bought a house," Zola wrote to Flaubert on August 9, 1878, " a rabbit-hutch, between Poissy and Triel, in a charming spot on the banks of the Seine; nine thousand francs, I tell you the price so that you will not be too deeply impressed. Literature has paid for this modest rustic retreat, which has the merits of being far from a station and without a single bourgeois neighbour." When Zola bought the property, the " rabbit-hutch " consisted only of a small cottage or *pavillon*. He left the original building, but added two large wings: that on the right contained Zola's study, an immense room two storeys high in which most of his later novels were written: *Nana, Pot-Bouille, Germinal, L'Œuvre, La Terre,* and the rest of the long series of the *Rougon-Macquart,* as well as *Lourdes, Rome,* and *Paris, Travail,* and *Vérité.*

242

In spite of his talk about being far from a station and without neighbours, Zola was a gregarious soul; he loved to be surrounded by his friends, and the ample accommodations for guests at Médan were seldom empty. Madame Denise Le Blond-Zola tells us in her biography of her father that " the comrades of his youth, Cézanne, Solari, Marius Roux came there often. Literary friends, Flaubert, Goncourt, Daudet, the publisher Georges Charpentier, the painter Guillemet soon came to learn the road to Médan; Alexis, the disciple from Aix, enthusiastic and sincere, devoted to Zola since 1869."

Among the other writers entertained at Médan by the hospitable Zola were Henry Céard, Léon Hennique, Huysmans, and Guy de Maupassant. Zola was enchanted with his country home; from 1878 until his temporary exile in England at the time of the Dreyfus affair he spent approximately eight months of each year at Médan.

The novelist must have told Cézanne about the purchase of the estate almost immediately, for on July 29, 1878 Cézanne wrote:

" I congratulate you on your acquisition, and with your permission I shall take advantage of it to become better acquainted with that part of the country. . . ."

During the next seven years Cézanne was a frequent visitor at Médan. But he was careful not to be drawn into the social and artistic circle that revolved around Zola. So far he had successfully avoided all such *grappins;* he continued to avoid them all his life.

Cézanne's letter of September 14 contains a paragraph of literary criticism:

" I have received your volume of Plays, I have read only five acts so far, 3 of *Les Héritiers Rabourdin,* and 2 of *Le Bouton de Rose,* they are very interesting and in particular *Le Bouton de Rose,* I find. *Les Héritiers Rabourdin* has a certain family resem-

blance to Molière, whom I re-read last winter. I have no doubt that you will have great success in the theatre. Having read nothing of yours along these lines, I had no idea that your plays would contain such fine and vivid dialogue."

Notwithstanding Cézanne's expression of confidence in their success, the reception accorded the three plays was not encouraging. *Les Héritiers Rabourdin* was withdrawn after seventeen performances; *Thérèse Raquin,* which was published in the same volume, was played only nine times; and *Le Bouton de Rose* held the boards for no more than a week.

The letter goes on:

" I met Huot the architect, who enthusiastically praised your entire series of the *Rougon-Macquart,* and told me that it was highly thought of by people who know about such things.

" He asked me if I ever saw you: I said, ' Sometimes '; if you wrote to me, I said: ' Recently.' Stupefaction, and I rose in his estimation, he gave me his card with an invitation to visit him. So you see it is useful to have friends, and nobody can say of me what the oak tree said to the reed

Encore si vous naissiez à l'abri du feuillage, etc."

Cézanne did not carry out his intention, announced in July, of spending the winter in Marseilles. On August 27 he wrote to Zola from L'Estaque:

" I have not yet been able to find a lodging in Marseilles, because I do not want to pay much for it. I expect to pass the whole winter there, if my father will agree to give me some money. Then I could continue some studies that I am making at L'Estaque, which place I shall leave only at the latest possible moment."

This was written before Louis-Auguste's little flirtation had loosened his purse-strings. But even after Cézanne was assured,

for the time being, of a regular allowance, the rapacity of the Marseilles landlords was too much for his thrifty nature. He decided to remain at L'Estaque until it was time to go to Paris in the spring, and to content himself with occasional trips to town to see Hortense and little Paul. On September 24 he wrote again to Zola:

" I received your letter just as I was making a *soupe aux vermicelles à l'huile,* so dear to Lantier. I shall be at L'Estaque all winter, I am working here. — Mamma left a week ago to look after the wine-making, the putting-up of fruit, and the removal to Aix [from the Jas de Bouffan], they are going to live in town behind Marguery's or thereabouts. I am alone at L'Estaque, I am going to spend the night in Marseilles and come back tomorrow. — Marseilles is the oil capital of France just as Paris is the butter capital. You have no idea of the brutality of these ferocious people, they have only one instinct, the desire for money, it is said that they make a lot, but they are certainly ugly. — Ease of communication is effacing the salient features of different types, from an external point of view. In a few hundred years there will be no point in living, everything will be flattened out. But the little that is left is still very dear to the heart and to the eye."

The Lantier who was so fond of vermicelli soup was not Claude Lantier of *L'Œuvre* — which was not yet written — but his father, one of the principal characters in *L'Assommoir.*

When Hortense was suddenly called to Paris in the autumn, little Paul went to live with his father for a few weeks. " The boy is staying with me at L'Estaque," Cézanne wrote to Zola on November 20. " The weather has been frightful for the last few days. . . . I am waiting for it to clear so that I can go on with my researches in painting."

The use of the word *recherches* is characteristic of Cézanne's humble attitude towards his art. He was always searching, always discovering new subtleties of colour and form in nature to be

245

studied and absorbed. Every canvas, almost every brush-stroke, was a new problem requiring a fresh approach. Once that problem was solved, the finished picture lost all interest for Cézanne. If he failed to find a satisfactory solution, as often happened, he threw the picture aside and started another.

The letter continues:

" I have bought a very curious book, a web of observations of a delicacy which escapes me sometimes, I feel, but what anecdotes and true incidents! — And conventional people call the author paradoxical. It's a book by Stendhal: *Histoire de la Peinture en Italie,* no doubt you have read it, if not permit me to recommend it to you. — I had read it in 1869, but not very carefully, now I am re-reading it for the third time. — I have just bought the illustrated edition of *L'Assommoir.* I suppose that finer illustrations would not have served the publisher's purpose any better. When I can talk to you in person, I shall ask you if your opinion about painting as a means of expressing sensations is not the same as my own."

Cézanne's jubilation over the increase in his allowance did not last long. He was safe for the moment, but he had not yet come to a satisfactory understanding with his father, and he had ample cause to be uneasy about the future. On December 19 he wrote to Zola:

" My dear Émile,
" I have probably forgotten to tell you that in September we moved from the rue du Vieux Chemin de Rome. We are now living, that is Hortense is living, at 32 rue Ferrari. — As for me, I am still at L'Estaque, where your last letter reached me. —
" Hortense came back from Paris four days ago, which has relieved me a little, as I had the child with me and my father might have caught us unawares. — One would say there is a sort of conspiracy to reveal my situation to my father, my fool of a landlord

246

has a finger in it too. — It is more than a month since Hortense received the money I asked you to send her and I thank you for it, she needed it very badly. She had a little adventure in Paris, I won't put it in writing, I will tell you about it when I return, moreover it didn't amount to much. — I intend to remain here [at L'Estaque] several months longer, and to leave for Paris about the beginning of March. — I expected to enjoy the most complete tranquillity in this place, but on the contrary a lack of understanding between myself and the paternal authority has caused me to be only more tormented. The author of my days is obsessed with the idea of setting me free [from my entanglements]. — There is only one sensible way to do that, and that is for him to hand over two or three thousand francs a year extra, and not to wait until his death to make me his heir, for I shall certainly die before he does."

At this time Cézanne seems to have been haunted by the spectre of his own early dissolution, and he frequently referred to the subject in later letters to Zola. There does not appear to have been any physical basis for this melancholy anticipation. He was only about forty, and in excellent health; the first symptoms of the diabetes which was to carry him off in the end did not make an appearance until ten years later. And Cézanne was far from being a hypochondriac. But at the moment he was depressed — and small wonder.

This was the last letter he wrote to Zola in 1878. It is somehow fitting that this unhappy year should have ended on a sombre note.

MELUN: 1879–1880

THE STORMS of 1878 were followed by several years of relative calm. There was peace, or at any rate an armistice, between Cézanne and his father. Just how this was achieved we do not know, but it is certain that any concessions that may have been involved were made by Louis-Auguste, not by his son. Henceforth Cézanne's allowance — a modest one, but sufficient — was secure. Within the limits of his income he was free to live his own life without paternal interference. The relief must have been tremendous. Naturally the advent of fair weather produced an almost instantaneous rise in the barometer of his painting. Rivière lists sixty-eight pictures as belonging to the next five years — about fourteen a year, which was well above Cézanne's average output of finished, undestroyed canvases.

In the spring of 1879 Cézanne left L'Estaque for the north. He spent a few weeks in Paris and then settled down at Melun, where he remained for about a year. Now that the financial crisis was past, there was no longer any reason to write quite so frequently to Zola; the correspondence was still fairly regular, but the intervals between letters were much longer than in the previous year. In a letter from Melun dated June 3, 1879, Cézanne proposes to visit Zola:

" Here it is the month of June, and am I to come to see you, as you suggested a little while ago? I am going to Paris on the 8ᵗʰ of this month, and if you will write to me before that date I shall take advantage of the opportunity to pay you a visit at your country-house at Médan. — However if you think I had better postpone this little excursion, let me know all the same."

Zola's reply must have confirmed his earlier invitation, for the projected visit came off according to schedule. After his return to Melun Cézanne wrote a bread-and-butter letter on June 23. He is careful to assure his host that he did not miss the train home — for a change:

" I reached the station at Triel without getting splashed with mud, and the arm I waved through the door as I passed your castle should have disclosed to you my presence in the train, which I did not miss. . . . During my absence your volume *Mes Haines* had arrived, and today I bought the issue of *Le Voltaire* in order to read your article on Vallès. —

" I have just read it, and I find it magnificent. — The book *Jacques Vingtras* had already aroused in me much sympathy for the author."

Jules Vallès was a Socialist author and journalist who had taken an active part in the Communist uprising of 1871. His most important work was the long autobiographical novel mentioned by Cézanne. The letter ends with a polite inquiry concerning the water-supply at Médan, which appears to have been one of the problems discussed during Cézanne's recent visit: " When the time comes, let me know at what depth water is found in the well."

The summer passed peacefully for Cézanne, so peacefully that there was no news to write to Zola. Meanwhile *L'Assommoir*, made into a five-act play by Busnach and Gastineau, had been produced at a Paris theatre. In spite of much adverse criticism the

dramatization was a success; it ran for almost three hundred performances. Cézanne's curiosity was aroused, and on September 24 he wrote to Zola and asked, with many apologies, for tickets:

" This is my reason for writing to you, for not a thing has happened since I left you last June that would give me an excuse for a letter, even though in your last letter you were kind enough to ask me for news of myself. Since one day has been so much like the next, I could think of nothing to tell you. But this is what I should like: to see *L'Assommoir*. May I ask you for three seats? — But that is not all, there is a difficulty in connection with it, the definite date for which I ask this favour; that is for October 6. Please see if what I ask does not involve too many difficulties, on account of your absence from Paris. — I am not there either, and I fear it will not be easy to reconcile the date of my trip to Paris, with the acquisition of the tickets. — Therefore if this is too much trouble, tell me, and don't be afraid to refuse my request, as I understand perfectly that you must be overwhelmed by similar demands. — I see by the *Petit-Journal* that a play by Alexis has been produced with success.

" I am constantly trying to find my direction in painting. Nature presents the most prodigious difficulties to me — but I am not getting along too badly, after an attack of bronchitis, a recurrence of one I had in '77, which has laid me low for a month — I trust that you have been spared any annoyances of this kind."

Cézanne seldom went to the theatre; in fact this is the only recorded instance of his attendance at a playhouse, though it is unlikely that it was actually a unique experience for him. Of course Zola made short work of all the " difficulties " anticipated by the timid and unsophisticated painter and sent him the tickets at once.

On October 9 Cézanne wrote his impressions of the play:

250

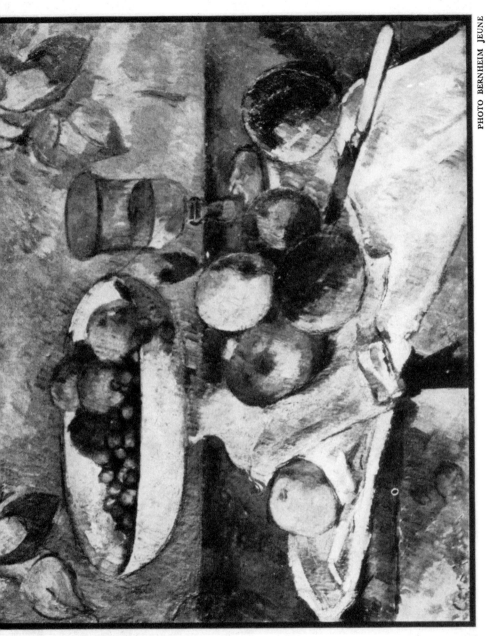

25. NATURE MORTE: LE COMPOTIER

ABOUT 1877. PELLERIN COLLECTION

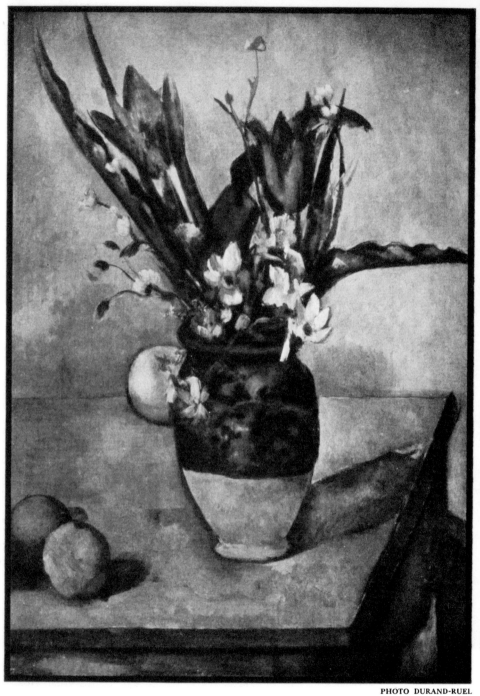

26. NATURE MORTE: POT DE FLEURS

ABOUT 1885 (?). ART INSTITUTE, CHICAGO

" I have been to see *L'Assommoir,* with which I was delighted. — I could not have had better seats, and I did not go to sleep at all, though I generally go to bed a little after eight o'clock. The interest does not flag at any time, but after seeing this perform- ance, I find the actors so amazing that I venture to say they must be able to make successes of a great many plays that are plays in name only. Good literary form cannot be necessary to such fine actors. The death of Coupeau is really extraordinary, and the actress who plays Gervaise is most sympathetic. But indeed they all act very well."

Zola must have smiled when he read this letter, so full of left- handed compliments. Cézanne's naïve assurance that he did not " go to sleep at all " during the performance was hardly flattering, to be sure, but there is no doubt that it was perfectly ingenuous: he was accustomed to early hours and had he not found the play absorbing he would certainly have fallen asleep like a tired child that had been kept up too late. It is possible, however, that Cé- zanne's suggestion that such talented actors could have made a success of almost any play was not quite so guileless. Without making any overt criticism he managed to convey a fairly obvious hint that he had been more deeply impressed by the performance than by the literary merit of the play.

After this little flurry of dissipation no further excitement dis- turbed the calm of Melun for some months. The winter of 1879– 1880 was an unusually cold one in northern France: the whole countryside was frozen tight for weeks, and the suffering among the poor was intense. Cézanne himself was in no imminent danger of freezing, but like everyone else he was affected by the shortage of fuel; it was impossible to go on working at Melun. On the 18th of December he wrote to Zola:

" I have received your last two letters, the first telling me of the piling up of the snowdrifts, the other of the complete absence

of a thaw. I can believe it easily. On the score of cold you have no advantage over me. Wednesday we had as much as 25 degrees [presumably of frost, on the Centigrade scale — equivalent to 13 degrees below zero Fahrenheit] here. And what is still less amusing, I cannot get any fuel. — By Saturday I shall probably be entirely out of coal, and I shall be obliged to take refuge in Paris. It's a most extraordinary winter. I have some difficulty in turning my thoughts back to the month of July, the cold brings one back too forcibly to reality."

Cézanne left a record of this severe winter in the shape of a landscape, *Neige Fondante,* painted in the vicinity of Melun. He rarely painted snow scenes, perhaps because he worked so slowly that his *motif* was apt to melt away before his picture was well started; but this year the snow remained on the ground long enough for him to transfer at least one impression of it to canvas. The picture was bought by Monsieur Choquet, who afterwards gave it to Comte Doria in exchange for *La Maison du Pendu;* at the sale of the Doria collection in 1899 *Neige Fondante* was acquired by Claude Monet.

Whether Cézanne really was forced to abandon Melun temporarily, or whether a providential thaw or an unexpected shipment of coal came to his rescue, we do not know. If he did go to Paris to keep warm he did not stay very long, for on February 25, 1880 we find him writing to Zola again from Melun:

" This morning I received the book which Alexis has just published. I want to thank him, and as I do not know his address I must call on you to let him know that I am deeply touched by the mark of friendship he has been good enough to show me. This volume will be added to the literary collection you have sent me, and I have enough to keep me entertained and occupied during the winter evenings. Moreover I hope to see Alexis when I return to Paris, and then I shall be able to thank him myself.

" Our friend Antony Valabrègue has had a charming volume

of *Petits Poèmes Parisiens* brought out by the publisher Lemaire, You must have a copy, my paper speaks well of it."

Nana, the ninth volume of Zola's chronicle of the Rougon Macquart family, was issued in book form on February 15, 1880. The last part had been written under trying conditions. Following his usual custom, Zola had commenced the serial publication of the novel in *Le Voltaire* the previous autumn, when the manu script was about half finished. He wrote quickly and at a regular pace; ordinarily there was no danger that the later chapters would not be ready when required. But the very first instalment of *Nana* raised such a storm of discussion, and each succeeding number brought forth such a flood of comments in the press — comments more unfavourable than otherwise, but excessively vehement in either case — that Zola was obliged to finish the book under a disconcerting spotlight of publicity; for once he found it extremely difficult to concentrate on his writing and to keep his instalments up to date. Finish it he did, however, and his efforts were rewarded by an immediate success even more spectacular than that of *L'Assommoir*. Fifty-five thousand copies were sold in advance of publication, and ten thousand additional copies had to be printed directly after the book appeared: an almost unprecedented sale for a novel in those days.

As usual Zola sent a copy of the book to Cézanne, who acknowledged its receipt in a letter which is undated, but which must have been written towards the end of February 1880:

" I am a little late in thanking you for the last book you sent me. But the attraction of novelty led me to throw myself into it, and yesterday I finished reading *Nana*. It's a magnificent book, but I fear that through some prearrangement the newspapers have not mentioned it, in fact I have seen no review or advertisement in any of the three little papers I take. This situation annoys me, because it indicates an excessive indifference to artistic matters or else a puritanical and wilful neglect, without justification,

of certain subjects. But perhaps the commotion that the appearance of *Nana* should be causing has not reached me, in that case it is only the fault of my rotten papers, which is a consoling thought."

It would be hard to find more striking evidence of Cézanne's complete isolation from the world than this serene unconsciousness of all the heated controversy that had been raging about *Nana* in the newspapers during the past few months.

PLAISANCE: 1880–1881

By the spring of 1880 Cézanne, restless as always, had had enough of Melun. He moved to Paris, where he took lodgings at 32 rue de l'Ouest, in the quarter of the fourteenth *arrondissement* known as Plaisance, southwest of the Montparnasse cemetery. Here he remained for a full year. The district was familiar to him; he had lived here before, in 1877 — the catalogue of the Impressionist exhibition of that year gives Cézanne's address as 67 rue de l'Ouest.

Another show of the Impressionists — the fifth — was held in April 1880 at a gallery in the rue des Pyramides. Notwithstanding his resolution not to send his own pictures to any more of these exhibitions, Cézanne never failed to visit them whenever he was in Paris at the proper season. He wrote to Zola from Plaisance on April 1, 1880:

" After I received your letter this morning April 1st enclosing the one from Guillemet, I hurried to Paris, I learned from Guillaumin that the Impressionists were open, I rushed there."

Cézanne writes of hurrying " to Paris "; evidently he thought of Plaisance as a suburb, though it lay well within the lines of the old fortifications. Naturally he met a number of old friends at

the exhibition, and their warm greetings seem to have thawed him into an unusually sociable frame of mind:

" Alexis fell on my neck, Dr Gachet invited us to dinner, I kept Alexis from paying you his respects. May we be permitted to invite ourselves to dinner Saturday night? If it is inconvenient, be kind enough to let me know."

This was real dissipation for Cézanne — two dinner-parties in one week! His unwonted exuberance strikes a slightly sentimental note at the end of the letter: " I am with gratitude your old school-friend of 1854. . . ."

As a matter of fact, Cézanne had good reason to be grateful to Zola, who was always ready to do his " old school-friend of 1854 " a favour. Cézanne's appeals to the novelist were not always on his own account. Sometimes he called on Zola to use his influence on behalf of other friends who happened to be in difficulties. We have already seen how he solicited Zola's intervention in favour of Achille Emperaire; another such petition was incorporated in Cézanne's next letter, dated May 10, 1880. This time Monet and Renoir were to be the beneficiaries:

" I enclose herewith a copy of a letter that Renoir and Monet are going to send to the Minister of Beaux-Arts, to protest against the unsatisfactory placing of their pictures and to demand an exhibition of the pure Impressionist group for next year. — This is what I am requested to beg you to do. —

" It is to publish their letter in *Le Voltaire,* prefacing or following it with a few words concerning the earlier efforts of the group, these few words tending to demonstrate the importance of the Impressionists and the genuine feeling of curiosity they have aroused. I need not add that no matter what action you may think proper to take in response to this appeal, it will not have the slightest effect on the friendly feeling you have for me, nor will it affect the cordial relations that have always existed between

us. For I have been obliged more than once to make demands on you that you might have found a nuisance. — This time I am playing the rôle of a mouthpiece, nothing more. —

" Yesterday I heard the very sad news of Flaubert's death, I fear that this letter will reach you at a very troubled moment."

The letter of protest that Renoir and Monet proposed to send to the Minister of Beaux-Arts read as follows:

" *Monsieur le Ministre,*

" Two artists known as Impressionists confidently address themselves to you in the hope of being placed in a suitable manner at next year's exhibition in the Palais des Champs-Élysées.

" Please accept, *Monsieur le Ministre,* our respectful homage."

The situation that had led to this protest was a little complicated. The various exhibitions of the Impressionists had succeeded in attracting attention and provoking an enormous amount of discussion, but the financial results had not come up to expectation and the enthusiasm of certain members of the group had given way to a feeling of disappointment. First Renoir and then Monet abandoned the independent shows and turned once more to the official Salons. By this time the Impressionist movement had gained too much headway to be suppressed any longer, and their pictures were received, somewhat grudgingly, by the juries; but the hanging committees continued to express their disapproval of these newfangled paintings by placing them as disadvantageously as possible.

In 1880 Monet sent two pictures to the Salon, only one of which was accepted: a landscape depicting an island in the Seine, *Lavacourt,* which was so unmercifully " skyed " that it was practically invisible. Renoir exhibited two canvases, *Pêcheuses de Moules à Berneval* and *Jeune Fille Endormie;* they were not even hung in the main building, but were relegated to a sort of annex built around the garden, where they were exposed to the un-

friendly glare of direct sunlight and to accidental coloured reflections from the flowers and foliage.

Such discrimination was intolerable, and in the circumstances it was natural that the dissatisfied painters should have turned to Zola for support. Though his personal taste in painting was not above reproach, he was known to be consistently " agin the government" and ready to champion any movement of protest against bureaucratic oppression. And his influence was tremendous; after the successes of *L'Assommoir* and *Nana* everything that Zola wrote attracted immediate attention. The attention was not always complimentary: he was still the object of vitriolic attacks in the conservative press, but at least his provocative and vigorously expressed opinions were sure to be given wide publicity.

Moreover, Monet and Renoir were his friends — to say nothing of Cézanne, their " mouthpiece " and the most intimate and oldest friend of all — and Zola's pen was always at the service of his comrades. He took up the cudgels for them with characteristic energy. The " few words " requested by Cézanne were expanded into four long articles, each comprising three or four columns of small newspaper type, which appeared in *Le Voltaire* for June 18, 19, 21, and 22. Not all of this space was devoted to a protest against the treatment of Renoir and Monet: Zola's contribution was more in the nature of a general survey of the entire field of contemporary painting. But it included a vigorous denunciation of the committee for denying a suitable place to the three pictures in question, as well as a defence of the other Impressionists:

" Messieurs Pissarro, Sisley, and Guillaumin have followed the same path as Monsieur Claude Monet . . . they have devoted themselves to the interpretation of nature in the neighbourhood of Paris, in real sunlight, undaunted by the most unexpected effects of colour. Monsieur Paul Cézanne, with the temperament of a great painter who is still struggling with technical problems, is closer to Courbet and Delacroix. . . ."

258

But while Zola approved heartily of the Impressionist movement as a whole, he was unable to concede real genius to any of the individual painters:

" The great misfortune is that not a single artist of this group has powerfully and definitely applied the new formula which is followed by all of them, scattered throughout their works. . . . They are the forerunners, the man of genius is not yet born. We can see clearly what they are after, we approve; but we look in vain for the masterpiece which will impose the formula and force all heads to bow in admiration. . . . They are still unequal to the task they have set themselves, they stammer without being able to find the right word. . . . Nevertheless their influence is immense, for theirs is the only possible evolution, they are advancing into the future."

All of this was undoubtedly well-meant, but we know now that Zola was mistaken on two counts. The art of the present generation has demonstrated that the Impressionist doctrines were far from being " the only possible evolution "; and Monet, Pissarro, Sisley, and Guillaumin were not only the " forerunners " of Impressionism, they were also its climax. By 1880 all of these painters, as well as Berthe Morisot, Renoir, and Cézanne, had progressed far beyond the " stammering " stage. All had produced masterpieces which have withstood the test of time.

Notwithstanding their unnecessary reservations, the articles in *Le Voltaire* were helpful to the Impressionist cause. Cézanne expressed his appreciation of Zola's amiable co-operation in a letter dated June 19:

" I should have thanked you for the letter you wrote me concerning my request on behalf of Monet and Renoir. Through negligence I have allowed most of the month of June to slip by without replying. . . . I thank you heartily, I was able to get the number of the 19th and I shall go to the office of *Le Voltaire*

to buy the number of the 18ᵗʰ of this month. — Monet is having a very fine exhibition just now at Monsieur Charpentier's at *La Vie Moderne. —*

" I don't know if really hot weather is on the way, but whenever it will not be a nuisance to you, write to me, I shall come to Médan with pleasure. — And if you will not be upset by the length of time I may take over it, I shall permit myself to bring a small canvas and paint a *motif* there, if you have no objections.

" I thank Madame Zola warmly for the great pile of rags she has given me, which I am putting to good use. I go to the country every day to paint a little."

No doubt Madame Zola's rags came in handy. Cézanne was a most untidy painter, and after a few hours' work his face, hands, and clothes were always liberally smeared with all the colours of the rainbow.

Zola appears to have neglected to answer his friend's letter with his customary promptness, for Cézanne, quick to take offence, wrote again on July 4, rather huffily this time:

" I replied on June 19 to the letter you wrote me on the 16ᵗʰ. — I asked you, it is true, if I might come to your house to paint. But naturally I had no desire to be a nuisance to you. Since then I have had no word from you and as about a fortnight has elapsed since that time, I venture to ask for a few words to let me know how things stand — if you wish me to come to you, I shall come, or if you tell me the contrary, I shall not come for the present. — I have read, from number II on, the articles you have published in *Le Voltaire.* — And I thank you in my own name as well as in that of my colleagues. — Monet, I hear, has sold some of the pictures exhibited at Monsieur Charpentier's, and Renoir has some good commissions to paint portraits."

Zola was able to clear up the little misunderstanding about the visit to Médan, and in August Cézanne made a stay of several

weeks in the Zola household and did some painting there. "Paul is still here with me," Zola wrote to Antoine Guillemet on August 22. "He is working hard. . . ."

On October 17, 1880, Zola's mother died of heart-failure brought on by dropsy. Zola was heartbroken; he adored his mother, who, ever since the premature death of the engineer François Zola, had devoted her life to her son's welfare. In accordance with her last wish he accompanied her remains to Aix, where she was buried by the side of her husband. Cézanne wrote a letter of condolence on October 28:

"This morning Solari brought me the letter you sent me. I had learned from the papers that you had lost your mother, also that you were going to Aix, that is why I did not come to Médan. I meant to write to ask if you intended to come to Paris next month, but since you inform me that you will arrive in a little while, I shall wait until then, unless you prefer to have me come to see you, I am at your service for anything that I can do. —

"I understand the sadness of your misfortune perfectly, nevertheless I trust that your health will be affected by it as little as possible, and your wife's health also."

This year saw the publication of a volume of short stories by Zola and his friends, dealing with various aspects of the Franco-Prussian war and grouped under the general title of *Les Soirées de Médan*. The six tales that made up the book were *L'Attaque au Moulin* by Zola; *Sac-au-Dos* by Huysmans; *La Saignée* by Céard; *L'Attaque du Grand-sept* by Hennique; *Après la Bataille* by Paul Alexis; and the famous *Boule de Suif* by de Maupassant. Zola sent the book to Cézanne, who acknowledged it in a rather involved and formal letter dated vaguely "Saturday '80":

"I have just received the volume you sent me. — I shall entertain myself with it during the quiet evening hours. I beg you to be the interpreter of my feelings of artistic sympathy, which

bind together all sensitive people at sight — notwithstanding the differences of method employed in their expression — to your collaborators, and thank them for having associated themselves with you in the presentation of this book, which I am sure is full of substantial and nourishing matter."

The letter closes with an echo of one of Cézanne's favourite themes, his childlike inability to cope with the complications of life — a helplessness which, by the way, he was inclined to exaggerate:

" Affectionately yours, the Provençal in whom maturity has not preceded old age."

PONTOISE: 1881

A FEW months later Cézanne again became the mouthpiece for an appeal to Zola, this time in favour of their friend Cabaner, whom Vollard describes as " a good fellow, something of a poet, a fair musician, a bit of a philosopher." Cézanne had met Cabaner some years before at the home of Nina de Villars, whose salon was a rendezvous for the younger writers and artists. The parties at her house, which were quite informal, were among the very few social events that Cézanne ever attended. The only reference to these gatherings in his surviving correspondence occurs in a letter to his son written many years later, on August 3, 1906, only a few weeks before his death:

" I am deeply touched by the kind memories of me that Forain and Léon Dierx have been good enough to retain, my acquaintance with them goes back quite a long way. With Forain, to '75 at the Louvre and with Léon Dierx to '77 at Nina de Villars's in the rue des Moines. — I must have told you that when I dined at the rue des Moines there were present at the table Paul Alexis, Franck Lami [sic], Marast, Ernest d'Hervilly, L'Isle Adam, and many others, and the lamented Cabaner. Alas, how many memories have been swallowed up in the abyss of the years."

263

Cabaner was an enthusiastic admirer of Cézanne's work, and the painter, while he cared little about music, liked Cabaner for his whimsical humour and the unfailing good nature with which he accepted the various misfortunes that fell to his lot. These misfortunes reached a climax in 1881, and Cézanne, together with a number of Cabaner's other friends, set about raising a fund for the relief of the destitute musician by means of a sale of pictures. In this connection he wrote to Zola on April 12, 1881:

" In a few days the sale for Cabaner's benefit will take place. This is what I ask of you: would you kindly undertake to write a short article about it, as you did for Duranty's sale. — For there is no doubt that the mere association of your name would have great drawing power with the public to attract buyers and advertise the sale.

" Here is a list of the artists who have contributed their pictures. —

Manet	Gervex
Degas	Guillemet
Frank Lamy	Pille
Pissarro	Cordey, etc.
Béraud	and your humble servant.

" As one of your oldest friends, I have been delegated to ask this favour of you."

As usual Zola generously agreed to do as he was asked. Meanwhile Cézanne had installed himself at Pontoise for the summer, whence he wrote again on May 7:

" I came to Pontoise two days ago. — Since you so kindly wrote to inform me that you would undertake the article for Cabaner, I have not seen Frank Lamy, one of the organizers, I think, of the sale for the benefit of the unlucky musician.

" I should like to know if you have received the notes on which

264

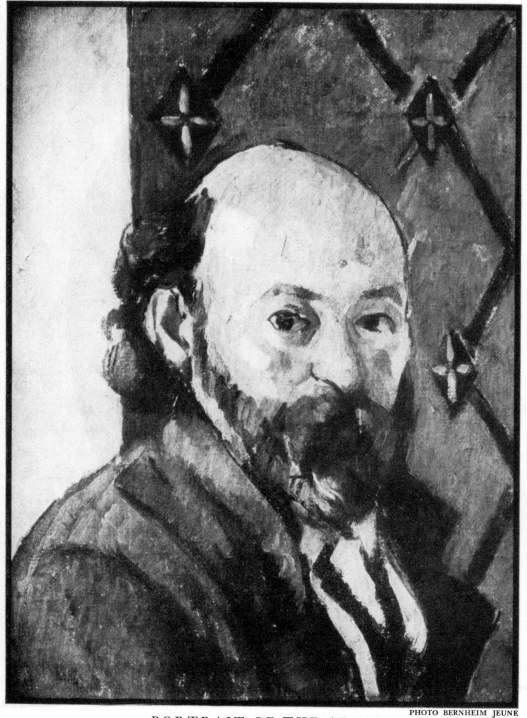

27. PORTRAIT OF THE ARTIST
ABOUT 1880 (?) . TATE GALLERY, LONDON

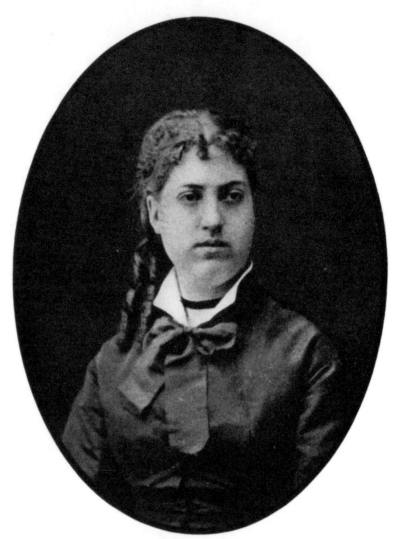

28. ROSE CÉZANNE ABOUT 1880
FROM A PHOTOGRAPH

you are to base your essay, and if you have written the little article which I was instructed to ask of you. —

" I have received from Huysmans and Céard, as well as from yourself, the latest volumes published by them and you, with all of which I was delighted. — I think that Céard will be very popular, because it seems to me that his book is very amusing, to say nothing of the great qualities of perception and observation contained therein. —

" I thank you heartily for having made me acquainted with these very remarkable people. . . . I am living for the present at: —

Quai de Pothuis 31
at Pontoise (Seine et Oise) "

Cézanne refers once more to the Cabaner sale in his next letter, dated May 20:

" Since your kind answer arrived the sale for Cabaner's benefit has taken place. As you say, I surmised that Frank Lamy had got in touch with you, and I thank you heartily for the preface you have written concerning the metaphysician who should have produced some substantial work, for there are [in Cabaner's philosophy] some truly bizarre and paradoxical theories which none the less are not lacking in a certain tang."

In the spring of 1881 Cézanne's younger sister, Rose, was married to Maxime Conil, also a native of Aix. At the time of her marriage Rose was twenty-seven and her husband a year older. Rose died in 1909; Monsieur Conil, now over eighty, is still living in Aix.

The young couple came to Paris on their honeymoon, and naturally Cézanne was called on to show them the sights, which he did conscientiously. The letter to Zola continues:

" My sister and brother-in-law are coming to Paris accompanied, I think, by his sister Marie Conil. — You can see me pilot-

ing them around the Louvre and other picture galleries. Certainly, as you say, my sojourn at Pontoise will not prevent me from coming to see you, in fact I have been planning to make the trip to Médan on foot. I think I am still equal to the effort."

The ten-mile jaunt from Pontoise to Médan with a pack on his back was nothing to Cézanne, always an energetic walker.

" I see Pissarro quite often, I lent him Huysmans's book, which he is gobbling up.

" I have several studies under way, some started in grey weather and some in sunshine. I hope you will soon recover your usual spirits through your work, which is, I believe, notwithstanding all the alternatives, the only refuge in which one finds true peace of mind. . . . Don't forget to remember me to my compatriot Alexis, whom I have not seen for a long time and whom you will surely see before I do."

Zola's output was enormous and he continued to shower Cézanne with his books. Between *Nana*, published in 1880, and *Pot-Bouille*, which appeared in 1882, Zola brought out a volume of literary criticism. Cézanne acknowledged it on " Tuesday, June 1881 ":

" I have been wanting to thank you for the last book you sent me, but by my constant procrastination I might well have allowed a long time to slip by, if I had not happened to get up before four o'clock this morning. — I have begun to read it but I have not finished it yet, though I think I have read a considerable part of it, having read, because of its division into sections, various portions here and there. I think the chapter on Stendhal is very fine. . . .

" My sister and brother-in-law have just been spending a few days in Paris. Sunday morning, my sister being ill, I was obliged to let them return to Aix. The first Sunday of the month I accom-

panied them to Versailles, the city of the *grand Roi,* to see the fountains play. —

" I wish you the best of health, that being the most precious blessing when one has plenty of the material comforts of life. . . . I am working a little, but with a good deal of flabbiness."

The ailment that precipitated the Conil family's return to Aix was rheumatism, from which complaint Rose was a constant sufferer.

In July Paul Alexis fought a duel with one Delpit, a journalist who had published a defamatory article about him. Alexis was wounded, much to the distress of Cézanne, who was deeply attached to his " compatriot "; fortunately the injury was not serious. Cézanne hastens to ask Zola for particulars of the affair in a letter headed merely " Monday 1881 ":

" When I went to Auvers I learned that Alexis had been wounded in a duel, in which, as always, the good cause was defeated. If it is not too much trouble you would do me a great favour by sending me news of my brave compatriot. I cannot go to Paris before the beginning of August, when I shall make inquiries about his health."

Cézanne describes his visit to Alexis in his next letter to Zola, written on August 5:

" While I was with Alexis Tuesday morning your letter was delivered at Pontoise. So I learned from two sources that Alexis's affair had been cleared up in a fashion not too unpleasant for him. I found my compatriot completely recovered, and he showed me the articles that preceded and followed his duel. —

" At my apartment in Paris I found a letter from Caserta, signed by someone called Etorre Lacquanitin or something like that, asking me to help him procure a number of critical articles concerning your works, both recent and prior to the *Rougon-*

Macquart. Probably you are acquainted with this writer, who wishes to make a critical study of your work.

" Alexis, to whom I showed this letter, said that he had received a similar one and would answer for both of us.

" Certain minor difficulties have held up my visit to Médan, but I shall surely come at the end of October. I must leave Pontoise about that time, and perhaps I shall go to Aix for a while. Before I make that journey I shall come to spend a few days with you, if you will write to me at that time."

Zola had gone to Grandcamp, not far from Cherbourg, for a month or two of sea-bathing, but returned to Médan in time to receive Cézanne, who wrote again on October 15:

" The time for my departure for Aix is approaching, before I go I should like to pay you a visit. As the bad weather has come I am writing to Médan, figuring that you must have returned from Grandcamp by this time. Therefore if you have no objection I shall come to see you about the 24th or 25th of this month. If you will write me a word about this matter, you will be doing me a favour."

The invitation arrived promptly and Cézanne went to Médan. The only record of this visit is an item in a letter from Zola to Numa Coste, written on November 5, after Cézanne's departure for Provence:

" Paul has been staying here with me for a week. He has gone on to Aix, where he will no doubt see you."

CHAPTER XXX

THE SALON BY THE BACK
DOOR: 1882

ALTHOUGH Cézanne had been away from Aix for two years and a half, he remained in the south only a few months before returning to Paris early in March 1882. The winter in Provence must have been uneventful, for Cézanne wrote to Zola but once during that period, and then only a short note to announce his approaching migration northward:

"*L'Estaque 28 February 1882*

" My dear Émile,

" Day before yesterday I received your volume of literary criticism [probably *Une Campagne*], which you were kind enough to send me. So I am writing to thank you, and at the same time to announce that after having spent four months in the Midi I am returning to Paris in about a week. And as I suppose you are at Médan I shall drop in to see you in your home. But first I shall stop at the rue de Boulogne [Zola's house in Paris] to find out if you are there."

One of the things that drew Cézanne back to Paris that spring was the assurance that at last his lifelong ambition was about to

269

be realized: he was actually going to have a picture in the Salon! But the admittance of a canvas by Cézanne into the sacred precincts of the "*Salon de Bouguereau*" did not mean that that conservative institution had suddenly undergone a change of heart. It happened that in 1882 Antoine Guillemet was a member of the jury; and according to the ruling then in force, each member had the privilege of introducing into the Salon one picture which was exempt from challenge by the jury. Such works were said to be accepted *pour la charité* — an unflattering phrase, but one that expressed quite frankly the contemptuous spirit in which these pictures were admitted. A painting received in this way was supposed to be the work of a pupil of the member of the jury who sponsored it. Of course Cézanne could not by any stretch of the imagination have been considered a pupil of Guillemet; but the rules were not very strictly enforced, and the good-natured Guillemet was able to "wangle" his friend's canvas into the Salon "*pour la charité.*"

It might be imagined that Cézanne, sensitive as he was, would have felt deeply humiliated by this undignified subterfuge. But he had had his heart set on seeing one of his pictures in the Salon for so many years that he was not inclined to boggle at such an opportunity to gain admission. He knew that there was no hope of being accepted in the regular way: he had been rejected too many times for him to have any illusions left in that direction. The only possible way to achieve his ambition was to avail himself of Guillemet's intervention, and he accepted the sop gratefully.

In fact there is good reason to believe that Cézanne himself had suggested the manœuvre to Guillemet, and that the possibility of entering the Salon by what Vollard aptly calls "the back door" — since the front door was closed to him — had been in his mind for some time. Guillemet had made repeated efforts to induce successive juries to accept one of Cézanne's pictures officially, but without success. Cézanne knew of these attempts: as early as June 3, 1879 he had written to Zola:

" Perhaps you know that I have paid a little insinuative visit to our friend Guillemet, who, they say, has recommended me to the jury — alas, without any response from those hard-hearted judges."

Why " insinuative," unless Cézanne, knowing that Guillemet was likely to be awarded a place on the jury within the next year or two, had proposed, or at any rate agreed to, the teacher-and-pupil solution that was finally adopted?

And on August 22, 1880 Zola wrote to Guillemet from Médan:

" Paul . . . is still counting on you for you know what. He has told me about the pleasant morning you spent together. And I am requested to send you his most affectionate greetings."

Zola's discreet " you know what " might mean almost anything, but there is little doubt that it refers to Guillemet's promise to facilitate Cézanne's admission to the Salon.

Cézanne was not an admirer of Guillemet's facile and mediocre painting, and probably he made no great effort to conceal his opinion, but his lack of enthusiasm for his benefactor's work seems to have had no effect on the warm personal friendship between the two men. Guillemet, whose own painting was intentionally modified to suit the popular taste, was nevertheless sincerely happy to be of service to his uncompromising and unappreciated colleague; and Cézanne had no scruples about accepting the patronage of any painter, good, bad, or indifferent, who could get him into the Salon.

If Cézanne was naïve enough to suppose that the mere hanging of one of his pictures in the official Salon would *ipso facto* bring him the recognition he desired, he was speedily disillusioned. For all the notice taken of his exhibit the wall space it occupied might as well have been left bare. In fact so little attention was paid to this picture, so inconspicuously placed among hundreds of others, that its very identity is uncertain. Rivière

271

says that it was a self-portrait, but this is contradicted by the entry in the official catalogue:

" Cézanne *(Paul)*, *né à Aix (Bouches-du-Rhône)*, *élève de M. Guillemet. — Rue de l'Ouest, 32.*
520 — Portrait de M. L. A— "

Who was Monsieur L. A—? It may have been Louis Aubert, the painter's godfather and maternal uncle; I have been unable to find any other acquaintance of Cézanne's whose name begins with those initials. But this is only a plausible suggestion; a positive identification of the sitter appears to be impossible, especially as the fate of the picture itself is unknown.

After this empty victory Cézanne abandoned his long and persistent siege of the Salon. He resigned himself to obscurity; but even if he had wanted to make another attempt to force himself into the Palais des Champs-Élysées, the way was now barred. Shortly after 1882 the privilege accorded to members of the jury of sponsoring pictures *pour la charité* was withdrawn. Thenceforth all paintings were obliged to pass the jury.

Only once again until a few years before he died did Cézanne have the satisfaction — such as it was — of seeing one of his canvases on the walls of a public gallery. That was at the Exposition Universelle of 1889. The circumstances attending the admission of Cézanne's work on this occasion are somewhat obscure. Vollard tells us that " here again he was accepted through favouritism, or, more accurately, by means of a ' deal.' The committee had importuned Monsieur Choquet to send them a very precious piece of furniture, which they counted on featuring at the exposition. He loaned it as a matter of principle, but he made the formal condition that a canvas of Cézanne's should be exhibited as well. Needless to say, the picture was ' skyed ' so that none but the owner and the painter ever noticed it."

If this account is correct, it is curious that no such piece of furniture or other *objet d'art* is listed in the official catalogue as having been loaned by Monsieur Choquet. His name appears in the

catalogue only once, and then as the owner of Cézanne's picture. The painting chosen for this exhibition was *La Maison du Pendu,* which was first shown at the Impressionist exhibition of 1874; it will be remembered that Monsieur Choquet had obtained it from Comte Doria in exchange for one of Cézanne's snow landscapes. The entry in the catalogue is not only laconic but inaccurate:

" CÉZANNE, *né à Paris* [*sic*].
124. — La Maison du Pendu. (App. à M. Choquet) "

Yet it is highly probable that the acceptance of *La Maison du Pendu* in 1889 was, as Vollard puts it, the result of some sort of " deal." Perhaps Monsieur Choquet, if not himself the lender of the desired bit of furniture, was instrumental in securing it for the exposition and was therefore in a position to insist on the admission of Cézanne's picture as a *sine qua non* of his co-operation. For it is most unlikely that the committee would have agreed to the hanging of a canvas by such a pariah as Cézanne — even if it were " skyed " in the darkest corner of the galleries — unless some powerful outside pressure had been exerted. In the first place the exhibition was essentially a retrospective one covering an entire century of French painting; the space devoted to the work of living artists was relatively restricted. And secondly the conservative temper of the jury was clearly indicated by the list of contemporary painters selected. An overwhelming proportion of them were followers of the academic tradition; the pure Impressionists, for example, were represented only by three landscapes by Monet and two by Pissarro. Renoir, Sisley, Guillaumin, and Berthe Morisot were conspicuous by their absence. In these circumstances it may safely be assumed that Cézanne owed his inclusion to some manœuvre of Monsieur Choquet's and not to any sudden burst of liberality on the part of the committee. In 1889 as in 1882 Cézanne was pushed into a public exhibition by the intervention of a loyal friend. And both times the public ignored him completely.

AIX AND L'ESTAQUE: 1882–1885

CÉZANNE spent the summer of 1882 in Paris and returned to Aix in October. Life was dull that autumn, according to a letter to Zola written from the Jas de Bouffan on November 14:

" Yesterday I received the book you sent me, for which I thank you. Since I arrived I have not stirred from this place, and I have met nobody except Gibert the Director of the Museum, whom I must go to see. —

" I have also seen Dauphin with whom we went to school, and little Baille, — both lawyers. . . .

" But here there is nothing new, not even the least little suicide. If you need anything from here, let me know. I shall be happy to be of service to you. I continue to work a little, though I do nothing else."

The book sent by Zola was presumably *Pot-Bouille,* the tenth volume of the *Rougon-Macquart* series. It will be noticed that Cézanne has given up his not very happy attempts to comment on Zola's novels: henceforth he contents himself with polite acknowledgments of the receipt of the rapidly accumulating volumes. On May 24, 1883 he wrote to Zola, probably in reference to *Au Bonheur des Dames:* " It pleased me very much, but my

appreciation does not run along literary lines." Which was not strictly accurate: he had a very sensitive appreciation of certain kinds of literature, as we have seen; but it was true enough of his attitude towards the majority of Zola's books.

" Little Baille " was not, of course, Baptistin Baille, the erstwhile boon companion of Cézanne and Zola who had drifted out of their lives so many years before, but one of his much younger brothers.

Cézanne's premonition of an early death — happily unfounded — seems to have been much in evidence at this time. He devoted a great deal of thought to the problem of making a will; to his unsophisticated and unworldly mind it was a most complicated problem, and naturally he turned to Zola for advice. He took the novelist into his confidence in a letter dated November 27, 1882:

" I have decided to make my will, since it appears that I am permitted to do so. The securities, from which I draw my income, being registered in my name. — Therefore, I want to ask your advice. Can you tell me in what form I should draw up this document? In the event of my death I wish to leave half of my income to my mother and the other half to my son. — If you know anything about this matter, please inform me. For if I should die [intestate] within a short time, my sisters would inherit from me, and I think that my mother would be cut off, and the boy (having been recognized when I acknowledged him at the *mairie*) would still have the right to half of my estate, I think, but perhaps not without a contest. — In case I can make a holographic will, I want to ask you, if you have no objection, to take charge of a duplicate thereof. — If that will cause you no trouble, because here the paper might be purloined."

It was only natural that Cézanne should have taken pains to ensure his son's inheritance, but the selection of his mother rather than Hortense as the other beneficiary is somewhat puzzling.

275

The elder Madame Cézanne was already well provided for, whereas Hortense had no money at all of her own. Though she was not yet married to Cézanne, he regarded her as his wife, and so did his intimate friends; letters addressed to " Madame Cézanne " had been largely responsible for the difficulties of 1878. The most reasonable explanation that suggests itself is that Cézanne, fearing that his father (who had consistently refused to recognize Hortense) might learn about the will, left half of his property to his mother with the private understanding that she would turn it — or at least part of it — over to Hortense at some future date.

For some months after this letter to Zola Cézanne did nothing more about the will. Meanwhile he continued to paint at the Jas de Bouffan and L'Estaque throughout the winter and spring, with only occasional brief interruptions such as the one mentioned in a letter dated March 10, 1883:

" I am rather late in thanking you for sending me your last novel [probably *Au Bonheur des Dames*, the eleventh volume of the *Rougon-Macquart* saga]. This, however, is the excuse for my delay: I have just come from L'Estaque, where I have been spending a few days. Renoir, who is about to have an exhibition of his works, following that of Monet which is on at present, has asked me to send him two of his landscapes which he left with me last year. I sent them to him on Wednesday, so now I am at Aix, where it snowed all day Friday. This morning the countryside had the appearance of a very beautiful snow scene — but it is melting. — We are still living in the country. — My sister Rose and her husband have been in Aix since October, where she gave birth to a little girl. All of this is not very entertaining. . . . I shall not be able to return to Paris for some time, I think I shall remain here five or six months longer. . . ."

The exhibitions referred to were organized by the courageous dealer Durand-Ruel, who had rented an empty gallery on the

boulevard de la Madeleine for four months, from March to July 1883. During that time he held in succession one-man shows of the work of Monet, Renoir, Pissarro, and Sisley.

In his next letter to Zola, written from L'Estaque on May 19, Cézanne reverts to the question of his will, in abeyance since the previous autumn:

" I asked you in December 1882, I think, if I might send you *Testamentum meum.* You answered yes. So now I ask if you are at Médan, as you probably are; in which case I shall send it to you by registered post, that is the best thing to do, I think. After not a little tergiversation, this is what has happened. My mother and I went to a notary in Marseilles, who advised a holographic testament, and, if I wished, the designation of my mother as residuary legatee. That is what I have done. When I return to Paris, if you will accompany me to a notary I shall have another consultation, and remake my will, and then I shall explain to you by word of mouth my reasons for doing so. —

" Now that I have set forth all the serious business I wanted to tell you — I shall end my letter by begging you to offer my respects to Madame Zola, and accept my greetings for yourself, and if good wishes are of any use, I hope that you are in good health, for things do happen that are not so pleasant. . . . These last words are inspired by Manet's catastrophe. . . ."

Édouard Manet died on April 20, 1883, at the age of fifty-one. Though never a close personal friend of the older painter, Cézanne had always been a sincere admirer of his work. Naturally he was deeply moved by Manet's premature death; it may have been this event that revived his forebodings concerning his own demise and impelled him to carry out his declared intention of making a will.

This letter was followed by another on May 24:

" Now that I am sure you are at Médan, I am sending you the document in question, of which my mother has a copy. But I

fear that all this will not be of much use, for these wills are very easily contested and nullified. . . .

" I shall not return to Paris until next year, I have rented a little house with a garden at L'Estaque, just above the station, and at the foot of the hill where the pine-covered cliffs rise behind me.

" I am still busy with my painting, I have some lovely vistas here, but they are not exactly *motifs*. — Nevertheless at sunset, by climbing the heights one gets a splendid panorama of the far end of Marseilles and the islands, the whole bathed in a very beautiful light in the evening. . . .

" The document is antedated, because the stamped official paper was bought last year."

Which shows that Cézanne was still practising economy in small ways, and did not believe in wasting stamps. There was no more correspondence with Zola until November 26, when Cézanne wrote again from L'Estaque:

" I received the book you were kind enough to send me, but again I have been prevented from thanking you until long afterwards, because since the beginning of November I have been back at L'Estaque, where I expect to remain until January. My mother came here a few days ago, and last week Rose, who is married to Maxime Conil, lost a child who was born in September or October I think. The truth is the poor infant did not last long. Otherwise everything is going along as usual. . . ."

Rose Conil's second child was a boy, who lived only two months.

The stream of Zola's writing was in full spate by now, and for the next two or three years almost every letter from Cézanne contains an acknowledgment of another volume from his friend's prolific pen. Thus he wrote from Aix on February 23, 1884:

" I have received the book you were good enough to send me recently, *La Joie de Vivre* [the twelfth of the *Rougon-Macquart* volumes], which has been appearing in *Gil Blas*, for I have read portions of it in that journal. Therefore I thank you heartily for your gift, and for not forgetting me in the isolation in which I find myself. I should have no news to tell you, were it not for the fact that a few days ago at L'Estaque I received a letter from good old Valabrègue, Antony, advising me of his presence in Aix, whither I hastened at once, yesterday, and where I had the pleasure of shaking his hand this morning, Saturday. We have just made a tour of the town together, invoking the memories of some of those we used to know. — But how differently we feel about things! My head was full of the idea of this country, which seems to me very remarkable. I have also seen Monet and Renoir who went to Genoa in Italy for a holiday, about the end of December."

And again on November 27, 1884:

" I have just received two new volumes that you so kindly sent me. I thank you, and I shall say that I have not much to tell you about the good city in which I first saw the light of day. Only, (but no doubt this does not affect you very much) art is becoming terribly transformed in its external aspect, and is too much inclined to take on a very paltry insignificant form, while at the same time the ignorance of harmony reveals itself more and more through discords of coloration and, what is even more unfortunate, through the aphony of tones. —

" After this complaint, let us cry long live the sun, which gives us such beautiful light."

TURMOIL: 1885–1886

FOR the last six years — ever since the troubled period of 1878 — Cézanne's life had been relatively calm and undisturbed. But in 1885 his peace was shattered again by an upheaval of a different kind, of short duration but exceedingly violent while it lasted. The year began badly with a painful attack of neuralgia, as he informed Zola on March 11:

" I received the book you sent me [*Germinal*] about ten days ago. But severe neuralgic pains which only left me for short intervals have made me forget to thank you. Now my head is better, and I am able to walk about on the hills, from which I can see beautiful panoramic views. . . ."

As spring advanced the neuralgia disappeared, but a much more serious disorder took its place. Cézanne fell in love. His letters to Zola at this time — all of them short, agitated little notes of a few lines — are full of hints and more or less veiled allusions to the affair. But Cézanne was too discreet to confide any details or names to paper, and the identity of the lady in the case remains a mystery. The first mention of this new complication in Cézanne's life occurs in a letter written from the Jas de Bouffan on

280

May 14, 1885, in which he implores Zola to " receive certain let-
ters for me, and to forward them to me at an address which I shall
give you later. . . . Do not refuse me this service, I do not know
which way to turn." The situation must have seemed pretty
desperate. Cézanne expresses his gratitude to Zola — in advance
— in a quaint postscript:

" I am helpless and can render you no service, but as I shall
die before you I shall intercede with the Almighty for a good
place for you."

Cézanne had called on Zola for aid on many previous occasions,
as we have seen: for small loans, for advice, and vicariously for
help for common acquaintances; but this was the first time he
had appealed to his friend for assistance in an affair of the heart.
Cézanne was no Lothario, and this mysterious passionate en-
tanglement, about which we know so little, appears to have been
the only episode of just this kind in his life. For his long estab-
lished relationship with Hortense was a different matter; he had
always considered her to be in fact what she soon afterwards be-
came in law: his wife.

Zola as usual good-naturedly agreed to do what he could. All
that summer he received and forwarded the letters that Cézanne
was so anxious to keep hidden from prying eyes.

Early in June Cézanne tore himself away from Aix and trav-
elled north with Hortense and young Paul — now thirteen years
old — to spend a month with the Renoirs at La Roche-Guyon, a
village on the Seine between Vernon and Mantes. But he was too
nervous and upset to do much painting. Fond as he was of Renoir
and his family, he was not happy at La Roche-Guyon. He was
anxious to visit Médan and talk over the situation with Zola, but
the novelist had not yet moved to the country for the summer,
and for some unknown reason Cézanne did not suggest meet-
ing him in Paris. " As soon as the time comes for your departure
for Médan, and you are settled there, please let me know," he

wrote to Zola on June 27. " The desire for a change of scene is tormenting me a little. Happy are faithful hearts! "

Cézanne waited a week, but strangely enough no reply came from Zola. On July 3 he wrote again: " Please tell me if you can receive me at your house. If you are not yet settled at Médan, be kind enough to send me a little message." Three days later the true explanation of Zola's silence suddenly dawned on Cézanne: he had forgotten that he had asked Zola to address him in care of Poste Restante at La Roche instead of at the Renoir house, and of course Zola's answer had been waiting for him for days! He wrote on July 6:

" I must beg you to forgive me. I am an awful fool. Just think, I forgot to collect your letters at the Poste Restante. That explains the insistence of my second letter. I thank you a thousand times."

Zola, though he was now at Médan, was not quite ready for the proposed visit, but Cézanne was too fidgety to remain at La Roche-Guyon any longer. " I leave today for Villennes. I shall go to the inn," he wrote to Zola on July 11. Villennes was but a stone's throw from Médan. " I shall come to see you for a moment as soon as I arrive, I want to ask you if you will lend me *Nana* to paint, I will bring her back to her harbour as soon as the sketch is done. When I am idle, I am all the more on edge."

Nana was a small boat that Zola used for paddling about among the nearby islands in the Seine. Guy de Maupassant had bought it for him and " had brought it himself from Bezons " just after Zola had acquired the property at Médan, according to a letter from Zola to Flaubert dated August 9, 1878. Zola was working on his novel *Nana* at the time and decided to name the boat after his principal character.

It is not clear from Cézanne's letter whether he wanted to paint a picture of the boat or whether he merely wanted to sit in it and paint the banks of the Seine. The point, as it happens, is unimportant, for he did not use it for either purpose. He could not get

lodgings at Villennes and went instead to Vernon, some miles farther down the river. " Impossible to find a room at Villennes during this week of fêtes, either at the Sophora, the Berceau or the Hôtel du Nord," he informed Zola on July 13. " I am at Vernon, Hôtel de Paris. If my canvas for painting should be sent to you, please take it in and keep it for me."

In his agitated frame of mind Vernon suited Cézanne no better than La Roche-Guyon. No sooner had he arrived than he decided to return to Aix, and once he had made up his mind he was anxious to be off at the earliest possible moment. On July 15 he wrote to Zola again:

" As I informed you in a note dated the 13ᵗʰ inst. I am at Vernon. I cannot find what I am looking for here under present conditions. I have decided to leave for Aix as soon as possible. I shall pass through Médan in order to greet you. . . . You must forgive me once more for dropping in on you at an inconvenient moment, but six or seven days longer are more than I can wait."

And on July 19:

" As you suggest, I shall come to Médan on Wednesday. I shall try to leave here in the morning. I should have liked to settle down to painting again, but I was in the greatest perplexity, for since I have decided to go to the Midi I think that the sooner I go the better. On the other hand perhaps it would be better for me to wait a little longer. I am in a state of indecision. Perhaps I shall pull myself out of it."

Cézanne did not remain in " a state of indecision " much longer. Ten or twelve days later he was back at Aix. On the way he stopped off at Médan for a day or two and unburdened himself to Zola. As far as we know, this was the last meeting between the two friends that ever took place, though neither of them suspected it at the time. Zola and his wife intended to leave shortly

for a sojourn of several weeks at Mont-Dore, after which they proposed to visit Aix early in September. Zola outlined these plans in a letter to Numa Coste written from Médan on July 25, and added that " Alexis and Cézanne, who are here with me at the moment, will be down there [at Aix] at the same time as ourselves." The first part of Zola's trip was carried out according to schedule, but the excursion to Aix had to be given up. There was an outbreak of cholera in Marseilles that summer, and although Zola thought that Aix would be safe enough, Madame Zola had not been well and they decided to take no chances of catching the infection.

Cézanne's next letter to Zola is dated August 20, from the Jas de Bouffan:

" I received your letter giving me your address [at Mont-Dore] last Saturday. I should have answered it right away, but the pebbles in my path, which to me seem like mountains, have distracted me. — You will please forgive me. I am in Aix, and I go to Gardanne every day."

Cézanne's nerves were still on edge, and his path was strewn with "pebbles," but the peaceful atmosphere of Aix was beginning to do its work. At least he was able to paint again. Gardanne, an ancient and rather dilapidated little town about five miles from Aix, perched on a hill and crowned by the ruins of an old church, was one of his favourite *motifs;* he painted it many times over from different viewpoints.

Five days later, on August 25, Cézanne wrote the following cryptic letter to Zola:

" The farce is beginning, I wrote to La Roche-Guyon the same day on which I sent you a line to thank you for having thought of me. Since then I have had no news; for me, the most complete isolation. The brothel in town, or some other, but nothing more. I *finance,* it's a dirty word, but I need peace of mind, and at that price I should have it.

" I beg you not to answer this, my letter should have arrived in good time.

" I thank you and beg you to forgive me.

" I am beginning to paint again, but because there is almost nothing to bother me [there] I go to Gardanne every day, and return to the country-house at Aix in the evenings.

" If I only had an indifferent family, everything would have been for the best."

There is much in this letter that needs explaining, but unfortunately it is not likely that an explanation will ever be forthcoming. The end of Cézanne's turbulent love-affair is shrouded in as deep a mystery as the commencement. We know nothing whatever about it except that, probably as an indirect consequence of the episode, Cézanne and Hortense Fiquet were married on April 28, 1886. Louis-Auguste, now very near the grave, withdrew his opposition to the union and consented to receive his daughter-in-law and grandson. For Cézanne's mother knew of his recent infatuation for another woman and may well have persuaded her husband that their son's marriage to Hortense was the lesser of two evils.

The witnesses at the civil wedding at the *mairie* of Aix were Cézanne's brother-in-law Maxime Conil; Jules Richaud, a clerk; Louis Barret, ropemaker; and Jules Peyron, a minor government official at Gardanne. After fifteen years or more of intimacy the ritual of marriage made no great impression on Cézanne; according to Monsieur Conil, the bridegroom celebrated the occasion by going out to lunch with his brother-in-law and the other witnesses, while his wife was escorted to the Jas de Bouffan by her new parents-in-law. The civil marriage was followed by a religious ceremony at the church of Saint-Jean-Baptiste on the Cours Sextius.

On October 23, 1886, at the age of eighty-eight, Louis-Auguste died. Cézanne was now head of the family, and a rich man. When the estate was finally settled his share came to some four hundred

thousand francs, which yielded an income amply sufficient for the maintenance of his wife and son as well as for his own modest requirements. For the first time in his life he was really free. He had nothing more to fear from the threat of disinheritance, of poverty, of the abrupt ending of his career as a painter, which like a sword of Damocles had been hanging over his head for forty-seven years.

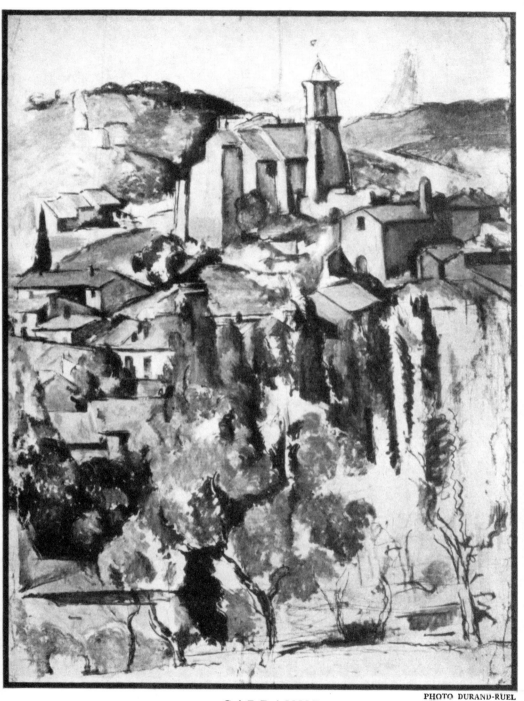

29. GARDANNE
ABOUT 1886. UNFINISHED. BROOKLYN MUSEUM

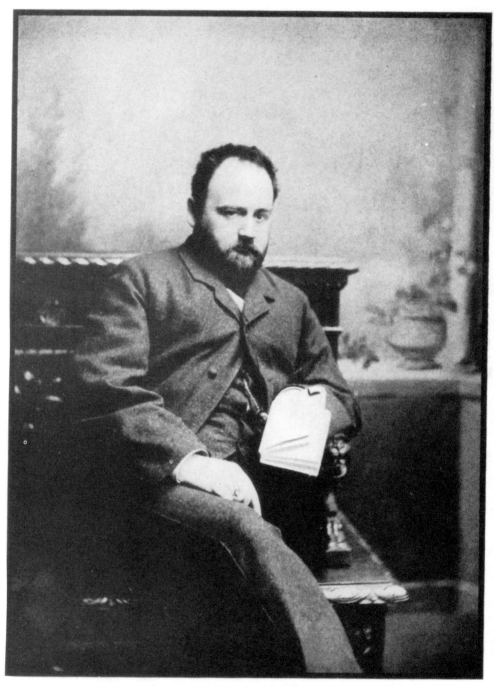

30. ÉMILE ZOLA ABOUT 1878

FROM A PHOTOGRAPH

THE BREAK WITH ZOLA: 1886

THE YEAR 1886 was a memorable one in Cézanne's life, not alone because of his marriage and his father's death, but on account of a third event that occurred before the year was out: the final break with Émile Zola.

Biographers of both men have written a great deal about the estrangement, and yet no really satisfactory explanation of it has ever been offered. Some of the accounts are violently partisan. Vollard and Coquiot in particular have thought it necessary to defend Cézanne by the rather dubious method of throwing great handfuls of mud at Zola. Vollard depicts him as a conceited, pompous, fatuous mediocrity with an incredibly banal taste in art and an overpowering respect for commercial success, especially his own. He suggests indirectly that Zola's energetic defence of Captain Dreyfus was nothing more than a spectacular play to the gallery, and as a final touch shows us the novelist weeping crocodile tears over the failure of his poor old friend Cézanne. And Coquiot echoes Vollard, a little more faintly.

On the other side Madame Denise Le Blond-Zola, in her biography of her father, very naturally absolves Zola of any responsibility for the rupture, and lays the blame squarely, though gently and without any trace of rancour, on Cézanne's difficult, cantankerous, and obstinate disposition.

Which of these diametrically opposed views is the correct one
— if either?

We have already seen that Vollard was under a misapprehen-
sion when he wrote that Zola had destroyed all of Cézanne's let-
ters. I believe that his estimate of Zola's character is equally mis-
taken. The letters that have survived, which were unknown to
Vollard and which have been quoted so often in these pages,
evoke a very different and far more attractive personality. From
this correspondence — or, more accurately, by reflection from
Cézanne's half of the correspondence, Zola's replies being unfor-
tunately lost — the novelist emerges as a loyal, generous, patient,
and understanding friend. We know that Cézanne made frequent
calls on Zola's time, purse, and sympathy, and to as busy a writer
as Zola these appeals may well have been irksome enough at
times; yet there is never a hint of impatience or irritation on
Zola's part, never a single instance of a refusal to accede cheer-
fully and promptly to any request his old friend saw fit to make.

How can this picture of Zola, which is borne out by so much
reliable documentary evidence, be reconciled with the unpleas-
ant portrait drawn by some of Cézanne's biographers? I do not
think it can, except in one respect. The low opinion held by
these writers of Zola's taste in pictures — and in plastic art in
general — is probably justified. Zola was frankly a poor judge of
painting; he was unable to discriminate between a good picture
and a bad one, and his own collection — which grew to a consid-
erable size after the success of his later novels brought him a more
than comfortable income — was a deplorable hodge-podge of
commonplace canvases interlarded with a few really good works
of the Impressionist school, most of which had been given to him
by his friends among the painters themselves.

Zola's collection included a number of pictures by Cézanne,
presented by the artist. They were all painted in the thick *couil-
larde* manner of his youth, before 1870. Zola did not understand,
and so was unable to appreciate, Cézanne's work; and the sensi-
tive painter, well aware of his friend's distaste, soon stopped giv-

ing Zola pictures that were only an embarrassment to their owner. Perhaps kind-hearted Zola himself might have been willing to hang Cézanne's pictures on his walls out of consideration for the painter's feelings, but Madame Zola was firm in her insistence that her house should not be desecrated by such trash. So to the storeroom they went, and there they stayed until they were sold with the rest of Zola's collection in March 1903, after the novelist's death.

Nine canvases by Cézanne were listed in the catalogue of that sale, all described as works of his *première jeunesse: Néreides et Tritons, L'Estaque, Coin d'Atelier, Une Lecture de Paul Alexis chez Émile Zola,* a still life known as *Le Coquillage, L'Enlèvement, Portrait d'Homme Barbu, Portrait de Femme,* and a second *Nature Morte.* Consisting as it did entirely of very early works, the collection included none of Cézanne's best pictures.

There is no reason to believe that Zola's failure to comprehend his painting ever disturbed Cézanne seriously or played any direct part in the ultimate estrangement of the two friends. For if Cézanne had chosen to take offence on that score, he would have broken with Zola at least fifteen years earlier. But it is conceivable and even probable that the fundamental divergence between their æsthetic convictions, of which Zola's dislike of Cézanne's work was only one of the outward signs, did count for something in the falling-out.

It must be remembered that Cézanne's opinion of Zola's novels — notwithstanding the polite but somewhat perfunctory expressions of appreciation in his letters — was not much higher than Zola's estimate of Cézanne's painting. Personally the two men had a great deal in common; professionally they had almost no point of contact.

Taking all the available evidence into consideration, one must conclude that Cézanne's unfortunate disposition was primarily responsible for the break. His temper was always uncertain, and when he was offended his rages were uncontrollable for a time. Moreover, he was morbidly sensitive and suspicious, and in cer-

tain moods was apt to misconstrue the most innocent and well-meant gestures. An anecdote related by Madame Marie Gasquet, widow of Joachim Gasquet, illustrates this tendency. Monet and several other Impressionist painters, all good friends of Cézanne's, once conceived the idea of giving a luncheon in his honour. When Cézanne arrived, the others were already gathered around the table, and Monet began a little speech of welcome in which he expressed the deep admiration and affection that all of those present felt for their colleague. Cézanne listened with his head bowed and his eyes full of tears; and when Monet had finished he said: " Ah, Monet, even you make fun of me! " To the consternation of everyone, and in spite of all protests, he rushed from the room. He did not come back, nor could he ever be convinced that the homage of the other painters had been sincere.

But this sheds no light on the immediate cause of the estrangement between Zola and Cézanne. If Cézanne's feelings were hurt or if he flew into a temper with Zola, something — reasonable or unreasonable — must have set him off. And what that something was remains a mystery. Even Madame Le Blond-Zola is unable to suggest a plausible reason for such a flare-up. She was not born until some years after the end of her father's friendship with Cézanne, so naturally she did not know the painter personally; and as she was only thirteen when Zola died, she had no opportunity to discuss the episode with him. She does tell us, however, that long afterwards she asked Zola's widow why the breach was never healed, and that Madame Zola had replied: " You did not know Cézanne; nothing could make him change his mind."

This recalls Zola's own remark in a letter to Baille many years before: " To convince Cézanne of anything is like trying to persuade the towers of Notre-Dame to dance a quadrille." And Cézanne's obstinacy, though it does not help us to account for the beginning of the coolness, was undoubtedly a factor in keeping the two friends apart once the breach had been made.

As a matter of fact, there is good reason to suppose that nothing like an outright quarrel ever took place. Vollard himself quotes

Cézanne as saying: " No harsh words ever passed between us. It was I who stopped going to see Zola. I was not at my ease there any longer, with the fine rugs on the floor, the servants, and Émile enthroned behind a carved wooden desk. It all gave me the feeling that I was paying a visit to a minister of state. He had become (excuse me, Monsieur Vollard — I don't say it in bad part) a dirty bourgeois."

And that, I believe, lay at the root of the estrangement. In the old days of Zola's struggling, poverty-stricken youth Cézanne felt at home with him. Cézanne had no use for luxury: his tastes were simple, his mode of living austere, and he had no social ambitions whatever. But Zola was by nature something of a sybarite, and as soon as his books became popular and royalties began to accumulate he proceeded to surround himself with expensive furniture and a profusion of knick-knacks and *objets d'art;* he had numerous servants, kept an elaborate table, and in general lived as luxuriously and extravagantly as his means permitted. His house at Médan was nearly always full of guests; there was an enormous amount of coming and going, an unending series of appointments and interviews. This hectic atmosphere suited Zola. His energy was prodigious, and he was able to turn out volume after volume, article after article, in the midst of a bustle that would have driven most writers to distraction.

Cézanne was made of different clay. The luxurious trappings and lively sociability of Zola's establishment were equally distasteful to him. The frugality and austerity of his own life were not forced on him by circumstances, but sprang from the very depths of his nature; he lived as simply after he inherited a fortune as he had lived on an allowance of a few hundred francs a month. He felt shy and awkward and thoroughly ill at ease in Zola's house, conscious of his baggy, untidy clothes, his uncouth Provençal accent, his surly temper, which was likely to get out of hand at any moment, his general lack of social *savoir faire*. And while on the one hand Cézanne was genuinely contemptuous of the superficial fuss and feathers of society, on the other he was

abnormally thin-skinned, acutely sensitive to the least hint of a slight or sneer. Subconsciously — and perhaps consciously too at times — he would try to conceal his sense of inferiority under an outburst of loud and violent speech, a perverse exaggeration of his provincial accent, or an excessive unconventionality of dress. Rivière tells us of an evening party at Zola's house at which Cézanne scandalized the elegant and well-dressed assemblage by appearing in an old workaday jacket:

" Zola felt it necessary to explain to his guests that the painter was a little eccentric, but at heart he was annoyed by this disregard of social conventions.

" In the middle of the evening, during which he had been silent and thoughtful, Cézanne suddenly spoke:

" ' Say, Émile, don't you think it's hot in here? Allow me to take off my coat.'

" And without waiting for an answer he took off his jacket and went about in shirt-sleeves among the crowd in evening dress. . . ."

This anecdote has a slightly apocryphal ring and must be accepted with reserve; but it is not unlikely that Cézanne often embarrassed Zola by his eccentric behaviour and that he was regarded by Madame Zola as something of a bull in the china-shop of her drawing-room. So that for some years before the actual break there was tension on both sides, hidden under the smooth surface of their friendship. The train was laid for an explosion; only a spark was needed to set it off.

What that spark was, nobody knows for certain. There have been hints of various trivial slights and insults suffered by Cézanne at Zola's hands. According to Vollard, Cézanne said that he was once refused admittance to Zola's house: " One day a servant told me that his master was not at home to anyone. I don't think the instructions were meant for me in particular; but I went there still less frequently." And Gasquet tells us that " a smile

exchanged between a servant and Zola, at the head of a staircase, one day that Cézanne was late in arriving at the house, loaded down with packages, his hat crooked, drove him away from Médan for ever."

These are trifling incidents to account for the abrupt termination of an intimate friendship that had survived through thick and thin for forty years, and yet Cézanne's touchiness was so extreme that some such fantastic explanation is not impossible.

* *

Much has been written about the part played in the break by Zola's novel *L'Œuvre*. The principal character, Claude Lantier, is unquestionably modelled on Cézanne. In Zola's preliminary notes for the book occur such specific entries as: " Cézanne's ateliers. All the traits of his character. Sittings in his studio. Excursions to Bennecourt." But Claude is only to a limited extent a portrait of Cézanne; he is after all a character in a novel, or, more accurately, a character who appears in two or three volumes of a long series of novels forming a single literary unit. The entire work is a dismal chronicle of decay — the gradual decline of the various members of the Rougon-Macquart family, partly through heredity, partly as a result of environment. In the various novels the sinister deterioration takes different forms and is brought about by different agencies: in *L'Assommoir*, for example, the downfall of the protagonists is caused by drink, in *Nana* by sexual excess. *L'Œuvre* in turn is the story of artistic failure: Claude Lantier, exhausted by his unsuccessful efforts to express his splendid visions on canvas, is inevitably doomed by his inherited emotional instability to madness and eventual suicide.

In his preliminary notes for *L'Œuvre* Zola sketched a Claude " who is never satisfied, who is tormented by his inability to give birth to his own genius, and who in the end kills himself before his unrealized masterpiece. He will not be an impotent artist, but a creator whose ambition is too great, who tries to include all of nature in a single canvas, and who dies in the attempt."

It was absolutely necessary for Zola's literary purpose that Claude, as a member of the doomed Rougon-Macquart family, should be a failure — a sublime one in a way, but still a failure. And Claude is Cézanne — but only in part. The Claude of the first part of the book, before discouragement and poverty have undermined his will-power, is a reasonably faithful portrait of Cézanne in his twenties; but the subsequent development of the character is largely Zola's invention. As I have already pointed out, nothing could be farther from Claude's weak and futile collapse than the real Cézanne's healthy, dogged persistence. Because his picture is a failure, Claude hangs himself; in similar circumstances Cézanne merely destroyed his unsuccessful canvas and began another. And Zola was well aware of the differences between his flesh-and-blood friend and the creature of his own imagination. He did consider Cézanne a failure in a certain sense: he felt — as did many others — that Cézanne was constitutionally incapable of expressing fully and adequately with his brush the magnificent conceptions that were in his mind. To that extent Zola thought of Cézanne as unsuccessful; and Cézanne himself unconsciously fostered this mistaken belief by his own genuine humility before his art, his constant iteration of the complaint that he found it so difficult to "realize." But Zola knew his old friend far too well to dream of imputing to him the unwholesome weakness of character that drives Claude, in the novel, to a miserable and violent death.

Even the elements in Claude that are drawn from life are not patterned exclusively after Cézanne. There is something of Manet in his composition as well as more than a dash of Zola himself. Monsieur Maurice Le Blond, Zola's son-in-law, writes in his commentary on *L'Œuvre* in the 1927–1929 edition of Zola's works that "Claude Lantier is often not so much Cézanne as Zola himself, with his creative pangs, his exasperations and his torments, his doubts concerning the work he has undertaken, which he fears he will not be able to finish."

Practically all of the other important characters in *L'Œuvre*

can be identified in the same way as friends or acquaintances of Zola, though all are modified and distorted to fit into their places in the literary design. Monsieur Le Blond gives us a list of such derivations from real life. Sandoz, of course, is Zola himself; his rôle is outlined in the notes: " I myself must inevitably be static. I bring only ideas, my own literary ideas." The unhappy Dubuche, according to Monsieur Le Blond, exhibits " many of the psychological traits " of Baptistin Baille. " In the first draft of the novel the architect Dubuche bore the too transparent name of Baude." The sculptor Mahoudeau is a combination of Philippe Solari and Antony Valabrègue, with Valabrègue predominating in the character although some of the incidents — notably the episode of the collapsing statue — are taken directly from the life of Solari. Bongrand, the great painter of a slightly earlier generation than Claude, is " a very chic Manet, more like a Flaubert." Jory, the art critic, is Paul Alexis; Fagerolles, the clever and facile but amiable dandy, " is derived from Bourget and Guillemet. In Mazel, personifying official art and the tradition of the *École,* one must perceive the cold Cabanel. Chaïne, Mahoudeau's companion, was also one of the old friends from Aix, a youth named Chaillan, who remained obscure and who frequented the Café Guerbois for a short time."

Was Zola guilty of treachery, or at least of a breach of good taste, in thus making use of his friends to bring to life the characters of a novel? He has been accused of both; but I cannot see that either charge is tenable. It is inevitable that a novelist — especially a realistic novelist like Zola — should use the people he knows and understands as the raw material from which his characters are fashioned. As long as there is no petty malice, no taint of personal spite in such derivations, they are a legitimate component of the novelist's stock in trade. And there is no evidence whatever that Zola was malicious in his treatment of his friends, however unpleasant some of the characters he created out of the ingredients they supplied may have turned out. His book required such characters, and to build them up he appropriated

from life a trait here, an incident there; but there was no animus behind his borrowings.

Nor did the friends who thus contributed portions of their living selves to *L'Œuvre* resent the rôles which Zola compelled them to assume. Manet, of course, was dead, and Baille had faded out of the picture long ago; but of those who were Zola's intimates at the time *L'Œuvre* was published — Guillemet, Valabrègue, Solari, Alexis, Bourget — all remained on the same friendly terms with him as before.

All, that is, except Cézanne. But it is very doubtful that *L'Œuvre* had much, if anything, to do with the break between Cézanne and Zola. It is true that their intimacy came to an end very soon after the appearance of the novel; it is also true that the last surviving letter from Cézanne to Zola is an acknowledgment of the receipt of *L'Œuvre*. The novel was finished on February 23, 1886. For some months it had been appearing serially in *Gil Blas;* Zola was forced to hurry towards the end in order to keep his manuscript an instalment or two ahead of the magazine. Late in March it was published in book form, and as usual Zola promptly sent a copy to Cézanne, who replied:

> *" Gardanne, April 4 1886.*
>
> " My dear Émile,
> " I have just received *L'Œuvre* which you were kind enough to send me. I thank the author of the *Rougon-Macquart* for this good evidence of his thoughtfulness, and I beg him to allow me to clasp his hand in memory of bygone years.
> " Wholly yours, under the spell of times that are past
>
> Paul Cézanne
> *at Gardanne, arrondissement of Aix."*

Monsieur Le Blond quotes this letter as proof that Cézanne did not take offence at Zola's treatment of him in *L'Œuvre*. Taken by itself, the letter seems cordial enough; but considered as the last item of an intimate correspondence covering almost thirty years,

it is a somewhat cold and formal document. In reality this letter proves nothing conclusively either way. That Cézanne acknowledged the book at all, however, is at least presumptive evidence that he was not deeply wounded by it.

At the same time there is a certain amount of testimony to the contrary which must be considered. In an article in the *Mercure de France* for October 1, 1907 Émile Bernard quotes Cézanne on the subject at some length. The date of the conversation is the early spring of 1904:

" We were speaking of Zola, whom the Dreyfus case had made the man of the hour. ' He had a very mediocre intelligence,' Cézanne told me, ' and was a detestable friend; he could see nothing but himself; that is why *L'Œuvre,* in which he claimed to describe me, is only a horrible distortion, a lie to increase his own glory. . . . Then when I came to Paris, Zola, who had dedicated *La Confession de Claude* to me and to Bail [*sic*], a comrade now dead, presented me to Manet. I was deeply impressed by that painter and by his cordial reception of me, but my natural timidity prevented me from going to his studio very often. Zola himself, as he established his reputation by degrees, grew unfriendly and seemed to admit me only as a favour; so much so that I became disgusted by the sight of him and let several years go by without looking him up. One fine day I received *L'Œuvre.* It was a blow to me; I saw in it his real attitude towards us. In fact, it's a very bad book and completely false.' "

Much of what Monsieur Bernard has written about Cézanne is of great value, but here his partisanship has certainly led him astray. The conversation as reported (three and a half years after it took place) is full of obvious errors. It is hard to believe, for example, that Cézanne could have referred to Zola as " a detestable friend "; if he did so, he was a monster of ingratitude. The mis-spelling of Baille's name is a minor inaccuracy, though very little effort would have been needed to check it up. But it is in-

conceivable that Cézanne should have called him a "dead com-
rade" when Baille did not die until 1918, twelve years after Cé-
zanne himself. Though Baille had dropped out of his life long
ago, Cézanne, living as he did in the same small city as Baille's
family, would surely have known at least that his former friend
was still alive. The most vital error, however, lies in the sugges-
tion that Cézanne had avoided Zola and had broken off relations
with him, to some extent, several years before the publication of
L'Œuvre. That we know from Cézanne's letters to be absolutely
untrue. Cézanne corresponded with Zola constantly, confided to
him his most intimate secrets, and visited him whenever he had
the opportunity— generally on his own initiative — until a few
months before the book appeared.

Monsieur Bernard's evidence on this point must therefore be
heavily discounted. On the other hand Joachim Gasquet, whose
views are almost always consistent with the known facts, tells a
different story. Gasquet maintains that Cézanne told him plainly
that *L'Œuvre* had nothing to do with the estrangement. Far from
being hurt by it, the painter was deeply impressed by the book:

"The early chapters of the novel always moved him pro-
foundly; he felt in them an extraordinary truthfulness, almost
unqualified and intimately touching to himself, who recaptured
in those pages the happiest hours of his youth. When the book
changed direction later on with the character of Lantier threat-
ened by madness, he understood perfectly that this took place ac-
cording to a necessity of the plan, that he himself was henceforth
entirely out of Zola's mind, that Zola, in short, had not written
his memoirs, but a novel that formed part of an immense carefully
thought-out whole. The character of Philippe Solari, set forth in
the guise of the sculptor Mahoudeau, was also very much altered
to suit the plot, and Solari did not dream, any more than Cézanne
did, of taking offence. His admiration for Zola never faltered. And
Zola, when I saw him in Paris fifteen years after *L'Œuvre*, spoke
to me of his two friends with the most profound affection. This

298

was about 1900. He was still fond of Cézanne, in spite of his sulkiness, with all the warmth of a great brotherly heart, ' and I am even beginning,' he told me, ' to have a better understanding of his painting, which I always liked, but which eluded me for a long time, for I believed it to be forced, whereas it is really incredibly sincere and true.' "

This is a very different version of Zola from that presented by other biographers of Cézanne, and one that is to my mind very much nearer the truth. It is in perfect harmony with the image of Zola reflected in Cézanne's letters: the image of a sincere, kind, and affectionate friend.

Furthermore, as Gasquet points out, the contents of *L'Œuvre* could have been no surprise or shock to Cézanne, who must have known a good deal about the book before it appeared in print. " In 1885, after a sojourn in Normandy at the house of his friend Choquet, the famous portrait of whom, against a background of green foliage, he was then painting, Cézanne came to Médan. He spent the whole month of July there. Zola was writing *L'Œuvre*. He must surely have talked a lot about the book and have read considerable fragments of it to Cézanne."

Gasquet is in error when he writes that Cézanne spent the whole month of July 1885 at Médan. The visit to Choquet in Normandy took place in 1886, after the publication of *L'Œuvre,* not in 1885; and we know from Cézanne's letters that he passed the month of July 1885 in an agitated flitting from La Roche-Guyon to Villennes, from Villennes to Vernon, and only turned up at Médan for a few days at the end of the month just before his departure for Aix. Zola was certainly working on *L'Œuvre* at that time. During this brief visit Cézanne was preoccupied with his own problems, as we have seen; nevertheless it is likely that he and Zola had time to discuss the latter's forthcoming book. And in any case Cézanne had had other opportunities to hear about *L'Œuvre,* for the plan of the book had been in Zola's mind for several years before he began to write it. Paul Alexis was able

to give a very accurate general idea of the proposed novel in his *Notes d'un Ami,* which was published in 1882, four years before *L'Œuvre* appeared. Alexis knew that Zola intended to model his characters on his acquaintances: " Naturally in this book Zola will find himself obliged to draw on his friends, to pick out their most typical traits. For my part, if I should find myself in its pages, and even if I should not be flattered therein, I promise not to bring suit against him." Between 1882 and 1885 Cézanne visited Zola at Médan only two or three times, for he was in Provence for long stretches at a time; yet he probably heard enough about the projected book to know that he and other friends of Zola's were to have a place in it.

All of this indicates that *L'Œuvre* had little connection with the cooling of the friendship between Zola and Cézanne. That the intimacy came to an end just about the time that *L'Œuvre* was published was probably a mere coincidence. Indeed, we cannot be absolutely certain that the tie was broken immediately after the appearance of the book; we cannot be sure that the two friends never saw each other again after Cézanne's visit to Médan at the end of July 1885; nor is there any real proof that Cézanne's letter of April 4, 1886, acknowledging the receipt of *L'Œuvre,* was actually the last he ever wrote to Zola. All we know is that it is the last letter which has come to light, and that the visit to Médan is the last meeting of which we have any record. Perhaps a few more letters which have disappeared did pass between them; perhaps they did meet again within the next year or two on the same friendly footing as before. In other words, it is possible that the concurrence in time between the publication of *L'Œuvre* and the final break-up was not really quite so close as it appears to have been.

But whether the friendship ended in the spring of 1886 or whether it dragged on a few months longer, end it did, completely and for ever; and it is still impossible for us to lay a finger on an adequate reason. If we dismiss *L'Œuvre* from our list of contributory causes — as I believe we must — what remains? In the first

place, an immense difference in æsthetic outlook. But that was an old story: the friendship had persisted in spite of it for years. Secondly, Cézanne's distaste for Zola's luxurious surroundings, his increasing uneasiness and sense of inferiority in Zola's presence; and, as a corollary, Cézanne's social awkwardness, which irritated Zola a little and Madame Zola a great deal. Lastly and more specifically, some hypothetical condescending remark by Zola, some fancied slight or slur, perhaps nothing more than a tactless wink, that rasped Cézanne's supersensitive nerves.

Set down in cold print these seem but trivial grounds for the destruction of a lifelong friendship. A clear-cut quarrel followed by a swift reconciliation would be comprehensible; but here we have no such quarrel and no such reconciliation. If it is difficult to explain the estrangement in the first place, it is harder still to account for its grim persistence.

I do not think that Cézanne's much-talked-of stubbornness was alone to blame. Cézanne and Zola do not appear to have deliberately avoided each other in after years; it was largely by accident, and because of the difference in their modes of living, that their paths never happened to cross. And on at least one occasion, according to Vollard, a meeting of reconciliation was frustrated by the chance interference of a busybody. Cézanne was working at a landscape when he heard the news that Zola was in Aix:

" Without even taking time to pack up my things, I rushed to the hotel where he was stopping; but a friend I met on the way told me that someone had asked Zola the day before: ' Aren't you going to take a meal with Cézanne? ' and that Zola had answered: ' What good would it do to see that failure again? ' So I went back to my landscape."

We may be permitted to doubt that Zola ever said any such thing. It does not sound in the least like him; but it is easy to understand that some perfectly innocent remark carelessly or maliciously twisted by a talebearer might have cut the sensitive

Cézanne to the quick. Had they met on this occasion, there can be little doubt that the feud would have ended then and there. But Cézanne returned to his *motif,* and they did not meet.

They dropped out of each other's lives completely. After 1886 there is not a single reference to Cézanne in any of Zola's published correspondence, nor is there any mention of Zola in the letters written by Cézanne to other friends. Apparently Cézanne took no interest in Zola's heroic efforts to obtain justice for the unfortunate Captain Dreyfus; politics were always a sealed book to him. It was only when the news of Zola's death reached him that Cézanne's long-buried affection for his old friend came to the surface again.

Zola died on September 29, 1902, at the age of sixty-two. He was asphyxiated during the night by the fumes from a coal fire in his bedroom in Paris; the chimney had been accidentally blocked up during the course of some repairs in the apartment upstairs, and Zola collapsed on the floor while attempting to reach and open a window. His wife, who occupied the same room and who had fainted from the effects of the poisonous gas, barely escaped death.

Marcel Provence, in his article on *Cézanne et ses Amis* in the *Mercure de France* of April 1, 1926, tells us that when Cézanne heard of Zola's sudden death, " he wept, suffered, and mourned for a whole day." That evening he went to see Philippe Solari, and no doubt the painter and the sculptor, now grown old, wept again for their lost friend and the memories of their youth. The following Sunday Cézanne attended mass as usual at the cathedral of Saint-Sauveur, and on the way out he happened to meet Numa Coste in the doorway. Monsieur Provence claims that Coste and Cézanne had not been on friendly terms for years; Coste was an ardent admirer of Zola, and Cézanne, perhaps unreasonably, had resented the other's partisanship. Gasquet however implicitly denies that Cézanne had broken with Coste; in his account of his own first meeting with Cézanne in 1896 he mentions that Numa Coste was among those gathered around the café table,

drinking an *apéritif* with Cézanne. In any case, if there had ever been bad blood between Cézanne and Coste it was forgotten now in their sorrow at the death of their old companion. The two men, their eyes full of tears, clasped hands in the sunny square in front of the cathedral and murmured: " Zola, Zola — "

PAINTING: MATURITY: 1877–1889

WE have already seen that Cézanne, having learned from Pissarro and the other Impressionists all they could teach him about the painting of reflected light out of doors and the use of pure colour applied in broken patches, came to the conclusion that for him at least Impressionism was not the alpha and omega of painting. During the later seventies he drew away from the main group of his radical contemporaries and embarked on a series of researches into the representation of solid, three-dimensional objects. His pictures, as distinguished from those of the orthodox Impressionists, acquired a new quality: depth.

Now, the representation of solid objects on a two-dimensional surface such as canvas or paper can be accomplished in various ways. One method involves the use of perspective — essentially a matter of drawing. Another is modelling: a process by which variations in the light and dark values of a picture are introduced to indicate changes in direction of the component planes or surfaces. Both of these systems, singly and in combination, have of course been employed by all painters later than the Byzantines; they were part of Cézanne's inheritance as they were part of the inheritance of every one of his fellows, and he saw no reason to discard them altogether. But he developed, and added to these

classic systems, a third method of rendering solidity on a flat canvas which he called *modulating,* as distinct from *modelling.* Cézanne's intense observation of nature convinced him that not only did the black and white values of a surface change as the planes composing that surface receded, but that the actual colours of the surface varied as well. The Impressionists had already substituted coloured shadows for the blacks and soupy browns of their immediate predecessors, but they were concerned primarily with the problem of representing the effects of reflected light. Cézanne, while he continued to make good use of their discoveries, went beyond the Impressionists and worked out, by patient experimentation, his own system of rendering the plastic structure of solid objects by means of colour.

It is in Cézanne's later still lifes that his achievement in this field can best be studied. The simple geometric forms of which they are composed — the spheres which are his apples, onions, and skulls, the cylindrical bottles, the ellipses of his plates and the tops of bowls and glasses seen in perspective, the rectangular shapes of kitchen tables bounded by flat planes — all of these are examples of his use of subtle colour gradations to indicate changes of direction of surface. In a still life by Cézanne the receding plane of the side of a table differs not only in *value* from the front of the same table which is parallel — or more nearly parallel — to the picture plane, it is different in *colour* also; the rounded surface of an apple as it turns away from the observer is touched with colours other than those used on the portions of the same apple that are directly in front of the eye. And the changes in colour are not wholly accounted for by the accidents of varying reflected lights on different parts of the object, as taught and practised by the Impressionists, but are due in large measure to the turning or recession itself. Cézanne neglected neither local colour nor the effects of reflected light; but he recognized that both are profoundly modified by plastic form.

Naturally Cézanne's use of colour to indicate structure enhanced the richness of his later canvases. Compared with the pic-

tures of his early years or with such paintings of his Impressionist period as *La Maison du Pendu,* the work of the eighties — and indeed of the remainder of his life — exhibits an astonishing brilliance of colouring. In the hands of a less gifted painter such intensity might easily have led to flamboyance; but Cézanne's colour sense was unerring. Moreover, he pondered each stroke with the utmost care and deliberation in order to satisfy himself that the touch of colour he was about to place on the canvas was exactly in the desired relationship to the rest of the picture. He never painted at random; nothing was ever left to chance; the happy accident did not exist in his work. He had no ready-made formula. Each picture was the result of fresh research, every brush-stroke the fruit of patient observation. Cézanne's procedure has been well characterized by Émile Bernard in the *Mercure de France* for October 1, 1907, as " a meditation, brush in hand."

Of course such a method of painting was slow and laborious to the last degree and must have been agonizing to the unfortunate models who sat for him. " For one who has not seen him paint," says Ambroise Vollard, whose portrait Cézanne painted in 1899, " it is difficult to imagine how slow and painful his progress was on certain days. In my portrait there are two little spots of canvas on the hand which are not covered. I called Cézanne's attention to them. ' If the copy I'm making at the Louvre turns out well,' he replied, ' perhaps tomorrow I shall be able to find the exact tone to cover up those spots. Don't you see, Monsieur Vollard, that if I put something there by guesswork, I might have to paint the whole canvas over, starting from that point? ' The prospect," adds Vollard, " made me tremble " — as well it might, considering that the portrait, even though the two bare spots of canvas were never covered, required a hundred and fifteen sittings.

Cézanne worked so slowly that even his inanimate subjects often disintegrated before he finished transferring their likenesses to canvas. Flowers faded, so that he was driven to the use of artificial substitutes of cloth or paper — and even these grew

dingy during the long process of painting. The hardiest fruits rotted in time and frequently had to be thrown out before the picture was completed. And his landscapes were sometimes worked on for several months at a stretch, regardless of the progression of the seasons — for in Provence, as Cézanne had written to Pissarro in 1876, " the vegetation does not change. . . . The olives and pines always keep their leaves."

While the true Impressionists were able to restrict their palettes to half a dozen colours and to eliminate black altogether, Cézanne's system of " modulation," with its infinitely subtle gradations of colour, required a much more extensive range. According to Émile Bernard, he used habitually no less than nineteen colours:

Cobalt Blue	Vermilion	Brilliant Yellow
Ultramarine	Red Ochre	Naples Yellow
Prussian Blue	Burnt Siena	Chrome Yellow
	Rose Madder	Yellow Ochre
Emerald Green	Carmine Lake	Raw Siena
Viridian	Burnt Lake	
Terre Verte		
		Silver White
		Peach Black

This list was made in 1904, towards the end of Cézanne's life, but from about 1880 onward his palette remained substantially unchanged.

Cézanne's passion for breaking up his planes and surfaces into a complex but always harmoniously graded patchwork of colour led him, somewhat arbitrarily, to deny all virtue to any painting in which large areas of the canvas were covered by flat unbroken colours. Gauguin in particular was his *bête noire*. Bernard tells us that Cézanne " spoke very harshly about Gauguin, whose influence he considered disastrous." When Bernard protested mildly that " Gauguin admired your painting very much and imitated you a good deal," Cézanne replied furiously: " Well, he never understood me; I have never desired and I shall never accept the absence of modelling or of gradation; it's nonsense.

Gauguin was not a painter, he only made Chinese images." Monsieur Bernard might have retorted that Chinese images were by no means the lowest form of art, though it is not recorded that he did so. Undoubtedly Cézanne's judgment on this point was a narrow one, but tolerance and genius do not always go hand in hand. His indifference to Byzantine art and the work of the great Italian primitives can be ascribed largely to this same abhorrence of flat painting in any form.

* *

But it was not only in his insistence on the third dimension, and in his method of rendering solidity by gradations in colour, that Cézanne overstepped the narrow limits of Impressionist doctrine. His researches into the properties of form were undoubtedly of immense value; but his supreme contribution to art lay in an entirely different direction.

It is no exaggeration to say that Cézanne, far more than any other single artist of his generation, has determined the course of " modern " painting — that is, the painting of the present day. His influence, acknowledged by practically all of the greatest living painters, has been paramount for at least three decades. Today he is almost universally conceded to be what, in his more confident moments, he predicted he would become: " The primitive of a new art." What is there in his work that entitles him to such consideration?

The answer is that Cézanne prepared the ground for the present movement away from realistic representation and towards abstraction. For centuries the tendency towards realism in European painting had been growing; and the Impressionists added the final touch by their quasi-scientific experiments in the faithful rendering of natural light. As Walter Pach says in his *Masters of Modern Art:* " The long slope of realism had been climbed." With Cézanne — or, more accurately, with the work of his last thirty years — the pendulum began to swing definitely in the opposite direction.

308

Mr Pach sums up Cézanne's revolt against realism in the following words:

" He continues to paint from nature until the end of his life; but the slightest sketch of his later years shows his growing preoccupation with the æsthetic qualities of the picture. Herein lies the difference between him and the Impressionists. With the latter one feels that the limits of the picture, and its subdivisions, were imposed from without, by the aspect of the scene portrayed. . . . Cézanne's immense authority proceeds precisely from his having rendered comprehensible to the next generation the laws of picture-making which the haste and confusion of the nineteenth century had obscured."

And again:

" Cézanne, superimposing color upon color to get their cumulative effect, watching the reverberation throughout his canvas of each new touch, was performing a mental operation similar to that of the musician, whose material, farther removed from the imitative than is the painter's, arrived much sooner at its purity as an agent of expression. Since form, more than color, renders the thing seen, Cézanne's organizing of the lines and planes of his pictures will stand as an even greater achievement than his work with color. A certain latitude has usually been permitted the colorist in his search for harmony — which has been pretty generally understood as the object of his effort. But drawing, ' the probity of art,' was another matter. For many hundreds of years, since the decline of Byzantine art, Europe had been working for an ever-greater completeness of representation; and Cézanne himself, when his need for an æsthetic structure forced him to modify, in his painting, the physical structure of objects, was tortured with doubts about his procedure. Yet he went on, always in the same direction, making a constantly more rigorous elimination of the sensations which to him represented only acci-

dents of vision and which were not essential to the new organism he was building up."

Cézanne's aim, in the years of his maturity, was not the imitation of nature. Unlike the Impressionists, he conceived his pictures not from without but from within. The natural forms that served as models for his paintings — the hills and trees and houses and chequered fields of his landscapes, the heads and torsos and limbs of his portraits, the apples and pears, flowers and earthenware of his still lifes — resolved themselves in his mind into simple geometrical solids: spheres, cubes, cones, and cylinders. Out of these abstract elements he constructed his pictures, organizing and modifying them to conform to his inner vision. Since his object was not primarily the representation of nature as it appeared to his eye, but the composition of an æsthetic organism, he could permit himself to distort the forms he saw before him so as to bring them into the desired relationship on his canvas. A good if rather extreme example of such distortion is illustrated in Plate 31: the right side of the carafe is swollen most unrealistically, and the left side contracted, in order to satisfy the æsthetic requirements of the pattern.

This metamorphosis of natural objects in Cézanne's pictures — with particular reference to the landscapes — is graphically presented in an article entitled *Cézanne's Country* by Erle Loran Johnson, published in *The Arts* for April 1930. Mr Johnson reproduces a number of the landscapes side by side with actual photographs of the same scenes, taken as nearly as possible from the same positions. From these comparisons we see clearly how Cézanne made use of natural elements — trees, rocks, houses, mountains, etc. — to build up his compositions. The objects are easily recognizable; but by eliminating non-essential details, by changing the direction of certain lines and planes, by simplifying, exaggerating, distorting, instead of slavishly copying the scene before him, he succeeded in transforming the most commonplace *motifs* into superb and highly individual masterpieces.

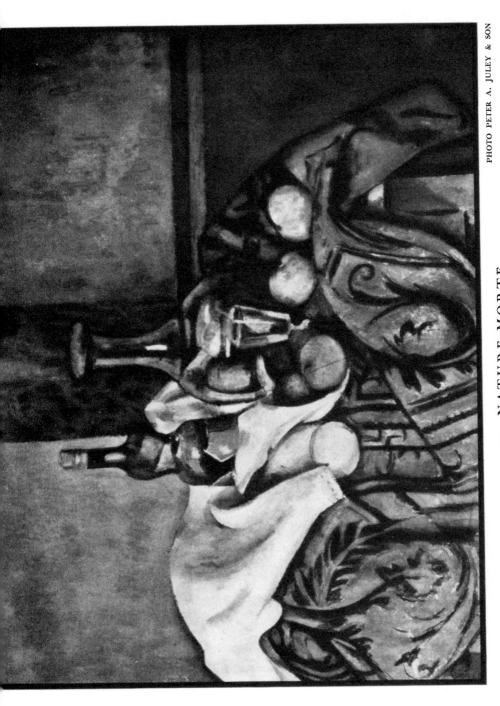

31. NATURE MORTE

1885–1890. CHESTER DALE COLLECTION, NEW YORK

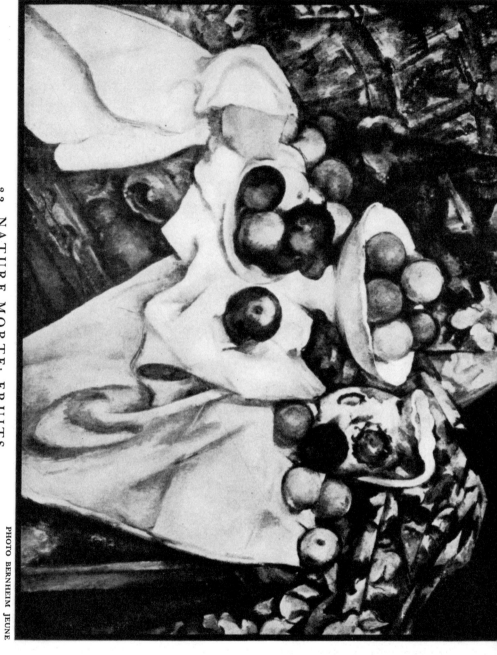

32. NATURE MORTE: FRUITS

ABOUT 1894. LOUVRE, CAMONDO BEQUEST

Mr Johnson's experiment is an interesting and valuable contribution to the study of Cézanne's method of landscape painting in his later years. Unfortunately the remainder of the article — the portion that deals with Cézanne's personal life as distinct from his art — bristles with inaccuracies to such an extent that it cannot be taken seriously.

But if Cézanne paved the way for the more or less purely abstract, non-representational painting that has come into being since his death, he himself ventured only a comparatively short distance along that road. It does not seem ever to have occurred to him to eliminate altogether the representation of natural forms from his pictures; in fact he deliberately and consciously based all of his work on the most minute and intensive observation of nature. He was after all, as Walter Pach points out, a man of the generation which set itself to represent natural appearances most fully.

Cézanne's daring conception of the abstract in art was in eternal conflict with his devotion to nature. He was for ever trying to reconcile the representation of nature, or, more accurately, of his " sensations in the presence of nature," as he expressed it, with his inner vision of an æsthetic, abstract entity. Sometimes he succeeded in balancing the two elements so perfectly that the mental struggle involved is scarcely perceptible, as in the serenely beautiful *Lac d'Annecy* (Plate 35), painted in 1896. But more often the effort to bring the *motif* into harmony with the laws of abstract composition is apparent, to some extent, in Cézanne's canvases.

He complained frequently that he could not " realize." His sense of frustration was largely the result of this antagonism between his organized, abstract mental conception of what his picture should be and his determination to remain faithful to his " sensations in the presence of nature." " Nature presents the greatest difficulties to me," he had written to Zola in 1879; and nature continued to present difficulties to him until the end of his life. Yet he never ventured to abandon the representation of

311

natural objects altogether; there is no reason to believe that so revolutionary an idea ever entered his head. Cézanne was a pioneer, but he was not ahead of his time to that extent. The modifications and distortions he introduced were shocking to most of his contemporaries, though they appear mild enough today. The objects in his paintings are always recognizable, except possibly in some of the slighter water-colours which were intended as suggestive notes and memoranda rather than as finished pictures.

The truth is that, for all his preoccupation with abstract geometrical forms, Cézanne was peculiarly dependent on concrete, tangible objects — mountains, trees, fruit, flowers, crockery, or human beings — to serve as models for his pictures. He could not conjure up his subjects from the depths of his imagination or from his knowledge based on previous experience. He had to observe and study each composition as a new problem.

This handicap was due in part to an inherent lack of a certain kind of imaginative power — a congenital inability to evoke a clear mental image of an object that was not there — and in part to the defects of his early training. If in his youth he had undergone the rigorous discipline administered to the apprentices in an artist's workshop during the Italian Renaissance, for example, it is probable that the disability could have been overcome to a considerable extent. But unfortunately the haphazard, go-as-you-please Académie Suisse offered no such discipline, and Cézanne remained tied to his model until the end of his days.

This statement, however, like so many categorical assertions about Cézanne, requires a certain amount of qualification. It would be a mistake to suppose that Cézanne was so completely dependent on the actual physical presence of his *motif*, his sitter, or his still-life lay-out that he was unable to paint a stroke unless he had a model, animate or inanimate, before him. On this point the testimony of Joachim Gasquet, whose portrait Cézanne painted in 1896 (Plate 40), seems conclusive:

" I posed only five or six times. I thought he had abandoned

the picture. I learned afterwards that he had devoted to it some sixty periods of work and that whenever during the course of the poses he studied me with intensity, he was thinking of the portrait, and that he worked at it after my departure. He was trying to bring out my very life, my features, my inner thoughts, my language; and without my knowledge he made me expand until he could catch my soul itself in the passionate transports of argument and the hidden eloquence that even the humblest being brings to his angers or his enthusiasms. It was a part of his method, especially when he was painting a portrait, to work often after the model had gone. It was in this way that he painted the beautiful and discerning portrait of Monsieur Ambroise Vollard. During many of the sittings, it appears, Cézanne applied only a few brushstrokes, but he constantly devoured the sitter with his eyes. On the day following such a sitting Monsieur Vollard would find the picture advanced by three or four hours of the most intense labour. The portrait of my father was also painted in the same fashion. I emphasize this because it has been claimed frequently that Cézanne was unable to paint, and indeed had never painted, without a model in front of him. He had a memory for colours and lines such as perhaps nobody else has ever had; it was only by a conscious effort, *à la* Flaubert, ' the contemplation of the hum blest realities,' that he forced himself with terrific will-power to the direct copying which restricted his poetic gifts."

Vollard, it may be noted in passing, does not mention that Cézanne ever worked on his portrait between sittings; but I think we may accept Gasquet's statement that he did occasionally, at any rate, paint from memory. This however only modifies, without actually invalidating, our assumption that Cézanne was dependent on his model. He could, and did, work on his portraits in the absence of the sitter; but only to a very limited extent. Unless he had the opportunity of renewing his impressions by frequent and protracted periods of intense observation, he was lost. Gasquet's suggestion that Cézanne consciously restricted himself

to the direct contemplation of nature, when he might have given free rein to his imagination, is not supported by any evidence. On the contrary, all that we know about Cézanne indicates that the close observation — and except in rare instances the physical presence — of natural objects was indispensable to him.

Only in one group of pictures, the long series of nude studies known collectively as *Bathers,* did he habitually work without having an actual model before him. This does not mean however that Cézanne miraculously freed himself from his usual dependence on a model when he painted these nudes; he merely substituted, at second hand, drawings he had made in life class years before or illustrations taken from old books and magazines. Occasionally he used a small articulated lay figure, when he wanted a pose that he could not find among his sketches and reproductions. But all of these were poor substitutes for the living model.

Some of the *Bathers* are very beautiful — though never sentimental or pretty — studies of the human form; but many of them are awkwardly, even grotesquely, posed, and on the whole they are the least " realized " of Cézanne's works. Compared with his landscapes, portraits, and still lifes, his nudes must be rated as incomplete, only partially successful attempts to solve a problem for which the means at his disposal were inadequate. The difficulty lay not in the conception but in the limitations imposed by temperament and circumstances. His knowledge of anatomy was too slight to enable him to paint figures without models; and it was impossible to obtain such models for his *Bathers.* The practical difficulties were insuperable, as the painter himself realized. In an article contributed to the *Mercure de France* for June 1, 1921, Émile Bernard reports the following explanation from Cézanne's own lips:

" As you know, I have often made sketches of male and female bathers which I should have liked to execute on a large scale and from nature; the lack of models has forced me to limit myself to haphazard glances. There were obstacles in my way; for example,

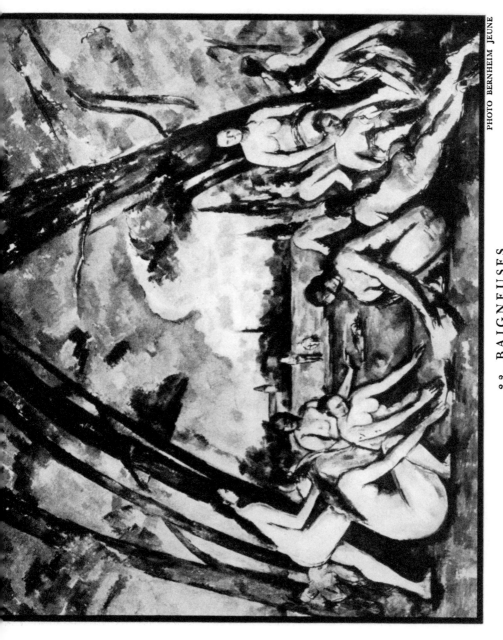

33. BAIGNEUSES

ABOUT 1900. PELLERIN COLLECTION

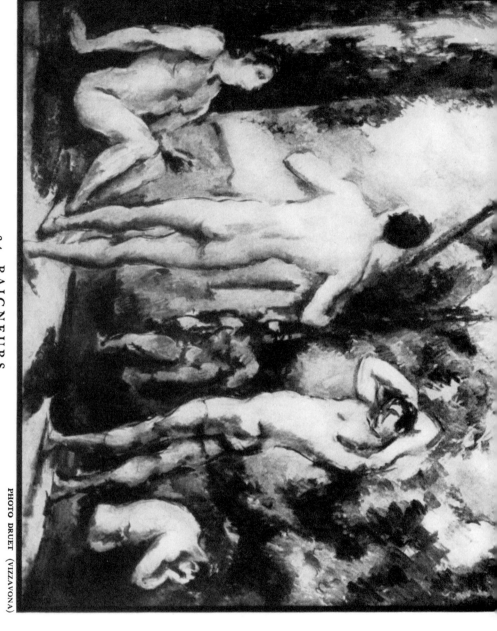

34. BAIGNEURS

ABOUT 1888. COLLECTION OF DR OTTO KREBS, WEIMAR

PHOTO DRUET (VIZZAVONA)

how to find the proper setting for my picture, a setting which would not differ much from the one I visualized in my mind; how to gather together the necessary number of people; how to find men and women willing to undress and remain motionless in the positions I determined. Moreover, there was the difficulty of carrying about a large canvas, and the thousand difficulties of favourable or unfavourable weather, of a suitable spot in which to place oneself, of the supplies necessary for the execution of a work of considerable dimensions. So I was obliged to give up my project of doing over Poussin entirely from nature, and not made up piecemeal from notes, drawings, and fragments of studies; in short, of painting a living Poussin in the open air, with colour and light, instead of one of those works created in a studio, where everything has the brown colouring of feeble daylight without reflections from the sky."

Yet the desire to " do over Poussin from nature " remained one of Cézanne's lifelong ambitions, amounting at times almost to an obsession. He returned to his nudes again and again, making the best of his schoolboy drawings, old engravings, and the occasional hasty notes he was able to make of soldiers bathing in the stream near Aix, in place of the living models he wanted and so desperately needed. Cézanne's estimate of the difficulties involved in the posing of nude models out of doors under the desired conditions may sound a trifle exaggerated, but as a matter of fact the obstacles were real enough. It must be remembered that his extraordinarily slow method of painting would have required the constant attendance of a group of models for weeks or even months for the execution of a single picture. Even if such models had been available — which they were not — and disregarding the element of cost (which would have been considerable, though perhaps not beyond Cézanne's means during the last two decades of his life) , it is most unlikely that the puritanical, provincial inhabitants of Aix would have tolerated the existence in the neighbourhood of what would have amounted to a small nudist

colony. And Cézanne himself was far too timid, and in many ways too bourgeois and conventional, to risk the scandal that would have been the inevitable outcome of such a venture.

Moreover, Cézanne was terrified of models, professional or otherwise, and morbidly suspicious of the *grappins* with which, he was convinced, they were trying to hook him. He was especially afraid of women; his frantic — and in most cases entirely unnecessary — efforts to escape their clutches have furnished material for a number of amusing anecdotes. Émile Bernard tells us that one day Cézanne's gardener, accidentally meeting the painter near his studio, presented his two young daughters. The embarrassed Cézanne tried to slip away and take refuge in his house, but to his horror found that he had forgotten the key. Trembling, he ordered the gardener to break in the door with an ax; and once safely inside he bolted himself in and remained there the rest of the day. And Maxime Conil, Cézanne's brother-in-law, contributes another story to illustrate the painter's excessive timidity. Cézanne had engaged a professional model to pose for him in his Paris studio; being a lady of considerable experience, she proceeded to undress before him without the slightest trace of self-consciousness, but as each garment was discarded, Cézanne grew more and more uneasy. Finally the model, now quite naked, sat beside him and said: "Monsieur, you seem to be upset," which only added to Cézanne's confusion. He made an attempt to pull himself together and start his picture, but it was no use; in a little while he dropped his brushes, hurried the woman into her clothes, and dismissed her with instructions not to return.

Cézanne's own comment on any such episode as the above was generally: "*C'est effrayant, la vie!*" And life was frightful to him, though nearly always it was the chimeras generated by his own imagination that made it so.

It has been suggested that Cézanne's shyness with women was due not so much to fear of them as to fear of himself: in other words, that his passions were so easily aroused that he could not trust himself in the presence of women and therefore kept away

316

from them in order to avoid temptation. But there is little evidence to support this view. There seems to be no really good reason why Cézanne should have refrained from indulging his appetites if he found them so overpowering; casual intercourse between an artist and his professional models was nothing unusual. That he was undoubtedly susceptible to feminine charms on occasion is proved by the violence of his shortlived love-affair in the summer of 1885, about which we know so little. But this episode is the only one of the kind on record, and there are no real grounds for the presumption that Cézanne was a man of such riotous passions that he could not control them and so forced himself to renounce the society of women altogether. Such an explanation seems not only exceedingly far-fetched, but inconsistent with what we know of his essentially austere nature. It is much easier to believe that his pronounced and at times ludicrous misogyny had its roots in the conviction that all social relationships were potential *grappins* that threatened his peace of mind, and indirectly his painting. For he was not only a misogynist, but a misanthropist as well, though he was inclined to distrust women more immoderately than men.

Cézanne's antisocial attitude — which was not a sweeping hatred of mankind, but the outgrowth of his intense desire for solitude and his exaggerated fear of entanglements — had a very direct influence on his painting, especially on his portraits. Professional models upset him, and he distrusted strangers in general. His choice of sitters, therefore, was restricted to a very small group: members of his own family, with himself at the head of the list; half a dozen friends like Choquet, Valabrègue, Geffroy, Vollard, and the Gasquets, father and son; and a few local types among the inhabitants of Aix — poor and unsophisticated people like the gardener Vallier, the men who posed for the various versions of *Les Joueurs de Cartes,* and the old woman he painted as *La Femme au Chapelet;* none of whom could be suspected even by the wary and sensitive Cézanne of trying to involve him in any way.

317

The number of his models was also limited by his uncompromising insistence on complete immobility during interminable and countless sittings. Few people were willing to undergo such an ordeal even once; only two had the patience and the stamina to sit for more than three or four portraits at most: Cézanne himself and his wife. And even long-suffering Madame Cézanne seems to have weakened in the end: according to Rivière's list, no portrait of her was executed later than 1891.

The beginning of Cézanne's departure from orthodox Impressionism coincides roughly with his withdrawal from participation in the Impressionist exhibitions after the show of 1877. Of course the process was gradual and progressive: one phase slipped almost imperceptibly into the next, and there is no one point at which one can say that Cézanne definitely turned his back on Impressionism. Indeed, in some respects he remained an Impressionist until the end. He continued to paint landscapes out of doors, and he maintained the high key and intensity of colouring acquired from his association with Pissarro and Monet, though he expanded their relatively restricted palettes enormously. But by 1885 it was evident that he was no longer to be classed among the true Impressionists. His interest in solidity rather than surface reflection, and, above all, his preoccupation with the laws of abstract composition, set him definitely apart.

Of approximately two hundred pictures ascribed by Rivière to the years 1877–1889 inclusive (and the list is by no means complete, especially of the water-colours, only fifteen of which are mentioned), by far the largest group — about ninety — is made up of landscapes. Portraits come next, to the number of forty; there are about thirty still lifes; some twenty-five studies of *Bathers* and other nudes; eight or nine pictures which might be called more or less literary; and three copies — or, better, interpretations — of paintings by Delacroix.

During 1877 and again from 1879 to 1881 Cézanne was in the north, and most of his landscapes of those years depict scenes in the environs of Paris, at Auvers, Pontoise, and Melun. The

greater part of 1878 was spent at L'Estaque, but it was a troubled year and produced few pictures, among them only three or four landscapes. From 1882 to 1887 nearly all of the landscapes were painted in Provence: some at L'Estaque, some at Gardanne, and a great many in the wild and unkempt garden of the Jas de Bouffan, where he painted the trees, the pools, the surrounding fields, and the square yellow house and outbuildings, from all directions and at different times of day.

About 1883 another local subject began to attract Cézanne: the Montagne Sainte-Victoire, a rugged limestone mountain something over three thousand feet high that dominates the broken country to the east of Aix. In reality the Sainte-Victoire is not a mountain at all, but a long ridge running approximately east and west; but from the neighbourhood of Aix — that is, from the position which Cézanne almost invariably chose for his easel — the great massif appears foreshortened into the shape of a single peak. During the last twenty years of his life Cézanne returned to this subject over and over again. He painted it innumerable times on canvases of all dimensions and proportions, as well as in water-colour, varying the compositions and frequently introducing trees and houses into the foregrounds.

The portraits of these middle years include, in addition to a number of studies of himself and Madame Cézanne, those of various members of the painter's family: his sister Marie with a scarf over her head (Plate 14), another portrait of his father, his son at the age of thirteen in a bowler hat (Plate 18), as well as some idealized studies of the same young man in Harlequin costume; a few friends — Choquet, Guillaumin, Valabrègue, and the wife and son of Guillaume the bootmaker, the entertainment of whose guests in Cézanne's apartment had plunged the painter into hot water with his father in 1878.

All of the canvases of this period illustrate Cézanne's transition from the thick, trowelled technique of the early years to the thin glazes characteristic of his later work. The still lifes in particular show this development most clearly. There is, for example, a

marked difference in this respect between the flower pieces in the Camondo collection in the Louvre, *Dahlias dans un Pot de Delft* and *Iris et Pois de Senteur* — both painted probably in the late seventies or very early eighties — and the *Nature Morte aux Oignons* of the Pellerin bequest, now also in the Louvre, which was executed about 1887.

The nudes, and the difficulties that beset Cézanne when he painted them, have already been discussed at some length. Of the few pictures belonging to this epoch which retain any traces of his early preoccupation with so-called " literary " subjects, the majority are merely new versions of old conceptions which had haunted him in former years and which had not yet quite lost their hold on him: *La Tentation de Saint-Antoine, Léda au Cygne, Les Brigands, La Lutte, La Belle Impéria, Le Jugement de Pâris,* etc. But such subjects were now of small and ever decreasing importance to Cézanne; while to us they are the driest, the least stimulating of all his works.

EXCURSIONS: 1886–1896

AFTER the cessation of the correspondence with Zola in 1886 the documentary record of Cézanne's life becomes much scantier. During his last twenty years his general movements are known, but owing to the relative scarcity of letters there are many gaps, and it is not always possible to pin down the events of this closing period to exact dates.

We know that in the summer of 1886 Cézanne visited Choquet at Hattenville in Normandy, where he painted the portrait of his friend " against a background of green foliage " which Gasquet mistakenly ascribes to the previous year. But 1887 is a complete blank; it is probable that Cézanne spent the greater part — perhaps all — of it in the vicinity of Aix, but no record of those months remains.

In 1888 Cézanne returned to Paris, where he took lodgings in a gloomy old house on the Quai d'Anjou on the north side of the Île Saint-Louis. He had never lived on the island before, and it is a curious coincidence that he should have chosen to install himself in the very spot selected by Zola several years earlier as the residence of Claude Lantier in *L'Œuvre*. Cézanne remained on the Quai d'Anjou for two years, interrupting his sojourn frequently to go off on solitary painting expeditions to Chantilly

or along the banks of the Marne. Probably he also returned to Provence once or twice during this period, but we do not know when or for how long.

Cézanne had long ago abandoned his fruitless attempts to storm the " *Salon de Bouguereau.*" The picture that had been exhibited there — almost furtively as it were — in 1882 had fallen quite flat, and the one at the Exposition of 1889 had fared no better. He had become resigned to obscurity and expected no recognition from any source. The cordial invitation to exhibit in Brussels that reached him late in 1889 must therefore have been something of a bombshell to Cézanne; so much so that he was shocked into accepting it.

In 1884 an independent group of more or less radical Belgian painters had organized themselves into a society of twenty members under the name of Les Vingt — generally written Les XX. For the next ten years the group held annual exhibitions in each of which twenty outside artists, including a number from other countries, were invited to take part. The society survived until 1894, when, having accomplished its mission, it was voluntarily disbanded, to be succeeded by La Libre Esthétique, similar to Les XX in ideals, but different in organization. La Libre Esthétique in turn was brought to an end by the outbreak of war in 1914.

The list of foreigners who had exhibited under the auspices of Les XX previous to 1890 — the year of Cézanne's participation — included Braquemond, Caillebotte, Cazin, Chase, Fantin-Latour, Forain, Gauguin, Guillaumin, Monet, Morisot, Pissarro, Redon, Renoir, Rodin, Sargent, Seurat, Sickert, Signac, Toulouse-Lautrec, and Whistler; while among Cézanne's co-exhibitors in 1890 were Segantini, Sisley, and Van Gogh.

Cézanne's reply to the invitation of Octave Maus, secretary of Les XX, is reproduced in *Trente Ans de Lutte pour l'Art* by Madeleine Octave Maus:

"Paris, 27 November 1889.

" Monsieur,

" In acknowledgment of your flattering letter, I thank you and accept with pleasure your kind invitation.

" May I be allowed, however, to deny the accusation of disdain with which you charge me in connection with my refusal to take part in exhibitions of painting?

" I must explain that having achieved only negative results from the numerous studies to which I have devoted myself, and dreading criticisms that are only too well justified, I had resolved to work in silence until such time as I should feel myself capable of defending theoretically the result of my experiments.

" But in view of the pleasure of finding myself in such good company, I do not hesitate to modify my resolution and beg you to accept, Monsieur, my thanks and fraternal greetings.

Paul Cézanne."

Cézanne sent three pictures to Brussels: a study of *Bathers,* the *Chaumière à Auvers-sur-Oise* belonging to Monsieur Choquet, and another landscape. The exhibition opened at the Musée Moderne on January 18, 1890, and the results, as far as Cézanne was concerned, were disappointing. Madame Maus tells us that his work " was scarcely noticed." This was bad enough, but the offerings of some of the other foreign painters caused an uproar that nearly disrupted the society. One of the Belgian members, Henry de Groux, threatened to withdraw his pictures rather than exhibit in the same room as Van Gogh; and at a banquet given by Les XX on the day of the *vernissage,* he so far forgot himself as to hurl insults at Signac and Toulouse-Lautrec, two of the guests of honour. This was too much for the other members; de Groux was expelled at once and peace was restored.

Meanwhile Cézanne continued to shuttle back and forth between Paris and Provence. He was more restless than ever and seemed unable to settle down in one place for more than a few

months at a time. While in the south, he wandered about from Aix to Gardanne, from Gardanne to L'Estaque, from L'Estaque back to Aix; when he went to Paris, he spent most of his time in the country, in various hamlets in the forests of Fontainebleau and Chantilly, in lonely villages on the banks of the Seine, the Marne, and the Oise. Even in Paris itself he had no fixed abode. After he left the Quai d'Anjou he lived for a while on the avenue d'Orléans; later on, in 1894, he rented a small apartment in the rue des Lions, very near the lodgings he had occupied in the rue Beautreillis some thirty years before. Between 1896 and 1900 he lived in a succession of studios on the western edge of Montmartre: in the rue des Dames, the rue Hégésippe-Moreau, and the rue Ballu. Moving was a simple matter for Cézanne. He travelled about with few possessions except his painting apparatus; he wanted little furniture and less clothing, and as long as he had a suitable studio with proper light, in a quiet neighbourhood — for noises caused him acute suffering — he was supremely indifferent to his surroundings. Perhaps Madame Cézanne might have preferred a more settled existence, but at least she was used to being uprooted by this time: her life with Cézanne had always been an unending succession of moves.

In 1891 Cézanne ventured a little farther afield. He went to Switzerland with his wife and son and for three months travelled through the western cantons, visiting Berne, Fribourg, Vevey, Lausanne, and Geneva. Most of the time, however, was passed at Neuchâtel. Apparently he did not find the scenery much to his taste, at any rate as a subject for landscapes; for there is no surviving pictorial record of this trip. Rivière mentions two unfinished canvases, *Bords du Lac de Neuchâtel* and *Vallée de l'Areuse,* which Cézanne left behind at the Hôtel du Soleil at Neuchâtel and which were afterwards found and painted over by another painter.

This was Cézanne's first — and last — excursion beyond the frontiers of France. Gasquet has written, mistakenly, that he visited Holland and Belgium. Élie Faure — perhaps relying on

Gasquet — also says that Cézanne " made short trips in Belgium, in Holland." Neither, however, gives any dates or details concerning these hypothetical excursions. There is no reference to any such expeditions in Cézanne's surviving letters, and the painter's son has assured me positively that his father never travelled outside of France except on the one occasion of his visit to Switzerland. Léo Larguier, in his book *Le Dimanche avec Paul Cézanne,* also states specifically that " he visited neither Holland, Belgium, nor Italy."

I think that a possible explanation of the mistaken belief that Cézanne travelled in Belgium may be nothing more than a typographical error. In various catalogues and reviews of exhibitions in which Cézanne has participated, pictures entitled *Paysage à Auvers* (meaning of course Auvers-sur-Oise) appear as *Paysage à Anvers;* and as Anvers is the French name for Antwerp, the misprint would naturally lead one to believe that Cézanne had visited Belgium. This is put forward merely as a suggestion, but it is at least a plausible one.

On this expedition to Switzerland in 1891 a curious incident occurred. Walking with his wife and son in the streets of Fribourg, Cézanne witnessed by chance an anti-Catholic demonstration that offended him deeply, for he was sincerely religious. He promptly disappeared, without a word of warning; Madame Cézanne and young Paul, though accustomed to his vagaries, grew somewhat uneasy when he failed to return to the hotel that night. They looked for him in every corner of the town, but the search revealed no trace of the vanished painter. At last a letter from Cézanne reached them from Geneva, and there they found him four days later, completely recovered from his momentary agitation.

Either on the way to Switzerland or on the return journey Cézanne stopped for a short time in the neighbourhood of Besançon, where he painted three landscapes: *Les Bords de l'Ognon, Sous-Bois,* and a *Paysage à Pin-l'Émagny.*

About 1890 Cézanne's health, hitherto robust, began to fail.

He suffered from diabetes, which lowered his vitality and sometimes caused him acute discomfort, though he never allowed his illness to interfere with the long hours of work to which he had accustomed himself. He was at his easel at five or six in the morning and remained there, with only a break for an early luncheon, until sundown. He was obliged to follow a diet, though not a very rigorous one; he had always been abstemious, and the mild régime imposed by his doctors troubled him very little. In 1896 he went to Vichy for a short cure. He remained there for the month of June, resting, drinking the waters, and painting a little, and then proceeded with his family to Talloires on the Lake of Annecy. Again, as in Switzerland five years before, the mountain scenery appealed to him less than his own Provençal countryside; but this time he did succeed in bringing back a number of landscapes, including the exquisite *Lac d'Annecy* (Plate 35) which is now in the Courtauld Institute in London.

From Talloires he wrote to Joachim Gasquet:

" This is a temperate zone. The height of the surrounding hills is considerable. The lake, which is narrowed here between two promontories, seems to lend itself to the drawing exercises of young Misses. It is always nature, of course, but rather as we have been taught to see it in the albums of young lady tourists."

In other words, a picture-postcard landscape — than which nothing could have been less inspiring to Cézanne.

However, there were compensations, according to a letter to his old friend Philippe Solari:

" Talloires 23 July 1896

" My dear Solari,

" When I was in Aix, I felt that I should be better off somewhere else; now that I am here, I wish I were in Aix. — Life is beginning to be sepulchrally monotonous for me. — I was at Aix three weeks ago, I saw *le père* Gasquet, his son had gone to

326

35. LE LAC D'ANNECY

1896. COURTAULD INSTITUTE, LONDON

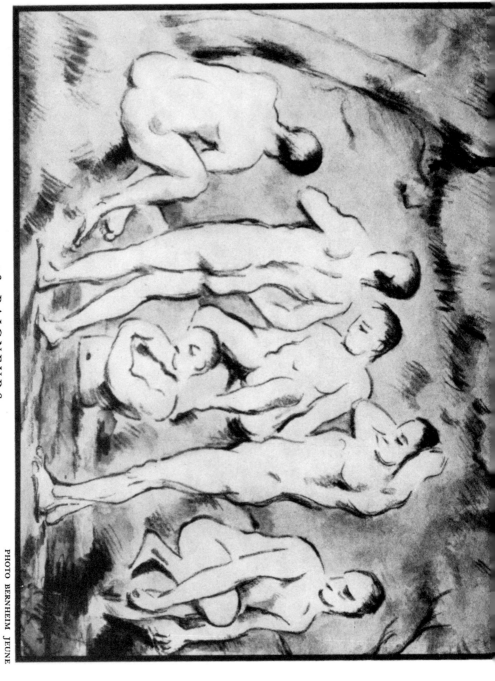

36. BAIGNEURS

ABOUT 1899. COLOURED LITHOGRAPH

Nîmes. In June I did a month of Vichy, the food is good there. Here the food is not bad either. — I am stopping at the Hôtel de l'Abbaye. — What a superb ancient road. — An approach 5 metres wide, a splendid doorway, an interior court with columns supporting a gallery on all sides, an enormous staircase, rooms opening off an immense corridor, all very monastic. . . .

" To keep myself busy I am doing some painting, it is not very amusing, but the lake is all right with great hills all around it, two thousand metres high they tell me; it does not compare to our own country, though it is well enough in its way. — But when one has been born down there, it's all up, nothing else is worth much. . . . And to think I am going back to Paris at the end of August. When shall I see you again? If your son should pass through Annecy on his way back, let me know."

The son was Émile Solari, who not only has been kind enough to allow me to quote from Cézanne's letters to his father and himself — none of which have hitherto been published — but who has supplied me with valuable notes and reminiscences of his own. Commenting on the above letter, Monsieur Solari writes that it " should not deceive the reader by its somewhat epicurean character. Cézanne was a moderate eater and drinker, and while occasionally, when he remembered his youthful days, he would indulge in a few glasses of wine to wash down some good regional dish, such a thing was exceptional. Cézanne lived only for his art."

Émile Solari's notes contain some further interesting personal recollections of Cézanne in his fifties. Under date of November 8, 1895, he writes:

" Yesterday we went on an excursion — my father, Cézanne, Emperaire, and I. We visited ' Bibemus,' a country-house whose outbuildings are marvellous. Old stone quarries have left strange caverns in the vicinity. Cézanne, tall, with white hair, and Emperaire, small and deformed, made a weird combination. One might

have imagined a dwarf Mephisto in the company of an aged Faust. Farther on, after having traversed a considerable stretch of ground planted with small trees, we found ourselves suddenly face to face with an unforgettable landscape with Sainte-Victoire in the background, and on the right the receding planes of Montaiguet and the Marseilles hills. It was huge and at the same time intimate. Down below, the dam of the Zola canal with its greenish waters. We lunched at Saint-Marc under a fig tree on provisions obtained from a road-menders' canteen. That night we dined at Tholonet after a walk over the stony hillsides. We returned in high spirits, marred only by Emperaire's tumble; he was a little drunk and bruised himself painfully. We brought him home."

During the course of that same autumn Cézanne and the two Solaris — this time Achille Emperaire with his twisted back and his proneness to fall down at inconvenient moments was left behind — started off on a more ambitious excursion. This was the ascent of the Mont Sainte-Victoire itself, which, writes Émile Solari, " though not dangerous, is rather fatiguing and requires three hours." Both Cézanne and Philippe Solari had climbed the mountain many times in their youth, but Cézanne was now almost fifty-seven — and diabetic to boot — and Solari only a year younger. Nevertheless both reached the summit. The party had spent the previous night in the village of Vauvenargues near the base of the mountain; the room in which they slept was adorned with clusters of smoked hams hung from the rafters. They started up the mountain at daybreak, and Émile Solari tells us that " Cézanne appeared to be surprised and almost chagrined when I innocently pointed out that the green bushes along the path looked blue in the morning light. ' The rascal! ' he said; ' he notices at a glance, when he's only twenty, what it has taken me thirty years to discover! ' " When they reached the top, " we had lunch in the ruins of the chapel of Calmaldules, the site of an episode in Walter Scott's *Charles le Téméraire* [*Anne of Geierstein*]. We did not go down into the Gouffre du Garagaï (a bottomless pit near the

summit) , which is also mentioned in that novel. But Cézanne and my father spoke of it and recalled the memories of their youth. There was a terrific wind blowing up there that day."

On the way down, Cézanne tried to prove to himself that he was as young and agile as ever by climbing a small pine tree by the wayside. But the long walk had tired him, and the attempt was not very successful. " And yet, Philippe, do you remember? " he said. " We used to be able to do that so easily! "

THE CAILLEBOTTE BEQUEST: 1894

ALTHOUGH the position of the Impressionist painters (not including Cézanne) was now firmly established, they had not as yet received official recognition by having their pictures permanently placed in any of the French public galleries. The bureaucracy still withheld its approval; and when in 1894 Gustave Caillebotte bequeathed his collection of contemporary paintings to the State, the officials in charge of the government museums were faced with a perplexing problem.

Caillebotte was a mediocre painter, but an enthusiastic and at the same time discriminating collector. He had been introduced to the little group of Impressionists by Degas about the time of their first exhibition in 1874, and although his sombre and academic painting added little to the slowly growing prestige of the young insurgents, his engaging personality soon won him their affection and esteem. He was a man of considerable wealth and so was able not only to help his fellow-artists by buying their pictures and subscribing generously to their exhibition funds, but to eke out their meagre earnings by means of occasional loans and even gifts.

Renoir and Monet in particular were Caillebotte's close friends. He was less intimate with Cézanne, but the following let-

ter of condolence elicited by the death of Caillebotte's mother indicates that Cézanne too thought highly of him:

" L'Estaque, 13 November 1878.

" My dear Colleague,

" When you learn that I am very far from Paris, you will forgive me for my neglect of the duty that is laid on me by your recent bereavement. It is about nine months since I left Paris, and your letter reached me at the other end of France after long detours and a long lapse of time.

" In your affliction please be good enough to accept the expression of my gratitude for the great services you have rendered our cause, and the assurance that I share your sorrow, though I did not know your mother, but understanding well the painful loss caused by the disappearance of the people we love. My dear Caillebotte, I send you affectionate greetings and beg you to devote your time and your energies to painting, as the surest way to ameliorate your sadness.

" Remember me to your father, and keep up your courage if you can.

Paul Cézanne "

Caillebotte himself died on February 21, 1894, at the age of forty-five. His will, dated November 3, 1876, was found to contain the following paragraphs:

" I bequeath to the State the pictures of which I die possessed; but, as I want this gift to be accepted, and accepted in such a way that these pictures will be placed neither in a storehouse nor in a provincial museum, but directly in the Luxembourg and later on in the Louvre, it is necessary that a certain time be allowed to elapse before this clause is executed; that is, until the public is ready — I do not say to understand — but to acknowledge this kind of painting. This period will be at most twenty years; in the interim my brother Martial, or in his default another of my heirs, will keep them.

" I beg Renoir to act as my testamentary executor and to accept a picture which he will choose himself; my heirs will insist that he select an important one."

The above clauses were confirmed when the will was revised in 1883.

Caillebotte was a good prophet when he estimated in 1876 that twenty years, more or less, would see Impressionism accepted by the public. By the time he died, some seventeen years later, the battle was won; the works of the Impressionist leaders were admired, sought after, and purchased (though often at low prices) by the most respectable private collectors.

The collection which Caillebotte left to the State consisted of three Manets, sixteen Monets, nine Sisleys, eighteen Pissarros, eight Renoirs, two Cézannes, seven Degas (all small pastels), and two Millets (a water-colour and a drawing) : sixty-five pictures in all.

But even now, although the tide had turned and the Impressionists were generally hailed as masters, the proposal to install some sixty-five of their works in the sacred Luxembourg aroused a storm of protest from the die-hards of the old school. The *Journal des Artistes* published a series of interviews with well-known painters — most of them violently reactionary — of which the following explosive extract from a statement by the aged Jean Léon Gérôme in the issue of April 8, 1894, is typical:

" Caillebotte? Didn't he use to paint himself? — I know nothing about it — I don't know these gentlemen, and I know nothing about this bequest except the name — there are paintings by M. Manet among them, aren't there? — and by M. Pissarro and others? — I repeat, only great moral depravity could bring the State to accept such rubbish — they must have foolishness at any price; some paint like this, others like that, in little dots, in triangles — how should I know? I tell you they're all anarchists — and madmen! "

This intolerant and unenlightened attitude was perhaps to have been expected among the neo-classic painters whom the Impressionists were beginning to replace in public favour, and had it been confined to those circles the opposition would have done little harm. Unfortunately most of the State officials concerned were at least partly in sympathy with this reactionary point of view. Both Monsieur Roujon, Director of the Beaux-Arts, and Monsieur Léonce Bénédite, curator of the Luxembourg, were definitely on the conservative side. They lacked the authority — and perhaps the courage — to flout public opinion openly and refuse the bequest outright; but they proceeded at once to make difficulties.

The correspondence between the State officials on the one hand and the heirs and executors of the Caillebotte estate on the other is preserved in the Archives of the Louvre (*P. 8, 1896, 25 février*) . As far as I know none of it has been published before. It is all couched in very polite and diplomatic language; but it is not difficult, reading between the formal lines, to discover a determination on the part of Roujon and Bénédite to admit as little as possible of the collection to the Luxembourg.

Monsieur Roujon fired the first shot in a letter dated May 11, 1894. He pointed out that lack of space in the Luxembourg — a palpable subterfuge — made it impossible to hang such a large collection at once, and suggested that a selected portion of the pictures be accepted and placed in the gallery, the remainder to be held temporarily by the heirs until such time as space could be found for them. Renoir and Monsieur Martial Caillebotte agreed to this compromise.

Monsieur Bénédite then took a hand in the negotiations. On June 22 he wrote a memorandum objecting to the above arrangement on the grounds that the terms of the will required the acceptance or rejection of the bequest *in toto*. He proposed as an alternative solution that twenty-five or thirty of the sixty-five pictures, the selection to include some of the work of each of the painters represented, should be hung in the Luxembourg im-

333

mediately; the balance to be sent to the State museums of Fontainebleau or Compiègne, "which cannot be considered either storehouses or provincial museums." To this suggestion Martial Caillebotte, Renoir, and Monet, still in a conciliatory mood, also agreed.

But in December Monsieur Caillebotte changed his mind and refused to accept these conditions, which were certainly a violation of the spirit as well as the letter of his brother's will. Monsieur Bénédite then offered another and still more tortuous solution. He proposed that Martial Caillebotte should formally reject the State's compromise; the collection would then automatically revert to the heirs, who would then donate to the Luxembourg, in memory of Gustave Caillebotte, such paintings as the committee chose to accept, while the rest were to belong permanently and irrevocably to the Caillebotte family.

Negotiations dragged on for six months longer. Finally, in May or June 1895, an agreement was reached. Disregarding the terms of the will, the heirs consented to allow the legacy to be divided. The State selected forty of the pictures for the Luxembourg and relinquished all claim to the remaining twenty-five, which were restored to the heirs. The accepted pictures were turned over to the Luxembourg in 1896. In 1928 they were transferred to a special room in the Louvre.

Between 1896 and 1908 Monsieur Martial Caillebotte, animated by a most commendable public spirit and an earnest desire to carry out the original provisions of his brother's testament, made repeated efforts to persuade the Luxembourg to admit the twenty-five rejected canvases. But his overtures met with an obstinate refusal, and after twelve years of futile struggle his patience was exhausted. He exacted a promise from his wife and daughter that after his death they would have no dealings with the State museums. That promise has been kept; and although within recent years the museum officials have undergone a complete change of personnel, and with it a change of heart with

334

respect to the Impressionists, the rejected portion of the Caille-botte bequest remains in private hands.

In connection with the exclusion of part of the Caillebotte col-lection, there is some doubt as to the status of Cézanne's pictures. Vollard and Coquiot both claim that among the rejected works were three pictures by Cézanne: a *Baigneurs,* a *Bouquet de Fleurs,* and a *Scène Champêtre.* An article by Tabarant in the *Bulletin de la Vie Artistique* for August 1, 1921 places only the first two of these canvases on the list of rejections; the *Scène Champêtre* is not included. But the correspondence in the Ar-chives of the Louvre conflicts with both statements. The Caille-botte dossier contains several tentative partitions of the bequest as well as the division finally agreed upon; and none of these lists mentions any rejected Cézannes at all. The following is a com-plete inventory of the Caillebotte bequest as it was finally divided:

	ACCEPTED	REJECTED	TOTAL
Manet	2	1	3
Monet	8	8	16
Cézanne	2	0	2
Renoir	6	2	8
Degas	7	0	7
Sisley	6	3	9
Pissarro	7	11	18
Millet	2	0	2
	40	25	65

Thus it will be seen that according to the official lists there were only two paintings by Cézanne under consideration, and that both of these were among the forty accepted for the Luxem-bourg. The discrepancy between the committee's lists on the one hand and the statements of the abovementioned commentators on the other can be explained by either of two possible hypotheses.

There can be little doubt that the three " rejected " Cézannes spoken of by Vollard and Coquiot did form part of the Caille-

botte collection; but it is by no means certain that the Caillebotte *collection* and the Caillebotte *bequest* were necessarily identical. There appear to have been pictures in the collection which were not included in the bequest: pictures which were never offered to the State at all and which therefore did not come up for consideration. This suggestion is supported by an entry in the minutes of a committee meeting held on March 20, 1894, containing a report of the preliminary inspection of the proposed bequest. In this report mention is made of " an unfinished picture by Cézanne which is not offered by the heirs "; and if there was one Cézanne in the collection which was not left to the State, there may well have been others.

The alternative theory assumes that the two or three Cézannes in question were included in the original bequest, but were either rejected or withdrawn at the very beginning of the negotiations, before the first tentative list was drawn up. Unfortunately it appears to be impossible to settle the problem definitely at this late date. All of the older members of the Caillebotte family are now dead, and Monsieur Chardeau, the son-in-law of Martial Caillebotte and present owner of the rejected remnant of the collection, is unable to throw any light on the events of forty years ago.

Tabarant's article contains an interview with Léonce Bénédite in which the curator of the Luxembourg makes the rather surprising assertion that the committee was originally in favour of accepting the bequest as a whole, and that the suggestion of a partition came from the painters themselves, in particular Renoir and Monet. According to Monsieur Bénédite, Monet said that Caillebotte had purchased many of the pictures merely to encourage and assist the struggling artists, and that he had not always shown proper discrimination in making his selections. The painters felt that only their best works should represent them in the Luxembourg, and that all others should be withdrawn; Monet, for example, suggested that two of his own canvases, *Gare Saint-Lazare* and *Après le Déjeuner,* be discarded.

This interview took place some twenty-seven years after the

336

death of Gustave Caillebotte. On the face of it Monsieur Béné-
dite's belated attempt to shift the responsibility for the rejection
of part of the bequest to the shoulders of Monet and his colleagues
is not very convincing. It is hard to believe that Monet actually
advised the rejection of eight out of sixteen of his own pictures,
or that Pissarro considered eleven out of eighteen of his works
unworthy of a place in the Luxembourg. Moreover, if Monet had
modestly proposed the withdrawal of some of his own canvases,
he would surely have been permitted to separate the sheep from
the goats himself; yet the two pictures mentioned specifically by
Léonce Bénédite were not, in fact, among the eight rejected
Monets.

The committee's opinion of Cézanne's work is indicated in a
memorandum by Bénédite dated July 27, 1895 and containing an
estimate of the value of the forty accepted paintings. Compared
with the present values of the pictures, of course, all of the figures
are absurdly low; but with the exception of the two very small
and relatively unimportant sketches by Millet, Cézanne's pictures
are rated a good deal lower than any of the others:

	WORKS ACCEPTED	TOTAL VALUE	AVERAGE VALUE
Manet	2	13,000 francs	6,500 francs
Monet	8	46,000	5,750
Cézanne	2	1,500	750
Renoir	6	30,000	5,000
Degas	7	28,500	4,070
Sisley	6	8,000	1,333
Pissarro	7	13,000	1,857
Millet	2	1,000	500
	40	141,000 francs	

In the interview quoted by Monsieur Tabarant, Bénédite re-
fers to Monsieur Roujon, Director of the Beaux-Arts, as the most
reactionary member of the committee. Roujon's disapproval of
Cézanne and all his works is illustrated by his reception of Octave
Mirbeau in 1902. Cézanne, who in spite of all rebuffs never quite

lost his curious, almost perverse, respect for official recognition, had expressed a desire for the Cross of the Legion of Honour. Mirbeau, who had influence and was a sincere admirer of Cézanne's work, good-naturedly if a little doubtfully approached Roujon on the painter's behalf. Vollard gives an account of the meeting:

" Mirbeau had no sooner said that he was pleading the cause of a certain painter for the Cross than the Director, presuming that his visitor had the judgment not to demand the impossible, reached for the drawer which contained the ribbons committed to his keeping. But the name of Cézanne made him jump. ' Ah! Monsieur Mirbeau, while I am Director of the Beaux-Arts I must follow the taste of the public and not try to anticipate it! Monet if you wish. Monet doesn't want it? Let us say Sisley, then. What, he's dead? How about Pissarro? ' Then, misinterpreting Monsieur Mirbeau's silence: ' Is he dead too? Well, then, choose whomever you wish. I don't care who it is, as long as you do me the favour of not talking about Cézanne again! ' "

AMBROISE VOLLARD

In 1895 Cézanne's work, and even his name, were practically unknown to the public. With the exception of the *Portrait de Monsieur L. A—* by " a pupil of Monsieur Guillemet " in the Salon of 1882, *La Maison du Pendu* in the Exposition of 1889, and the three pictures shown in Brussels in 1890 — all of which were ignored by critics and public alike — no paintings by Cézanne had been exhibited for eighteen years. Few people knew of the heap of canvases stored in Tanguy's dingy little colour-shop in the rue Clauzel, where half a dozen young enthusiasts were allowed to look at them from time to time.

But Cézanne's self-imposed obscurity came to a sudden end with the exhibition organized by Ambroise Vollard in 1895. Vollard has told the full story of the exhibition in his own biography of Cézanne, and I shall give only a short summary of that entertaining chapter.

Vollard saw Cézanne's pictures for the first time at Julien Tanguy's shop in 1892. The young dealer, who had a small gallery of his own in the rue Laffitte, conceived the rather daring idea of holding a one-man show of the unknown painter's works; and when the controversy over the Caillebotte bequest had been fought out in the newspapers, and public interest in the work of

339

Cézanne's former associates — though not yet of Cézanne himself — had been stimulated by the uproar, Vollard felt that the time was ripe.

Pissarro offered to lend Vollard such of Cézanne's canvases as belonged to him, with the proviso that Vollard should first obtain Cézanne's authorization for the proposed exhibition. But how could Cézanne be reached? He had dropped completely out of sight; Pissarro himself had lost touch with him; nobody knew his address. Vollard gives an amusing account of his search for the elusive painter through the forest of Fontainebleau, picking up the trail in one village only to lose it in the next. " I learned that Cézanne had actually had a studio at Fontainebleau. I thought my quest was ended, but no, the owner of the studio told me that his tenant had returned to Paris, and that he could not remember the address. The only fact that had stuck in his memory was that the street where Cézanne now lived bore the name of a saint coupled with the name of an animal." By a combination of good luck and clever guesswork Vollard succeeded in identifying this vague thoroughfare as the rue des Lions-Saint-Paul, more commonly called simply rue des Lions; and at Number 2 he found Cézanne's residence. But by this time Vollard's quarry had returned to Aix.

Young Paul, however, was at home and promised to write to his father at once. The upshot was that Cézanne not only gave his consent to the exhibition, but sent almost one hundred and fifty canvases. They arrived rolled up: Cézanne found that wooden stretchers took up too much room and were too clumsy to handle in his frequent migrations. For some reason Pissarro changed his mind and withdrew his offer to lend his own collection, but luckily the consignment from Cézanne himself was large enough to supply Vollard with ample material for his show.

The exhibition opened in November 1895 at 39 rue Laffitte. Unfortunately a full list of the works shown is not available; there was no printed catalogue, and no complete inventory of the canvases seems to have survived. But Vollard mentions the following

pictures as particularly noteworthy; the dates, which are Vollard's, agree fairly well with those in Rivière's chronological list: *La Léda au Cygne*, 1868; *Le Festin*, 1868; *Portrait de l'Artiste par Lui-même*, 1880; *La Maison Abandonnée*, 1887; *Étude de Baigneuses*, 1887; *La Forêt de Chantilly*, 1888; *Le Grand Pin*, 1887; *Portrait de Madame Cézanne dans la Serre*, 1891; *Les Bords de la Marne*, 1888; *Portrait de l'Artiste par Lui-même*, 1890; *Jeune Fille à la Poupée*, 1894; *Sous-Bois, Forêt de Fontainebleau*, 1894; *Madame Cézanne au Chapeau Vert*, 1888; *Baigneuses devant la Tente*, 1878; *Portrait de Monsieur G.*, 1880 [possibly the portrait of Guillaumin ascribed by Rivière to 1879]; *Le Déjeuner sur l'Herbe*, 1878; *La Corbeille de Pommes*, 1885; *L'Estaque*, 1883; *Le Jas de Bouffan*, 1885; *Auvers*, 1880; *Gardanne*, 1886; *La Lutte*, 1885; *Portrait de Madame Cézanne*, 1877.

The exhibit attracted an enormous amount of attention, a good deal of it of an unflattering nature. Vollard recounts a number of diverting anecdotes: the scandal caused by the display of nudes in the window; the first purchaser, who turned out to have been blind from birth; the man who forced his wife to look at the Cézannes as a punishment for some domestic peccadillo; and many others in the same vein.

Perhaps Vollard has somewhat exaggerated the hostility of the man in the street just because that hostility did give rise to the most humorous incidents. As a matter of fact, although his venture unquestionably required both courage and vision, Vollard had chosen a very propitious moment for his exhibition. The more enlightened section of the public was ready for it, and on the whole the response was not unfriendly. Some of the visitors to Vollard's gallery were genuinely enthusiastic, among them Monsieur de Camondo, whose collection of Impressionist and other late nineteenth-century paintings, including six Cézannes, now hangs in the Louvre; and Monsieur Auguste Pellerin, whose famous collection of Cézannes — now divided among his heirs — is the largest and most important in the world.

Comment in the press was also varied. In its issue of December 1, 1895 the *Journal des Artistes* describes the exhibition as a "nightmarish apparition of atrocities in oil, eclipsing even legally authorized outrages," and expresses anxiety lest the sight of these pictures should cause heart-failure to its delicate feminine readers.

Such vicious attacks were, however, exceptional. Most of the contemporary newspaper reviews were a good deal more moderate, and some spoke respectfully and even appreciatively of the work of the mysterious and unknown artist. Pre-eminent among the defenders of Cézanne was Gustave Geffroy, who wrote in the *Journal* for November 16, 1895:

" At the Vollard gallery, in the rue Laffitte, all passers-by may enter and find themselves confronted by some fifty canvases: figures, landscapes, fruits, flowers, upon which at last may be based an estimate of one of the finest, greatest personalities of our time. When this test has been made, and it is high time that it should be made, all that is obscure and legendary in Cézanne's career will be cleared up, and there will remain his work, severe but charming, and furthermore erudite, powerful, yet simple. . . . He is supremely sincere, intense and artless, rugged and subtle. His work will be hung in the Louvre, and the collection contains more than one canvas which will enter the museums of the future."

Through his books and articles Geffroy exerted a powerful and beneficent influence over public taste, and his championship of Cézanne at this time was one of the most important factors in the establishment of the painter's reputation. Geffroy himself had a distinguished career. He was not only a writer and critic of note, but Director of the Manufacture Nationale des Gobelins, and before his death in 1926 was elected President of the Académie Goncourt. His portrait (Plate 37) — executed, according to Vollard, in 1890; according to Rivière, in 1895 — is one of the

finest pictures Cézanne ever painted. Geffroy is shown seated at his desk with several open books before him; at the back are the shelves of his library, with some of the books stacked in vertical rows, others subtly inclined towards the sitter's head. The portrait was never quite finished. Cézanne did not find Geffroy's personality altogether sympathetic and after a long series of sittings abruptly stopped work and went off to Aix. Vollard reports Cézanne's explanation of the episode: " Understand me: Geffroy is a fine man and has a great deal of talent; but he was constantly talking about Clemenceau; so I ran away to Aix! " " Clemenceau is not your sort then? " asked Vollard. " Listen, Monsieur Vollard! He has temperament; but for a man like me, who is helpless in this life, it is safer to lean on Rome."

* *

At the time of the exhibition at the rue Laffitte Vollard had never met Cézanne; more accurately, he had met him once without being aware of it. In 1896 he made a pilgrimage to Aix in order to buy more of Cézanne's pictures, and as soon as he saw the painter Vollard recognized him: Cézanne had visited his gallery two years before to see an exhibition of works by Forain.

Vollard's account of his experiences in Aix is given at length in his own book, and again I shall only summarize the circumstances briefly. The painter's son was at hand to effect the introduction, and Cézanne welcomed his visitor cordially without any display of his customary shyness. Vollard was shown into the studio, which was disorderly and bare — a real workshop: " In his studio there were no rare pictures, no precious furniture, in fact none of the bric-à-brac of which most artists are so fond. On the floor lay a big cardboard box full of water-colour tubes; some apples, in the last stages of decay, were still posing on a plate; near the window hung a curtain which always served as a background for figure studies or still lifes; lastly, on the walls were engravings and photographs, good and bad, mostly bad, representing the *Bergers d'Arcadie* by Poussin; *Le Vivant Portant le Mort* by Luca

343

Signorelli; several Delacroix; *L'Enterrement à Ornans* by Cour-
bet; *L'Assomption* by Rubens; an *Amour* by Puget; some For-
ains; *Psyché* by Prud'hon; and even *L'Orgie Romaine* by
Couture."

Vollard dined with Cézanne and his family. The painter was
in a gay mood and almost overpoweringly polite: " His favourite
expression was: ' *Excusez un peu!* ' " The guest, knowing Cé-
zanne's reputation for irascibility, did his best to steer the con-
versation into safe channels. " All my precautions, however, did
not prevent me from making a bad break. We had been talking
of Gustave Moreau. I said: ' It seems that he is an excellent
teacher.' When I began to speak, Cézanne was in the act of lifting
his glass to his lips; he stopped without setting it down, while he
cupped the other hand behind his ear, being a little hard of hear-
ing. He got the full force of the word ' teacher,' which affected
him like an electric shock: ' Teachers! ' he shouted, setting down
his glass so hard that it broke, ' they're all swine, eunuchs, God-
damned asses; they have no guts! ' " But after this outburst the
painter calmed down and the rest of the meal was harmonious
and uneventful.

Another day Cézanne took Vollard to his sister Marie's house
to see one of his pictures. The spinster, who was devoutly, almost
fanatically, religious, was at vespers, and the house was locked; so
Cézanne and Vollard strolled about in the garden: " Rarely has
a walk been so profitable to my soul. Everywhere were posted
prayers entitling one to indulgences, some good for a few days,
some for several months, and some, indeed, for whole years."

Vollard tells us that he came to Aix under the impression that
pictures by Cézanne were scattered about the countryside wait-
ing to be picked up by anyone who wanted them. He had heard
that Cézanne was in the habit of leaving discarded canvases lying
in the fields or wherever he happened to be working. This how-
ever was an exaggeration, as Vollard soon discovered; although
Renoir is said to have picked up a water-colour study of *Bathers*
which was tossed away among the rocks at L'Estaque. But if Vol-

lard did not find Cézannes growing on every bush as he had expected, he did come across one literally growing on a tree: a still life of some apples that Cézanne had flung out of his studio window in a rage. The canvas had caught in the branches of a cherry tree and hung there precariously for several days, until Cézanne came to the conclusion that it might be worth finishing after all and rescued it with a pole. In general, however, Cézanne did not leave his pictures, finished or unfinished, lying about in the open. If they satisfied him they were stacked up in his studio; if not, they were slashed to pieces and burnt.

Cézanne gave away his pictures freely, though there was hardly anyone in Aix who really appreciated them. Still they were usually accepted, since they cost nothing. Vollard set to work to hunt out and buy as many of these canvases as he could find. His adventures on this quest constitute one of the most entertaining episodes in his book. Some of the owners refused to take the trouble to look for such worthless daubs, which they had thrown into some storeroom and buried under heaps of discarded junk. One such snub was administered by the Comtesse de R., who had stored the paintings Cézanne had given her in the granary. Vollard pointed out that they might be destroyed by rats; to which the lady replied firmly: " Well, let my rats eat my Cézannes; I'm no shopkeeper! "

Among the citizens of Aix were a number who had tried their hands at painting, and when it became known that Vollard was in the market for Cézannes, he was swamped under a deluge of pictures by all the would-be artists in the district. But some of his efforts to purchase genuine Cézannes were successful, and his account of one such triumph is so amusing that it must be quoted in full:

" A man came to my hotel with something wrapped up in a cloth. ' I've got one of them,' he said at once, ' and since the Parisians are making a fuss about them, I want to be in on it! ' Untying the parcel, he showed me a Cézanne. ' Not less than a

hundred and fifty francs! ' he cried, slapping himself smartly on the thigh, the better to assert his claim and at the same time to bolster up his courage. When I had counted out the money: ' Cézanne thinks he's smart,' he said, ' but he got fooled when he made me a present of that! ' After he had given full rein to his joy, he added: ' Come along! ' I followed him to a house where, in the hall, which at Aix is generally used as a junk-room, several magnificent Cézannes rubbed elbows with an odd assortment of articles: a bird-cage, a cracked chamber-pot, old shoes, a broken syringe (everyone knows that the people of the Midi are unwilling to throw away or destroy anything whatever that once belonged to them) . My guide knocked at a door, which was opened a little way; it was fastened by an iron chain. A man and his wife appeared. They asked a number of questions. But they were not yet ready to trust me, for as I crossed the threshold I overheard one of them ask my guide: ' How well do you know this stranger who is with you? ' An interminable discussion followed; at last they demanded a thousand francs for the Cézannes in the hallway. I hastily produced a bank-note. Another conference between the three natives; finally they informed me that the transaction could not be settled until the note had been verified at the Crédit Lyonnais. The husband undertook that mission; his wife advised him to bring back the money in gold, if the note were found to be good: ' it would be safer in case of fire.' When the husband returned laden with the precious metal, their joy was so great that they gave me, without extra charge, a piece of string to tie up the Cézannes. ' It's very good string,' the wife assured me; ' we wouldn't give it to everyone.' There was another surprise in store for me. I had hardly left the house when I heard a hail from the window: ' Hey, mister artist, you've forgotten one! ' And a Cézanne landscape fell at my feet! ''

* *

Vollard returned to Paris, where he continued to see Cézanne from time to time. In 1899 he asked Cézanne to paint his portrait.

346

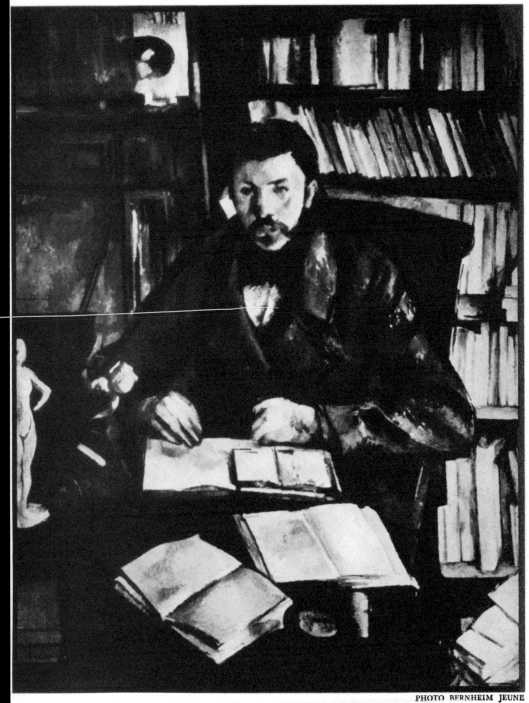

37. PORTRAIT OF GUSTAVE GEFFROY
ABOUT 1895. PELLERIN COLLECTION

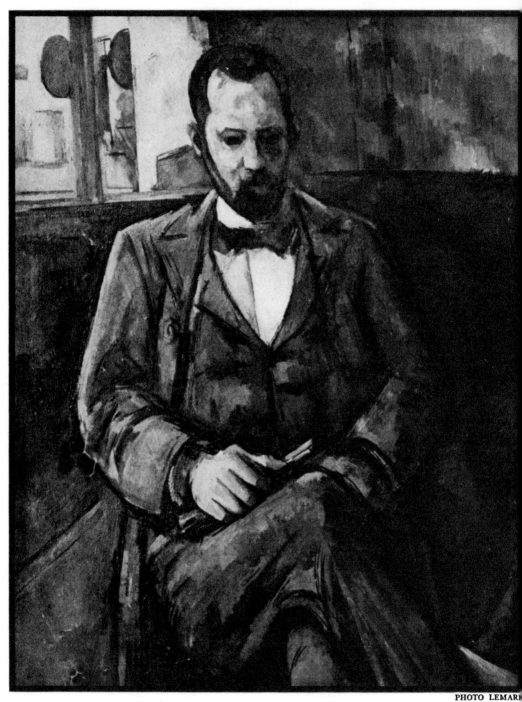

38. PORTRAIT OF AMBROISE VOLLARD
1899. VOLLARD COLLECTION

Cézanne, who always found it difficult to secure willing sitters, agreed and made an appointment for the following day at his studio in the rue Hégésippe-Moreau.

The first sitting was disastrous. When Vollard arrived, he found the model-stand already prepared: a chair perched on a packing-case " which was in turn supported on four rickety legs." Very gingerly he climbed onto this throne, and the sitting began. Cézanne always insisted on complete immobility on the part of his models; he treated his human sitters as if they were the subjects of still-life studies rather than portraits; they were not allowed to talk or move a muscle during the poses. The unnatural rigidity of his cramped position was too much for Vollard. He fell asleep; nodded, swayed, and lost his balance; and the sitter, the chair, and the packing-case collapsed in a heap on the floor. Cézanne was furious. " Wretch! You've ruined the pose! I tell you, you must sit like an apple. Does an apple move? " Thereafter Vollard took the precaution of fortifying himself with a cup of black coffee before each sitting; and if in spite of the stimulant he found himself nodding occasionally, a look from Cézanne was enough to recall him to his senses at once.

The sittings lasted from eight to half past eleven in the morning. In the afternoons Cézanne often copied in the Louvre or the Trocadéro — a practice he had started when he first came to Paris in 1861 and had kept up with more or less regularity whenever he was in the city.

Vollard tells us that Cézanne painted with very flexible brushes of sable or polecat, which he washed in a cup of turpentine after each stroke. " No matter how many brushes he began with, he used them all during a sitting "; and incidentally succeeded in smearing himself and his clothes to such an extent that after a few hours he was scarcely recognizable under the layers of paint.

Cézanne was easily upset while he was working, and there was little chance of a peaceful and successful sitting unless certain conditions were fulfilled. The weather — which to Cézanne meant the light — had to be propitious. Then if the work in hand

347

happened to be a portrait, the model was obliged to be not only as motionless as an apple, but as dumb as one: Cézanne could not bear to be distracted by chatter, though he himself was quite willing to talk before the pose began and during the infrequent rest-periods he grudgingly vouchsafed his sitter. He hated to have anyone watch him when he was painting; it made him so nervous that if he were out of doors he would hastily gather up his paints and brushes, canvas and easel, and rush off in the opposite direction if anyone came too near. He was also abnormally sensitive to noise. The sound of hammering, the rattle of a nearby elevator that he called the " pile-driver factory," or, worst of all, the barking of a dog — such disturbances drove him almost to frenzy. Finally, any unexpected change in his routine, any accidental rearrangement of the familiar objects around him, irritated him. Vollard recalls Cézanne's fury when he discovered that a nondescript rag of dirty carpet had been removed from its accustomed corner of the studio and taken out for a badly needed beating: the temperamental painter, trembling with rage and swearing violently, hacked a perfectly innocent canvas to pieces and was unable to do another stroke of work that day.

Cézanne was seldom satisfied with his own work, and the portrait of Vollard (Plate 38) was no exception. With the noncommittal remark that he was "not displeased with the front of the shirt " he abandoned the picture, almost but not quite finished, after one hundred and fifteen sittings, and returned to Aix. He intended vaguely to go on with it at some future time, and asked Vollard to leave with him the clothes in which he had posed — which were promptly devoured by moths.

JOACHIM GASQUET

In middle age Cézanne had withdrawn himself almost entirely from his old friends. He rarely saw any of the Impressionist painters, his contemporaries and erstwhile companions, any more; and of the comrades of his youth, only a very few — Philippe Solari, Numa Coste, and Paul Alexis — were still in touch with him.

But during the last decade of his life Cézanne's misanthropy diminished notably. He did not become exactly gregarious, but he grew less suspicious, more approachable. A new set of friends began to spring up around him, a group of much younger men who admired his work and listened to him with respect, without violating his jealously guarded privacy or presenting any redoubtable *grappins*. He was still lonely, by choice; but he was no longer completely isolated.

Among these friends of a younger generation were the writers Joachim Gasquet, Edmond Jaloux, Joseph d'Arbaud, Emmanuel Signoret, Marc Lafargue, Louis Aurenche, and Léo Larguier, and the painters Émile Bernard, Maurice Denis, and Charles Camoin. Bernard and Larguier have left valuable records of their meetings with Cézanne, and Maurice Denis has added some slighter notes. But Joachim Gasquet, whose friendship with the

349

painter began earlier and was always far more intimate than that of any of the others, has made the most important contribution to our knowledge of Cézanne. A poet, sensitive, sympathetic, intelligent, and sincere, Gasquet appears to have grasped the inner workings of Cézanne's complex personality better than anyone else; as a study of Cézanne the man as distinct from Cézanne the painter Gasquet's book — written in 1912 but not published until 1921 — is incomparably the most understanding of all the biographies.

Henri Gasquet, Joachim's father, was a highly respected baker in Aix and an old acquaintance of Cézanne. He is described in an article in the *Mémorial d'Aix* for December 1929 as " a neat little man of prosperous appearance, with shaven lips and chin and with cheeks aristocratically ornamented with exactly symmetrical side-whiskers; he always wore white cravats, like a councillor of state." And so he appears in the portrait Cézanne painted of him.

Joachim Gasquet was born at Aix in 1873 and died in 1921. His account of his first meeting with Cézanne in the spring of 1896 presents an excellent picture of the painter in his late fifties:

" The first time I saw him he was sitting at a café. Solari, Numa Coste, and my father were chatting with him. It was a Sunday, at the *apéritif* hour. They were at a table on the Cours Mirabeau outside the Café Oriental, a favourite rendezvous of Alexis and Coste. Night was falling under the great plane trees. The Sunday crowd was coming home from the band concert. It was a serene Provençal evening. His friends talked among themselves, he himself listened and watched, with his arms crossed. With his bald pate, his long grey hair still abundant at the back, his short beard and the thick moustaches, like those of an old colonel, that concealed his sensual mouth, his freshly shaven cheeks and ruddy complexion, one might have thought him an old retired soldier had it not been for his immense bulging forehead, the brow of a genius, remarkable for its shape and size, and his reddened piercing eyes, which held you at once and never let you go again. That

day a well-cut jacket covered his body, the robust body of a peasant and a master. A low collar exposed his throat. His black cravat was neatly tied. Sometimes he neglected his appearance, going about in sabots and a ragged hat. He was well dressed when he thought about it. That Sunday he had probably spent the day with his sister."

Cézanne was not used to deference from younger men, and at first he regarded Gasquet's too evident enthusiasm with suspicion. But as soon as he was convinced that the youth was sincere, he became charmingly frank and cordial:

" I was a nobody, scarcely more than a child. In some haphazard exhibition at Aix I had seen two of his landscapes, and the whole of painting was made clear to me. Those two canvases had opened up the world of colour and line, and for a week I had been going about enraptured by this unknown universe. My father had promised to introduce me to the painter, who was scoffed at by the whole town. I guessed that it was he who was sitting there. I approached, and murmured some words of admiration. He reddened, began to stammer. Then he pulled himself together, shot a terrible glance at me that made me blush in my turn, a look that burned right through me.

" ' Don't you make fun of me, young man! '

" The table shook under a terrific blow of his fist. The glasses rattled. Everything fell over. I don't think I have ever been more embarrassed. His eyes filled with tears. He took hold of me with both hands.

" ' Sit there — is this your son, Henri? ' he asked my father. ' He is charming.' The anger had gone out of his voice, which was now gentle and kind; he turned to me. ' You are young — you don't understand. I don't want to paint any more. I've given up everything — listen to me, I am an unhappy man — you must not hold it against me — how can I believe that you can see something in my painting, in the two pictures you have seen, when all

these fools who write nonsense about me have never been able
to perceive anything? What a lot of harm they have done me! It
is *Sainte-Victoire* in particular that has struck you, isn't it? That
picture pleases you — tomorrow I shall send it to you — and I
shall sign it, too.' "

Cézanne was as good as his word. He signed the picture and
presented it to young Gasquet. This canvas, with the many-arched
viaduct of the railway in the middle distance, and in the left fore-
ground a great pine tree whose spreading branches follow and
accentuate the splendid contours of the mountain, is perhaps
the best, and is certainly the best-known, of the entire *Sainte-
Victoire* series (Plate 39). It is now a part of the Courtauld col-
lection and hangs in the National Gallery, London.

Gasquet's account continues:

" Cézanne turned back to the others.
" ' Go on talking, all of you. I want to chat with the youngster.
I am going to carry him off — shall we have dinner together,
Henri? '
" He emptied his glass and took me by the arm. We walked
away into the darkness, along the boulevards on the edge of town.
He was in a state of inconceivable exaltation. He opened his heart
to me, told me of his discouragement, the loneliness of his old age,
the martyrdom of his painting and his life, that ' profound feel-
ing,' that ' unity ' of which Renan speaks, which I should like to
transmit, and of which, that evening, I had a sensation that was
more than wonder; it was ecstasy. I was aware of his genius with
my whole soul. I could feel it. I should never have believed that
anyone could be so great and so unhappy, and when I left him I
could not be sure whether I was possessed by the holiness of his
human suffering or by the worship of his amazing talents.
" During the next week I saw him every day. He took me to
the Jas de Bouffan, he showed me his pictures. We made long
excursions together. He would call for me in the morning, we

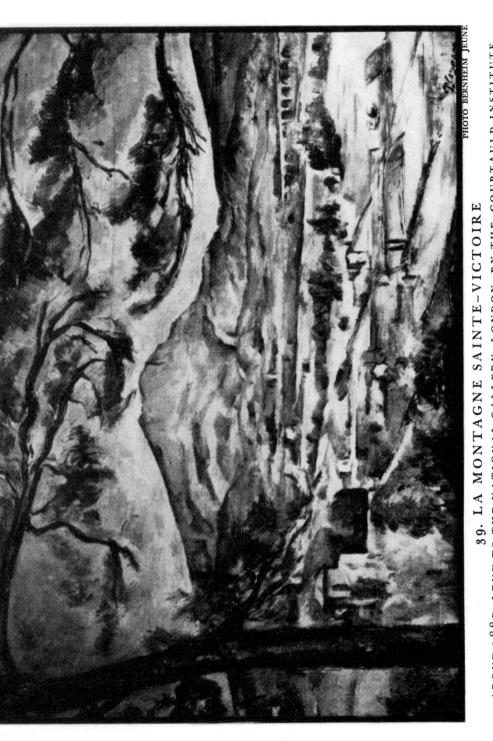

39. LA MONTAGNE SAINTE-VICTOIRE

ABOUT 1887. LENT TO THE NATIONAL GALLERY, LONDON, BY THE COURTAULD INSTITUTE

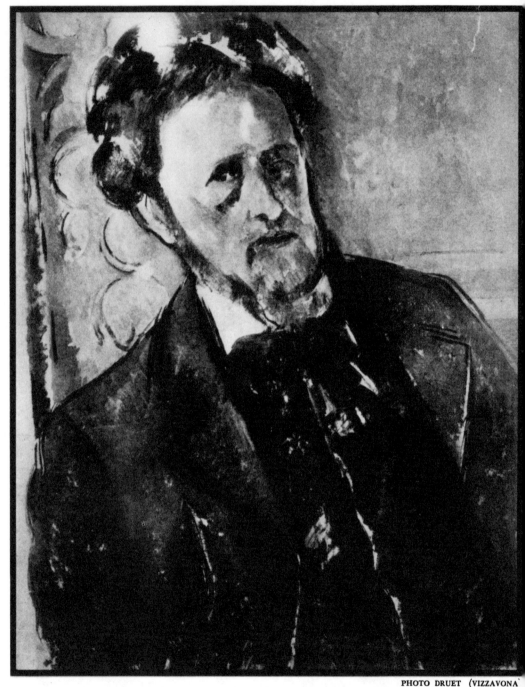

40. PORTRAIT OF JOACHIM GASQUET
1896

would not return until dark, tired out, dusty, but enthusiastic, ready to start again the next day. It was an enchanted week, during the course of which Cézanne seemed to be reborn. He was like a drunken man. I think the same simplicity created a bond between my ignorant youth and his clear rich wisdom. All subjects of conversation were alike to us. He never spoke of himself, but he said that he would have liked to give me the benefit of his experience, since I was just on the threshold of life. He regretted that I was not a painter. The countryside thrilled us. He showed me, and explained to me at length, the beauty of all his conceptions of poetry and art. My enthusiasm refreshed him. All that I brought him was a breath of youth, a new faith that made him young again. But in that great soul anything one added, no matter how insignificant, was tremendously magnified. He wanted to paint portraits of myself and my wife. He started one of my father. He abandoned it after the first sitting, lured from his studio by our expeditions to Le Tholonet, to the bridge over the Arc, our meals, washed down with old wine, in the open air. It was spring. He drank in the countryside with delighted eyes. The first pale leaves moved him deeply. Everything touched him. He would stop to look at the white road or to watch a cloud float by overhead. He picked up a handful of moist earth and squeezed it as if to bring it closer to him, to mix it more intimately with his own reinvigorated blood. He drank from the shallow brooks.

" ' This is the first time I have really seen the spring,' he said."

* *

But even Gasquet, for whom Cézanne felt such a deep and sincere affection, was not spared a glimpse of the darker, morbid side of his nature. The change came suddenly and without warning:

" All his self-confidence came back to him. At last he began to talk about his own genius. One evening he let himself go and declared: ' I am the only living painter! '

" Then he clenched his fists, relapsed into gloomy silence. He went home grimly as if some disaster had overtaken him. The next day he did not come for me. He refused to see me at the Jas de Bouffan. For several days I called on him without result. Then I received this letter:

" ' Dear Sir, I am leaving tomorrow for Paris. Please accept my kind regards and sincere greetings.'

" It was the 15th of April. The almond trees around the Jas, where I wandered about trying to conjure up the image of the departed painter, had lost their blossoms. The friendly outline of the Pilon du Roi shimmered, pale blue against the evening sky. It was there, among these fields, these orchards and these walls, that Cézanne always painted. Suddenly, on the 30th, I met him coming back from the Jas, with his knapsack on his shoulder, going towards Aix. He had not gone away after all. My first impulse was to run after him. He was walking as if crushed, sunk into himself, overcome, unseeing. I respected his solitude. An immense, sorrowful wonder took hold of me. I bowed to him. He went on without seeing us, at any rate without returning my salute. The next day I received the following tragic, amazing letter . . . :

" ' Dear Monsieur Gasquet,

" ' I passed you at the end of the Cours this evening. You were accompanied by Madame Gasquet. If I am not mistaken, you seemed very angry with me.

" ' If you could see my real self, my inner man, you would not be angry. Don't you see after all to what a sad state I am reduced? Not master of myself, a man who does not exist, and you try to be a philosopher who in the end will annihilate me altogether. But I curse the ——s and the clowns who have drawn the attention of the public to me in order to sell their fifty-franc articles. All my life I have worked in the hope of being able to earn a living, but I thought it would be possible to paint well without drawing attention to my private affairs. Certainly an artist wants to reach the highest possible intellectual heights, but the man should re-

354

main in obscurity. The joy should be in the work. Had the ability to realize been given me, I should have stayed in my corner with the few studio comrades with whom I used to drink a glass of wine a long time ago. I still have one good friend of those days; well, he has not made a success, but just the same he was an infinitely better painter than all these fools who are so bemedalled and decorated they make one sick; and still you expect me, at my age, to have faith in anything. Moreover, there is no life left in me. You are young, and I can understand your desire to succeed. But as for me, what is there left for me to do in my position except to give up, and if it were not for the fact that I have a great love for the scenery of this part of the country I should not be here.

" ' But I have bored you enough with all this, and now that I have explained my position to you, I hope that you will no longer look at me as if I had committed some crime against you.

" ' I beg you, dear sir, on account of my great age, to accept all the good wishes I should like to make for you.'

" I ran to the Jas. As soon as he saw me he opened his arms. ' Let us say no more about it,' he said, ' I am an old fool. . . .' "

Thenceforward Cézanne and Gasquet seem to have understood each other perfectly. The letter marked the end of Cézanne's melancholy for the time being; and although discouragement, ill health, and nervous agitation brought on occasional recurrences of these surly moods in after years, Gasquet always realized that the painter's outbursts were not directed at him, that they had no personal significance whatever; and he was able to endure them with equanimity.

The above letter, and extracts from several others, are reproduced in Gasquet's biography of Cézanne. In a footnote Gasquet announced that all of Cézanne's letters to him were to be published after his (Gasquet's) death. Unfortunately there is little hope that this promise will ever be fulfilled. Madame Gasquet, the poet's widow, has told me that the letters in question — some twenty of them all told — were kept in the drawer of an old desk,

In 1914, just before the outbreak of war, her husband gave the desk to his godson; he remembered the letters at the last moment, but as the key to the drawer was lost and the moving-van was already at the door, he let the desk go, relying on the young man's promise to have it broken open at once and to return the letters to Gasquet. But the turmoil of the next four years drove all thought of the documents out of the minds of everyone concerned; and after the war the desk, with its drawer still locked, was sold to some unknown purchaser. Thus all trace of the letters has been lost. There is a faint chance that they may still come to light some day, but in all probability they have been destroyed.

YOUNG FRIENDS AND OLD AGE: 1896–1906

FOR a month after the episode of the letter — the month of May 1896 — Cézanne and young Gasquet were once more inseparable companions. Then Cézanne went to Vichy, and afterwards to Talloires for the rest of the summer. He spent the following winter with his wife and son in Paris, whence he wrote to Gasquet:

"I have devoted quite a few days to the search for a studio in which to pass the winter. I am much afraid that for some time to come circumstances will keep me in Montmartre, where my studio is at present. I am within gunshot of Sacré-Cœur, whose campaniles and turrets leap to the sky."

Notwithstanding the "circumstances," whatever they were, Cézanne moved down from Montmartre about the first of the year and installed himself at 73 rue Saint-Lazare. Weakened as he was by diabetes, he found the raw northern winter too severe for him. He wrote to Philippe Solari on January 30, 1897:

"Since the 31st of last month I have been confined to the house by an attack of grippe; Paul attended to the moving from Mont-

357

martre. Though I have not gone out yet, I am much better. . . .
Except for a little weakness, natural enough under the circum-
stances, it is not so bad; but if I could have arranged my life so as
to live down there [in Provence], it would have suited me better.
But one's family obliges one to make a lot of concessions."

This mild complaint is one of the few hints in any of Cézanne's
letters that his wife and son did not always see eye to eye with
him when it came to a choice of residence. To tell the truth, Cé-
zanne did not often make such " concessions." Most of the time
he wandered about very much as he pleased, and his family either
followed him or remained in Paris.

As spring advanced he grew stronger and recommenced his
landscape painting in the environs of Paris and the forest of
Fontainebleau. On May 24 he wrote a short note from the Hôtel
de la Belle Étoile at Mennecy, a village near Corbeil, to Philippe
Solari's son Émile:

" I must leave for Aix very soon. In all probability my depar-
ture will take place on Monday night, May 31 to June 1, if God
wills. — I am going to Paris on Saturday the 29ᵗʰ inst.; if you are
free and would like to see me before I go, please come round to 73
rue Saint-Lazare."

When Cézanne returned to the Midi he rented an old stone
farmhouse at Le Tholonet, a few miles from Aix near the foot
of the Montagne Sainte-Victoire, and worked there all that sum-
mer. He saw scarcely anyone except Gasquet and occasionally
Philippe Solari. Cézanne relished the gentle old sculptor's visits;
on September 2 he wrote to the latter's son from Le Tholonet:

" Last Sunday your father came to spend the day with me —
poor fellow, I deluged him with theories about painting. He must
have a sweet disposition to put up with all my talk."

358

And again on September 8:

" Your father is coming to eat a duck with me next Sunday. He will be served with olives (I mean the duck of course). I wish you could join us. Think of me kindly in the days to come. . . ."

During these summer months at Le Tholonet Cézanne painted almost every day from early morning to sunset, but he often returned to Aix for the night in order to have supper with his mother, who at eighty-three was growing feeble and a little childish. Cézanne had always been devoted to his mother, and though towards the end he found her querulous senility difficult to cope with he invariably treated her with the utmost gentleness, patience, and affection. Gasquet tells us that " he went driving with her, took her to the Jas to sit in the warm sunshine. He carried her, light and frail as a child, from the carriage to her chair in his own strong arms. He told her countless stories to amuse her."

The old lady died on October 25, 1897. Cézanne was deeply affected by her death, but he found comfort in his religion and probably even more in his work, to which he applied himself more passionately than ever. Work, as he had written to Gustave Caillebotte twenty years before, is the best antidote to sorrow; work gives one the courage to go on. He continued to preach that gospel all his life, and practised it as well. Work and courage are the keynotes of a letter to young Émile Solari, dated November 2, 1897:

" I have received your letter announcing your impending marriage. I have no doubt that you will find in your future mate the support which is indispensable to any man who has a long and probably arduous career before him. I am praying for the realization of your fondest hopes.

" You tell me also of your difficulties in finding an opening for the production of your works on the stage; in that connection I assure you that I can understand the difficulties you are experi-

encing. What else can I say except that I sympathize with your position, and urge you to have courage, for you will need it in order to succeed. —

" By the time these few lines reach you, you will have heard about the death of my poor mother. —

" Renewing my exhortations to courage and hard work, I am very cordially yours,

P. Cézanne

" A few days ago I had the pleasure of seeing your father, who has promised to visit me at the Jas."

After his mother's death Cézanne lived quietly at Aix until the autumn of 1898, when he returned to Paris. He stayed in the capital for about a year; it was his last lengthy sojourn in the north. Late in 1899 he went back to Aix determined to spend the remaining years of his life in the country he had always loved. He made one final trip to Paris in 1904, but after three months — part of which he spent in the forest of Fontainebleau — he returned to Provence. He did not leave Aix again.

* *

In 1899 the Jas de Bouffan was sold to Monsieur Granel, and Cézanne rented an apartment in Aix, on the upper floors of an old house at 23 rue Boulegon. It was a modest lodging, and like all of Cézanne's many residences, except the Jas itself, it was furnished cheaply and austerely. The rooms were small, the walls covered with paper of commonplace and unfashionable design. In the attic he arranged a studio with a large window facing north. Madame Cézanne and young Paul continued to spend the summer months in Aix, but most of the year Cézanne lived there alone, tended only by a faithful and efficient housekeeper, Madame Brémond. Émile Bernard describes her in 1904 as " a woman of about forty, rather stout and good-natured in appearance." An excellent cook, she watched over Cézanne's diet, re-

moved the daubs of paint from his clothes, and conscientiously burned the canvases he consigned to destruction. But Léo Larguier, in his book *Le Dimanche avec Paul Cézanne,* insists that this wholesale annihilation of discarded pictures has been exaggerated: " The dining-room stove was not fed exclusively with broken stretchers and torn canvas."

Larguier was performing his military service in Aix when he first met Cézanne in 1901. He was twenty years old, and shy; but the old painter received him cordially enough and soon put him at his ease. During the time that Larguier spent at Aix — a little less than two years — he dined with Cézanne almost every Sunday, and frequently accompanied him to the *motif;* Cézanne even accorded him the privilege, granted to few people, of watching him paint. Larguier mentions the prodigality with which the painter squeezed out the expensive contents of his colour-tubes: " I paint," said Cézanne gaily, " as if I were Rothschild! "

Charles Camoin, a budding painter, was another youth whose fresh enthusiasm helped to rejuvenate the ageing Cézanne, to overcome his disillusionment and give him renewed faith in the future of art. Camoin came to Aix in November 1901; like Larguier he had been sent there to pass his term of military service. He was determined to meet Cézanne, whose pictures, seen some years before at Vollard's gallery, had impressed him deeply. As soon as he reached Aix he began to make inquiries; but the painter led such a retired life that it was not easy to find anyone who could direct him to the house. Finally, through the beadle of the cathedral, he succeeded in locating Cézanne. That evening about seven he called at the house in the rue Boulegon; the table was laid for supper, but Cézanne had not yet come in. Camoin was too shy to wait, but he returned about eight-thirty and rang the bell. A head was poked out of a second-storey window and a man's voice shouted: " Who's there? " It was Cézanne, who as usual had gone to bed immediately after supper. But down he came with his shirt-tails hanging out of his trousers, invited the abashed visitor up to the dining-room, and after a short conversa-

tion about painting (in which Cézanne did almost all the talking) asked the young man to come to see him again whenever he could.

Camoin remained in Aix only three months, but in that time he saw Cézanne frequently and became a sincere admirer of the man as well as of his work. Both Camoin and Larguier display a wholesome skepticism towards the fantastic accounts of Cézanne's misanthropy, which they dismiss as part of the Cézanne legend. To them the old painter showed nothing but gentleness and a slightly quaint, old-fashioned courtesy. Larguier writes: " For two years I saw Paul Cézanne constantly, almost every day, and there was never a shadow between us. He has been called a barbarian, morose and persecuted; in reality he was only shy and one had to gain his confidence." To which must be added the testimony of Cézanne's brother-in-law, Maxime Conil: " Paul was not a savage; he was a *solitaire*."

Monsieur Camoin has told me that in his opinion the stories of Cézanne's persecution by the citizens of Aix, the jeering and stoning by impudent small boys, are also greatly exaggerated. It will be recalled that in 1878 Cézanne had complained to Zola that Villevielle's pupils had made fun of him; and in those days he must have presented a somewhat outlandish appearance with his mane of long reddish-brown hair and bushy beard. But now, in his old age, what hair he had left was iron grey and his beard was short and neatly trimmed. Monsieur Larguier denies that Cézanne's clothing at this time was excessively untidy or bizarre: " he was better and more comfortably dressed than most of the people in Aix." He lived quietly, kept to himself, and was in general ignored by his fellow-townsmen; but he was not actively molested. " But legends," adds Monsieur Larguier, " have a long life."

Charles Camoin, to whose reminiscences Larguier devotes one chapter of his book, relates an amusing anecdote to illustrate Cézanne's intense concentration on his work:

" One day at lunch he suddenly rose from the table without any apparent reason and disappeared into the next room. Madame Brémond, his housekeeper, brought in the next course, but Cézanne did not come back. He was working at his easel and had forgotten us completely."

After Camoin left Aix he wrote frequently to Cézanne, and the latter's replies have fortunately been preserved. Four of the painter's letters to Camoin are reproduced in Larguier's *Le Dimanche avec Paul Cézanne:*

" *Aix, 28 January 1902.*

" Dear Monsieur Camoin,

" Several days have passed since I last had the pleasure of reading a letter from you. I have very little news to tell you; one is able to talk more, and perhaps better, about painting when one is in front of one's *motif,* than when one hazards purely speculative theories — in which one very often goes astray. In my long hours of solitude I have thought of you more than once. . . . Monsieur Larguier, whom I see quite often, especially on Sundays, gave me your letter. He yearns for the day of his liberation, it will come in six or seven months. My son, who is here, has made his acquaintance and they often go out together in the evenings; they talk a little about literature and the future of art. When his term of military service is finished, Monsieur Larguier will probably return to Paris to continue his studies (social and political sciences) in the rue Saint-Guillaume, where Monsieur Hanoteau teaches, without however abandoning poetry. My son will also return to Paris, he will therefore have the pleasure of meeting you when you go back to the capital. Vollard was here in Aix about a fortnight ago. I received news of Monet, also the card of Louis Leydet, son of the Senator, district of Aix. The latter is a painter, he is in Paris at present and has ideas similar to yours and mine. You can see that a new era of modern art is on the way,

you feel it; continue to study without wavering, God will do the rest. . . ."

The next letter was written on February 3, 1902:

". . . Since you are now in Paris, and you are drawn to the masters in the Louvre, make studies from the great decorative painters Veronese and Rubens if you like, but make them as you would from nature — which I have only partially succeeded in doing myself. But you would do even better to work directly from nature. From what I have seen of your work you are going ahead rapidly. I am glad to hear that you esteem Vollard, who is both sincere and earnest. I congratulate you on being with your mother, who in times of sadness and discouragement will be the soundest possible moral support, and the most vigorous source from which you can draw new courage to work at your art, which you must try to do not passively and feebly, but in a calm and steady manner; which cannot fail to lead to the clear-sightedness so necessary for firmness in this life. . . ."

The third letter is dated February 22, 1903:

" Tired out, 64 years old, I beg you to forgive me for my long delay in answering your letter. I shall write only a few words.
" My son, at present in Paris, is a *great philosopher*. By that I don't mean to suggest that he is either the equal or the rival of Diderot, Voltaire or Rousseau. Will you honour him with a visit, at 31 rue Ballu: near the Place Clichy, where the statue of General Moncey is placed. — When I write to him I shall mention you; he is rather shy, *indifferent,* but a good fellow. He helps me to overcome my difficulties in understanding life.
" I thank you heartily for your last letter. But I must get to work. Everything, particularly *in art,* is theory developed and applied in contact with nature.
" We shall talk more about all this when I have the pleasure of seeing you again.

364

" This is the most precise letter I have written you so far.
" *Credo.*

<div align="right">Very cordially yours,

P. Cézanne.</div>

" When I see you again, I shall talk to you about painting more precisely than anyone. I have nothing to hide *in art*.

" It is only the initial force, *id est* temperament, that can carry one to the goal one is seeking."

And again on September 13, 1903:

" I am delighted to hear from you, and congratulate you on being free to devote yourself entirely to the study of art.

" I thought I had told you, in conversation, that Monet was living at Giverny; I hope that the artistic influence that this master must inevitably exert, more or less directly, on the people who surround him, will be effective only to the strictly necessary extent that it can and should be felt by a hard-working young artist. Couture told his pupils: ' Choose your company carefully,' in other words, ' Go to the Louvre.' But after having looked at the great masters preserved there, you must hasten to leave them and revive, through contact with nature, the instincts, the sensations of art that belong to yourself. I regret that I cannot be with you. My age would not matter, if other circumstances did not prevent me from leaving Aix. Nevertheless I hope to see you again one day. Larguier is in Paris. My son is at Fontainebleau with his mother.

" I hope you will make some good studies from nature, they are the best of all.

" If you should meet the master we both admire [Claude Monet], remember me to him.

" I don't think he is very fond of being bothered, but perhaps your sincerity will soften him a little."

Cézanne's fifth and last letter to Charles Camoin has not been published heretofore, to the best of my knowledge:

" Aix, 9 December 1904.

" My dear Camoin,

" I received your welcome letter from Martigues. Come whenever you like, you will always find me at work; you will go to the *motif* with me, if you want to. Let me know the day of your arrival, because if you come to the studio on the Montée des Lauves I shall have lunch for two brought there. — I eat at eleven, and then I go to my *motif,* unless it rains. I keep my paraphernalia stored at a spot 20 minutes from my own place. —

" The study of the model, and its realization, sometimes come very slowly to the artist. — Whoever your favourite master may be, he should never be more than a guidepost to you. Otherwise you will be only an imitator. With a feeling for nature, such as it is, and a few fortunate talents — which you have — you should succeed in liberating yourself; the advice, the method of someone else must not cause you to change your own way of feeling. Should you fall temporarily under the influence of somebody older than yourself, you may be sure that as soon as you begin to feel, your own individual emotion will always emerge and take its place in the sun. *Get the upper hand,* be confident — that is a good method of *construction* which you will have to acquire. Drawing is only the configuration of what you see. —

" Michelangelo is a constructor, and Raphael an artist who, no matter how great, is always limited by his model. — When he tries to be a thinker he falls below his great rival."

In all of the above letters Cézanne preached the gospel of a return to nature; not to imitate blindly, of course, but to observe, to feel, and to construct a work of art based on the painter's own personal perceptions, sensations, and temperament. He conceded a certain value, but a limited one, to the study and copying of masterpieces in the museums. It was a creed in which he

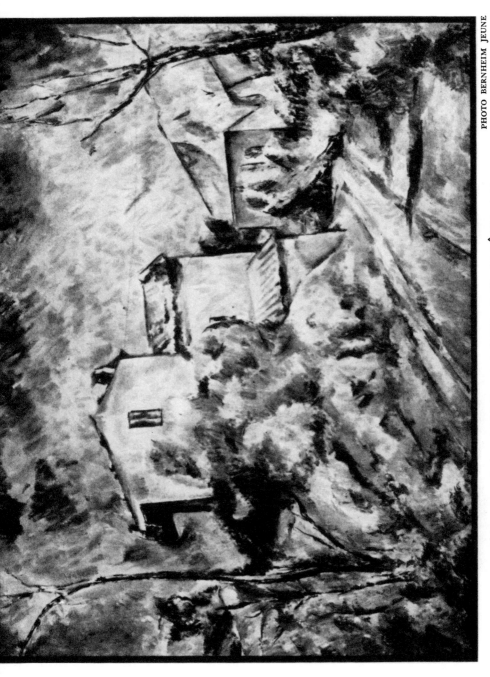

41. LE THOLONET: ROUTE DU CHÂTEAU NOIR

ABOUT 1896. PELLERIN COLLECTION

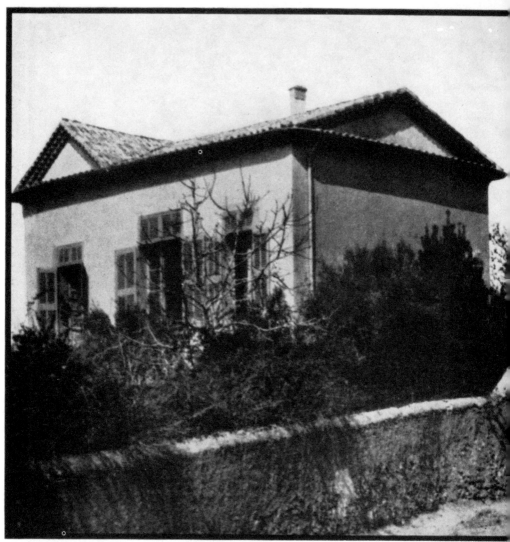

42. CÉZANNE'S STUDIO ON THE CHEMIN DES LAUVES

FROM A PHOTOGRAPH

believed devoutly; he had endeavoured to practise it all his life, and in his old age he strove to pass it on to the younger painters who came to him for advice.

* *

Cézanne's studio under the roof of the house in the rue Boulegon was not very satisfactory; he wanted a quiet workroom outside of the town where he could paint undisturbed and where there would be no annoying coloured reflections from nearby walls and roofs. In November 1901 he bought from a Monsieur Bouquier a small piece of property — a little more than an acre in extent — on the hillside about half a mile north of Aix, fronting on the country road then known as the Chemin des Lauves and overlooking the beautiful old town and the tranquil countryside beyond. He paid two thousand francs for the land and commissioned a local architect named Mourgues to tear down the little hovel which encumbered the property and build a studio to suit his requirements, which he set forth in detail. His orders given, Cézanne went back to his painting. He rented the Château Noir, a farmhouse at Le Tholonet, for use as a temporary studio, and neglected to supervise the construction of the new building. The result, notwithstanding the painter's specific instructions, was a typical Provençal villa of the worst type, plastered over with hideous gingerbread in the form of " picturesque " wooden balconies and glazed tile ornaments. When Cézanne beheld the completed masterpiece he blew up in a rage. Coquiot says that the offending house had to be demolished, but this is an exaggeration. It was, however, stripped of its excrescences and converted into the existing simple, practical, unpretentious, but well-proportioned structure.

Cézanne had an enormous respect for trees and insisted that the building should be placed so that none would have to be cut down. The roots of one old olive tree that still flourishes very close to a corner of the house were carefully protected by a wall of stones and earth.

The building consists of two storeys surmounted by a gabled roof of tiles. On the ground floor are the little entrance hall and stairway and two rooms of moderate size. In one of these Cézanne was accustomed to lie down and rest occasionally between periods of intense, exhausting labour at his easel; the other he used as a dining-room, in which Madame Brémond served his midday meal. He did not, however, actually live at the studio, but always returned to the rue Boulegon to sleep. Upstairs is a large high-ceilinged studio about twenty by twenty-five feet, with a small storeroom at the eastern end. On account of the steep slope of the terrain the floor of the studio is almost on a level with the ground on the north side, so that the windows on the lower floor open only towards the south. The studio itself also has two south windows, but the principal source of light is a glazed opening of huge proportions, reaching almost to the ceiling, in the north wall. The interior partitions are of plain plaster tinted a neutral grey. It is a straightforward, well-planned workroom: restful, serviceable, and unassuming. The pleasant, informal little hill-side garden is a tangle of brambles, flowering shrubs, olive trees, almond trees, and a few old apple and cherry trees, broken up by narrow winding paths. In Cézanne's day the place was well looked after by an old gardener and man-of-all-work, Vallier, whose duties included that of posing occasionally for his portrait: the last brush-stroke Cézanne ever painted was applied to a portrait of Vallier, only five or six days before he died.

After Cézanne's death the studio property was sold. The present owner, Monsieur Marcel Provence, the founder of the local Société Paul Cézanne, has made some attempt to turn the little building into a sort of Cézanne shrine. A caretaker has been installed on the lower floor, and the big studio upstairs remains very much as it was when Cézanne laid down his brushes for the last time. His easels, the few odd bits of furniture he used, his palette, his lay figure, some of the pots and bowls and bottles that served as models for his still-life studies, are still in their accustomed places; even an assortment of hats, and the cloak he wore

when he trudged to the *motif* on cold and rainy days, hang on their hooks against the wall. Only the litter of rotting fruit and faded paper flowers and the stack of canvases, finished and unfinished, are gone.

A tablet has been placed on the outer wall of the building, which is known today as the Pavillon Paul Cézanne:

CET ATELIER
FUT ÉLEVÉ PAR
PAUL CÉZANNE
IL Y TRAVAILLA
JUSQU'À SON DERNIER JOUR

À PAUL CÉZANNE
LE PAYS D'AIX
ET LA PROVENCE

SOCIÉTÉ PAUL CÉZANNE MCMXXV

There are other memorials to Cézanne today, belated symbols of the honour which was denied him while he lived. Another tablet marks the house in the rue Boulegon:

DANS CETTE MAISON
EST MORT LE 23 OCTOBRE 1906
PAUL CÉZANNE

The date, however, is incorrect: Cézanne died on October 22. The entry in the municipal records of Aix also gives the date of death as October 23, but there the error was intentional, so that the interment might be postponed without violation of the letter of the law, long enough to permit Cézanne's wife and son to reach Aix in time for the ceremony.

The Chemin des Lauves (a *lauve,* in Provençal, is a flat stone), the hilly road running northward from Aix past the studio, is now the avenue Paul Cézanne. And in the town itself, at the corner of the rue des Chapeliers and the rue des Bagniers, is an old stone fountain into which has been fixed, somewhat incon-

gruously, a bronze medallion of Cézanne's head modelled by Renoir. In Marseilles the former Place d'Aubagne has been renamed in Cézanne's honour, and in Paris too there is now a rue Paul Cézanne, as well as a statue by Aristide Maillol in the Tuileries which is dedicated to the painter.

* *

In the autumn of 1902 Cézanne, with his wife and son, accepted an invitation to spend a few days at the home of his young friend Léo Larguier in the Cévennes. Larguier's parents were simple country-folk who understood nothing of the subtleties of Cézanne's painting; it was enough for them that he had befriended their son during his period of military service at Aix, and they extended such a charming and honest welcome to their guests that the painter's reserve, his suspicious distrust of strangers, his obsession concerning *grappins,* all melted away in the warm glow of their unpretentious hospitality. During this visit, says Larguier, Cézanne cast aside his tormented preoccupation with his work: he was serene, amiable, and gay, and his temper did not give way even under the strain of a dinner-party to which the Larguiers had invited, in his honour, several members of the local four hundred. The table conversation turned to art, and some of the remarks and opinions of the unsophisticated provincials might have been expected, under ordinary circumstances, to open the flood-gates of Cézanne's hasty wrath; but on this occasion he only listened politely with a genial smile on his lips. The entire visit seems to have passed off without the slightest untoward incident. It was one of the few idle, calm, contented interludes in Cézanne's unhappy, thwarted existence.

PAINTING: 1890–1906

THE GENERAL orientation of Cézanne's painting towards the representation of three-dimensional solidity rather than of surface reflection, and particularly towards the use of natural forms as a basis for the construction of compositions conceived as abstractions, instead of mere imitations of nature — an orientation which had become firmly established by the end of the eighties — remained essentially unchanged during the last fifteen years of his life. But he did modify his technique to some extent. While in many of the canvases of his latest period Cézanne carried his system of thinly applied, transparent, endlessly superposed brushstrokes even farther than before, in others he showed a tendency to return to the thicker, heavier painting of his youth. Not, however, to an exaggerated degree: the texture of even the most densely painted of his later pictures does not approach the excessively trowelled, lumpy *impasto* of his earliest works. And even the faint technical resemblance between certain canvases of Cézanne's last phase and some of his first paintings is a superficial one; the spirit behind them is quite different. In his work on Cézanne Mr Roger Fry distinguishes clearly between the productions of the two periods:

371

" It would appear that there was at the end of Cézanne's life a recrudescence of the impetuous, romantic exuberance of his early youth. It is deeply affected and modified by the experience of the intervening years. There is nothing wanton or willful about it, nothing of the defiant gesture of that period, but there is a new impetuosity in the rhythms, a new exaltation in the colour. This is of course a well-known phenomenon among artists who live to an advanced age. Titian's is the classic example."

We have already seen that Cézanne did actually undergo a sort of spiritual rebirth during the last decade of his life, a regeneration apparent in a sloughing-off of some of the more extreme manifestations of his misanthropy, in an increased gentleness and serenity, and in a new-fledged sympathy with the aspirations and enthusiasms of the group of young acquaintances who came to him, now and again, for guidance. His contacts, rare and fleeting as they were, with a new generation refreshed and reinvigorated the ageing and tired painter. It was only to be expected that some evidences of this rejuvenescence should appear in his work. But the paintings of Cézanne's last years were mellowed and enriched by four decades of experience and suffering, during the course of which the raw defiance of youth had given way to a profound humility.

The last ten or twelve years are marked by an enormous increase in the number of Cézanne's water-colours. As his system became slowly weakened by diabetes, the terrible strain of his intense and endless efforts to " realize " exhausted him more and more. But water-colour made no such demands on his waning vitality as did his infinitely slow and laborious method of painting in oils. The very nature of the medium requires speed and decision rather than prolonged, meditative searching for subtle tones and values. Many of the water-colours of this period are mere notes and hasty sketches; sometimes they consist of nothing more than half a dozen pencil lines and a wash or two of pale

43. PAUL CEZANNE ABOUT 1890
FROM A PHOTOGRAPH

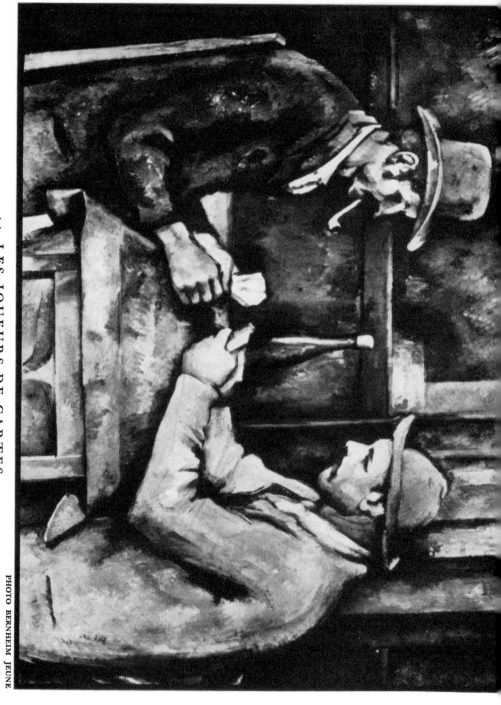

colour. Others are complete pictures, rich in colour and thoroughly organized in design.

But oil remained the only medium in which he could express himself completely. On October 13, 1906, only a few days before he died, Cézanne wrote to his son: " My nervous system is very much weakened, there is nothing but painting in oils that can keep me going." The oils of his last phase include the same categories as before: portraits, landscapes, still lifes, nudes.

Most of the outstanding portraits of this period have already been mentioned: Vollard (Plate 38), Geffroy (Plate 37), Henri Gasquet, Joachim Gasquet (Plate 40), the gardener Vallier, *La Femme au Chapelet,* and *Le Jeune Homme et la Tête de Mort,* sometimes known as *Le Jeune Philosophe.* For some reason Cézanne seems to have lost his fondness for painting himself and his wife during his last years: after 1890 only one portrait of Madame Cézanne and three self-portraits appear on Rivière's list.

Among the most important works of the nineties are the various versions of *Les Joueurs de Cartes,* which may be classed either as portraits or *genre* pictures. There are five different canvases in the series: one containing five figures, another four, and the remainder only two figures each. Of the three two-figure paintings one is in the Pellerin collection (Plate 44), one in the Camondo collection in the Louvre, and the third in the Courtauld Institute in London. In addition to these five pictures Cézanne painted and drew a number of more or less finished studies of each of the individual players in various poses. One of these, commonly called *L'Homme à la Pipe,* also hangs in the Courtauld Institute.

The landscapes of the last fifteen years were for the most part painted in Provence and comprise a number of variations on the Mont Sainte-Victoire theme, the valley of the Arc, and other scenes in the neighbourhood of Aix, and several pictures of houses, rocks, and quarries near Le Tholonet, including the *Le Tholonet: Route du Château Noir* reproduced on Plate 41. In

1892 and 1894, however, Cézanne painted *motifs* along the Marne and in the forest of Fontainebleau, and in 1896 on the Lake of Annecy (Plate 35).

* *

As a result of Vollard's pioneer exhibition in 1895, Cézanne's work now began to attract a limited but enthusiastic clientele in Paris. After the close of the exhibition a number of his canvases remained on view at the gallery in the rue Laffitte. At last there was an opportunity for the public to see the pictures of this unknown artist. They were discussed, criticized, attacked, and sometimes ridiculed; but every year there were more converts and more purchasers. Prices began to rise: the day of forty-franc and hundred-franc Cézannes was over.

The official Salon remained obstinately closed to him, but invitations to exhibit in less conservative galleries soon made their appearance. In 1899 three canvases — two still lifes and a landscape — were hung at the Salon des Indépendants; in 1901 one still life and one landscape, and in 1902 a still life and two landscapes, were exhibited under the same auspices. At the Paris Centennial Exposition of 1900 Cézanne was represented by three pictures: a still life from the Viau collection, a landscape lent by Monsieur Pellerin, and *Mon Jardin* (Plate 8) from the Vollard galleries. In 1901 one of his still lifes was shown at the exhibition of La Libre Esthétique — successor to Les XX — in Brussels: the same still life that forms a part of the composition in Maurice Denis's large group picture *Hommage à Cézanne,* which was exhibited in Brussels at the same time. And nine canvases by Cézanne were hung at the Exposition des Peintres Impressionistes held at Brussels by La Libre Esthétique in 1904: four landscapes, four still lifes, and a study of nudes: *Idylle Antique.*

In 1905 Cézanne made his début at the Salon d'Automne in Paris with ten pictures: four landscapes, two still lifes, two portraits (one of himself), a study of nudes, and *Les Moissonneurs.* And in 1906, at the exhibition of the Salon d'Automne that

opened only a fortnight before he died, ten more canvases were displayed: six landscapes, two still lifes, and two portraits.

After Cézanne's death his fame grew rapidly. Exhibition followed exhibition; in the summer of 1907 a group of about eighty water-colours was shown at the Bernheim Jeune galleries, and in October of the same year a large retrospective exhibition was held at the Salon d'Automne, comprising forty-eight canvases and seven water-colours. All types and periods of Cézanne's work were represented in this show.

As his posthumous renown spread abroad, his productions became more and more eagerly sought after, until today Cézanne's pictures, so recently despised, occupy an honoured place in most of the large public galleries of the world as well as in innumerable private collections of the first water. The least scribble from his pencil, the hastiest of his water-colour sketches, the most incomplete of his discarded canvases are highly prized — sometimes, it must be admitted, too highly. We are still too close to Cézanne and his epoch to attempt to determine his permanent place among the ranks of the masters of all time; but it is not too early to say that if the reputation of any nineteenth-century painter seems to be secure, that painter is Paul Cézanne.

* *

Some of Cézanne's theories and conceptions of art are set forth in a series of articles by Émile Bernard published in the *Mercure de France* for October 1 and 15, 1907; March 1, 1920; and June 1, 1921. Bernard had cherished a desire to meet Cézanne ever since he had first seen his pictures in Tanguy's colour-shop, years before. Those canvases had made an ineradicable impression on the young art student and had exerted a considerable influence on his subsequent work. He was one of the first to render homage to Cézanne in print; he wrote a laudatory chapter on the painter for a series of biographical sketches published in 1889 under the general heading of *Les Hommes d'Aujourd'hui*. But no opportunity to make Cézanne's acquaintance presented itself until

1904. In February of that year Bernard and his wife landed at Marseilles on their return journey from Egypt; Aix was but a short distance away, and Cézanne lived at Aix. Like all strangers who attempted to seek out Cézanne in his seclusion Bernard was able to locate him only after persistent inquiry; but when he did succeed in tracking him down to the rue Boulegon he met with a cordial reception.

Bernard immediately moved over to Aix, installed himself and Madame Bernard in lodgings, and remained there for a month. During that time he saw Cézanne almost daily. The older painter placed one of the downstairs rooms of his studio on the Chemin des Lauves at the disposal of his new friend, who frequently painted there. He also went to the *motif* with Cézanne, and consequently had excellent opportunities to watch him at work. They entered into long discussions about art, the gist of which in the form of a dialogue is contained in the article in the *Mercure de France* for June 1, 1921.

One day, however, the smooth course of the friendship was disastrously, if temporarily, interrupted. Returning from the *motif,* they decided to try a short cut over a steep and slippery path. Cézanne, who was walking ahead, caught his foot in some obstruction and almost fell, and Bernard instinctively took hold of his arm to steady him. Cézanne immediately exploded with rage. He cursed violently, pushed away Bernard's protecting hand, and dashed off at full speed, throwing wild and terrified glances over his shoulder at his dumbfounded companion. Bernard, keeping at a safe distance behind him, followed Cézanne to his studio and attempted to explain that he had only wanted to save him from falling; that he had meant no disrespect. But Cézanne would not listen: " I allow nobody to touch me! " he shouted, " nobody can put the *grappin* on me! " Bernard, dazed and upset, returned to his rooms. That evening as he was preparing to go to bed, Cézanne knocked at the door. He had come to inquire about an ear-ache from which Bernard had been suffering for some days past; he was in a most amiable mood and had ap-

parently forgotten all about the incident that had occurred a few hours earlier. The next day Bernard told the story to Madame Brémond, Cézanne's housekeeper, who assured him that the outburst meant nothing and that Cézanne had spent the entire evening singing Bernard's praises. Madame Brémond herself had strict orders never to touch Cézanne, not even to the extent of allowing her skirts to brush against his chair when she served at table.

Some time afterwards Cézanne himself explained his curious behaviour. He told Bernard that once in his childhood, as he was walking downstairs, another small boy came sliding by down the banister and gave him a vicious and unexpected kick in the rear as he whizzed past. Cézanne had just saved himself from falling downstairs and ever since had been obsessed by a subconscious fear that something of the kind might happen again; hence his uncanny horror of even the slightest physical contact.

Monsieur Bernard's unfortunate experience, however, seems to have been rather exceptional; it illustrates another of those picturesque eccentricities which have become overemphasized in the Cézanne legend. His reaction to the touch of a hand, the accidental brush of a skirt or sleeve, depended largely on the mood of the moment. He was inconsistent and unpredictable in this as in so many other ways. A casual gesture might pass unnoticed one day and throw him into a violent rage the next. But on the whole Cézanne's excessive touchiness appears to have been exaggerated, and his outbursts of bad temper, while they undoubtedly occurred often enough, were probably less frequent than the numerous anecdotes concerning them might lead one to believe.

Cézanne and Bernard carried on a more or less regular correspondence after the latter's departure from Aix. On April 15, 1904, Cézanne wrote:

" Let me repeat what I told you here: you must see in nature the cylinder, the sphere, the cone, all put into perspective, so

that every side of an object, of a plane, recedes to a central point. The parallel lines at the horizon give the extension, that is a section of nature, or, if you prefer, of the spectacle which the *Pater omnipotens æterne Deus* spreads before our eyes. The perpendicular lines at that horizon give the depth. Now to us nature appears more in depth than in surface, hence the necessity for the introduction into our vibrations of light, represented by reds and yellows, of enough blue tones to make the atmosphere perceptible.

" Permit me to tell you that I have looked again at your study of the ground floor of the atelier, it is good. I believe that you have only to continue in this way, you know what should be done and you will soon be able to turn your back on the Gauguins and the Van Goghs! "

On May 12 he wrote again:

" My preoccupation with work and my advanced age will be sufficient explanation of my tardiness in answering your letter.

" Moreover, you have brought up so many different points in your last letter, all of them however connected with art, that I cannot altogether follow your train of thought.

" As I have already told you, Redon's talent attracts me very much and I share his appreciation of and admiration for Delacroix. I don't know if my uncertain health will permit me ever to realize my dream of painting his Apotheosis.

" I go ahead very slowly, as nature appears very complex to me and incessant effort is required. One must look at the model carefully and feel very exactly, and then express oneself with distinction and power.

" Taste is the best judge. It is rare. The artist can only appeal to an extremely restricted number of people.

" The artist should scorn any opinion that is not based on an intelligent observation of character. He should avoid the literary spirit, which so often leads the painter astray from his real mis-

378

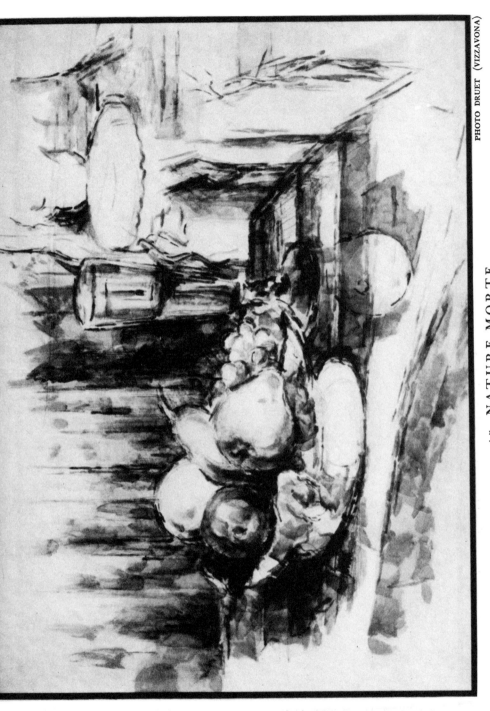

45. NATURE MORTE

ABOUT 1900. WATER-COLOUR

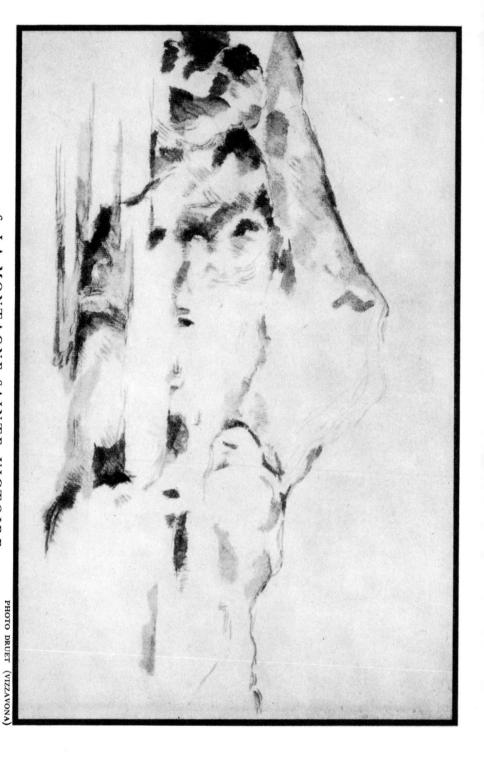

46. LA MONTAGNE SAINTE-VICTOIRE
ABOUT 1890 (?). WATER-COLOUR

sion, the concrete study of nature — and causes him to lose himself for too long a time among intangible speculations.

" The Louvre is a good book to consult, but it should be only an intermediary. The true and immense study to be undertaken is the diversity of the spectacle of nature."

The next letter, written on May 26, 1904, refers to an article on Cézanne that Bernard was preparing for the July number of *L'Occident:*

" I quite agree with the ideas you propose to develop in your forthcoming article in *L'Occident*. But I always come back to this point: the painter must devote himself entirely to the study of nature and try to produce pictures that have real meaning.

" To talk about art is almost useless. The labour which brings about progress in one's own calling is sufficient compensation for a lack of comprehension on the part of fools. The *littérateur* expresses himself by means of abstractions, the true painter by means of design and colour, his sensations and perceptions.

" One cannot be too scrupulous, too sincere, or too humble before nature; but one is more or less master of one's model, and above all of one's means of expression. One must penetrate what is in front of one and persevere in expressing oneself as logically as possible."

The succeeding letter, dated June 27, 1904, is less technical and somewhat more gossipy:

" If I have delayed my answer to your last letter it is because I have been suffering from pains in my head which interfere with my freedom of action. I live under the impact of sensations, and in spite of my age I am tied to my painting. The weather is fine, I am making the most of it by working. It would be a good thing to make ten good studies and sell them at a high price, now that collectors are speculating in them. . . . I hear that Vollard gave

379

a dancing party a few days ago at which he did himself well. —
All of the younger group were there, it appears, Maurice Denis,
Vuillard, etc.; Paul met Joachim Gasquet there. I think the best
thing of all is to work hard. You are young, realize and sell your
pictures.

"You remember the fine pastel by Chardin, with a pair of
spectacles, and a visor shading the eyes. He is a clever chap, that
painter. Haven't you noticed that the placing of a faint cross-
plane like a ridge across the nose brings out the values more
clearly? Verify this phenomenon and tell me if I am wrong."

And again on July 25:

"I have received the *Revue Occidentale* [*L'Occident*]. I can
only thank you for what you have written about me.

"I regret that we cannot be together, for I do not want to be in
the right theoretically, but in the presence of nature. Ingres, in
spite of his *estyle* (as pronounced in Aix) and his admirers, is
but an insignificant painter. You know the greatest masters bet-
ter than I do: the Venetians and the Spaniards.

"For progress towards realization there is nothing but nature,
and the eye becomes educated through contact with her. It be-
comes concentric through observation and work: I mean that in
an orange, an apple, a sphere, a head, there is a focal point, and
this point is always the nearest to our eye, no matter how it is
affected by light, shade, sensations of colour. The edges of objects
recede towards a centre located on our horizon. With a little tem-
perament one can be very much a painter. One can do fine
things without being a great harmonist or colourist. It is enough
to have a feeling for art — and no doubt it is that feeling which
horrifies the bourgeois. So that institutes, pensions and honours
are intended only for idiots, tricksters and knaves. Don't be an
art critic; paint. Therein lies salvation."

The last letter of the year is dated December 23:

380

" I have received your letter from Naples; I won't try to discuss æsthetic problems with you at great length. Yes, I share your admiration for the most valiant of the Venetians; we both do homage to Tintoretto. Your desire to find a moral and intellectual point of support in works that will never be surpassed must surely keep you constantly on the *qui vive,* on a perpetual search for the system of interpretation which will surely lead you to arrive at your means of expression in the presence of nature. And when you reach that point, you may be certain that, without effort and through nature, you will hit upon the methods employed by the four or five masters of Venice.

" This I declare to be indisputable — I am very dogmatic: an optical sensation is produced in our visual organ which causes us to grade the planes represented by sensations of colour into full light, half-tones and quarter-tones (light does not exist for the painter). Necessarily, while we are proceeding from black to white, the first of these abstractions being a sort of point of departure for the eye as well as for the brain, we are floundering, we do not succeed in mastering ourselves, in ruling over ourselves. During this period (I cannot help repeating myself a little), we go to the great masterpieces the ages have handed down to us, and we find in them a solace and a support, like a plank held out to a swimmer. All that you say in your letter is very true. We shall soon see each other again, I hope."

On his way home from Naples Bernard stopped at Aix to see Cézanne, but was able to remain only a few hours. It was the last time they were to meet. The correspondence, however, continued to the end. The following letter is undated:

" I shall reply briefly to some of the paragraphs in your last letter. As you say, I do believe that I have made some very slight progress in the latest studies you saw here. But all the same it is sad to realize that such improvement as has taken place in my understanding of nature from a pictorial point of view, and in

the development of my methods of expression, is coincident with increasing age and feebleness of body.

" If the official Salons are still so inferior, the reason is that they employ only more or less perfunctory methods.

" It would be better to introduce more personal emotion, more observation and more character.

" The Louvre is the book in which we learn to read. But we must not be content to memorize the beautiful formulas of our illustrious predecessors. Let us get out and study beautiful nature, let us try to discover her spirit, let us express ourselves according to our own temperaments. Time and meditation tend to modify our vision little by little and finally comprehension comes to us.

" In this rainy weather it is impossible to put these theories, however reasonable they may be, into practice out of doors. But perseverance teaches us to understand interiors like the rest of nature. Only our old habits stifle our intelligence, which needs stimulation.

" You will understand me better when we meet again; observation modifies our vision to such an extent that the humble and colossal Pissarro finds his revolutionary theories justified."

On October 23, 1905 Cézanne wrote once more:

" I value your letters from two different viewpoints, the first purely selfish, because their arrival relieves the monotony produced by the constant pursuit of one single aim, which brings on a kind of intellectual exhaustion during periods of physical fatigue; the second because they enable me to scrutinize you, perhaps a little too closely, for signs of that persistence with which I seek the realization of that part of nature which, coming into our view, gives us the picture. Now the idea to be insisted on.is — no matter what our temperament or power in the presence of nature — to produce the image of what we see, forgetting every-

thing that has been done before. Which, I believe, should enable the artist to express his entire personality, great or small.

" Now that I am old, almost seventy, the sensations of colour which produce light are a source of distraction, which do not permit me to cover my canvas or to define the delimitations of objects when the points of contact are tenuous, fragile; the result is that my image or picture is incomplete. Then again the planes are superimposed on one another, from which springs the Neo-Impressionist system of outlining the contours with a black line, an error which should be opposed with all our strength. Now if we consult nature we shall find a way to solve this problem. I remembered quite well that you were at T—, but the difficulties connected with the installation of my own household force me to put myself entirely into the hands of my family, who use me for their own convenience and forget me a little. That is life; at my age, I should have more experience and make use of it for the general good. I owe you the truth about painting and I shall tell it."

The last few sentences indicate some sort of domestic tension in the rue Boulegon, but its nature remains a mystery.

Cézanne's repeated exhortations to Émile Bernard to free himself from the museums and to draw his inspiration directly from nature sprang from his own deepest convictions. On September 13, 1906 he wrote to his son with reference to Bernard:

" I am sending you a letter which I have just received from Emilio Bernardinos, the most distinguished æsthete, whom I regret not to have under my thumb in order to suggest to him the idea, so wholesome, so helpful and so right, of a development of art in contact with nature. . . . The good fellow turns his back completely on what he maintains in his writings, in his work he does only old-fashioned things, which show the influence of his ideas of art suggested not by the emotions of nature, but by what

he has been able to see in museums, and still more by a philo-
sophic spirit, which comes from a too great knowledge of the
masters he admires."

In his next letter to his son, dated September 22, he returned
to the subject: " It is true, one can develop theories with Bernard
indefinitely, for he has the temperament of a logician." And on
September 26: ". . . he is an intellectual, stuffed with memories
of museums, but not looking at nature enough, and the great
thing is to get away from the school and from all the schools. —
So Pissarro was not wrong, although he went a little too far when
he said that all the graveyards of art should be burnt." But Cé-
zanne was now far too ill and tired to argue. " I have come to the
conclusion," he wrote to his son on September 22, " that one can
be of no use to another person."

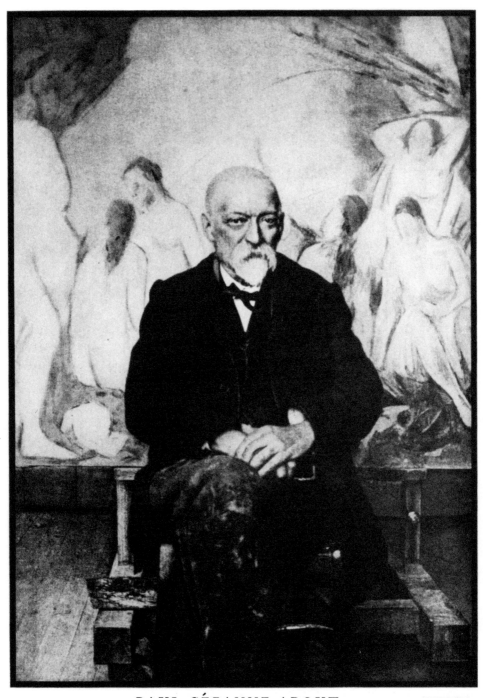

47. PAUL CÉZANNE ABOUT 1904
FROM A PHOTOGRAPH

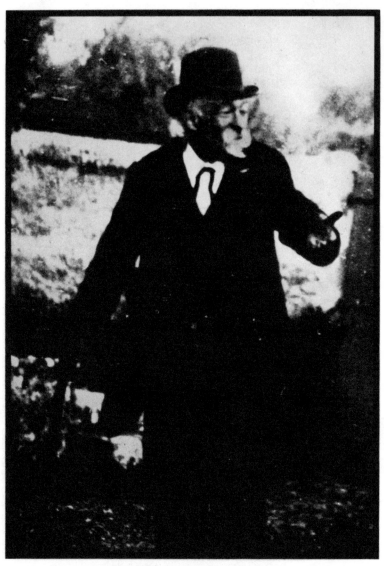

48. PAUL CÉZANNE ABOUT 1904
FROM A PHOTOGRAPH

THE LAST SUMMER: 1906

THE LAST three months of Cézanne's life can be reconstructed in some detail from a group of sixteen letters to his son — all that have survived of an intimate correspondence covering a quarter of a century. These last letters are a tragic record of shattered health, of a once vigorous constitution undermined by disease and growing weaker day by day. At sixty-seven Cézanne looked and felt much older than his years. Diabetes had bowed his shoulders, whitened his beard and the long mane of hair that still covered the back of his head, and robbed his movements of their former elasticity. He suffered from almost constant headaches, he had a pain in his back, and one of his feet hurt him. He found the oppressive heat of the Provençal summer almost insupportable, although he had been accustomed to it all his life and had never minded it before. His feebleness was reflected in his handwriting, which had become excessively shaky and untidy and in some cases almost illegible.

Yet his dogged determination to go on painting, to study nature, to " realize," never faltered. The overpowering heat kept him indoors during the middle of the day, but the early mornings and late afternoons saw him at the *motif*, working, meditating,

observing. While there was a spark of life in him he would not give up.

On July 20, 1906, Cézanne wrote to young Paul:

" This morning, my head feeling somewhat relieved, I am replying to your two letters, which always give me the greatest pleasure. At half past four in the morning — the temperature will be insupportable by eight o'clock — I go on with my studies, I ought to be young and do a great many, the atmosphere is sometimes full of dust and unpleasant in colour; — it is only beautiful at certain moments."

On July 25:

" Vallier [the gardener] massages me, my back is a little better, Madame Brémond says my foot is better. — I am following Boissy's treatment [homœopathic], it is terrible. It is very hot. — After eight o'clock, the weather is insupportable."

The heat runs through these letters like a *Leitmotiv*. On August 3 he writes again:

" I have received your letters of different dates, written quite close together. If I have not answered right away, the oppressive heat we are having is the reason. It weighs on my brain a good deal and prevents me from thinking. I get up very early, and it is only between five and eight o'clock that I feel alive. After that hour the heat becomes stupefying, and brings on such a cerebral depression that I no longer think even of painting. I have been obliged to call in Doctor Guillaumont, having caught bronchitis, I have quit homœopathy for the compound syrups of the old school. — I have been coughing quite a lot, *la mère* Brémond has put on an application of cotton soaked in iodine, and it has done me good. I regret my advanced age, on account of my sensations of colour. . . . It is unfortunate that I cannot make a great

386

many specimens of my ideas and sensations, long live the Goncourts, Pissarro, and all of those who have inclinations towards colour, the representative of light and air. . . . My foot is not doing badly just now."

The heat still troubles Cézanne on August 12:

" It has been hideously hot for several days; today, especially this morning, it was all right from five o'clock, the time I got up, until about eight o'clock. My painful sensations bother me so much that I cannot overcome them, and they force me to live in retirement, which is the best thing for me. . . . Two days ago *le Sieur* Rolland came to see me, he made me talk about painting. He has offered to pose for a study of a bather on the banks of the Arc — that would suit me quite well, but I fear that the fellow would like to get his hands on my study, nevertheless I am almost tempted to try it."

On August 14:

" It is two o'clock in the afternoon, I am in my room, the heat has come on again, it is awful. — I am waiting for four o'clock to come, then the carriage is coming for me and will take me to the river, to the bridge of the *Trois Sauters*. There it is a little cooler, I was very comfortable there yesterday, I have begun a water-colour similar to those I used to do at Fontainebleau, it seems to me to be more harmonious, the whole thing is to get as much harmony as possible. . . . My right foot is better. But how hot it is, the odour of the air is nauseating. . . . At the river a poor little child, very wide awake, approached me and my ragged clothes and asked me if I were rich, another older child had told him that it wasn't nice to ask that question. When I had taken the carriage again to go back to town, he followed me, when we came to the bridge I threw him a couple of sous, you should have seen how he thanked me."

Cézanne's hired carriage — it was always the same one, and the same coachman always sat on the box — was a somewhat dilapidated relic of a bygone day. Léo Larguier gives us a description of it in his *Le Dimanche avec Paul Cézanne:* " an ancient closed carriage upholstered in faded red velvet, drawn slowly by a pair of old and gentle white horses." Into this vehicle Cézanne would bundle his canvases, his easel, his bag of paints and brushes, and himself; on his way home after a long afternoon of work he sometimes dropped off to sleep, lulled by the rhythmic bouncing of the old springs and the muffled sound of hoof-beats on the dusty white road.

There is a rather longer interval than usual before the next letter, written on August 26:

" When I forget to write to you, it is because the weather drives the thought out of my head. It has been terribly hot and moreover my nervous system must be very much weakened. I am living a little as if I were in a vacuum. Painting is what is most worth while to me. I am very much annoyed by the cheek of my compatriots who try to compare themselves to me as artists, and who would like to put their hands on my studies. — You ought to see the rubbish they turn out. I go to the river every day in the carriage. It is all right there but my state of weakness bothers me a lot. . . .

" I am going up to the studio, I got up late, after five o'clock. I continue to study with pleasure, and yet sometimes the light is so unpleasant that nature appears ugly to me. . . . I embrace you both with all my heart and recall myself to the kind memory of all the friends who still think of me, through time and space."

Again on September 2:

" It is almost four o'clock, there is no breeze. The weather is still stifling, I am waiting for the carriage to take me to the river. I spend some pleasant hours there. There are big trees, they form

a vault over the water. I go to the spot called the pool of Martelles, it is on the little road that leads to Montbriant. Towards evening cows come there, on their way to pasture. There is enough to study and make pictures in quantity. Sheep come there also to drink, but they disappear rather quickly. Some journeyman painters came up to me, and said they would like to do the same kind of painting, but that it isn't taught at the art school, I said that Pontier was a dirty swine, they seemed to agree. You can see there is nothing new. It is still hot, there is no rain, and it does not seem likely to rain for a long time."

Cézanne's irritation at the provincials of Aix breaks out again in his next letter, dated September 8:

" Today (it is nearly eleven o'clock) another terrific hot spell. The air is overheated, not a breath of wind. This temperature can be good only for the expansion of metals, to help out the wine-shops, and to fill with joy the brewers, an industry which seems to be taking on respectable proportions in Aix, and to swell the pretensions of the intellectuals of my province, a bunch of idiots and fools. —
" There are exceptions, but they keep in the background. Modesty is always unaware of its own worth. — I must tell you that as a painter I am becoming more lucid in the presence of nature, but that with me, the realization of my sensations is always very painful. I cannot reach the intensity which appears to my senses, I have not the magnificent richness of colour that animates nature. Here on the banks of the river the *motifs* are teeming, the same subject seen from a different angle suggests a subject for study of the highest interest, and so varied that I think I could keep myself busy for months without moving from one spot, just by leaning now to the right, now to the left."

On September 21 Cézanne interrupted this series of letters to his son long enough to write to Émile Bernard:

" I have been having such terrible headaches, I have suffered so much, that for a time I feared that I should lose my mind. After the awful heat we have had recently, the milder temperature has brought back a little peace to our spirits, and it has not come any too soon; now I think I am better and I am able to continue my studies more logically. Shall I ever reach the goal so eagerly sought and so long pursued? I hope so, but as long as it has not been attained a vague feeling of discomfort persists which will not disappear until I shall have gained the harbour, that is until I shall have accomplished something more promising than what has gone before, thereby verifying my theories which, in themselves, are easy to put forth. The only thing that is really difficult is to prove what one believes. So I am going on with my researches.

" But I have just re-read your letter and I see that I am answering it very indirectly. You will kindly forgive me; as I have told you, the reason is my constant preoccupation with the goal to be attained. I am continually making observations from nature and I feel that I am making some slight progress. I should like to have you here with me, for my solitude always oppresses me a little; but I am old, ill, and I have sworn to die painting rather than sink into the nasty corruption that threatens old men who allow themselves to be dominated by degrading passions. If I ever have the pleasure of being with you again some day, we can discuss things more easily by word of mouth. You will forgive me for harping constantly on the same string, but I am progressing towards the logical development of what we see and feel by studying nature; a consideration of processes comes later, processes being for us nothing but simple methods for making the public feel what we ourselves feel, and for making ourselves intelligible. The masters we admire can have done no more than that.

" A hearty greeting from the obstinate old man who cordially clasps your hand."

On September 26 Cézanne wrote again to his son:

390

" Yesterday I saw the valiant Marseillais Carlos Camoin again, who came to show me a bundle of canvases, and to ask my opinion, what he has done is good, he will probably make good progress, he has come to spend a few days at Aix, and is going to work on the little road to Le Tholonet. . . . I am still working from nature, on the banks of the Arc, storing my paraphernalia with a man named Boissy, who has offered to take in my baggage."

With the cooler days of early autumn Cézanne's health improved a little and his headaches left him. On September 28 he wrote:

" The weather is splendid, the landscape superb. Carlos Camoin is here, he comes to see me from time to time. — I am reading Baudelaire's criticisms of the work of Delacroix. As for me, I must remain alone, the knavery of people is such that I could never cope with it, it is robbery, conceit, fatuousness, violation, hands laid on your work, and yet nature is very lovely. I am still painting Vallier, but my realization is so slow that I am very sad about it."

The letter of October 8 contains some bad news:

" Emery has raised the price of the carriage 3 francs for a round trip, when I used to go all the way to the Château Noir for 5 francs. I have fired him."

Cézanne was a rich man, but he always counted his pennies carefully, as we have seen on several occasions, and moreover he was always suspicious of anyone who seemed to be trying to exploit him. In this case the petty economy was quite literally fatal. From now on he walked to his *motif*, carrying his heavy knapsack of equipment; and by so doing he hastened his own end by several weeks, if not by months. But in his next two letters — the last he

ever wrote — there is no hint that death is so near. He orders
new supplies of wine and paint-brushes, and looks forward to the
approaching visit of his wife and son. On October 13 he writes:

" Today after a torrential downpour during the night, and
since it was still raining this morning, I am staying in the house.
As you remind me, I forgot to tell you about the wine, Madame
Brémond tells me we shall have to have some sent down. When
you see Bergot, you had better order some white wine at the same
time for yourself and your mother. It has been raining hard and
I think that for the present the hot weather is over. The banks of
the river having become a little too cool, I have abandoned them,
and I have gone up to the neighbourhood of Beauregard, where
the road is hilly, very picturesque but very much exposed to the
mistral. At present, I go there on foot with only my water-colour
bag, postponing oil painting until I find a place in which to store
my equipment, formerly that could be had for thirty francs a
year. I am conscious of exploitation everywhere. — I am waiting
for you to come before I make a decision. The weather is stormy
and very changeable. Nervous system very much weakened, there
is nothing but painting in oils that can keep me going. One must
persevere. So I must realize from nature. — Sketches, canvases,
if I should do any, would only be constructions after nature,
based on the methods, the sensations and the developments sug-
gested by the model, but I keep on repeating the same thing."

On Monday, October 15, Cézanne wrote his last letter:

" Saturday and Sunday it rained and stormed. Now the weather
is much fresher. It is not even the least bit hot. You are quite
right in calling this *la basse province* [a reference to the interfer-
ing, small-town provincialism of Cézanne's compatriots]. I am
still working with difficulty, but I am accomplishing something.
That is the important thing, I believe. Since sensations are the
basis of my work, I think I am safe from interference. So I am

willing to let the wretched person you know of [Gauguin] imitate me as much as ever he likes, there is no danger in it.

" When you have a chance give my regards to Monsieur and Madame Legoupil, who will be kind enough to remember me. And don't forget Louis [Guillaume] and his family, and Père Guillaume. Time passes with terrifying speed. My health is not bad. I take care of myself and my appetite is good.

" I must ask you to order me two dozen *émeloncile* brushes, like those we ordered last year.

" My dear Paul, in order to be able to give you news of as satisfactory a nature as you would like to have, I should have to be twenty years younger.

" I repeat, I have a good appetite, and a little mental satisfaction would help me a lot; but nothing can give me that except work. — All my compatriots are asses compared to me. — I forgot to tell you that I received the cocoa. —

" I embrace you and your mother. Your old father

Paul Cézanne

" I think the younger painters are much more intelligent than the others, the old ones can see nothing in me but a disastrous rival. — Fondly your father

P. Cézanne."

That same Monday afternoon Cézanne started out for his *motif* as usual, on foot, with his knapsack of water-colours on his shoulder. While he was working a violent rainstorm came up. For some time he remained obstinately at his easel, hoping the weather would clear; but as it did not, and there was no shelter within reach, he was thoroughly drenched by the time he decided to give up and make for home. Hampered as he was by his heavy load of equipment, the strain of plodding through the storm over the hilly country was too much for his feeble strength. Wet to the skin and shaken by a severe chill, he collapsed by the roadside, where he was found some time later by the driver of a laundry

393

cart, who recognized him and brought him back, half conscious, to the rue Boulegon.

Madame Brémond sent for the doctor and Cézanne's sister Marie, neither of whom appeared to realize the seriousness of the painter's illness. It was not until five days later that Marie notified young Paul, and when she did write, it was not because she was particularly alarmed, but because her nephew's presence was required so that he could help to nurse his father:

" Aix October 20 1906

" My dear Paul,

" Your father has been ill since Monday; Dr Guillaumont does not think his life is in danger; but Madame Brémond cannot take care of him by herself. You had better come as soon as possible. At times he is so weak that a woman cannot lift him; with your help it could be done. The doctor has suggested hiring a male nurse; your father won't hear of such a thing. I think your presence is necessary in order that he may be looked after as well as possible.

" Last Monday he was out in the rain for several hours; he was brought home in a laundry cart; and it took two men to get him upstairs to bed; early the next morning he went out to the garden [at his studio on the Chemin des Lauves, more than half a mile from the rue Boulegon] to work at a portrait of Vallier, under the lindens; he came home in a state of collapse. You know what your father is like; it would make a long story — I repeat that I believe your presence is necessary.

" Madame Brémond particularly wishes me to tell you that your father has taken your mother's dressing-room for his studio, and that he doesn't intend to move out of it for the present; she wants your mother to know this fact; and since the two of you were not expected back here for another month, your mother can remain in Paris for some time longer; by then perhaps your father will have moved his studio.

" There, my dear boy, is what I think it my duty to tell you; it

is for you to make your own decision. I hope I shall see you soon,
I embrace you affectionately.

" Your devoted aunt,

M. Cézanne "

Marie's letter reached Paris on October 22. On its heels came
a telegram from Madame Brémond urging Hortense and young
Paul to come to Aix at once. Cézanne was rapidly growing
weaker; at moments he was delirious and called out: " Pontier!
Pontier! " — the name of the Director of the Aix Museum whose
long-standing, obstinate refusal to permit Cézanne's pictures to
enter that institution preyed on the dying painter's clouded
mind.

His wife and son started south immediately, but it was too late.
The end came quickly. After receiving the last sacrament Cé-
zanne died peacefully on Monday, October 22. The funeral serv-
ices were held on Wednesday at the cathedral of Saint-Sauveur,
where he had attended mass for so many years. Victor Leydet,
Senator from the department of Bouches-du-Rhône, spoke a few
simple words over the open grave; and Paul Cézanne was buried
beside his father and mother in the old cemetery at Aix.

APPENDICES, BIBLIOGRAPHY
AND INDEX

CHRONOLOGICAL OUTLINE OF CÉZANNE'S LIFE

1839	January 19. Born at 28 rue de l'Opéra, Aix-en-Provence.
	February 22. Baptized at church of Sainte-Madeleine, Aix.
1841	July 4. Marie Cézanne born at 55 Cours Mirabeau, Aix.
1844	January 29. Louis-Auguste Cézanne and Anne-Élisabeth Aubert married at Aix.
1844 (?) –1849 (?)	Cézanne attended primary school, rue des Épinaux, Aix.
1848	June 1. Bank of Cézanne and Cabassol founded at Aix.
1849 (?) –1852	Cézanne at school of Saint-Joseph, Aix.
1852–1858	Cézanne at Collège Bourbon, Aix.
1854	June 30. Rose Cézanne born at 14 rue Matheron, Aix.
1858	February (?). Zola left Aix for Paris.
	November. Cézanne graduated from Collège Bourbon.
1859–1861	At Law School, Aix.
1859	Jas de Bouffan purchased by Louis-Auguste.

1861	April–September (?). Cézanne's first visit to Paris. Lived in rue Coquillière, later in rue des Feuillantines.
	September (?) Returned to Aix.
1862	Employed in bank of Cézanne and Cabassol, Aix.
	November (?). Returned to Paris.
1863	Probably in Paris all year.
	May 15. Opening of Salon des Refusés.
1864	July (?). Returned to Aix.
1865	In Paris most of year, at 22 rue Beautreillis. Returned to Aix in late autumn (?).
1866	Returned to Paris in early spring.
	April 19. Letter of protest to de Nieuwerkerke.
	July. At Bennecourt with Zola and Valabrègue.
	August–December. In Aix.
1867	January–June. In Paris, 22 rue Beautreillis.
	June–October (?). In Aix.
	October (?). Returned to Paris.
1868	May–December. In Aix.
1869	Probably in Paris most or all of year.
1870	July. Beginning of Franco-Prussian war.
	Cézanne in L'Estaque latter half of year.
1871	January 28. Armistice signed.
	Cézanne in Paris most of year, living with Hortense Fiquet.
1872	January 4. Paul Cézanne Jr born in Paris.
1872–1873	Cézanne at Auvers-sur-Oise.
1874	Spring. In Paris.
	April 15 to May 15. First Impressionist Exhibition.
	June–August (?). Cézanne in Aix.
	September (?). Returned to Paris, 120 rue de Vaugirard.
1875	Probably in Aix part of year.
1876	In Aix and L'Estaque most of year.
1877	Probably in Paris all year, at 67 rue de l'Ouest.
	April. Third Impressionist Exhibition.
1878	In Aix, L'Estaque, and Marseilles all year. Finan-

cial crisis caused by difficulties with his father.

1879	March. In Paris.
	April–December. In Melun.
	June. Visited Zola at Médan.
1880	January–March. In Melun.
	March–December. In Paris, 32 rue de l'Ouest.
	August. Visited Zola at Médan.
1881	January–April. In Paris, 32 rue de l'Ouest.
	May–October. At Pontoise, 31 Quai du Pothuis.
	June. Visit of Rose and Maxime Conil to Paris.
	October. Cézanne visited Zola at Médan.
	November. Returned to Aix.
1882	March–October. In Paris, 32 rue de l'Ouest.
	May. Portrait by Cézanne hung in Salon.
	October. Returned to Aix.
1883	At Aix and L'Estaque all year.
1884	Probably at Aix and L'Estaque all year.
1885	January–May. At Aix and L'Estaque.
	June–July. Disturbing and mysterious love-affair. Cézanne at La Roche-Guyon, Villennes, and Vernon.
	End July. Visited Zola at Médan.
	August–December. In Aix and Gardanne.
1886	In Aix and Gardanne most of year.
	March. Publication of Zola's *L'Œuvre*.
	April 4. Cézanne's last surviving letter to Zola.
	April 28. Cézanne and Hortense Fiquet married at Aix.
	Summer (?). Visited Choquet at Hattenville.
	October 23. Death of Louis-Auguste Cézanne at Aix.
1887	Probably in Aix most of year.
1888–1889	In Paris, Quai d'Anjou. Also in Chantilly and other suburbs. Possibly in Aix for short time (?).
1889	Picture by Cézanne hung at Exposition Universelle.

1890	In Paris, avenue d'Orléans. Possibly in Aix part of year.
	January. Three pictures by Cézanne exhibited by Les XX in Brussels.
1891	In Paris. Possibly in Aix part of year.
	Summer. In Switzerland and vicinity of Besançon.
1892–1894	In Aix, the forest of Fontainebleau, and Paris (rue des Lions-Saint-Paul).
1895	Autumn. In Aix. Excursions to Bibemus and Mont Sainte-Victoire with the Solaris.
	December. Exhibition of Cézanne's pictures at Vollard gallery.
1896	January–June. In Aix.
	April. First meeting with Joachim Gasquet.
	June. At Vichy.
	July–August. At Talloires, Lake of Annecy.
	September (?)–December. In Paris (Montmartre).
1897	January–April. In Paris, 73 rue Saint-Lazare.
	May. At Mennecy, forest of Fontainebleau.
	June–December. In Aix and Le Tholonet.
	October 25. Death of Cézanne's mother at Aix.
1898	In Aix most of year.
	Autumn. Returned to Paris, rue Hégésippe-Moreau.
1899	In Paris most of year.
	Autumn. Returned to Aix. Lived at 23 rue Boulegon from 1899 to end of life.
	Jas de Bouffan sold to Monsieur Granel.
	Three pictures by Cézanne exhibited at Salon des Indépendants.
1900	In Aix.
	Three pictures exhibited at Paris Centennial Exposition.
1901	In Aix.
	November. Purchased property on Chemin des Lauves for studio.
	Two pictures exhibited at Salon des Indépen-

dants, and one at La Libre Esthétique, Brussels.

1902 In Aix and Le Tholonet. Built studio on Chemin des Lauves.

Three pictures exhibited at Salon des Indépendants.

Autumn. Visited Larguier family in the Cévennes.

September 29. Death of Émile Zola in Paris.

1903 In Aix.

1904 In Aix most of year.

Last visit to Paris and forest of Fontainebleau.

Nine pictures exhibited at La Libre Esthétique, Brussels.

1905 In Aix.

Ten pictures exhibited at Salon d'Automne.

1906 In Aix.

Ten pictures exhibited at Salon d'Automne.

October 22. Death of Paul Cézanne, 23 rue Boulegon, Aix.

CÉZANNE'S POETRY

THE GREATER part of Cézanne's verse is contained in nine letters to Émile Zola written in 1858 and 1859, when Cézanne was about twenty years of age. These letters have not been published before, except for a few extracts in Madame Denise Le Blond-Zola's biography of her father: *Émile Zola, Raconté par sa Fille.* The complete text of the letters is given here, with spelling and punctuation unchanged:

Aix le 9 avril 1858

Bonjour cher Zola

> Enfin je prends la plume
> et selon ma coutume
> je dirai tout d'abord
> pour nouvelle locale
> qu'une forte rafale
> par son ardent effort
> fait tomber sur la ville
> une eau qui rend fertile,
> de l'Arc le riant bord.
> Ainsi que la montagne
> notre verte campagne
> se ressent du printemps
> le platane bourgeonne,
> de feuilles se couronne
> l'aubépin verte, aux bouquets blancs.

Je viens de voir Baille, ce soir je vais à sa campagne (c'est du Grand Baille que je veux parler), donc je t'écris,

> Le temps est brumeux
> sombre et pluvieux,
> et le soleil pâle
> ne fait plus aux cieux
> briller à nos yeux
> ses feux de rubis et d'opale.

Depuis que tu as quitté Aix, mon cher, un sombre chagrin m'accable; je ne mens pas, ma foi. Je ne me reconnais plus moi-même, je suis lourd, stupide et lent. Dis-donc, Baille m'a dit que dans une quinzaine il aurait le plaisir de faire parvenir jusques aux mains de ton éminentissime grandeur une feuille de papier sur laquelle il t'exprimera et son et sa, et ses chagrin et douleurs d'être loin de toi. Vraiment j'aimerai à te voir, et je pense que je te verrons, moi et Baille (bien entendu) aux vacances, et alors nous exécuterons, nous ferons les projets que nous avons formés, mais en attendant je gémis sur ton absence.

> Adieu, mon cher Émile,
> non, sur le flot mobile
> aussi gaîment je file
> que jadis autrefois
> quand nos bras agiles
> comme de reptiles
> sur les flots dociles
> nageaient à la fois.
> Adieu, belles journées
> de vin asaisonnées [*sic*]!
> pêches fortunées
> de poissons montrueux [*sic*]!
> lorsque dans ma pêche,
> à la rivière fraîche
> ma ligne revêche
> n'attrapait rien d'affreux.

Te souviens-tu du pin, qui sur le bord de l'Arc planté, avançait sa tête chevelue sur le gouffre qui s'étendait à ses pieds. Ce pin, qui protégeait nos corps, par son feuillage, de l'ardeur du soleil, ah! Puissent les dieux le préserver de l'atteinte funeste de la hache du bûcheron!

Nous pensons, que tu viendrais à Aix aux vacances, et qu'alors, nom d'un chien, alors la joie. Nous avons projeté des chasses monstrueux, et aussi difformes que nos pêches.

Bientôt, mon cher nous allons recommencer la chasse aux poissons, si le temps continue, il est magnifique aujourdhui car c'est le 13 que je reprends ma lettre.

> Phébus en parcourant sa brillante carrière
> inonde Aix tout entier des flots de sa lumière.

Poème inédit.

> C'était au fond d'un bois
> quand j'entendis sa voix brillante
> chanter et répéter trois fois
> une chansonnette charmante.

Sur l'air du mirliton.

1. J'aperçus une pucelle,
 ayant un beau mirliton.
 en la contemplant si belle
 je sentis un doux frisson
 pour un mirliton etc;

2. ses graces sont merveilleuses
 et son port majestueux
 sur ses lèvres amoureuses
 erre un souris gracieux.
 gentil mirliton etc;

3. je résous de l'entreprendre:
 j'avance résolument:
 et je tiens ce discours tendre

à cet objet charmant.
 gentil mirliton etc;

ne serais-tu pas venue
inexprimable beauté,
des régions de la nue,
pour ma félicité.
 joli mirliton etc;

cette taille de déesse
ces yeux, ce front, tout enfin,
de tes attraits la finesse
en toi tout semble divin.
 joli mirliton etc;

ta démarche aussi légère
que le vol du papillon
devance aisément, ma chère
le souffle de l'aquilon.
 joli mirliton etc;

l'impériale couronne
n'irait pas mal à ton front.
ton mollet, je le soupçonne
doit être d'un tour bien rond.
 joli mirliton etc;

grâce à cette flatterie
elle tombe en pâmoison.
tandis qu'elle est engourdie
j'explore son mirliton.
 ô douce mirliton etc;

puis revenant à la vie
sous mes vigoureux efforts;
elle se trouve ébahie
de me sentir sur son corps.
 ô douce mirliton etc;

elle rougit et soupire,
lève des yeux langoureux
qui semblaient vouloir me dire
je me complais à ces jeux.
 gentil mirliton etc;

au bout de la jouissance
loin de dire: " c'est assez "
sentant que je recommence
elle me dit: " enfoncez."
 gentil mirliton etc;

je retirai ma rapière,
après dix ou douze coups.
mais trémoussant du derrière:
" pourquoi, vous arrêtez-vous? "
 dit ce mirliton etc;

Je ne serais à l'avenir pas aussi paresseux.

Aix le 14 avril.

<div align="right">P. Cézanne</div>

Salve, Carissime Zola.

(P.S.) Tu diras, lorsque tu m'écriras, s'il fait beau temps là-haut. A très-prochainement.

(1). Nota: Bernabo Léon avec Bambou[?] et Alexandre, sont, m'a-t-on dit, au collège, au lycée (je ne sais quelle sorte d'engin c'est) Ste. Barbe à Paris. Quant aux autres deux individus susdits je m'en informerai et t'en donnerai l'adresse dans une prochaine lettre. (Celle-ci est criblée de couillonades.) Si tu voyais les Bernabo souhaite leur le bonjour.

(2). Nota: J'ai reçu ta lettre dans la quelle se trouvaient les affectueux mirlitons que nous avons eu l'honneur de chanter avec la basse Boyer et le ténor léger Baille.

<div align="center">* *</div>

Aix le 29 1858

Mon cher

Ce n'est pas seulement du plaisir que m'a procuré ta lettre, en la recevant j'en ai éprouvé de plus de bien-être. Une certaine tristesse intérieure me possède et vrai dire, je ne rêve que de cette femme dont je te parlai. J'ignore qui elle est; je la vois passer quelquefois dans la rue en allant au monotone collège. J'en suis morbleu à pousser des soupirs, mais des soupirs qui ne se trahissent pas à l'extérieur, ce sont soupirs men*tals* ou men*taux,* je ne sais.

Ce morceau poétique, que tu m'envoies m'a fort réjoui, j'ai beaucoup aimé te voir ressouvenir du pin qui ombrage les bords de Palette. Que j'aimerais, foutu sort qui nous sépare, que j'aimerais te voir arriver. Si je ne me retenais, je lancerais quelques kyrielles de nom de Dieu, de Bordel de Dieu, de sacrée putain, etc, contre le ciel; mais à quoi bon se mettre en colère, cela ne m'avancerait de rien, donc je me résigne. Oui, comme tu le dis dans un autre morceau non moins poétique, cependant je préfère ton morceau sur la nage, tu es heureux, oui tu es heureux toi, mais moi, malheureux, je sèche en silence, mon amour (car c'est de l'amour ce que je ressens) ne saurait éclater au dehors. Un certain ennui m'accompagne partout et par moments seulement j'oublie mon chagrin, c'est lorsque j'ai bu un coup. Aussi, j'aimais le vin, je l'aime plus encore. Je me suis grisé, je me griserai plus encore, à moins que par un inespéré bonheur, hé bien! je puisse réussir, nom d'un Dieu! Mais non, je désespère, je désespère, aussi je vais m'abrutir.

Mon cher, j'expose à tes yeux un tableau représentant: " Cicéron foudroyant Catilina, après avoir découvert la conspiration de ce citoyen perdu d'honneur."

Admire, cher ami, la force du langage
Dont Cicéron frappa ce méchant personnage,
Admire Cicéron dont les yeux enflammés
Lancent de ces regards de haine envenimés,
Qui renversent Statius, cet ourdisseur de trames
Et frappent de stupeur ses complices infâmes.
Contemple! cher ami, vois bien Catilina

409

Qui tombe sur le sol, en s'écriant " Ah! ah! ah! "
Vois le sanglant poignard dont cet incendiaire
Portait à son côté la lame sanguinaire.
Vois tous les spectateurs émus, terrifiés
D'avoir été bien près d'être sacrifiés.
Vois-tu cet étendard, dont la pourpre romaine
Autrefois écrasa Carthage l'Africaine?
Quoique je sois l'auteur de ce fameux tableau
Je frissonne, en voyant un spectacle si beau.
A chaque mot qui sort, (j'ai horreur, je frissonne)
De Cicéron parlant tout mon sang en bouillonne.
Et je prévois déjà, je suis bien convaincu
Qu'à cet aspect frappant, tu seras tout ému.
Impossible autrement. Non jamais, autre chose
Dans l'empire romain ne fut plus grandiose.
Vois-tu des cuirassiers les panaches flottants,
Ballottés dans les airs par le souffle des vents.
Vois aussi, vois aussi cet appareil de piques
Qu'a fait poster par là l'auteur des Philippiques.
C'est te donner, je crois, un spectacle nouveau
Que t'exposer aussi l'aspect de l'écriteau.
" Senatus, Curia." Ingénieuse idée
Pour la première fois par Cézanne abordée!
Ô sublime spectacle aux yeux très surprenant
Et qui plonge dans un profond étonnement.

Mais c'est assez avoir fait ressortir à tes yeux les beautés incomparables incluses dans cette admirable aquarelle. Le temps se remet, je ne sais pas trop si ça continuera. Ce qu'il y a de sûr c'est que je brûle d'aller:

En plongeur intrépide
Sillonner le liquide
 De l'Arc.
Et dans cette eau limpide
Attraper les poissons que m'offre le hasard.

Amen! amen! ces vers sont stupides.

Ils ne sont pas pleins de goût
Mais ils sont stupides
Et ne valent rien du tout.

Adieu, Zola, adieu.

Je vois qu'après mon pinceau, ma plume ne peut rien dire de bien
et en vain aujourdhui tenterais-je de

Te chanter quelque nymphe de bois
Je ne me trouve pas une assez belle voix
Et les beautés des campagnes agrestes
Sifflent de mes chansons les tours trop peu modestes.

Enfin je termine, car je ne fais qu'entasser bêtises sur stupidités.
Tel on voit vers les cieux, un tas d'absurdités s'élever avec les stu-
pidités.
C'est assez.

P. Cézanne

* *

le 9 juillet 1858

Carissime Zola, Salve.

Accepi tuam litteram, inqua mihi dicebas te cupere ut tibi rimas
mitterem ad bout-rimas faciendas, gaude; ecce enim pulcherrimas
rimas. Lege igitur, lege, et miraberis!

révolte	Bachique	borne
récolte	chique	corne
vert	uni	brun
découvert	bruni	rhum
chimie	métaphore	aveugle
infamie	phosphore	beugle
Zola	bœuf	
voilà	veuf	

Lesquelles susdites rimes tu auras la licence, primo de les mettre
au pluriel, si ta vénérissime majesté ainsi l'aura jugé, secundo; tu
pourras les mettre dans l'ordre que tu voudras; mais tertio, je te de-

411

mande des Alexandrins, et enfin quarto, je veux; non je ne veux pas; mais je te prie de tout mettre en vers même Zola.

Voici de moi de petits vers que je trouve admirables, parcequ'ils sont de moi — et la bonne raison c'est que j'en suis l'auteur.

Petits vers.

Je vois Leydet
sur un bidet.
Poignant son âne
et triomphant
il va chantant
sous un platane.

l'âne affamé
tout enflammé
tend vers la feuille
joyeux et fol
un très-long col
qui bien la cueille.

Boyer chasseur
plein de valeur
met dans sa poche
un noir cul-blanc
qui plein de sang
verra la broche.

Zola nageur
fend sans frayeur
l'onde limpide.
son bras nerveux
s'étend joyeux
sur le doux fluide.

Le temps est très-brumeux ajourdhui [*sic*].
Dis-donc je viens de faire un couplet: le voici

de la dive bouteille
célébrons la douceur

sa bonté sans pareille
fait du bien à mon cœur.

Ceci doit être chanté sur l'air:

d'une mère chérie célébrons la grandeur etc.

Mon cher, je crois assurément que tu doives suer lorsque tu me dis
dans ta lettre,

que ton front tout baigné d'une chaude sueur
était environné de la docte vapeur
qu'exhale jusqu'à moi l'horrible Géométrie!
(ne prends pas au sérieux cette dure infamie)
si je qualifie
ainsi la Géométrie!

c'est qu'en l'étudiant je me sens tout le corps se fondre en eaux sous
mes trop impuissants efforts.
Mon cher lorsque tu m'auras fait parvenir ton bout-rimé,

car dans les bouts-rimés je te trouve adorable
et dans tes autres vers vraiment incomparable!

je me mettrais à la recherche d'autres rimes et plus riches et plus dif-
formes, j'en prépare, j'en élabore, j'en distille dans mon alambic-
cerveau. Ce seront des rimes neuves, Heum! des rimes comme on en
voit guère, morbleu, enfin des rimes accomplies.
Mon cher après avoir commencé cette lettre le 9 juillet il est juste
au moins que je la termine aujourdhui 14, mais hélas, dans mon aride
esprit, je ne trouve pas la moindre petite idée, et cependant avec toi
que de sujets n'ai-je pas à traiter et la chasse, et la pêche, et la nage
en voilà-t-il pas de sujets variés, et l'amour (Impudens n'abordons
pas ce sujet corrupteur:

notre âme encore candide,
marchant d'un pas timide,
n'a pas encore heurté
au bord du précipice

où si souvent l'on glisse;
cette époque corruptrice
je n'ai pas encore porté,
à mes lèvres innocentes,
le bol de la volupté
où les âmes aimantes
boivent à satiété.

En v'là une détirade mistique [*sic*], heum, dis-donc, il me semble que je te vois lire ces vers soporifiques, je te vois (c'est un peu loin pourtant) branler la tête en disant ça ne ronfle pas chez lui la poésie.

Lettre finie le 15 au soir

Chanson en ton honneur!

(Je chante ici comme si nous nous étions ensemble adonnés à toutes les joies de la vie humaine, c'est pour ainsi dire une élégie; c'est vaporeux [*sic*] tu vas voir.

Le soir assis au flanc de la montagne
mes yeux au loin erraient sur la campagne
je me disais, quand donc une compagne,
de tant de mal qui m'accable aujourdhui
viendra, grands dieux, soulager ma misère?
Oui, avec elle, elle me paraîtrait légère
si Gentillette ainsi qu'une bergère
aux doux appas, au menton rond et frais
aux bras bondis, aux mollets très-bien faits,
à la pimpante crinoline
à la forme divine
à la bouche purpurine
 digue, dinguedi, dindigue, dindon
 et ô le joli menton.

Je termine enfin car je vois que je ne suis vraiment pas en verve, hélas.

Hélas! Muses, pleurez, car votre nourisson [*sic*]
ne peut pas même faire une courte chanson.

Ô du bachot examen très-terrible!
des examinateurs à face trop horrible!
si je passais, ô plaisir indicible
grands dieux je ne sais ce que je ferais

Adieu mon cher Zola je divague toujours

P. Cézanne

J'ai conçu l'idée d'un drame en 5 actes, que nous intitulerons (toi et moi) : Henri VIII d'Angleterre. Nous ferons ça ensemble, aux vacances.

* *

The following composite letter is written partly by Cézanne, partly by Baille. The beginning is in Cézanne's handwriting:

le 26 juillet 1858

Mein liebe Freund [*sic* — in German script]

C'est Cézanne qui écrit, et c'est Baille qui dicte. Muses! de l'Hélicon descendez jusque dans nos veines pour célébrer le triomphe baccalauréatal de moi (c'est Baille qui parle et moi ce ne sera que la semaine prochaine).

In Baille's handwriting:

Cette bizarre originalité convenait assez à nos caractères. Nous allions te donner une foule d'énigmes à deviner: mais, les destins en ont décidé autrement. Je venais chez l'ami poétique, fantastique, bachique, érotique, antique, physique, géométrique, que nous avons. Il avait déjà mis le 26 juillet 1858, et attendait l'inspiration. Je lui en donne une: je mets le titre en allemand. Il allait écrire sous ma dictée, et semer à profusion en même temps que les figures de sa réthorique [*sic*], les fleurs de ma géométrie (permets-moi cette transposition, tu aurais pu croire que nous allions t'envoyer des triangles, et autres choses pareilles). Mais, mon cher, l'amour qui perdit Troie cause encore bien du mal. J'ai des graves soupçons pour croire qu'il

415

est amoureux (il ne veut pas en convenir).

In Cézanne's handwriting:

Mon cher, c'est Baille, qui d'une main téméraire, (ô vain esprit) vient de tracer ces lignes perfides, son esprit n'en fait jamais d'autres. Tu le connais assez bien, tu sais ses folies avant qu'il eut subi l'examen terrible, que n'est-il donc maintenant? Quelles idées burlesques, informes ne naissent point de son esprit malignement railleur. (Tu sais Baille est bachelier en lettres — moi je me présente le 4 août, fassent les dieux tout-puissants que je n'aille pas me briser le nez dans ma chûte, hélas, prochaine. Je bûche, grands dieux, je me casse la tête à ce travail abominable.

> Je frémis, quand je vois toute la géographie,
> l'histoire, et le latin, le grec, la géométrie
> conspirer contre moi; je les vois menaçants
> ces examinateurs dont les regards perçants
> jusqu'au fond de mon cœur portent un profond trouble.
> Ma crainte, à chaque instant, terriblement redouble!
> Et je me dis: " Seigneur, de tous ces ennemis,
> pour ma perte certaine impudemment unis,
> dispersez, confondez la troupe épouvantable.
> La prière, il est vrai, n'est pas trop charitable!
> Exaucez-moi pourtant, de grâce, mon Seigneur
> je suis de vos autels un pieux serviteur.
> D'un encens quotidien j'honore vos images.
> Ah! terrassez, Seigneur, ces méchants personnages.
> Les voyez-vous déjà, prompts à se rassembler,
> ils se frottent les mains prêts à nous tous couler?
> Les voyez-vous, Seigneur, dans leur cruelle joie
> compter déjà des yeux quelle sera leur proie?
> Voyez, voyez, Seigneur, comment sur leurs bureaux
> ils groupent avec soin les fatals numéros!
> Non, non, ne souffrez pas que victime innocente
> je tombe sous les coups de leur rage croissante.
> Envoyez votre Esprit-Saint sanctificateur!
> qu'il répande bientôt sur votre serviteur
> de son profond savoir l'éclatante lumière,

416

et si vous m'exaucez, à mon heure dernière
vous m'entendrez encore beugler des oremus,
dont vous, saintes et saints, serez tout morfondus.
De grâce, veuillez bien, veuillez, Seigneur, m'entendre,
Daignez aussi, Seigneur, ne pas vous faire attendre
 (dans l'envoi de vos grâces sous-entendu)
Puissent mes vœux monter jusqu'au céleste Éden:
 In sæcula, sæculorum, amen!

En v'là une digression sogrenue [*sic*]! qu'en dis-tu? n'est-elle pas difforme? Ah! si j'avais le temps tu en avalerais bien d'autres — à propos, un peu plus tard, je t'enverrai tes bout-rimés.

Adresse quelque prière au Très-Haut (Altissimo) pour que la faculté me décore du titre tout souhaité.

In Baille's handwriting:

A mon tour à continuer: je ne vais pas te faire avaler des vers: je n'ai presque plus rien à te dire, sinon que nous t'attendons tous: Cézanne et moi, moi et Cézanne. Nous bûchons en attendant. Viens donc: seulement je ne viens pas chasser avec vous: entendons nous seulement: je ne chasserais pas mais je vous accompagnerais. Enfin quoi! Nous pourrons faire encore de bonnes parties: je porterais la bouteille, moi: quoique ce soit le plus pesant! Cette lettre t'a déjà ennuyé: Elle est faite pour cela: je ne veux pas dire que ce soit dans cette intention que nous l'ayons fait.

Présente nos respects à ta mère (je dis *nos* et pour cause: La Trinité n'est qu'une seule personne).

Nous te serrons la main: cette lettre est de deux originaux.

BaCézanlle

In Cézanne's handwriting:

Tu vois dans cette lettre l'œuvre de deux originals.

Mon cher, quand tu viendras, je laisserai pousser barbe et moustache: je t'attends ad hoc. Dis-donc as-tu barbe et moustache.

Adieu, mon cher, je ne comprends pas comment je suis si bête.

* *

417

mercredi 17 9^{bre} [novembre] 1858

Travaille, mon cher, nam labor improbus omnia vincit.

Excuse, ami, excuse-moi! Oui, je suis coupable, cependant à tout péché misericorde. Nos lettres doivent s'être croisées, tu me diras, lorsque tu m'écriras encore, tu n'a pas besoin pour cela de te déranger, si tu n'as pas reçu une lettre datée de ma chambre

> rimant avec le quatorze novembre.

J'attends la fin du mois pour que, m'envoyant une nouvelle lettre, tu m'y donnes le titre d'un longissime poème que je veux faire, et dont je te parle dans ma lettre du 14 novembre, ce que tu pourras voir, si tu la reçois, sinon, je ne puis guère m'intrepréter [*sic*] sa non arrivée chez toi, mais comme rien n'est impossible, je me suis donc hâté de t'écrire. J'ai été reçu bachelier, mais tu dois le savoir par cette même lettre du 14 en admettant qu'elle te soit parvenue.

Sacre nom, sacre nom de 600,000 bombes! Je ne peux pas rimer.

> Je tombe et tu sucombes [*sic*]
> aux 600,000 éclats des 600,000 bombes.

> C'est trop d'esprit en un seul coup, oui je le sens (bis)
> je dois jeune en mourir
> car comment tant d'esprit en moi pourrait tenir?
> Je ne suis pas assez vaste, et ne puis suffire
> à contenir l'esprit, aussi jeune j'expire.

J'ai écrit à Baille, pour lui faire part, et lui annoncer irrévocablement et définitivement que je suis bachelier. Hein! Hum!

> Oui, mon cher, oui mon cher une très-vaste joie,
> à ce titre nouveau, dans mon cœur se déploie,
> du latin et du grec je ne suis plus la proie.
> Ô très-fortuné jour, ô jour très-fortuné
> où, ce titre pompeux pût m'être décerné;
> oui, je suis bachelier — c'est une grande chose,
> qui dans l'individu fait bachelier, suppose
> du grec et du latin une fameuse dose!

Matière de vers latins donnée en Rhétorique et traduite en français
par nous, poète.

Songe d'Annibal.
Annibalis Somnium.

Au sortir d'un festin le héros de Carthage,
dans lequel on avait fait trop fréquent usage
du Rhum et de Cognac, trébuchait, chancelait.
oui, déjà le fameux vainqueur de Carme allait
s'endormir sous la table: ô étonnant miracle!
Des débris du repas effrayante débâcle!
Car d'un grand coup de poing qu'applique le héros
sur la nape [*sic*] le vin s'épandit à grands flots.
Les assiettes, les plats et les saladiers vides
roulèrent tristement dans des ruisseaux limpides,
de punch encore tout chaud, regrettable dégat!
Se pouvait-il, messieurs, qu'Annibal gaspillât,
infandum, infandum, le Rhum de sa patrie!
Du vieux troupier français, ô liqueur si chérie!
Se pouvait-il, Zola, commettre telle horreur,
sans que Jupin vengeat cette affreuse noirceur!
Se pût-il qu'Annibal perdit si bien la tête
pour qu'il pût s'oublier d'une façon complète,
ô Rhum! — Éloignons-nous d'un si triste tableau!
ô Punch tu méritais un tout autre tombeau!
que ne t'a-t-il donné ce vainqueur si farouche
un passe-port réglé pour entrer dans sa bouche
et descendre tout droit au fond de l'estomac!
Il te laisse gisant sur le sol, ô Cognac!
Mais par quatre laquais, irrévocable honte,
est bientôt enlevé le vainqueur de Sagonthe
et posé sur un lit: Morphée et ses pavots
sur ses yeux alourdis font tomber le repos,
il baille, étend les bras, s'endort du côté gauche;
Notre héros pionçait après cette débauche,
quand les songes légers le formidable essaim
s'abattit tout-à-coup auprès du traversin.

Annibal dormait donc. — Le plus vieux de la troupe
s'habille en Amilcar, il en avait la coupe —
Les cheveux hérissés, le nez proéminent
une moustache épaisse extraordinairement.
ajoutez à sa joue une balafre énorme
donnant à son visage une binette informe
et vous aurez, messieurs, le portrait d'Amilcar.
quatres grands chevaux blancs attelés à son char
le traînait: Il arrive, et saisit Annibal par l'oreille
et bien fort le secoue: Annibal se reveille,
et déjà le courroux. . . . Mais il se radoucit
en voyant Amilcar qu'affreusement blémit
la colère contrainte: Indigne fils, indigne!
vois-tu dans quel état le jus pur de la vigne
t'a jeté, toi, mon fils. Rougis, corbleu, rougis,
jusques aux blanc de l'œil. Tu traînes sans souci,
au lieu de guerroyer, une honteuse vie.
Au lieu de protéger les murs de ta patrie,
au lieu de repousser l'implacable Romain,
au lieu de préparer, toi vainqueur au Tesin.
à Trasimène, à Carme, un combat où, la ville,
qui fut des Amilcars toujours le plus hostile
et le plus acharnés de tous les ennemis,
vit tous ses citoyens par Carthage soumis.
Ô fils dégénéré, tu fais ici la noce!
hélas, ton pourpoint neuf est tout taché de sauce,
du bon vin de Madère et du Rhum! C'est affreux!
Va, suis plutôt, mon fils, l'exemple des aïeux.
Loin de toi, ce cognac et ces femmes lascives
que tiennent sous le joug nos âmes trop captives!
Abjure les liqueurs — c'est très-pernicieux
et ne bois que de l'eau, tu t'en trouveras mieux.
A ces mots Annibal appuyant sur son lit
sa tête, de nouveau profondément dormit.

As-tu trouvé jamais style plus admirable?
si tu n'es pas content, tu n'es pas raisonnable.

<div align="right">P. Cézanne</div>

* *

Aix le 7 decbre 1858

Mon cher, tu m'avais pas dit que ta maladie avait été grave, très-grave. Il fallait me l'apprendre, monsieur Leclerc me l'a appris à ta place; mais puisque te voilà bien, salut.

Après avoir quelque temps balancé — car je te l'avoue ce Pitot ne m'allait pas d'abord — je me suis enfin décidé de le traiter le moins pitoyablement possible. Ainsi donc je me suis mis à l'œuvre; mais, par ma foi, je ne sais pas ma mythologie; cependant je me rangerai de façon à connaître les exploits de master Hercule, et les convertirai en hauts faits de Pitot, autant que faire se peut. Je t'annonce que mon œuvre — si cela peut mériter le nom d'œuvre plutôt que celui de gachis — sera longtemps par moi élaborée, digérée, perfectionnée, car j'ai peu de temps à consacrer au récit aventureux de Pitot Herculéen —

Hélas, j'ai pris du Droit la route tortueuse.
J'ai pris, n'est pas le mot, de prendre on m'a forcé.
Le droit, l'horrible droit d'embages enlacé
rendra pendant trois ans mon existence affreuse!

Muses de l'Hélicon, du Pinde, du Parnasse
venez, je vous en prie, adoucir ma disgrâce.
Ayez pitié de moi, d'un malheureux mortel
arraché malgré lui d'auprès de votre autel.
du Mathématicien les arides problèmes
son front pali, ridé, ses lèvres aussi blêmes
que le blême linceul d'un revenant terreux,
je le sais, ô 9 soeurs, vous paraissent affreux!
mais celui qui du droit embrasse la carrière
de vous et d'Apollon perd la confiance entière.
Sur moi ne jetez pas un œil trop dédaigneux
car je fus moins coupable, hélas, que malheureux.
Accourez à ma voix, secourez ma disgrâce
et dans l'éternité je vous en rendrai grâce.

Ne dirais-tu pas à entendre, non à lire, ces insipides vers que la muse de la poésie s'est à jamais retiré de moi. Hélas, v'là ce qu'a fait ce misérable droit

Ô droit qui t'enfanta, quelle cervelle informe
créa, pour mon malheur, le digeste difforme?
Et ce code incongru que n'est-il demeuré
durant un pêche encore dans la France ignoré?
Quelle étrange fureur, quelle bêtise et quelle
folie avait troublé ta tremblante cervelle,
ô piètre Justinien des Pendectes fauteur,
et du Corpus juris impudent redacteur?
N'était-ce pas assez qu'Horace et que Virgile,
que Tacite et Lucain, d'un texte difficile
vinssent, durant 8 ans, nous présenter l'horreur
sans t'ajouter à eux, causes de mon malheur!
S'il existe un enfer, et qu'une place y reste,
Dieu du ciel, plongez y le gérant du Digeste.

Informe-toi du concours de l'Académie, parceque je persiste dans l'intention que nous avions pris de concourir à quel prix que ce fut, pourvu que cela ne coutât rien, bien entendu.

Tu sais que de Boileau l'òmoplate cassé
fut trouvé l'an dernier dans un profond fossé,
et que creusant plus bas des maçons y trouvèrent
tous ses os racornis — qu'à Paris ils portèrent.
là, dans un muséum, ce roi des animaux
fut classé dans le rang des vieux Rhinocéros.
puis on grava ces mots, au pied de sa carcasse:
" Ci-repose Boileau le recteur du Parnasse "
ce récit que voilà, tout plein de vérité
te fait bien voir le sort qu'il avait mérité
pour avoir trop loué dans sa verve indiscrète
le quatorzième Louis, de nos rois le plus bête.
Puis cent francs l'on donna, pour les recompenser,
aux ardents travailleurs, qui pour cette trouvaille,
portent, avec ces mots, une belle médaille:
" Ils ont trouvé Boileau dans un profond fossé."

Hercule, un certain jour, dormait profondément
dans un bois, car le frais était bon, car vraiment

s'il ne s'était tenu sous un charmant bocage
et s'il avait été exposé à la rage
du soleil, qui dardait, des rayons chaleureux
peut-être aurait-il pris un mal de tête affreux.
Donc il dormait très-fort. Une jeune dryade
passant tout près de lui, . . .

mais je vois que j'allais dire quelque sottise donc je me tais. Permets-
moi de finir cette lettre aussi bêtement finie que commencée.

Je souhaite mille et une bonnes fortunes, joies, voluptés, adieu mon
cher, salut à monsieur Aubon [?], à tes parents, adieu, je te salue

<div align="right">

ton ami

P. Cézanne

</div>

P.S. Je viens de recevoir ta lettre, ça me fait fort plaisir; cependant
je te prie à l'avenir d'employer du papier un peu plus mince, car tu
as occasionné à ma bourse une saignée qui lui a porté préjudice,
grands dieux, ces monstres-là d'administrateurs de poste m'ont fait
payer, 8 sous, j'aurai eu de quoi t'envoyer deux lettres de plus —
ainsi donc emploie du papier un peu plus fin. Adieu, mon cher —

<div align="center">

* *

</div>

The following letter is undated. The text indicates that it was written
on July 29, and the year is almost certainly 1858 or 1859:

Mon cher Zola,

Tu me diras peut-être, Ah! mon pauvre **Cézanne**
quel démon féminin a démonté ton crâne,
toi que j'ai vu jadis marcher d'un pas égal,
ne faisant rien de bien, ne disant rien de mal?
Dans quel chaos confus de rêves si bizarres,
comme en un océan aujourdhui tu t'égarres [*sic*]
aurais-tu vu danser par hazard [*sic*] la Polka
par quelque jeune nymphe, artiste à l'Opéra?
m'aurait-tu pas écrit, endormi sous la nappe
après t'être énivré comme un diacre du pape,
ou bien, mon cher, rempli d'un amour rococo,

<div align="right">

423

</div>

le vermouth t'aurait-il frappé sur le coco?
ni l'amour, ni le vin n'ont touché ma sorbonne
et je n'ai jamais cru que l'eau seule fut bonne,
ce seule raisonnement doit te prouver, mon cher,
que bien qu'un peu rêveur je vois pourtant très-clair.

N'aurais-tu jamais vu dans tes heures rêveuses
comme dans un brouillard des formes gracieuses,
indécises beautés dont les ardents appas,
rêvés durant la nuit, le jour ne se voient pas;
comme on voit le matin la vapoureuse [sic] brume,
quand le soleil levant de mille feux allume
les verdoyants coteaux où bruissent les forêts,
les flots étincelants des plus riches reflets
de l'azur; puis survient une brise légère
qui chasse en tournoyant la brume passagère,
c'est ainsi qu'à mes yeux se présentent parfois
des êtres ravissants, aux angéliques voix,
durant la nuit. Mon cher, on dirait que l'aurore
d'un éclat frais et pur à l'envi les colore,
ils semblent me sourire et je leur tends la main,
mais j'ai beau m'approcher, ils s'envolent soudain,
ils montent dans le ciel, portés par le Zéphyre
jetant un regard tendre et qui semblent me dire,
adieu; près d'eux encore je tente d'approcher
mais c'est en vain, en vain que je veux les toucher,
ils ne sont plus, déjà la gaze transparente
ne peint plus de leur corps la forme ravissante.

Mon rêve évanoui, vient la réalité,
qui me trouve gisant le cœur tout attristé,
et je vois devant moi se dresser un fantôme
horrible, monstrueux, c'est le Droit qu'on le nomme.

Je crois que j'ai plus fait que de rêver, je me suis endormi, et je
dois t'avoir congelé par ma platitude, mais j'avais rêvé que je tenais
dans mes bras, ma lorette, ma grisette, ma mignonne, ma friponne,
que je lui tapais sur les fesses et bien autre chose encore.

424

Ô crasse lycéenne! ignoblissimes croûtes!
ô vous qui barbotez dedans les vieilles routes
que dédaignent tous ceux dont la moindre chaleur
fait naître quelque élan sublime dans leur cœur;
quelle insane manie à critiquer vous pousse
celui là qui se rit de si faible secousse
myrmidons lycéens! admirateurs forcés
de ces tristes vers plats que Virgile a laissés:
vrai troupeaux de pourceaux qui marche sous l'égide
d'un pédant tout pourri, qui bêtement vous guide
vous forçant d'admirer sans trop savoir pourquoi
des vers que vous trouvez beaux sur sa seule foi,
quand au milieu de vous surgit comme une lave
un poète sans frein, qui brise toute entrave,
comme autour de l'aiglon l'on entend criailler
mille chétifs oiseaux; bons rien qu'à fouailler,
ô mesquins détracteurs, prêtres de la chicane
vous vomissez sur lui votre bave profane.
Je vous entends déjà, vrais concerts de crapeauds [*sic*]
vous égosiller tous chantant sur un ton faux
non, on a jamais vu, dans le monde, grenouille
qui, comme vous, messieurs, plus sottement bredouille.
Mais remplissez les airs de vos sottes clameurs
les vers de mon ami demeureront vainqueur
ils ressisteront [*sic*] tous à votre vilainie,
car ils sont tous marqués au vrai coin du génie.

Baille m'a dit que les lycéens, tes confrères en travail avait [*sic*] eu
l'air, assez saugrenu par ma foi, de vouloir critiquer ta pièce à l'im-
pératrice, ça m'a chauffé la bile et quoique un peu tard, je leur lance
cependant cette apostrophe dont les termes ne sont que trop faibles
pour qualifier ces pingouins littéraires, ébauches avortées, asthma-
tiques persifleurs de tes rimes sincères; si bon te semble tu leur fera
passer mon compliment et tu leur ajouteras que s'ils veulent dire
quelque chose, je suis ici à les attendre tous tant qu'ils sont prêt à
boxer le premier qui me tombera sous le poing.

Ce matin 29 juillet à 8 heures du matin j'ai vu monsieur Leclerc,
qui m'a dit que la plus jeune fille M——— et jadis la plus jolie était

chancrée des pieds à la tête, et sur le point de rendre le souffle sur les sangles de l'hôpital, sa mère qui a également trop guigné du cul gémit de ses fautes dernières, enfin l'ainée des deux filles, donc celle qui jadis était la plus laide et qui l'est actuellement le plus encore, porte, pour avoir trop bandé, un bandage.

ton ami, qui boit du Vermouth à ta santé,

P. Cézanne

adieu à tous les parents et également à Houchard.

* *

Aix 30 novembre 1859

I

Mon cher, si je suis si tardif
à te donner en rime en if
le résultat définitif
sur l'examen rébarbatif
dont le souci m'était très-vif

c'est que (je ne suis pas en verve) vendredi, mon examen a été remis à lundi 28, pourtant j'ai été reçu.

chose facile à croire
avec deux rouges et une noire.
Aussitôt j'ai voulu rassurer tes esprits,
dans le doute flottant sur mon sort indécis.

II

La Provence bientôt verra dans ses colonnes
du flasque Marguery l'insipide roman;
à ce nouveau malheur, Provence, tu frissonnes!
et le froid de la mort a glacé tout ton sang.

III

Esprits inspirateurs de Gaut, Gaut lui-même
redigeant le sublime Mémorial.

Un Esprit.
Grand maître, avez-vous lu le roman feuilleton
que la Provence vient de mettre en livraison.

Gaut.
C'est du dernier mauvais.

Un Second Esprit.
J'en dis de même, maître,
la Provence jamais au jour n'a fait paraître
rien de plus saugrenu.

Gaut.
Quel est le polisson
assez présomptueux pour braver mon renom
et venir après moi, moi flambeau de la Presse,
d'un roman si mesquin étaler la détresse.

Un Esprit.
Son nom jusqu'à ce jour plongé dans le brouillard
veut se produire enfin. . . .

Un esprit autre.
juste ciel, quel écart!

Gaut.
Et que pense-t-il faire, aurait-il donc l'audace
de vouloir ici-bas marcher sur notre trace
oserait-il prétendre atteindre la hauteur
audessus du vulgaire où je règne en vainqueur?

Un esprit.
Non, maître, non jamais, car sa plume débile
ne connait nullement comme un roman se file,
comment par une intrigue embrouillée, aux lecteurs
qui vous lisent on fait arriver les vapeurs.

427

Un autre esprit.
Il ignore surtout cet art si difficile
cet art, où plus que vous aucun autre est habile
cet art si précieux, et pénible d'autant,
cet art ambitionné, dont Dieu nous fit présent
cet art, enfin, cet art, que tout le monde admire,
et que pour l'exprimer nul mot n'y peut suffire.

Gaut.
C'est bien, je te comprends, c'est la *Verbologie*.
du grégo-latin sort son étymologie.
En effet sous l'azur des cieux aux mille feux
quel est le *gunogène* assez audacieux
pour proclamer avoir inventé quelque chose
de plus beaux que les noms employés dans ma prose,
mes *carmines* français sont très-supérieurs
à tout ce qu'ont produit un tas de rimailleurs;
et mes romans surtout, ce champ que je domine
et comme le soleil, se levant, illumine
les *excelses* hauteurs des *virides* forêts,
comme un prisme brillant au monde j'apparais.

Un Esprit.
Domine souverain, Esprit incomparable
louange soit rendue à votre inestimable
vertu,

Un chœur d'esprits.
toi seul, toi seul grand Gaut, innovateur
sublime, dans les cieux planes avec grandeur.

Les plus brillants *sidères*
au feu de tes paupières
courbent leur front confus.
Ébloui de ta gloire,
sans tenter la victoire
croissant ses bras moulus
et remuant la tête,

428

Ludovico s'arrête
et dit: je n'écris plus.

Gloire, à toi, gloire à toi, Gaut *philonovostyle,*
pour t'égaler, grand Gaut, ce sera difficile.

Dictionnaire explicatif du langage Gautique.

Verbologie — art sublime inventé par Gaut, cet art consiste à
tirer du latin et du grec des mots nouveaux.
gunogène — du grec Γυνή (femme) et du latin gignere (engen-
dre), le gunogène est donc celui qui est engendré par la
femme, c'est-à-dire l'homme.
carmines — du latin carmina (vers)
excelses — de excelsus (élevé)
virides — du latin virides (verdoyants)
Domine — Dominus (maître)
sidères — sidera (astres)
philonovostyle — de Φίλος ami, novus, nouveau, et de style (ami
du nouveau style).

Mon cher, maintenant que je t'ai assez ennuyé, permets-moi de
mettre fin à ma stupide épitre, adieu, carissime Zola, salve. Salut à tes
parents, à tous.

ton ami
P. Cézanne

Quand il adviendra quelque chose de nouveau je te l'écrirai.
Jusqu'ici le calme régulier et habituel environne toujours de ses
ailes moussades notre plate cité.
Ludovico est toujours un écrivain plein de feu, de verve et d'ima-
gination.
Adieu, mon cher, adieu.

* *

The next letter is without a date. According to the text it was writ-
ten on December 29, and the year is probably either 1858 or 1859:

Cher ami, cher ami quand des vers l'on veut faire
la rime au bout du vers est chose nécessaire;
dans cette lettre donc, s'il vient mal à propos
pour compléter mon vers se glisser quelques mots,
ne vas pas t'offusquer d'une rime stérile
qui ne se cogne là que pour se rendre utile;
te voilà prévenu: je commence et je dis
aujourdhui 29 décembre je l'écris.
Mais, mon cher, aujourdhui fortement je m'admire
car je dis aisément tout ce que je veux dire;
pourtant il ne faut pas se réjouir trop tôt
la rime, malgré moi, peut me faire défaut.
De Baille, notre ami j'ai reçu la visite
et pour t'en informer je te l'écris bien vite.

mais le ton que je prends me semble être trop bas
sur les hauteurs du Pinde il faut porter mes pas:
car je ressens du ciel l'influence secrète;
je vais donc déployer mes ailes de poète
et m'élevant bientôt d'un vol impétueux
je m'en irai toucher à la voûte des cieux.
mais de peur que l'éclat de ma voix t'éblouisse,
je mettrai dans ma bouche un morceau de Réglisse,
le quel interceptant le canal de la voix
n'étourdira plus par des cris trop chinois.

— Une terrible histoire. —

C'était durant la nuit. — Notez bien que la nuit
est noire, quant au ciel aucun astre ne luit.
Il faisait donc très-nuit, et nuit même très-noire
lorsque dût se passer cette lugubre histoire.
C'est un drame inconnu, monstrueux, inouï
et tel qu'aucune gens n'en a jamais ouï.
Satan, bien entendu, doit y jouer un rôle,
la chose est incroyable, et pourtant ma parole
que l'on a toujours crue est là pour constater
la vérité du fait que je vais te conter.

430

Écoute bien: c'était minuit, heure à laquelle
tout couple dans son lit travaille sans chandelle,
mais non pas sans chaleur. Il faisait chaud — c'était
par une nuit d'été; dans le ciel s'étendait
du nord jusqu'au midi, présageant un orage
et comme un blanc suaire, un immense nuage.
La lune par instants déchirant ce linceul
éclairait le chemin, où, perdu, j'errais seul.
Quelques gouttes tombant à de courts intervalles
tachaient le sol: des terribles rafales
précurseur ordinaire, un vent impétueux
soufflant du Sud au Nord, s'éleva furieux;
Le simoun qu'en Afrique, on voit épouvantable
enterrer les cités sous des vagues de sable,
des arbres qui poussaient leurs rameaux vers les cieux
courba spontanément le front audacieux.
Au calme succéda la voix de la tempête.
Le sifflement des vents que la forêt repète
terrifiait mon cœur. L'éclair avec grand bruit,
terrible sillonnait les voiles de la nuit:
vivement éclairés par sa lueur blafarde
je voyais les lutins, les gnomes, Dieu m'en garde,
qui volaient, ricanant, sur les arbres buissants.
Satan les commandait: je le vis, tous mes sens
se glacèrent d'effroi; son ardente prunelle
brillait d'un rouge vif; parfois une étincelle
s'en détachait jetant un effrayant reflet.
La ronde des démons près de lui circulait . . .
je tombai; tout mon corps, glacé presque sans vie,
tremble sous le conctat [sic] d'une main ennemie.
Une froide sueur inondait tout mon corps,
pour me lever et fuir faisant de vains efforts
je voyais de Satan la bande diabolique
qui s'approchait, dansant sa danse fantastique;
Les lutins redoutés, les vampires hideux
pour s'approcher de moi se culbutaient entre eux;
ils lançaient vers le ciel leurs yeux pleins de menaces,
rivalisant entre eux à faire des grimaces . . .

431

"Terre, ensevelis-moi! Rochers, broyez mon corps!
je voulus m'écrier, ô Demeure des morts,
recevez-moi vivant." Mais la troupe infernale
resserrait de plus près son affreuse spirale:
les goules, les démons grinçaient déjà des dents,
à leur festin horrible ils préludaient. — Contents,
ils jettent des regards, brillants de convoitise.
C'en était fait de moi . . . quand, ô douce surprise!
tout-à-coup au lointain retentit le galop
des chevaux hennissants qui volaient au grand trot.
Faible d'abord le bruit de leur course rapide
se rapproche de moi; le cocher intrépide
fouettant son attelage, excitant de sa voix
le quadrige fougueux qui traversaient les bois.
à ce bruit, les démons, les troupes morfondues
se dissipent, ainsi qu'au zéphyre les nues.
moi, je me réjouis, puis plutôt mort que vif
je hèle le cocher: l'équipage attentif
s'arrête sur le champ. Aussitôt du calèche
sortit en minaudant une voix douce et fraîche.
"montez, elle me dit, montez. — Je fais un bond:
la portière se ferme, et je me trouve front
à front d'une femme . . . Oh! je jure sur mon âme
que je n'avais jamais vu de si belle femme.
cheveux blonds: yeux brillants d'un feu fascinateur,
qui, dans moins d'un instant, subjuguèrent mon cœur.
je me jette à ses pieds: pied mignon, admirable,
jambe ronde; enhardi, d'une lèvre coupable
je dépose un baiser sur son sein palpitant;
mais le froid de la mort me saisit à l'instant,
la femme, dans mes bras, la femme au teint de rose
disparait tout-à-coup et se métamorphose
en un pâle cadavre aux contours anguleux;
ses os s'entrechoquaient, ses yeux éteints sont creux . . .
il m'étreignait, horreur! . . . un choc épouvantable
me réveille, et je vois que le convoi s'ensable . . .
Le convoi dérayant, je vais, je ne sais où,
mais très-probablement je me romprai le cou.

432

— Charade —

mon premier, fin matois à la mine trompeuse
destructeur redouté de la classe rongeuse,
pleins de ruse, a toujours sur les meilleurs fricots,
avec force impudeur, prélevé des impôts.
mon second au collège avec de la saucisse
de nos ventres à jeun faisait tout le délice.
mon troisième est donné dans l'indigestion,
et pour bien digérer, l'anglaise nation,
après un bon souper, chaque soir s'en régale;
mon entier est nommé vertu théologale.

 ton ami, qui te souhaite bonnam [*sic*] valetudinem
 P. Cézanne

Mon cher, je n'ai pas pu, ni Baille deviner ton énigme qui en est vraiment une, à ta prochaine lettre tu m'en diras le mot.

Quant à ma charade je pense que je n'aurai pas cette peine. — Salut à tes parents. —

 P. Cézanne

The solution of the charade is *chat — riz — thé*, or *charité*.

* *

The following is an extract from a letter from Cézanne to Numa Coste dated January 5, 1863. It is published in an article on *Cézanne et ses Amis* by Marcel Provence in the *Mercure de France* for April 1, 1926 (see page 119).

. . . je regrette
 Ce temps où nous allions sur les prés de la Torse
 Faire un bon déjeuner, et la palette en main
 Retracer sur la toile un paysage rupin:
 Ces lieux où tu faillis te donner une entorse
 Dans le dos, quand ton pied glissant sur le terrain
 Tu roulais jusqu'au fond de l'humide ravin,

433

Et *Black,* t'en souviens-tu! Mais les feuilles jaunies
Au souffle de l'hiver ont perdu leur fraîcheur.
Sur le bord du ruisseau les plantes sont flétries
Et l'arbre, secoué par les vents en fureur,
Agite dans les airs comme un cadavre immense
Ses rameaux dépouillés que le mistral balance.

Black was a dog belonging to Coste.

* *

In the *Mercure de France* for October 15, 1907 Émile Bernard
quotes a short poem by Cézanne which was scribbled on the back of a
sketch of his *Apothéose de Delacroix.* The date of the verses is un-
known:

Voici la jeune femme aux fesses rebondies.
Comme elle étale bien au milieu des prairies
Son corps souple, splendide épanouissement;
La couleuvre n'a pas de souplesse plus grande
Et le soleil qui luit darde complaisamment
Quelques rayons dorés sur cette belle viande.

* *

Lines quoted in a letter from Marie Cézanne to Paul Cézanne *fils*
dated March 16, 1911. They were written by Cézanne, probably in
1862, on the margin of one of the ledgers of the Cézanne and Cabas-
sol bank (see page 117):

Mon père le banquier ne voit pas sans frémir
Au fond de son comptoir, naître un peintre à venir.

In Ambroise Vollard's biography of Cézanne a slightly different
version of this couplet is given:

Cézanne, le banquier, ne voit pas sans frémir
Derrière son comptoir naître un peintre à venir.

434

BIBLIOGRAPHY

BOOKS

ALEXIS, PAUL. *Émile Zola: Notes d'un Ami.*
 G. Charpentier, 13 rue de Grenelle, Paris. 1882.
BERTRAM, ANTHONY. *Cézanne.*
 The Studio, Ltd., 44 Leicester Square, London. 1929.
BURGER, FRITZ. *Cézanne und Hodler.*
 Delphin-Verlag, München. 1920.
COQUIOT, GUSTAVE. *Paul Cézanne.*
 Albin Michel, 22 rue Huyghens, Paris. 1919.
DENIS, MAURICE. *Théories.*
 Bibliothèque de l'Occident, 17 rue Éblé, Paris. 1912.
DENIS, MAURICE. *Nouvelles Théories, 1914–1921.*
 L. Rouart et J. Watelin, 6 Place Saint-Sulpice, Paris.
DURET, THÉODORE. *Les Peintres Impressionistes.*
 H. Floury, 4 rue de Condé, Paris. 1922.
DURET, THÉODORE. *Manet and the French Impressionists.*
 G. Richards, London. J. B. Lippincott Co., Philadelphia. 1910.
FAURE, ÉLIE. *P. Cézanne.*
 G. Crès et Cie., Paris. 1926.
FRY, ROGER. *Cézanne: a Study of his Development.*
 Hogarth Press, London. 1927.
GASQUET, JOACHIM. *Cézanne.*
 Bernheim Jeune, Paris. 1921. *Smaller edition, 1926.*

435

BIBLIOGRAPHY

GASQUET, JOACHIM (notice de). *Cézanne*. (Albums d'Art Druet.)
 Librairie de France, 110 Boulevard Saint-Germain, Paris. 1930.
KLINGSOR, TRISTAN-L. *Cézanne*.
 Éditions Rieder, 7 Place Saint-Sulpice, Paris. 1928.
KLINGSOR, TRISTAN-L. *Cézanne*. Translated by J. B. Manson.
 Dodd, Mead and Company, New York. 1924.
LARGUIER, LÉO. *Le Dimanche avec Paul Cézanne*.
 L'Édition, 4 rue de Furstenberg, Paris. 1925.
LE BLOND-ZOLA, DENISE. *Émile Zola, Raconté par sa Fille*.
 Fasquelle, 11 rue de Grenelle, Paris. 1931.
MAUS, MADELEINE OCTAVE. *Trente Années de Lutte pour l'Art*.
 L'Oiseau Bleu, 62 rue de Namur, Bruxelles. 1926.
MEIER-GRAEFE, JULIUS. *Cézanne*. Translated by J. Holroyd-Reece.
 Ernest Benn, Ltd., London. Charles Scribner's Sons, New York.
 1927.
MIRBEAU, OCTAVE (and others). *Cézanne*.
 Bernheim Jeune, Paris. 1914.
ORS, EUGENIO D'. *Paul Cézanne*.
 Chroniques du Jour, Paris. 1930.
PACH, WALTER. *The Masters of Modern Art*.
 B. W. Huebsch, Inc., New York. 1924.
PFISTER, KURT. *Cézanne: Gestalt — Werk — Mythos*.
 Gustav Kiepenheuer Verlag, Potsdam. 1927.
RIVIÈRE, GEORGES. *Le Maître Paul Cézanne*.
 H. Floury, 4 rue de Condé, Paris. 1923.
RIVIÈRE, GEORGES. *Cézanne — Le Peintre Solitaire*.
 Floury, 136 Boulevard Saint-Germain, Paris. 1933.
VOLLARD, AMBROISE. *Paul Cézanne*.
 Galerie A. Vollard, Paris. 1914.
VOLLARD, AMBROISE. *Paul Cézanne*.
 G. Crès et Cie., Paris. 1924.
VOLLARD, AMBROISE. *Paul Cézanne: His Life and Art*. Translated by
 Harold L. Van Doren.
 Brentano's, Ltd., London. 1924.
WEDDERKOP, HANS VON. *Paul Cézanne*.
 Klinkhardt und Biermann, Leipzig. 1922.
ZOLA, ÉMILE. *Correspondance: Lettres de Jeunesse*.
 François Bernouard, Paris. 1928.

436

ZOLA, ÉMILE. *Correspondance: Les Lettres et les Arts.*
François Bernouard, Paris. 1929.
ZOLA, ÉMILE. *L'Œuvre.*
François Bernouard, Paris. 1928.

PERIODICALS

BERNARD, ÉMILE. *Cézanne.*
L'Occident, Juillet 1904. Paris.
BERNARD, ÉMILE. *Souvenirs sur Paul Cézanne.*
Mercure de France, Tome LXIX, Nos. 247–248, 1–16 Octobre 1907. 26 rue de Condé, Paris.
BERNARD, ÉMILE. *Julien Tanguy.*
Mercure de France, Tome LXXVI, No. 276, 16 Décembre 1908. 26 rue de Condé, Paris.
BERNARD, ÉMILE. *La Méthode de Paul Cézanne.*
Mercure de France, Tome CXXXVIII, No. 521, 1 Mars 1920. 26 rue de Condé, Paris.
BERNARD, ÉMILE. *Une Conversation avec Cézanne.*
Mercure de France, Tome CXLVIII, No. 551, 1 Juin 1921. 26 rue de Condé, Paris.
JOHNSON, ERLE LORAN. *Cézanne's Country.*
The Arts, Volume 16, No. 8, April 1930. New York.
PROVENCE, MARCEL. *Cézanne Collégien.*
Mercure de France, Tome CLXXVII, No. 639, 1 Février 1925. 26 rue de Condé, Paris.
PROVENCE, MARCEL. *Cézanne et ses Amis. Numa Coste.*
Mercure de France, Tome CLXXXVII, No. 667, 1 Avril 1926. 26 rue de Condé, Paris.
RIVIÈRE, GEORGES. *Les Premiers Essais de Paul Cézanne.*
L'Art Vivant, 1 Août 1929. Paris.
TABARANT. *Le Peintre Caillebotte et sa Collection.*
Bulletin de la Vie Artistique, 2e Année, No. 15, 1 Août 1921. Bernheim-Jeune, Paris.

INDEX

INDEX

INDEX

CPSIA information can be obtained
at www.ICGtesting.com
Printed in the USA
FSOW04n1800100616
21399FS